add

BRITISH LANDSCAPE PAINTING
OF THE
EIGHTEENTH CENTURY

BRITISH
LANDSCAPE PAINTING
OF THE
EIGHTEENTH CENTURY

Luke Herrmann

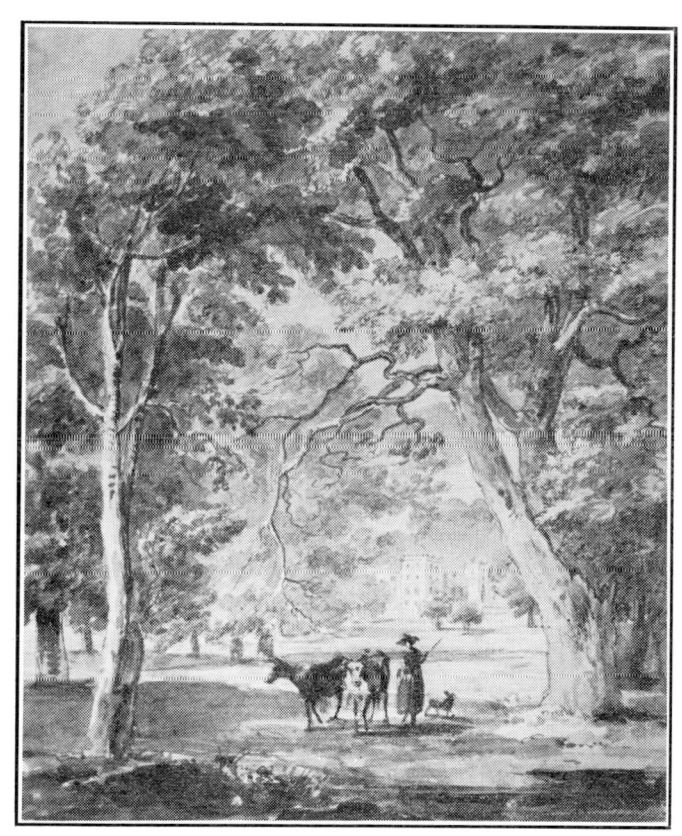

FABER & FABER

3 QUEEN SQUARE

LONDON

First published in 1973
by Faber & Faber Limited
3 Queen Square, London WC1

Printed in Great Britain:
Text by University Printing House, Cambridge
Monochrome plates by Alden & Mowbray, Oxford
Colour plates by W & J Mackay, Chatham

ISBN 0 571 09394 9

© Luke Herrmann 1973

CONTENTS

5

268745

To the memory of
Bruce Ingram

PREFACE

The history of British landscape painting between 1700 and 1900 can be broadly divided into three phases. During the first sixty years of the eighteenth century the influences of the Netherlandish and Italian Schools predominated but were at the same time becoming assimilated into the makings of a native style. Between about 1760 and 1840 the art of landscape painting in Britain was at its height. At the earlier date Richard Wilson, Thomas Gainsborough and Paul Sandby were all reaching maturity in their depiction of landscape. Eighty years later J. M. W. Turner was producing his greatest masterpieces and John Constable had already been three years dead. Among the contemporaries of these masters were Francis Towne, J. R. Cozens, Thomas Girtin, J. S. Cotman, David Cox, Peter de Wint and R. P. Bonington. When considered in the context of the landscape art of their time, all the artists named are of European stature and form the largest coherent group of British artists to have achieved that status.

While these painters were forging ahead in the development of landscape art, their French, German, Italian and Netherlandish contemporaries were mostly content to continue in the accepted traditional styles of their countries. In the second half of the nineteenth century the tables were turned. In Britain landscape art grew weaker and more diluted, while on the Continent, and in France especially, revolutionary advances were made by the Impressionists, their precursors and their successors. At the end of the century there was some revival in Britain when artists such as Sickert and Wilson Steer made their contributions to Post-Impressionist developments.

Such is the history that is traced in this work, which in its two parts will be the first devoted to a study of British landscape painting in the eighteenth and nineteenth centuries. My chief 'raw material' has been the experience of looking at paintings and drawings by landscape artists. Both oil paintings and water-colours are included – the separation of these two mediums has often led to confusion – and topography, but not marine painting, is treated as a branch of landscape art. While much use has been made of contemporary printed material, little has been done in the way of documentary research. In such a large field it has been necessary to be selective. This is not a book for those who require a reference to every artist concerned with the painting of landscape in these islands. It does, however, try to provide a framework into which all the artists omitted can be incorporated.

For convenience the work is divided into two distinct and independent books. The second part, *British Landscape Painting of the Nineteenth Century*, is in the writing and should, it is hoped, be appearing shortly. It will closely follow the approach and character of the present volume, with Constable and Turner at its centre. In both books the illustrations are chosen and arranged to support and elucidate the text. The majority of the principal paintings and drawings referred to are reproduced, and the order of the black and white reproductions reflects that of the text.

There is hardly a museum or gallery in this country which does not include examples of British landscape art in its collections. Over the years I have visited a large number of these, and on all occasions I have received generous help and co-operation from curators. In making my acknowledgements my first debt of gratitude is to all these museum officials. I am similarly indebted to the owners of many private collections, who have allowed me the privilege of seeing their paintings and drawings. I am, of course, especially grateful to the officials and owners of those public and private collections from which I have selected works for reproduction here. In all cases permission has been readily granted. The selection includes several works from the Royal Collection and these are reproduced by gracious permission of Her Majesty The Queen, who has also given leave to print the quotations from *The Farington Diary*.

Much of the work for this book has been done in the Print Room at the British Museum, where I have been given every help and facility. I would like to thank especially the Keeper, Mr. E. Croft-Murray, C.B.E., and Mr. R. Williams (as well as his predecessor Mr. D. Snelgrove). I have also spent long hours in the Western Art Library at the Ashmolean Museum, and here I owe much to Mrs. Gunn and her colleagues. The great resources of the Witt Library at the Courtauld Institute have proved an invaluable aid, and I have received much kindness from the Witt Librarian and his staff. Other librarians and library staffs whom I would like to thank include those of the British Museum, the Victoria and Albert Museum, the Bodleian Library and the University of Leicester. I must also thank the Research Board at Leicester for a travel grant. The Registrar of the Royal Academy, Mr. K. J. Tanner, and members of his staff, have given me considerable assistance in obtaining photographs for reproduction.

There are numerous friends and colleagues who have helped me in many different ways. Some of these are specifically referred to in the footnotes, but I would in addition like to record my special gratitude to Martin Butlin, Malcolm Cormack, Francis Hawcroft, John Hayes and Oliver Millar, who have all shared with me their own special knowledge of British landscape art. John Hayes very kindly read the final typescript and made many valuable suggestions. The Indexes have been compiled by Brian Burch, of the University of Leicester Library.

Lastly, I must thank several people who have lived with this book for a considerable period. Among these are some of my former colleagues at the Ashmolean Museum, and my present colleague, Michael Greenhalgh, who has been admirably understanding while I have been 'landscaping'. My wife, Georgina, has been married to *British Landscape* as long as she has been married to me, and my greatest debt of all is to her, for encouragement, constructive criticism and faultless typing.

In 1843 John Ruskin dedicated the first volume of *Modern Painters* to 'the landscape artists of England'. The present author cannot repeat that dedication, and has chosen instead to commemorate the very remarkable man who opened his eyes to the beauties of British landscape painting.

Clipston, July 1971 L.H.

CHAPTER ONE

The Beginnings, and the Rise of the Classical Tradition

T HE KNOWN FACTS concerning the position of landscape painting in seventeenth-century England have been masterfully assembled by Henry and Margaret Ogden in their *English Taste in Landscape in the Seventeenth Century*,[1] published in 1955. From these it emerges that, while at the beginning of the century there was almost no interest in paintings and drawings of landscape, that interest developed strongly in the 1630s. When Rubens was in England in 1629 and 1630 he painted the well-known canvas of *St. George and the Dragon* for Charles I, in the background of which he incorporated a beautiful view of the Thames valley.[2] During his second stay in England, from 1632 until his death in 1641, Van Dyck made a number of exquisite landscape drawings.[3] In these aspects of their work Rubens and Van Dyck not only reflect the developing taste of the moment but also show how strongly the scenery of England could affect the sensitive artist's eye. As typifying the increasing interest in the painting and drawing of landscape and topography we cannot do better than cite the example of the Earl and Countess of Arundel. When the Earl set out on his famous mission to Vienna in 1636 he was accompanied by the Bohemian artist, Wenceslaus Hollar, who made for him a memorable series of drawings of places on the Rhine and Danube.[4] The 1641 inventory of the new house which the Countess of Arundel had just built in London reveals that a quarter of the 119 pictures listed were landscapes, and that many of these were hanging in the principal rooms.[5] This high proportion of landscape paintings was certainly exceptional at the time but is of especial interest as the Arundels were recognized leaders of taste.

It is unlikely that any of the landscape paintings which decorated Lady Arundel's new house were by British-born artists; indeed only two paintings that could have fulfilled this qualification are known today – a tiny Italianate landscape by Sir Nathaniel Bacon (1585–1627) in the Ashmolean Museum,[6] and a wooded scene with figures, traditionally attributed to Inigo Jones (1573–1652),[7] in the Devonshire Collection. Among British collectors of the first half of the seventeenth century the most popular landscape paintings

1. The author has relied on this painstaking survey for much of his material on landscape painting in seventeenth-century England.

2. In the Royal Collection at Buckingham Palace. See E. Croft-Murray, 'The Landscape Background in Rubens's *St. George and the Dragon*', *Burlington Magazine*, LXXXIX (1947), pp. 89–93.

3. See A. P. Oppé, 'Sir Anthony Van Dyke in England', *Burlington Magazine*, LXXIX (1941), pp. 186–90.

4. See F. C. Springell, *Connoisseur and Diplomat*, 1963, pp. 136 ff.

5. H. V. S. Ogden and M. S. Ogden, *English Taste in Landscape in the Seventeenth Century*, 1955, p. 17.

6. *Paintings in the Ashmolean Museum*, 1962, p. 16.

7. E. K. Waterhouse, *Painting in Britain: 1530–1790*, 1954, p. 56; there attributed to Frans Wouters.

were those by contemporary or near-contemporary Flemish, Roman and Italo-Dutch artists; the names of Bril, Elsheimer, Breenbergh, Poelenburgh, De Momper and Keerincx are among those which feature most often in the inventories. Two of these, Poelenburgh and Keerincx, belonged to the considerable number of foreign landscape artists who worked for a time in England, though actual English views by any of them are extremely rare. As a conclusion to this survey of the place of landscape painting in Britain before the Commonwealth an example of atypical but highly prophetic patronage should be cited. In or about 1644 an unidentified Englishman commissioned two paintings from Claude Lorrain, Nos. 77 and 78 of the *Liber Veritatis*.[1] One of these, *Landscape: Narcissus*, is now appropriately in the National Gallery, to which it was presented in 1826 by Sir George Beaumont.

The rising prestige of the Roman landscape painters is reflected in a publication of 1658, *Graphice: The Use of the Pen and Pencil. Or, the Most Excellent Art of Painting*, by Sir William Sanderson. It includes the first references to Claude in an English book. In a section of advice on where to hang paintings, Sanderson designates landscapes as appropriate for 'The Great Chamber' and also comments that they 'become Chimney pieces'. Throughout the later seventeenth century it was principally as overmantels, overdoors and in other decorative positions that landscape paintings found their place in English houses. In this context it should be remembered that a considerable proportion of the tapestries which decorated the walls of houses in the sixteenth and early seventeenth centuries were of landscape subjects, and thus this decorative use of paintings may be considered as a continuation of that tradition.

Ham House, on the Thames near Richmond, is today the best place in which to see an extensive number of such inset landscape paintings still in their original positions. They are all of idealized or pastoral scenes, and were introduced as part of the major alterations and improvements carried out by the Duke and Duchess of Lauderdale between 1673 and 1675.[2] The artists represented are typical of the Netherlandish painters working in England during these years. Most distinguished among them is Willem van de Velde the Younger (1633–1707) by whom there are four sea-pieces, dated 1673, in the Duchess's Bedchamber; but marine painting does not concern us here. There is a large group of pastoral and idealized scenes by Dirck van Bergen (1640–95), a pupil and imitator of Adriaen van de Velde, who is known to have been in London in 1675. The next largest group is by Abraham Begeyn, also called Bega (1637–97), another Dutch artist who was in London for a time in the 1670s. The remaining landscape panels at Ham House were painted by Thomas Wyck (*c*. 1616–77), and his son Jan (*c*. 1645–1700). The latter spent most of his working life in England and is best known for his battle pieces, though he also painted landscapes, usually featuring horsemen and often panoramic in character.

Jan Wyck was but one of numerous Netherlandish landscape artists who spent

1. M. Röthlisberger, *Claude Lorrain, The Paintings*, 1961, Nos. LV 77 and LV 78.

2. R. Edwards and P. Ward-Jackson, *Ham House – A Guide*, 1951, p. 18.

considerable periods in England in the last decades of the seventeenth century. These are fully discussed by Henry and Margaret Ogden; mention must, however, be made here of two more of the most notable among them – Hendrik Danckerts (*c.* 1630–after 1679) and Jan Siberechts (1627–*c.* 1703). Both these Dutch artists painted actual British views as well as the ideal landscapes that preoccupied most of their contemporaries. In the Royal Collection there are sixteen paintings by Danckerts; eight of these are entitled 'Classical Landscape', two are of Italian scenes (Danckerts travelled to Italy in 1653), and one is a biblical subject set in a spacious landscape, in which the figures are probably by a different hand. The remaining works are views of Hampton Court Palace, Falmouth Harbour, Tangier, and two of Portsmouth.[1] Described by Buckeridge in 1706 as 'a good landskip-Painter',[2] Danckerts successfully combined in his work the predominant ideal, or classical, and the topographical landscape traditions. The same is true of Jan Siberechts, who is best known for his mellow pastoral compositions, in which a stretch of water is usually featured. However, he too painted a number of English views, having come to England between 1672 and 1674. These are much less mechanical than those of Danckerts, and Siberechts was justly described by Buckeridge as 'a close imitator of nature in all his landskips'.[3] His English landscapes range from the delightful and sensitive views of Longleat,[4] which are still in the house, to such extensive and impressive visions as Lord Middleton's well-known *Nottingham and the Trent*.[5] In the Mellon Collection's large *Wollaton Hall and Park*,[6] dated 1697, we see Siberechts successfully mastering the current topographical tradition.

A few English-born artists were also painting landscapes at this time. Most successful of these were Robert Aggas (*c.* 1619–*c.* 1682) and Robert Streater (1624–80). Only one painting definitely by the former, who was also much employed as a scene painter, has survived until today; this is the essentially Italianate river scene in the Painter-Stainers' Hall.[7] Though competent, it provides too little evidence with which to verify Buckeridge's comment on Aggas: 'He is reckoned among the best of our English landskip Painters.'[8] There is more material by which to judge the work of Robert Streater, though much confusion has been caused by the fact that his son, another Robert who died in about 1711, pursued a very similar career – both, for instance, held the appointment of Serjeant-Painter. The elder Streater's best-known work is the allegorical painting on the ceiling of Sir Christopher Wren's Sheldonian Theatre at Oxford, and the only surviving landscape painting that is indubitably by his hand is the *Boscobel House and Whiteladies* in the Royal Collection.[9] Painted for Charles II to commemorate his escape

1. O. Millar, *The Tudor, Stuart and Early Georgian Pictures in the Collection of Her Majesty the Queen*, 1963, nos. 397–412.

2. B. Buckeridge, *An Essay towards an English School of Painters*, 3rd ed. 1754, p. 367.

3. *Loc. cit.* p. 421.

4. M. Whinney and O. Millar, *English Art, 1625–1714*, 1957, pl. 77 *b*.

5. Waterhouse, *loc. cit.* pl. 73.

6. *Painting in England 1700–1850 – Collection of Mr. and Mrs. Paul Mellon*, Richmond, Virginia, 1963, no. 5, pl. 168.

7. Ogden and Ogden, *loc. cit.* frontispiece.

8. *Loc. cit.* pp. 354–5.

9. Millar, *loc. cit.* no. 317, pl. 119.

after the Battle of Worcester, this shows the strong influence of earlier seventeenth-century Flemish landscape painting. It seems likely that Streater also painted landscapes more in keeping with the Italian style, but none of these are known today. Nor are there any Italianate landscape paintings that can definitely be ascribed to Thomas Manby (?1633–95), an English-born artist of whom Buckeridge wrote, 'a good English landskip Painter, who had been several times in Italy, and consequently painted much after the Italian manner'.[1] However, a small number of Manby's Italian drawings, most of them in wash, has survived. These show him to have been an adequate draughtsman in the Italo-Dutch manner with a considerable feeling for problems of light and shade. No drawings of English scenes by Manby appear to be recorded.

The majority of the landscape painters working in England in the later seventeenth century continued to produce ideal or classical landscapes, most of which were imaginary. The title of this chapter calls for a satisfactory definition of the term 'classical landscape', but this has still to be written. What is certain is that the father of the 'classical landscape tradition' was Claude Lorrain. Though he took many of his ideas from earlier example, his own particular rendering of 'a world both ordered and varied, at once simplified,... and full of incident for the eye to dwell upon; a world designed for the imagination to enter and wander about in' set the pattern for future painters of classical landscape. The basic formula was simple – 'an open foreground, like a stage...framing trees on one side balanced by an answering motive on the other, and a circuitous path taking the eye by easy and varied stages to a luminous distance. This distance is the goal of the imaginary traveller in Claude's landscapes and is the point on which the whole composition depends.'[2] The formula allows for infinite variations, and also enables a painter to achieve a 'classical' rendering of a suitable scene in nature. Because the tradition was born in Italy, many of its idealized features are Italian, and thus a distinguishing factor of much classical landscape painting is its Italianate character. A famous example of an Italianate classical landscape painting, which actually depicts a scene in Devonshire, is J. M. W. Turner's *Crossing the Brook* in the Tate Gallery.

Some further seventeenth-century artists who worked in England in this classical vein, and who are still well represented in the Royal Collection, are Jan Loten, Adriaen van Diest, Gerard van Edema, and Jacques Rousseau. While the first three were Dutch by birth, Rousseau was a Frenchman, and he was a specialist in architectural fantasies. There is often also something of an air of fantasy about the castles, palaces and great houses in this country as seen through the eyes of artists painting in the topographical style of the period. Johannes Vorsterman (?1643–c. 1699), who was active in England from about 1673 to 1686, enjoyed widespread patronage, although, as his three views of Windsor Castle in the Royal Collection show, his topographical accuracy was frequently sacrificed to artistic effect. The long-lived Jan Griffier (c. 1646–1718) spent two lengthy periods

1. *Loc. cit.* p. 406.
2. These quotations are taken from M. Kitson's *Introduction* to the Catalogue of the 1969 Arts Council Exhibition *The Art of Claude Lorrain*, shown in Newcastle upon Tyne and London; London ed., p. 7.

of his life in England, from about 1665 to 1695 and again from about 1705 until his death. Though Griffier's life-span brings us well into the eighteenth century, his work is consistently in the seventeenth-century manner, as we see in the Tate Gallery's *View of Hampton Court Palace* (Plate 1 A), which is thought to date from about 1710. In style the fanciful and 'romantic', semi-bird's-eye view of the great palace and its formal surroundings is typical of this kind of topographical painting of the last quarter of the seventeenth century, although it displays greater artistic licence and less accuracy than most of them.

Another Dutch artist who spent much of his life in England, and painted topographical subjects in the seventeenth-century manner well on into the eighteenth century, was Leonard Knyff (1650–1722). His paintings are starker and more naïve than those of Griffier, as is seen in the *View of Hampton Court* (Plate 1 B) in the Royal Collection, which is thought to have been painted early in the eighteenth century. While the details of the palace and its gardens are very similar to those in the contemporary view by Griffier, the effect of the foreground *staffage* and the vivid sky of the latter is replaced in Knyff's composition by a more forceful sense of pattern and line. These qualities are also to be found in some of the few surviving drawings by Leonard Knyff (Plate 2 C), and in the many plates after his drawings that were engraved by Johannes Kip (1653–1722) for the first volume of his monumental *Britannia Illustrata, or Views of several of the Queen's Palaces, as also of the principal Seats of the Nobility and Gentry of Great Britain*, which appeared in 1707.

Before discussing further this and similar topographical publications of the late seventeenth and early eighteenth centuries it will be necessary to examine the life and work of Wenceslaus Hollar (1607–77), who has already been briefly mentioned as accompanying the Earl of Arundel on his mission to Vienna in 1636, and who was undoubtedly the outstanding exponent of landscape art in seventeenth-century England. Hollar was born in Prague, came to England with Lord Arundel late in 1636, and stayed until 1644. After spending some years in Antwerp, he returned to England in 1652 and, except for a visit to Tangier in 1668/9, he remained here until his death in 1677. While most of the landscape painting that has been discussed so far was distinctly second-rate, the drawings and etchings of Hollar reached a standard of individuality and execution which place them among the major achievements of seventeenth-century European landscape art. His topographical work formed only one element in Hollar's immense output of drawings and prints, which also included portraits, figure, animal and botanical studies, biblical and historical subjects, and plates after a variety of other artists. In most of these subjects his work has survived in etchings rather than drawings, but of Hollar's topographical drawings a very considerable number is still known today. Both as an engraver and as a draughtsman Hollar combined confidence and sensitivity of line with an impressive and convincing sense of composition. He knew how to use detail when it was needed, and how to achieve effects with the greatest economy of line when it was not. As a result of these qualities his drawings and etchings of the English scene stand

13

out for their authority and realism, though it must be admitted that frequently Hollar's vision of England is much influenced by the Northern topographical tradition within which he was working. Nevertheless, drawings such as the Barber Institute's *A View of the Thames below Westminster Pier* (Plate 2A), and etchings such as the six views of the countryside around Albury, Lord Arundel's Surrey seat, show Hollar's genuine reaction to the English scene which he recorded with great subtlety. It was a reaction which, as we shall see, was to point the way for all the topographical artists working in England during the next century.

Hollar was far from being the only topographical draughtsman and engraver to work in England during his own lifetime, and he was, in fact, one of the least successful in obtaining patronage or commissions for illustrations for the topographical books that were becoming the vogue. An artist much influenced by Hollar, and more successful in the latter sphere, was David Loggan (1635–92), who was of Scottish descent but was born in Danzig and studied there and in Amsterdam. His best-known works are the two impressive volumes of engravings illustrating the buildings and scenery of Oxford and Cambridge; the *Oxonia Illustrata* was published in 1675, and the *Cantabrigia Illustrata* was completed in 1690. Most of the colleges are shown in detailed bird's-eye views, but there is something of a sense of landscape in the panoramic distant views of the cities. Loggan was assisted by several foreign artists, including Michael Burghers (*c.* 1640–1727), who succeeded him in the office of 'public sculptor' (engraver) at Oxford, to which he had been appointed in 1669. The series of Oxford Almanacks, on which Loggan and Burghers were engaged, began in 1674, but the first purely topographical head-piece did not appear until long after their deaths.

The outstanding surviving group of topographical drawings of England made in the later seventeenth century is that preserved in the Van der Hem Atlas in the National Library in Vienna. Three better-known Netherlandish artists, Willem Schellinks, Jacob Esselens and Lambert Doomer, drew the fifty-five English views, which have been fully published and illustrated in Volume xxxv of *The Walpole Society*.[1] Although these drawings are much more alive and less stereotyped than the topographical work of artists such as Knyff and Loggan, few of them reveal any true feeling for the character of this country. The series had little influence on the development of landscape art in Britain, in spite of the fact that a few English drawings by these artists remained here. However, the mention of Schellinks, Esselens and Doomer serves to remind us that Dutch landscape art achieved its greatest heights in the second half of the seventeenth century. Unfortunately, it was only the minor exponents who were tempted to seek their fortunes in Britain, and this fact added to the essentially provincial character of the work in this country.

As has already been indicated the most notable exception to that tendency was the art of Wenceslaus Hollar, and despite his lack of material success during his own lifetime

1. P. H. Hulton, 'Drawings of England in the seventeenth century by Willem Schellinks, Jacob Esselens and Lambert Doomer', in *The Walpole Society*, xxxv (1954–6).

(he died in absolute poverty) his example and work were to bear ever-increasing fruit in the decades after his death. He had few actual pupils, but numerous followers – foremost among whom was Francis Place (1647–1728).[1] It is tempting to exaggerate the importance of Francis Place, for he is the first undoubtedly British-born artist who devoted himself largely to landscape, and about whom enough is known to bring his career and work to life. In one sense Place was an amateur, since he had sufficient means not to be dependent on his art for a livelihood. Having studied law in London, the outbreak of the Plague enabled him to forsake that career. A few years later he settled in York, where he spent most of the rest of his lengthy life, and became a leading member of the group of *virtuosi*, which also included William Lodge the engraver, Henry Gyles the glass painter, and the antiquary, Ralph Thoresby. Place was prolific as an etcher and a draughtsman, and was also one of the pioneers of mezzotint. While the bulk of his work was concerned with landscape or pure topography, he also tackled many other subjects, among them a series of plates of animals and birds after drawings by Francis Barlow.

While in London, Place had made the acquaintance of Wenceslaus Hollar, and in collaboration with him he executed the illustrations for John Ogilby's English edition of Nieuhoff's *An Embassy from the East India Company to the...Emperour of China*, which was published in 1669. In a letter that Place wrote to George Vertue in 1716 in response to a request for information about Hollar, he described him as 'a person I was intimately acquainted withal', and continued that he himself was 'never his disciple nor anybody's else, which was my misfortune'.[2] The influence of Hollar is strongly felt in most of Place's topographical work, as will be seen when comparing Hollar's *View of the Thames* (Plate 2 A) with Place's view of *Kingston Basin, Hull* (Plate 2 B),[3] one of the considerable group of his drawings in the British Museum. This on-the-spot pen-and-wash drawing repeats several of the mannerisms to be found in similar sheets by Hollar, but in other more intimate landscape drawings Place's style is closer to that of contemporary Netherlandish and Italo-Dutch draughtsmen (the evidence of a small group of drawings formerly in the Bruce Ingram Collection suggests that Place paid at least one visit to the Netherlands). Outstanding among this type of later drawing by Place are the British Museum's two views of *The Dropping Well, Knaresborough*[4] (Plate 4), in which there is real feeling for the character of the landscape that he is depicting with such delicacy.

Place made several sketching tours in the British Isles, often on foot, and he also drew assiduously in York and the area surrounding it. It may be assumed that many of his smaller and slighter drawings, all usually in pen and wash, were executed on the spot, and they frequently have brief inscriptions indicating the location and the date of the

1. See *Francis Place, 1647–1728*, exhibition at York and Kenwood, April–May 1971. Catalogue compiled by R. Tyler.

2. H. M. Hake, 'Some Contemporary Records relating to Francis Place, etc.', in *The Walpole Society*, x (1921–2), p. 67.

3. E. Croft-Murray and P. Hulton, *Catalogue of British Drawings, Vol. I: XVI and XVII Centuries*, 1960, p. 462, no. 13 *recto*.

4. *Loc. cit.* p. 464, no. 19. Dated by R. Tyler (*op. cit.* p. 66) to 1711.

study. Place certainly had a lively and sensitive love of the natural scenery of his native country and was the first British artist for whom the drawing of that scenery was more than a mere technical exercise. This was not only the case with his small sketches and studies but also with many of his larger 'finished' drawings, such as the three impressive panoramic views which were among a small group of Francis Place's drawings rediscovered in about 1951.[1] One of these, the large *View of Drogheda*, dated 1698 and now in the Fitzwilliam Museum, is strongly reminiscent of the work of Hollar, but combines a feeling of atmosphere with its topographical content. The latter is also true of the much smaller pen-and-wash drawing inscribed '*Part of St. Maries nigh York*' (Plate 3A) and dated 1719, which is in the considerable collection of Place's drawings that has been built up by the City of York Art Gallery.

Leonard Knyff, who was an almost exact contemporary of Francis Place, has already been briefly referred to. The drawing by him reproduced here as Plate 2C, the *View from Richmond Hill*, was engraved by Kip for his *Britannia Illustrata*. Though freer than the stiff architectural drawings by Knyff in the British Museum,[2] this panoramic view is so overcrowded with niggling detail that it fails to convey any of the sense of atmosphere that we find in similar drawings by Place. In the engraving it becomes even more conventional, as are the majority of the plates in Johannes Kip's ambitious volume. When published in 1707 this was one of the first of a succession of such eighteenth-century topographical volumes which achieved something of the status of our own 'coffee-table' art books by the subtle means of exploiting the vanity of the nobility and gentry. It became fashionable to have your house illustrated in such a work. A second edition of *Britannia Illustrata* appeared in 1714 and was enlarged to three volumes; a fourth volume was added for the third edition twelve years later. Topographical works of the kind appeared in ever-increasing numbers throughout the eighteenth century, and usually their chief *raison d'être* was the illustrations – the text was unimportant and often almost non-existent. It was in books such as these that the topographical tradition introduced by Hollar was continued, but only rarely did his successors achieve anything like the standards that he had set.

A Flemish-born artist employed in such work, who came to England in 1708, was Pieter Tillemans (1684–1734). He was at first employed by a dealer to make copies of old masters, but an early commission was to execute many of the drawings required by John Bridges to illustrate his *History of Northamptonshire*, which was not, however, published until a long time after the death of both author and artist. Tillemans was something of an all-rounder, for in addition to topography and landscape he also painted animal and sporting subjects, while a signed painting by him in the Royal Collection is a large and ambitious canvas showing *Queen Anne in the House of Lords*.[3] Tillemans's feeling for the English landscape is best seen in some of his rare drawings, such as the delicately coloured sheet inscribed '*From my Turit in Blackfriars Lambeth*' (Plate 3B) in

1. T. Moorman, 'Some newly discovered Drawings by Francis Place', *Burlington Magazine*, XCIV (1952), pp. 159–60.

2. Croft-Murray and Hulton, *loc. cit.* pp. 396–9.

3. Millar, *loc. cit.* no. 489, pl. 206.

the Ashmolean Museum. Most of the landscape paintings and views of gentlemen's country seats by Tillemans include figures, often portraits, in the foreground, as, for instance, in the painting of Windsor Castle attributed to him in the Fairhaven Collection at Anglesey Abbey. From such landscapes with figures it was but a short step to sporting subjects, and in his racing and hunting scenes Tillemans achieves most successfully the placing of the figures in their natural setting. An excellent example of this is the Mellon Collection's *Mr. Jemmet Browne at a Meet of Foxhounds*[1] (Plate 5). In this the framing trees, which give the painting something of a classical character, were no doubt added for their effect, but the inn, the valley, the house on the hill and the village on the skyline all appear to be an authentic representation of the scenery in which Mr. Browne was wont to ride.

Even more of an all-rounder than Tillemans was the English-born artist John Wootton (?1686–1765). Traditionally he is said to have been a pupil of Jan Wyck and an assistant of Jan Siberechts, in which case, if the currently accepted date of 1686 for his birth is correct, he must have been precocious. There is no doubt that he was exceptionally prolific and, though usually regarded principally as an animal painter, he made an important contribution to the development of landscape painting in this country, not least as the teacher of George Lambert. It should also be noted here that in a list of the Stewards of the St. Luke's Club, drawn up in 1744, Wootton, who held the office in 1717, is described as 'Painter, Landskip'.[2] In his racing, sporting and battle scenes the landscape backgrounds are usually painted with confidence,[3] and even in the series of huge canvases that decorate the entrance halls at Althorp (1733) and Longleat (c. 1740) Wootton has used his skill in the painting of landscape to enhance the effect of the almost life-size figures and animals. In the pair of large hunting scenes at Windsor Castle, *The Death of the Stag* and *The Return from the Chase*,[4] both dated 1737, Wootton has placed the royal huntsmen, their mounts and their dogs, in classically composed landscapes, which depict the actual scenery of Windsor Forest; in the latter Windsor Castle is seen on the skyline. More in the Netherlandish tradition are the three 'prospects' of the Thames valley at Henley painted in about 1742 for Lady Archibald Hamilton, the owner of Park Place, in the grounds of which these views were taken.[5] In the *Distant View of Henley-on-Thames* (Plate 6), belonging to this group, the landscape is composed in a manner very like that found in similar views included in the publications of Loggan and Kip, and it appears somewhat stiff and stereotyped, especially in the painting of the distant hills. The same is true of most of the 'house portraits' by Wootton, such as the Duke of Beaufort's *Stoke Park, Gloucestershire*,[6] although these are usually enlivened by delightful groups of figures in the foreground.

1. *Painting in England, loc. cit.* no. 300, pl. 187.

2. W. T. Whitley, *Artists and their Friends in England, 1700–1799*, 1928, vol. II, p. 243.

3. See Rutland Gallery, London, *Paintings by John Wootton*, 1963; this exhibition comprised a representative collection of the artist's work.

4. Millar, *loc. cit.* nos. 545 and 546, pls. 203 and 204.

5. *Loc. cit.* nos. 548–50, pl. 197.

6. Exhibited in *The Origins of Landscape Painting in England*, Kenwood, 1967, no. 33, repr.

Wootton was certainly more in his element when he painted landscapes in the classical tradition, and there are overmantels with classical landscapes by or attributed to Wootton in many houses. In the early 1720s or thereabouts, according to another long-standing tradition, Wootton was enabled to visit Rome through the generosity of the third Duke of Beaufort, and it has been presumed that it was there that he developed his taste for classical landscape painting. It has also been frequently stated that he only began to paint such works in his later years. There is, however, considerable evidence that Wootton must have been painting landscapes much earlier in his career, and perhaps even before his visit to Rome. In a note-book used between 1721 and 1725, George Vertue wrote as follows; 'Mr. J. Wotton. has bravely distinguished himself in his late paintings of Landschape. very much like the pictures of Gaspar Pousin. both as to Invention design & Colouring. he haveing studied from several peices of that masters painting. has perfectly entered into his Manner.'[1] This much earlier painting of landscapes is also confirmed by Horace Walpole, who, when he visited Shortgrove in Essex in 1762, recorded that 'there are many landscapes over Chimnies and doors by Wotton, but done when he was very young'.[2] Walpole also visited Stourhead in 1762 and noticed, 'in the sky-light room…a Landscape by Claud Lorrain – Its companion by Wotton. good'.[3] Neither the Claude nor its companion are at Stourhead today, but among the three works by Wootton that still remain there is the *Hunting Scene* with Henry Hoare, dated 1729, which is relatively early in the artist's career. In this the figures play a subordinate role in what is essentially a classical landscape composition. A painting which shows Wootton at his most classical, and which might well have been painted as a companion piece to a Claude, is the Whitworth Art Gallery's *Classical Landscape* (Plate 7). This has all the ingredients which its title suggests, and, though essentially a pastiche, it is painted with considerable sensitivity. In some of Wootton's classical and pastoral compositions the brushwork is remarkably loose and somewhat nervous in manner, and it may well be that these were painted under the influence of Francesco Zuccarelli, whose paintings were well known in England, where he himself worked from 1752 to 1762 and again from 1765 to 1771.[4]

We may well ask why John Wootton, who enjoyed widespread patronage and was always well-provided with commissions for animal and sporting subjects, should have made time in his busy life to paint such canvases, of which a considerable number are still known today. The taste for landscape painting had become established by the early eighteenth century, and, while during the first three decades of the century the popularity of Dutch and Flemish landscapes continued, those years also saw the rise of interest in the great classical landscape painters, Claude, Nicolas Poussin, Gaspard Dughet and

1. 'Vertue Note Books – Volume I' in *The Walpole Society*, XVIII (1929–30), p. 101.
2. 'Horace Walpole's Journals of Visits to Country Seats, etc.', ed. by P. Toynbee, in *The Walpole Society*, XVI (1927–8), p. 33.
3. *Loc. cit.* p. 42. For details of Wootton's work at Stourhead see K. Woodbridge, *Landscape and Antiquity*, 1970, pp. 22, etc. Here we learn that the companion to the Claude was painted in 1746 (p. 30).
4. See below, Chapter Three, pp. 54–5.

Salvator Rosa, and of their lesser followers. This was due to several causes, of which one of the most important was the great increase of travel in Italy – in the early eighteenth century the Grand Tour, with several months spent in Italy, became established as an essential part of the education of the young English nobleman and gentleman of means. Many of these purchased paintings and drawings while abroad; others on their return home commissioned artists to paint compositions that reminded them of their travels.

At first it was not an accurate topographical record of the Italian scene that was in demand; it was rather that generalized rendering of the Italian landscape in the classical tradition in which artists like Claude and Dughet excelled. As has been pointed out earlier in the chapter, the similar paintings of the Italo-Dutch landscape painters, such as Poelenburgh and Breenbergh, were already known in England and strongly represented in many collections. That it was these, rather than their much greater French and Italian contemporaries, that were so represented reflects the dominant role of Netherlandish art and artists among English patrons in the seventeenth and early eighteenth centuries. An important factor in this situation was, of course, the availability of fresh supplies of these paintings at no great distance, and several English dealers quite frequently visited the Netherlands in search of them. However, once the patrons had themselves become familiar with Rome they soon sought to own the more monumental and evocative classical landscapes of Claude and his followers. How quickly they were brought to England is shown in the series of forty-two engravings after old-master landscape paintings published by Arthur Pond and Charles Knapton between 1741 and 1746. No less than thirty of these were after Dughet, and eight after Claude, while Salvator Rosa, G. Borgognone, Lauri and Rembrandt were represented by one each. Further evidence of the popularity of classical landscape painting among British collectors can be found in their patronage of the French artist Claude-Joseph Vernet (1714–84), who was working in this tradition in Rome (and whose Irish wife gave him the entrée to the British circle). He specialized in coastal and harbour scenes, and most of his inland views also feature water. In the decade from 1738 more than forty pictures were commissioned from Vernet by British patrons, among them Henry Hoare.[1]

The attitude of early eighteenth-century British patrons and collectors towards classical landscape paintings was summed up by the following passage from Jonathan Richardson's influential *An Account of the Statues, Bas Reliefs, Drawings and Pictures in Italy, etc.*, which appeared in 1722. Here Richardson wrote:

'Landskips are in Imitation of Rural Nature, of which therefore there may be as many Kinds, as there are Appearances, of This sort of Nature; and the Scenes may be laid in any Countrey, or Age, With figures, or Without; but if there are Any, as 'tis necessary there should be, Generally speaking, they must be Suitable, and only subservient to the landskip, to Enrich, or Animate it; Otherwise the Picture loses its Denomination, it becomes a History, a Battel-piece, &c. or at least it is of an Equivocal kind. This sort of painting is like Pastoral in Poetry; and of all the Landskip-Painters *Claude Lorrain* has

1. Woodbridge, *loc. cit.* pp. 62–3.

the most Beautiful, and Pleasing Ideas; the most Rural, and of our own Times. *Titian* has a Style more Noble. So has *Nicolas Poussin*, and the landskips of the Latter are usually Antique, as is seen by the Buildings, and Figures. *Gaspar*'s Figures are Such, otherwise he has a Mixture of *Nicolas* and *Claude*. *Salvator Rosa* has generally chosen to represent a sort of Wild, and Savage Nature; his Style is Great, and Noble; *Rubens* is pleasant, and loves to enrich his Landskips with certain Accidents of Nature, as Winds, a Rain-Bow, Lightning, &c. All these Masters are Excellent in their Several kinds, but I think *Poussin* has sometimes Err'd in the Figures he has put into his landskips.'[1]

The demand for originals by these 'Masters' exceeded the supply, and therein lies the reason why an artist such as Wootton turned to producing pastiches of this kind of painting. That he was considered successful by his contemporaries is reflected in the piece about him included by Horace Walpole in his *Anecdotes of Painting in England*. Having discussed Wootton's paintings of horses and dogs, Walpole continues: 'He afterwards applied to landscape, approached towards Gaspar Poussin, and sometimes imitated happily the glow of Claud Lorrain.'[2]

Another artist active in satisfying the same demand was George Lambert (1700–65). Having studied with the portrait painter William Hassel and under Wootton, he was employed as a scene-painter at the Lincoln's Inn Theatre and later became the principal scene-painter at Covent Garden, of which Hogarth's friend and patron, John Rich, was the manager. Though Horace Walpole devotes only a few lines to Lambert himself, he prefaces those lines with some most perceptive comments on the state of landscape painting in Britain:

'In a country so profusely beautified with the amenities of nature, it is extraordinary that we have produced so few good painters of landscape. As our poets warm their imaginations with sunny hills, or sigh after grottoes and cooling breezes, our painters draw rocks and precipices and castellated mountains, because Virgil gasped for breath at Naples, and Salvator wandered amidst Alps and Apennines. Our ever-verdant lawns, rich vales, fields of haycocks, and hop-grounds, are neglected as homely and familiar objects. The latter, which I never saw painted, are very picturesque, particularly in the season of gathering, when some tendrils are ambitiously climbing, and others dangling in natural festoons; while poles, despoiled of their garlands, are erected into easy pyramids that contrast with the taper and upright columns. In Kent such scenes are often backed by sandhills that enliven the green, and the gatherers dispersed among the narrow valleys enliven the picture, and give it various distances.'[3]

There can have been few Englishmen in the mid-eighteenth century who reacted as sensitively to the English landscape as Walpole here proves himself to have done.

Lambert is thought to have been born in Kent, but as far as is known he never painted the hop-fields. Many of his landscape paintings were inspired by those idealized and classical foreign scenes which Walpole regrets, and the originals of which Lambert

1. *Loc. cit.* 1722, pp. 186–7. 2. 1862, ed. R. N. Wornum, vol. II, p. 706. 3. *Loc. cit.* pp. 717–18.

probably never saw, for there is no record that he visited Italy. However, among the surviving canvases of Lambert there are two, both signed and dated 1733 and both formerly in the Duke of Bedford's Collection at Woburn,[1] which show that this artist was able to see the English landscape with eyes aware of its natural beauty. One is the Tate Gallery's *Hilly Landscape with a Cornfield* (Colour Plate I), which has a true understanding of the colours, light and atmosphere of an English summer's day; the other, now in a private collection, is the *Extensive Landscape with four Gentlemen on a Hillside*,[2] featuring a closer view of the right-hand side of the same scene. As views of a specific spot without any obvious topographical feature, these canvases are as exceptional for early eighteenth-century British landscape painting as a whole as they are for Lambert's own work. It is not known for certain, though it is possible, that these two paintings were commissioned for Woburn, where they were not, however, recorded until 1802. The place depicted in them has not been positively identified, but it could well be a view in south Bedfordshire, which has a number of quite hilly areas. Each composition features a group of gentlemen of whom one is drawing, and it has been suggested that they may be engaged on a survey. In the left foreground of the *Extensive Landscape*, a man is seen emerging from a hole in the ground with a heavy basket on his shoulder; one can assume that he is employed in some mining activity. In the more general view of the hill in the *Hilly Landscape* there are various features that could also be interpreted as signs of mining activities. Mining – for fuller's earth – has taken place on the Woburn Estate since the sixteenth century (as it still does today). Have we here the clue as to why Lambert painted this spot? Could these two canvases have been commissioned to record a specific activity on the extensive Woburn Estate?

Whatever the accuracy of this tentative supposition, these paintings are outstanding for their freshness and accuracy of vision. Hogarth, in the only reference to landscape painting in *The Analysis of Beauty*, links Claude and Lambert (who was a friend and an artist with whom he often co-operated) in a brief comment on the painting of the sky: 'The sky always gradates one way or other, and the rising or setting sun exhibits it in great perfection, the imitating of which was Claud de Lorain's peculiar excellence, and is now Mr. Lambert's.'[3] It is certainly true that Lambert painted his skies with much more feeling and veracity than other British artists at this time, and the summer sky in the *Hilly Landscape* is a fine example of this.

Lambert painted landscapes throughout his life, but these are usually much more contrived and 'posed' than the *Hilly Landscape* and its former companion. It is significant that the example of his work which Lambert presented to the Foundling Hospital in 1757 was a rustic scene, the *Landscape with Figures*, which is framed in an overmantel designed by Hogarth. In the foreground there are several buildings among trees, with small figures, rather out of scale, in front of them; through the trees on the right there

1. Christie's sale, 19 January 1951, lots 29 and 32.
2. *George Lambert (1700–1765)*, exhibition at Kenwood, 1970, nos. 5 and 6, both repr. Catalogue compiled by Miss E. Einberg.
3. W. Hogarth, *The Analysis of Beauty*, edited by J. Burke, 1955, pp. 109–10.

is a fine expanse of distant landscape. One must presume that Lambert chose this canvas as a good and typical example of his painting, for it was at the Foundling Hospital that potential patrons might see an artist's work. It seems likely that Lambert painted the figures in this composition himself, but it is known that in other examples they were often painted by Hogarth. That is the case in the charming *Landscape with Farmworkers*[1] (Plate 8) in the Mellon Collection. Here Lambert has deliberately left the foreground somewhat empty for the inclusion of Hogarth's figures, and has concentrated on the valley and the hills in the middle distance and the distance. The effect is something like that of a stage-set, and in many of his rather theatrical landscape compositions Lambert was certainly influenced by his work as a scene painter.

In all these English rural landscapes Lambert was also under the influence of the Netherlandish traditions,[2] and the same is true of his more topographical country-house portraits, such as the view of *Wotton Park*[3] (Plate 9), dated 1739. Other outstanding examples of these are the pair, signed and dated 1746, of *Copped Hall, Essex*.[4] In each the great house, which had just been completed, is shown on its hill-top in an extensive and well-observed landscape; while one features the woodland surroundings on a calm summer's day, the other has a fresh atmosphere of wind, beautifully rendered in the movement of the water of the lake, the leaves of the trees, and the clouds in the sky. In the series of four views of *Westcombe House, Blackheath*, now at Wilton,[5] and in his paintings of *Chiswick Villa*, at Chatsworth,[6] Lambert again incorporates quite extensive landscapes, and shows his awareness of the importance of the surroundings and setting of the house that he is 'portraying'; this was a considerable innovation at the time. In these examples the impression made by the landscapes is one of realism and truth to nature; in the earlier view of *Richmond Castle, Yorkshire*[7] at Goodwood, which is dated 1735, the castle and town are seen in the middle distance, framed by a foreground landscape wholly reminiscent of stage scenery. It was Lambert's success in developing beyond this artificial style that marks him out as one of the pioneers of landscape painting in Britain and as one of the first British-born painters of 'natural' landscape.

In the last sentence of his remarks on Lambert, Horace Walpole draws attention to another of his pioneering activities, his work in 'crayons' or gouache. A few examples of this branch of Lambert's art have recently come to light, including a large and impressive composition of *The great Falls of the Tees*, which is signed and dated 1746.[8] Though some-

1. *Painting in England, loc. cit.* no. 10, pl. 118.

2. See, for instance, the *View of Utrecht*, dated 1745 and adapted from an etching by Herman Saftleven (Kenwood Exhibition, no. 17).

3. Kenwood Exhibition, no. 11.

4. J. Steegman, *The Artist and the Country House*, 1949, pls. 22 and 23. Kenwood Exhibition, nos. 18 and 19.

5. The Earl of Pembroke, *A Catalogue of the Paintings and Drawings in the Collection at Wilton House*, 1968, nos. 34–7.

6. Kenwood Exhibition, nos. 14 and 15.

7. Kenwood Exhibition, no. 7. A version dated 1734 was formerly in Colonel Grant's collection and is reproduced as Fig. 95 in vol. II of his *History of the Old English Landscape Painters*, 1958.

8. Kenwood Exhibition, no. 20. I am most grateful to Miss Elizabeth Einberg for informing me of these Lambert pastel drawings.

what rubbed, this still provides ample evidence to show that Lambert was working very much in line with the gouache style of Marco Ricci and his followers, which was in vogue throughout Europe in the eighteenth century and which will be more fully discussed in the following chapter.

Lambert's English scenes, real and imaginary, have been overshadowed both in the minds of many of his contemporaries and in the judgement of succeeding generations by his landscape paintings in the classical style. His most consistent model for these was Gaspard Dughet, but he also sometimes imitated Claude, and it is a mixture of these two influences that is seen in the National Museum of Wales's *Landscape with a Coastal Inlet*[1] (Plate 10), which is signed and dated 1763. An earlier work, the Tate Gallery's *Classical Landscape* (Plate 11), dated 1745, is more reminiscent of the work of Nicolas Poussin, while in the Victoria and Albert Museum there is a copy after that master's *Landscape with Diogenes throwing away his Bowl*[2] in the Louvre, which Lambert could have known from an early copy in an English collection or from the engraving by E. Baudet. The City Art Gallery in Birmingham has an almost square composition, *The Mouth of an Estuary*, in which the twisted rough tree trunks and other features are typical of the manner of Salvator Rosa. Thus it will be seen that Lambert was well able to produce work in the style of the four major exponents of classical landscape painting, and no doubt he alternated his manner from one to the other in order to meet the particular demands of his patrons. The fact that a number of these compositions are square or almost square in shape indicates that they were probably painted as overmantels.

George Lambert held an honoured place among the leading artists centred on London. He was a founder member in 1760 of the Society of Artists and became its Chairman in 1761; when the Society was incorporated by Royal Charter early in 1765 he was declared President. For a landscape painter to have reached such a position at the time was a considerable achievement. In London Lambert had few, if any, rivals until the very last years of his life, but elsewhere, notably in Edinburgh and in Chichester, the demand for decorative landscape paintings was met by local artists who enjoyed a high reputation. In Edinburgh it was James Norie (1684–1757), his son – another James (1711–36) – and other members of the same family who satisfied this demand in work showing various influences, which often included that of the fanciful compositions of ruins and monuments by Giovanni Paolo Panini (c. 1692–1765/8), who was himself patronized by British visitors to Rome. The *Classical Landscape with Architecture* (Plate 12A) is one of a pair in the Scottish National Gallery that are both signed and dated, *Ja. Norie, Edin. 1736*, and it is not certain whether they are by the father or the son. They are, however, typical of the stiff and insensitive decorative work of this family workshop. One of the apprentices in that workship was Alexander Runciman (1736–85) who, though primarily a history painter, also painted and drew landscapes both in Scotland, and in Italy where he was from 1766 to 1771. The Scottish National Gallery's small *Italian River Landscape, with a Hermit* is reminiscent of Richard Wilson, but some of Runciman's Scottish water-colour

1. Kenwood Exhibition, no. 30. 2. Kenwood Exhibition, no. 16.

views in the Print Room at Edinburgh show a more individual approach to the depiction of landscape.

The position enjoyed by the Norie family in Edinburgh had much in common with that of the three Smith brothers in Chichester. These were William (1707–64), George (1713–76) and John (1717–64), all of whom painted landscapes, though the eldest brother was chiefly employed in portraiture. The youngest brother worked very much in the manner of George, with whom he often co-operated. The three brothers spent the bulk of their lives in Chichester and enjoyed considerable patronage in Sussex and the neighbouring counties. In their later years they all exhibited in London, and George, the most successful of the three – perhaps because he was also the longest-lived – showed over a hundred works between 1760 and 1774. A substantial number of George Smith's landscape compositions were engraved by such leading men as William Woollett and James Peak. On all counts, Smith of Chichester achieved a widespread reputation and it should be remembered that he won this enviable position at the very time when, as we shall see, Gainsborough could not afford to devote himself to the landscape painting he loved and had to concentrate on portraiture to make a living, and when Richard Wilson had difficulty in finding sufficient outlets for his landscape paintings. Today the tables have been turned, and Smith of Chichester is a name that comes to mind as typical of the host of minor artists immensely popular in their own day but largely forgotten since. His success is symptomatic of the fact that the artist who follows the fashion of the moment treads an easier road materially than his contemporary whose work is ahead of his time.

Though there are some surviving canvases by George Smith which show his feeling for the rural and pastoral character of his native Sussex, the bulk of those known today, and also of those that were engraved in his own day, have been justifiably described by Samuel Redgrave as 'pleasing, well coloured, with a tendency to blackness, but mere imitations of Claude and Poussin'.[1] The Tate Gallery's small *Classical Landscape* (Plate 12 B) serves as a typical example of this stylized kind of work. Frequently Smith also borrowed inspiration from Netherlandish landscape artists, particularly in his winter scenes, of which there is a pleasant specimen in the Mellon Collection.[2] That element of George Smith's painting no doubt reflects the fact that in the mid-eighteenth century the taste for the leading seventeenth-century Dutch landscape artists was fast developing in this country. The works of men such as Jacob Ruisdael, Hobbema and Wijnants, which had been previously neglected, were now eagerly sought after, mostly by the same middle-class collectors among whom the Smiths found their own patronage.[3] The growing interest in these natural landscape (as opposed to topographical) paintings was part of the larger movement towards naturalism in art – this was a time when Hogarth could succeed by making the everyday contemporary world the subject of his paintings and engravings.

1. *A Dictionary of Artists of the English School*, 1878, p. 402.
2. *Painting in England, loc. cit.* no. 30, pl. 169.
3. See J. Hayes, 'British Patrons and Landscape Painting – Eighteenth Century Collecting' in *Apollo*, LXXXIII (1966), pp. 188–97.

But compared to the immense popularity of classical landscape painting the growing interest in Dutch naturalism was, as yet, a relatively minor factor. The cult of classical landscape was not only confined to decorating the walls of the great Palladian houses being built during these years – the dominance of the Palladian style was still another aspect of the fashion for all things Italian and classical. This was also the great era of landscape gardening, and in the middle years of the century the character of numerous parks and gardens was being radically altered to create vistas and features designed to excite the imagination and to stimulate literary and historical associations. Many were also reminiscent of the idealized classical compositions of Claude, Dughet and their followers. Two of the outstanding gardens, or 'pleasure grounds' as they were appropriately named, developed at this time are still to be seen: Stowe, where Lord Cobham employed some of the leading architects and gardeners of the time to create areas such as the 'Elysian Fields' and the 'Grecian Valley', and Stourhead, where Henry Hoare [1] developed a variety of tranquil vistas based on both literary and pictorial allusions, among which Claude would have felt truly at ease.

A leading professional figure in the field was the architect William Kent (?1685–1748), who started life as a historical and decorative painter in rivalry to Sir James Thornhill,[2] having studied under Luti in Rome. Under the guidance of Lord Burlington he took up architecture, and one of his earliest tasks in this new sphere was to assist Burlington and the Earl of Leicester with designs for Holkham Hall and its grounds. Here Kent introduced a series of spectacular vistas, which were echoed in the Earl's collection of paintings. This included sufficient classical landscapes to allow for the creation of the 'Claude Room' hung entirely with works by or attributed to that master and his followers. Kent was also concerned in developing Lord Burlington's own garden at Chiswick, one of the most influential of the day. Chiswick House was among the first of the numerous villas close to the Thames, within easy reach of London, being built by wealthy men of all classes in the middle years of the century, and almost invariably set in carefully designed 'pleasure grounds'. This fashion was yet another aspect of the growing interest in the beauties of nature and of landscape, for such villas were specifically built to provide accessible relaxation from the pressures of city life.

Another pioneer of landscape gardening, at his wonderfully sited riverside home in Twickenham (Plate 13 B), was the poet Alexander Pope, who had been trained as a painter and is recorded as having said 'all gardening is landscape painting'.[3] It seems that Horace Walpole would have agreed with this, for in his laudatory remarks about William Kent's achievements as a landscape designer he described him as 'painter enough to taste the charms of landscape, bold and opinionative enough to dare and to

1. See Woodbridge, *loc. cit.*, also for Henry Hoare's collecting of landscape painting.

2. A few landscape drawings by Thornhill are known, including two – *View of Hampton Court Ferry* and *River at Hampton Court* – in the Whitworth Art Gallery, and several in his travel diaries now in the Victoria and Albert Museum (E. de N. Mayhew, *Sketches by Thornhill in the Victoria and Albert Museum*, 1967, nos. 10 and 11).

3. C. Hussey, *English Gardens and Landscapes, 1700–1750*, 1967, p. 40.

dictate, and born with a genius to strike out a great system from the twilight of imperfect essays. He leaped the fence, and saw that all nature was a garden.'[1] The earlier eighteenth-century developments in landscape gardening had mostly been inspired by literary sources; Pope and Kent were largely responsible for the change to the pictorial source of classical landscape painting, which was to dominate the design of gardens in the fruitful years of the middle of the century. As we see in many of Kent's drawings, such as that of the Shell Temple with the entrance to the Grotto beyond in Pope's Twickenham garden (Plate 13 B), and the fanciful landscape drawing relating Hampton Court with Esher Place (Plate 13 A), he was certainly 'painter enough' to extract what he needed from the work of Claude, Dughet and the rest.

While painting-inspired landscape vistas were appearing in all parts of the country, many English ladies and gentlemen travelled with their Claude Glass ready to hand. This was a small blackened convex mirror, which was held up so that the landscape behind could be viewed in it in order to 'catch' a composition reminiscent of the paintings of its namesake. The blackened mirror gave a rather weak reflection, so that the prominent features of the scene were stressed at the expense of the detail, while the colours were also toned down nearer to those found in actual varnished paintings. On returning home from such a 'Claude-seeking' expedition, the same ladies and gentlemen might well spend a happy hour looking through engravings after the paintings of their favourite landscape artists, which men such as Woollett, Pond and Earlom were producing. And then they could go to their shelves and take down James Thomson's *Seasons*, that influential pastoral poem first published as a whole in 1730, and read numerous passages reminding them of the classical landscape compositions that they had seen that day. Some might take paper, pen and brush, and execute their own drawings in the classical taste, as did George III when he was Prince of Wales. A number of the King's drawings are preserved at Windsor, and most of them are classical compositions of trees, parkland, temples and shrines.[2] The vogue for classical landscape had penetrated deeply into the culture and art of mid-eighteenth-century England, but, as the next chapter will show, there was also ample interest in the work of the topographical artist and in the actual British land-scape he depicted.

1. *Anecdotes, loc. cit.* vol. III, p. 801.
2. A. P. Oppé, *English Drawings at Windsor Castle*, 1950, p. 19.

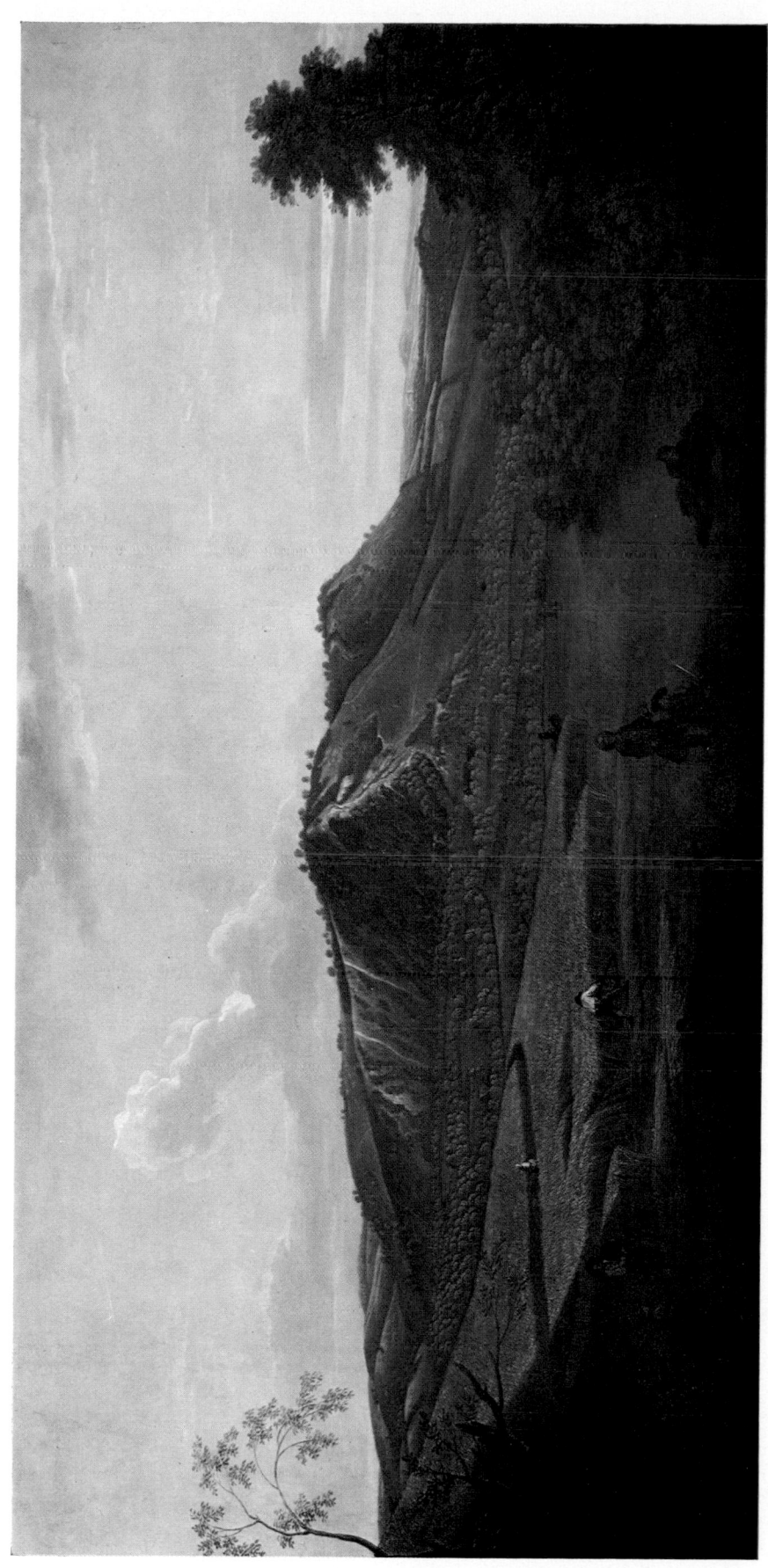

I George Lambert *Hilly Landscape with a Cornfield*, 1733

Canvas, 35¾ × 72¼, 90·8 × 184·2
Tate Gallery, London. *See page 21*

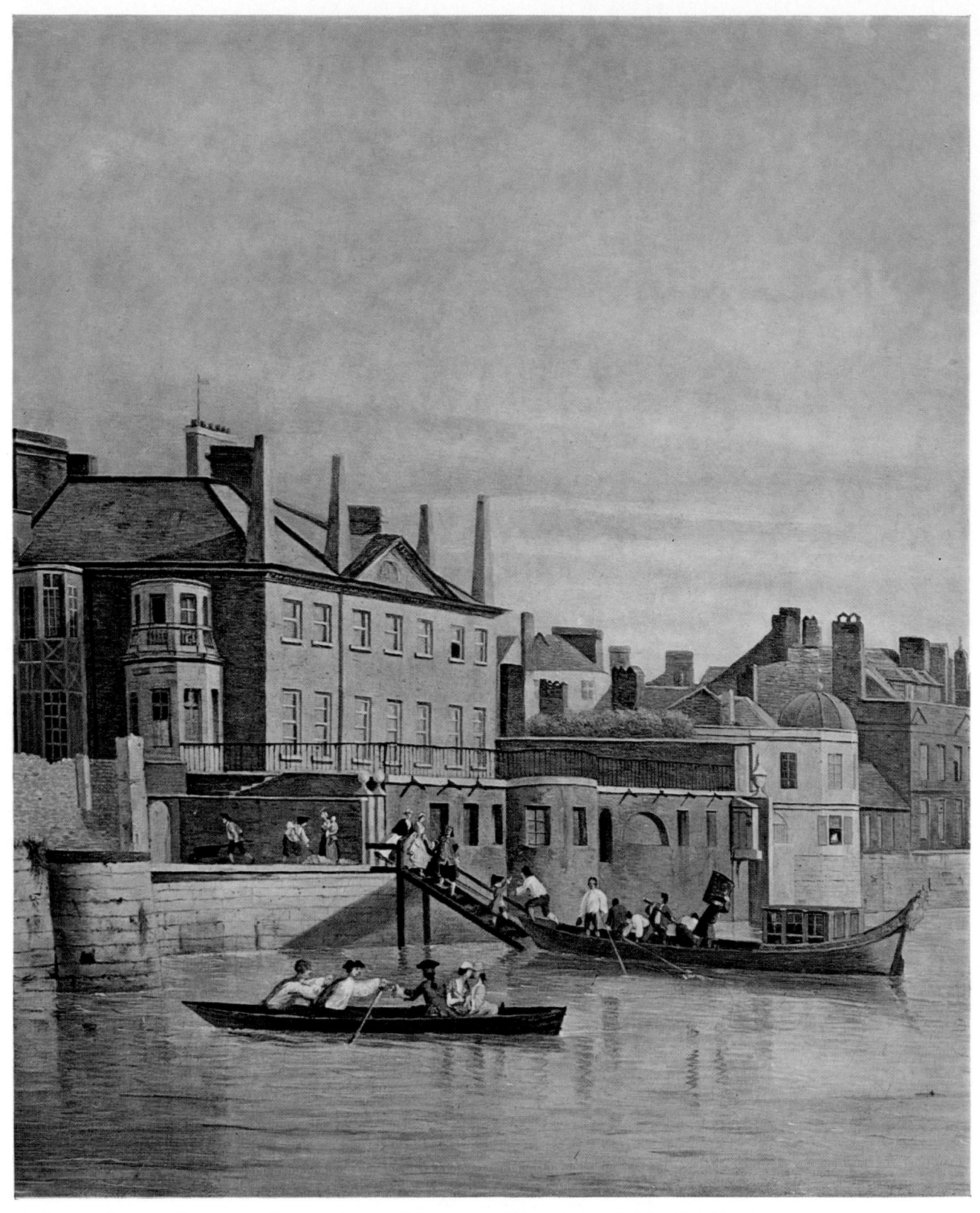

II Samuel Scott *View on the Thames from a Point close to Westminster Bridge* (detail)

Guildhall Art Gallery, London. *See page* 32
For whole canvas see Plate 24B

CHAPTER TWO

The Topographical Tradition

HE BEGINNINGS of topographical art in Britain have been outlined in the previous chapter, where it has been suggested that the work and influence of Wenceslaus Hollar were all-important. In addition much topographical painting and drawing was executed in England by a variety of lesser Netherlandish artists, and these also had their followers. There was little real change in this situation in the first forty years of the eighteenth century, though attention must now be drawn to some more of the artists working in that tradition during those years.

Two families which continued the Hollar tradition, albeit at a low standard, were the Lens's and the Bucks. There were four artists called Bernard Lens, each of a succeeding generation, and it is not certain which of them executed the considerable number of topographical drawings known today, which are signed or inscribed 'Bernard Lens'. Iolo Williams has suggested that it may well have been the third Bernard (1682–1740), rather than the more generally accepted second (1659–1725), who was responsible for these,[1] and it was probably the former artist who drew the *View of Gloucester* (Plate 14) in the Sutherland Collection at the Ashmolean Museum. This dull pen-and-wash drawing is typical of most of Lens's work, though a group of drawings illustrating a trip through Wookey Hole in Somerset is more sensitive.[2] This Bernard Lens was drawing-master to Horace Walpole.

Samuel Buck (1696–1779) and his younger brother Nathaniel, who assisted him from 1727 to 1753, were immensely prolific in producing drawings and engravings of the cities and towns, and ruined abbeys and castles in England and Wales. Over five hundred of their engravings were published in three volumes known as *Buck's Antiquities*. They travelled in the summer making their drawings, and spent the winter engraving the plates from them. The *North East Prospect of Richmond, in the County of York* (Plate 15) is one of four panoramic views of that town in the Sutherland Collection, of which two are dated 1745. They are typical of the painstaking and stiff pen-and-wash drawings of the Buck brothers, and the engravings after them are similar in character, although they often differ considerably in detail from the drawings on which they are based. The work of Samuel and Nathaniel Buck was largely of an antiquarian nature, and their success reflects the growth of interest in the ancient buildings of Britain during the eighteenth century. While those who could afford to go on the Grand Tour tended to be concerned with classical and renaissance antiquities, the far larger number of educated Englishmen who were unable so to travel satisfied their thirst for knowledge of the past by studying the ruins and remains in their own islands. Although the vogue for archaeology did not come until late in the century, there was plenty to be seen above ground, and it became

1. I. A. Williams, *Early English Watercolours*, 1952, pp. 16–17. 2. *Loc. cit.* fig. 29.

as fashionable to visit these ancient ruins as it was to see the new country houses and gardens that were being developed during these years.

Many counties already had their first local historians and antiquaries, and the publications of such learned men were usually illustrated with topographical engravings, though the standard was low and the artists of many of them have long been forgotten. One of the first projects undertaken by the artist John Joshua Kirby (1716–74) was a history of his native Suffolk, and he published twelve plates connected with this in 1748. The work was never completed, and Kirby, a friend of Hogarth and of Gainsborough, went on to greater things, including the position of drawing-master to the future George III when Prince of Wales. The products of that instruction have already been briefly referred to:[1] it may also have been the influence of Kirby, who was an authority on perspective, that resulted in George III's interest in the work of Canaletto.

It was from Italy, and especially from Canaletto, that the state of topographical art in this country received a much needed injection of new life and interest in the 1740s. From the beginning of his career as a painter of Venice, Giovanni Antonio Canal, called Canaletto (1697–1768), found his chief patronage among the English visitors and residents in that city. Throughout the later 1720s and the 1730s numerous works by Canaletto came to England; one of his outstanding commissions was that for the twenty-four canvases now at Woburn, which were ordered by the 4th Duke of Bedford in 1732. The magnificent group of fifty paintings and over one hundred and forty drawings by Canaletto in the Royal Collection did not reach England until 1762, when they were purchased by George III from Consul Smith, who lived in Venice and had acquired them over the years direct from the artist. Long before this, Canaletto was already superbly represented in numerous British collections, and his work and manner must have been well known to many connoisseurs and artists in this country. However, it was not until Canaletto himself came to England, and painted and drew in London and elsewhere, that British artists were strongly influenced by his example.

The way for his impact in England had been prepared by the slightly earlier arrival of a minor follower, Antonio Joli (?1700–77), who was in London from 1744 until about 1750, and is known to have been patronized by the Duchess of Richmond while in England.[2] He was also employed as a scene-painter. Joli's London views have much in common with those of Canaletto, but they are stiff and lifeless in comparison. As a result of the War of the Austrian Succession the number of English visitors to Venice had much decreased, and Canaletto was quite easily persuaded to travel to England to seek out his erstwhile patrons as well as to find new ones. He arrived in England in the early summer of 1746, and his arrival was fully noted by George Vertue: 'Latter end of May. came to London from Venice the Famous Painter of Views Cannalletti...of Venice. the Multitude of his works done abroad for English noblemen & Gentlemen

1. Above, p. 26.

2. H. F. Finberg, 'Canaletto in England' in *The Walpole Society*, IX (1920–1), pp. 52–3. Joli is thought to have been responsible for decorating the painted hall in John Heidegger's house in Richmond, which is fully discussed by E. Croft-Murray in volume LXXVIII (1941) of *The Burlington Magazine*, pp. 105–12 and 155–9.

has procurd him great reputation & his great merrit & excellence in that way, he is much esteemed and no doubt but what Views and works He doth here, will give the same satisfaction – tho' many persons already have so many of his paintings.'[1]

The venture proved successful, and among his earliest commissions in England was that for the two magnificent London views which he painted for the Duke of Richmond, who already owned a number of his Venetian paintings. Though it has been suggested by recent research that these two masterpieces were not, as has always been thought, the very first works painted by Canaletto in England,[2] they are early enough to stand here as illustrations of the immediacy and freshness of Canaletto's reaction to the English scene. *Whitehall and the Privy Garden from Richmond House* (Plate 16) has the same intimacy and vivacity that make Canaletto's painting of Venice so appealing; accurate and beautifully drawn detail is skilfully combined with a real feeling of life and atmosphere, though it was, understandably enough, the crisp morning light of a clear English summer's day rather than the more commonly experienced tones of our humid weather that usually attracted the Italian artist. This great painting, and its companion, *The Thames and the City of London from Richmond House*,[3] rapidly set a new standard in the representation of London and of its river.

The two 'classic' Canaletto views of the Thames were taken from the terrace of Somerset House; each is represented in a drawing and a painting in the Royal Collection, all originally acquired by Consul Smith. It appears probable that the paintings as well as the drawings were executed in London before Canaletto's temporary return to Venice in 1750, and not, as has been suggested, during his eight-month stay there.[4] In both the *View of Westminster from the Terrace of Somerset House*,[5] of which the drawing is reproduced here (Plate 17A), and in *The Thames from Somerset House Terrace towards the City*[6] (Plate 17B), the bold sweep of the river and the features of the skyline are combined into beautifully balanced compositions in which the dome of St. Paul's Cathedral and the bulk of Westminster Abbey are skilfully placed as the dominant features, while the play of light on the other higher buildings subtly enlivens the skyline. The overall light effect in these two canvases is definitely one of humidity and slight mist. This is especially so in the view of the City, in which dark rain clouds are lowering above the terrace on the left. Lost versions of both compositions were engraved, the Westminster view by J. S. Müller in 1751, and that of the City by Edward Rooker in the previous year. It was no doubt these engravings that stimulated so many later artists to paint and draw very similar compositions.

Another of Canaletto's London masterpieces is a second view of Whitehall from

1. 'Vertue Note Books – Volume III', in *The Walpole Society*, XXII (1933–4), p. 130.

2. W. G. Constable, *Canaletto*, 1962, vol. II, nos. 438 and 439; and J. Hayes, 'Parliament Street and Canaletto's Views of Whitehall', *Burlington Magazine*, c (1958), pp. 341–9.

3. Constable, *loc. cit.* no. 424.

4. M. Levey, *The Later Italian Pictures in the Collection of Her Majesty the Queen*, 1964, pp. 55–6.

5. K. T. Parker, *The Drawings of Antonio Canaletto in the Collection of His Majesty the King*, 1948, no. 115.

6. Levey, *loc. cit.* no. 374.

Richmond House, which belongs to the Duke of Buccleuch.[1] This is not a flattering topographical composition of an important part of London, but a candid record of a somewhat scruffy and ill-organized yet essentially living city, similar in feeling and effect to that marvellous painting of Venice, '*The Stonemason's Yard*' in the National Gallery. As we shall see, these and other London paintings of Canaletto were immensely influential on painters of London throughout the century after his own visits.

An example of the rapidity of this influence is seen in the impressive *Panorama of the City and South London from Montagu House*, painted in 1748 for the Duke of Montagu by Robert Griffier (1688–*c.* 1770), elder son of the artist Jan Griffier mentioned in the previous chapter. Hitherto Robert, and his brother John, had painted topographical subjects much in the same manner as their father. That tradition is still in evidence in the 1748 *Panorama*, but this also reveals the undoubted impact of Canaletto, both in its bold light effects and in its beautifully painted background, in which a mass of detail is recorded with remarkable facility. The connection between this canvas and the two famous London views (Plate 16) painted by Canaletto for the Duke of Richmond, who was the Duke of Montagu's London neighbour, has been convincingly outlined by Dr. John Hayes.[2]

Also very influential on British topographical art were Canaletto's views of a variety of landmarks outside London. The furthest removed from the capital is Alnwick Castle in Northumberland, which Canaletto was commissioned to paint by the future 1st Duke of Northumberland (of the third creation) just before its restoration, probably by James Paine, which began in 1752.[3] For the same patron he had already painted a view of Syon House;[4] in this the square pile is most effectively shown in its Thames-side setting. Another riverside view by Canaletto is the atmospheric painting of *Old Walton Bridge*[5] (Plate 18) at Dulwich, in which the pale grey wooden bridge is dramatically shown against the heavy dark clouds so typical of a threatening English summer sky. Most famous of Canaletto's views outside London, and again one in which the Thames is a prominent feature, is the National Gallery's *Eton College*[6] (Plate 19), which was probably painted in 1754, during Canaletto's final visit to England. (Having returned to England in the summer of 1751, he paid another visit to Venice two years later, from which he came back in 1754, returning finally to Venice late in 1755 or in 1756.) Except for 'the general position of the chapel and its relationship to the school buildings' (to quote from the National Gallery *Catalogue*) 'most of the details of topography in the picture are inaccurate'; even the architectural detail of the chapel is 'mostly wrong', and the buildings on the horizon at the left are 'probably inventions by Canaletto'.[6] In many ways the painting has the characteristics of a capriccio, and indeed a building strongly reminiscent of Eton Chapel does appear in a capriccio by Canaletto.[7] However, despite its

1. Constable, *loc. cit.* no. 439.
2. J. Hayes, '*A Panorama of the City and South London from Montagu House* by Robert Griffier', *Burlington Magazine*, cvii (1965), pp. 458–62.
3. Constable, *loc. cit.* no. 408.
4. *Loc. cit.* no. 440.
5. *Loc. cit.* no. 441.
6. *Loc. cit.* no. 450; M. Levey, *The Seventeenth and Eighteenth Century Italian Schools*, 1971, pp. 27–8.
7. Constable, *loc. cit.* no. 475.

inaccuracies, Canaletto's view of Eton from across the river remains one of the most memorable records of that much painted scene, and in its vivid rendering of light and colour it recreates, if perhaps somewhat idealistically, the atmosphere of a hot summer's day on the Thames.

It has been suggested that the most immediate and direct follower of Canaletto's style in the painting of London was Samuel Scott (*c.* 1702–72), and that, though already enjoying a considerable reputation as a marine painter in the tradition of the Van de Veldes, Scott was moved to take up topographical painting by the Italian artist's success in England. While the available evidence is still far from complete and raises many problems, it would seem to lead to a somewhat different conclusion, which is more in keeping with Horace Walpole's brief reference to Scott, who was for some years his neighbour in Twickenham and an artist whose work he greatly admired. He described him as 'not only the first painter of his own age, but one whose works will charm in every age...If he was but second to Vandevelde in sea-pieces,' continues Walpole, 'he excelled him in variety, and often introduced buildings in his pictures with consummate skill. His views of London-bridge, of the quay at the Custom-house, &c. were equal to his marines, and his figures were judiciously chosen and admirably painted; nor were his wash drawings inferior to his finished pictures.'[1] Walpole, who himself possessed eight canvases by Scott, while his brother, Sir Edward, owned several of Scott's 'largest and most capital works',[2] clearly considered Scott as first and foremost a marine painter.[3] He certainly continued to paint marine subjects well into the 1750s, though in these his style was very little altered from that which he had developed in the 1730s.

On the other hand there is considerable evidence that Scott, who spent the greater part of his life in London, was already engaged in topographical work well before the time of Canaletto's arrival in the city. A competent drawing of *Westminster Abbey and Hall from the River* in the British Museum can, on internal evidence, be dated before 1738. Several of Scott's marine paintings dating from the 1730s and earlier 1740s have landscape and topographical backgrounds that are skilfully executed – among these is the Mellon Collection's *Shipping off Dover*, which is dated 1738. From the painting of landscape and topographical backgrounds it was an easy step to the practice of pure topography, and while the earliest known dated topographical painting by Scott, one of his many views of the river at Westminster, is of 1746, there is no positive reason to believe that he had not executed others in the decade before this. However, it is certainly a fact that Scott's topographical work greatly increased in the later 1740s and in the 1750s.[4]

1. *Anecdotes of Painting in England*, 1862 ed., vol. II, p. 709.

2. *Loc. cit.* Three of these were bequeathed by Sir Edward Walpole to the Company of Fishmongers, which still owns them.

3. In 1732 Scott collaborated with George Lambert in a series of six views of their more important settlements, commissioned by the East India Company. Lambert painted the buildings and landscape, and Scott the shipping; presumably the work was similarly divided when these artists again collaborated in a series of five views of Plymouth and Mount Edgecumbe, which were published as engravings in 1750–55, and of which the originals are lost.

4. I am most grateful to Kenneth Sharpe, who is engaged on a monograph on Samuel Scott, for allowing me to discuss with him some of the problems concerning this artist.

The bulk of the London scenes are views on the River Thames and, as is only to be expected, in these the shipping and boats usually play an important role. Indeed it can be claimed that Scott is at his best and most impressive in compositions in which the topography and the shipping play more or less equal parts. One such is the large *The Thames and the Tower of London on the King's Birthday* (Plate 20), in the Mellon Collection, in which the vessel in the foreground successfully balances the bulk of the Tower on the skyline. The version illustrated is dated 1771 and is probably the painting which Scott exhibited at the Royal Academy that year with the title, '*A View of the Tower of London, supposed on his Majesty's birthday*'; it was Scott's only Academy exhibit. Another version of this composition, in the collection of Viscount Hambleden, is dated 1753, and though it antedates it by eighteen years there are only relatively minor variations from the Mellon painting. An undated and even larger canvas of the same scene in the Earl of Malmesbury's collection has more important divergences, particularly in the shipping.

The majority of Scott's London scenes are concerned with the stretch of the river at Westminster, where the bridge was being built in the mid-1740s – an event which was of paramount importance for Londoners. One of the grandest compositions of this scene, *A View over the River towards Westminster* (Plate 21), shows the Abbey on the skyline to the left, Westminster Hall in the centre, and the new bridge, in some versions, such as the one reproduced here, still incomplete on the right. This view was not painted by Canaletto, and, in fact, as a comparison of the two artists' paintings of the river quickly shows, Scott and Canaletto usually chose quite different viewpoints. An exception is the vista towards Westminster from near York Water Gate, of which the principal Canaletto version was in the Duke of Grafton's collection,[1] while a fine painting of much the same scene by Scott was formerly at Northwick Park.[2] Another Scott painting of *Westminster Bridge* (Plate 22), the detailed close-up of the northernmost arch seen from the west, also brings Canaletto much to mind, though in actual fact the only known comparable work by the Italian, the Duke of Northumberland's *London: seen through an Arch of Westminster Bridge*,[3] is very different in character.

A second Thames view formerly at Northwick Park and now in the Guildhall Art Gallery, the *View on the Thames from a Point close to Westminster Bridge*[4] (Colour Plate II and Plate 24B), reveals Scott's more personal vision of London. While, just like the Palazzi on the Grand Canal in Venice that feature so frequently in Canaletto's paintings, most of the houses shown in this painting were the homes of the rich and famous, the overall atmosphere of the composition is that of an intimate everyday scene, as it is in many of Canaletto's Venetian pictures. In these less formal views of London's river Samuel Scott is most truly himself. A successful combination of the two sides of Scott's painting of the river is seen in the Fishmongers' Company's *Westminster Bridge* (Plate 23) which is dated 1747 and which was one of the works that belonged to Sir Edward Walpole.

1. Constable, *loc. cit.* no. 427. 3. Constable, *loc. cit.* no. 412.
2. Sotheby's sale, 25 June 1965, lot 84. 4. Sotheby's sale, 25 June 1965, lot 85.

32

In 1748 Scott took a house on the river at Twickenham, then a highly fashionable village, and here he made a number of drawings which have survived, such as the *View of Twickenham from the River* formerly in the Bruce Ingram Collection, which is signed and dated 1758.[1] In the same collection was the *Study of Buildings by the Thames at Deptford* (Plate 25A), now in the Huntington Collection,[2] which has been identified as a study for the right half of the painting, *The Thames at Deptford* (Plate 25B), in the Tate Gallery. In such drawings we clearly see Scott's sensitive reaction to the less formal and more rural scenery of the Thames, which is also displayed in such atmospheric paintings as *The Thames at Deptford* and its companion, *The Thames at Battersea*.[3] In these drawings and in most of his paintings Scott proves himself to have been an able draughtsman. On the other hand, in one of his more formal compositions, the Bank of England's well-known *Building of Westminster Bridge*, which was painted in 1748 and 1749, there is considerable error in the drawing of the Abbey, which may be the result of distortion caused by using a *camera lucida* or the like. Such careless drawing is repeated in a number of other London scenes, but there is no positive evidence that Scott ever used such an aid.

Two London views of an entirely different character, and in which the Thames does not feature, are Scott's *View of Horse Guards Parade*, of which a fine version dated 1755 was recently on loan to the National Museum of Wales, and his ambitious painting of *Covent Garden*, which belongs to the Duke of Bedford. (An unfinished version of this is in the London Museum.[4]) In the *Covent Garden* the entire foreground is filled with scenes of market activity, in the painting of which Scott was assisted by his apprentice, Sawrey Gilpin, who worked with him for nine years from 1749, and who was later to achieve fame as an animal artist.

Scott retired from London in 1765, living first at Ludlow and then moving to Bath, where he died. There are few paintings which can be firmly attributed to these final years, when Scott was in any case a sick man as he had already been during his later years in London. *A Street in Ludlow*,[5] in the collection of Mr. Harald Peake, may be presumed to date from shortly after Scott's retirement from London. While it shows a certain decline in skill it remains nevertheless an appealing record of a small English town and is an interesting example of Scott's purely topographical work which frequently, as here, shows a sensitivity for specific effects of light and weather. Hitherto a true judgement of Scott's standing as a landscape painter has been impossible because of the large number of

1. Messrs. P. & D. Colnaghi, London, *Masters of Maritime Art. A third loan Exhibition from the Collection of Capt. Bruce S. Ingram*, March 1938, no. 50, repr.

2. R. R. Wark, *Early British Drawings in the Huntington Collection*, 1969, pp. 42–3.

3. Both illustrated by H. F. Finberg in 'Samuel Scott', *Burlington Magazine*, LXXX (1942), pp. 200–1. The two paintings were shown in the *Samuel Scott Bicentenary Exhibition* at the Guild-hall Art Gallery (May–June, 1972, nos. 42 and 41), where it was suggested that they could be identified with two items in Scott's studio sale of 1765 (nos. 56 and 55), entitled respectively, *A Morning, with a View of Cuckold's Point* and *A Sunset, with a View of Nine Elms*.

4. J. Hayes, *Catalogue of Oil Paintings in the London Museum*, 1970, no. 99.

5. *Bicentenary Exhibition*, 1972, no. 48, illustrated.

3

works attributed to him entirely without justification. From the relatively small number that can now be accepted as his work it becomes clear that he was an artist with a personal and original style which enabled him to record the scenery of London in a convincing and impressive manner. Further research into his life and work could well result in establishing him as a major figure in the development of British landscape painting as a whole: at the moment he stands out as very much the best among a number of even more shadowy artists working on similar lines during the middle years of the eighteenth century.

One such was Joseph Nickolls, who was active from 1726 to 1748, and who is represented in the Mellon Collection by a pair of views of the river at Twickenham, one of which is dated 1726, while the other depicts Pope's Villa.[1] These show him to have been a reasonably able topographical artist with some feeling for the atmosphere of the Thames, which is also seen in a broad *View of the Thames*, dated 1748. Two of Nickolls's London views were engraved in 1738. The few examples of his work that are known as such today prove that Nickolls was at least an adequate predecessor of Canaletto and Scott in the depiction of London. William James, who exhibited in London from 1761 to 1771, is an artist to whom large numbers of London views, in the manner of Canaletto and of Scott, but too weak to be by either of those artists, have been attributed. Edward Edwards states that James was actually Canaletto's pupil in London,[2] but thinks little of his work. The Royal Collection, the Ashmolean Museum, and several other public collections include London views that were for long attributed to James, but in no single case is that attribution based on firm evidence, and no fully authenticated painting by James appears to be known today. This artist has had the misfortune of having for long years been the most popular Canaletto–Scott 'waste-paper basket' among collectors, dealers and auctioneers.

An artist who was recorded as early as 1745 by George Vertue as a copyist and imitator of paintings by Canaletto, and also of Panini, is Francis Harding, 'painter of landskhipes etc., and coach painter',[3] who died before 1767. In 1766 Sir Gregory Page, of Blackheath, owned ten paintings by Harding, of which eight were after Panini and two after Canaletto. Three of the former reappeared quite recently in a London sale-room, having been long attributed to Panini himself.[4] There is no record today of the 'peices of Landskip in Rounds which he has presented to the Foundling hospital' also mentioned by Vertue. The eight roundels now in the Court Room of the Foundling Hospital, which will be discussed below, do not include any example by Harding, who, despite the researches of Mrs. Finberg,[5] remains, like William James, a very obscure figure. A contemporary

1. *Painting in England 1700–1850 – Collection of Mr. and Mrs. Paul Mellon*, Richmond, Virginia, 1963, no. 15, pl. 144.

2. E. Edwards, *Anecdotes of Painters*, 1808, pp. 26–7.

3. 'Vertue Note Books – Volume III', in *loc. cit.* pp. 126–7.

4. Sotheby's sale, 18 October 1970, lots 12–14 (property of John Cator, Esq.). They were exhibited as by Panini at Norwich in 1964 (*Fine Paintings from East Anglia*, nos. 45–7).

5. H. F. Finberg, 'Francis Harding: A Forgotten Painter of Architecture', *Country Life*, XLVII, no. 1217 (1 May 1920), pp. 596–7.

of these two artists also reputed to have painted London scenes in a similar manner was Thomas Priest, while the work of the slightly later Irish-born artist Herbert Pugh was in the same vein. Much research remains to be done in sorting out the numerous paintings of London which are imitations or copies of the works of Canaletto and of Samuel Scott. The large number of such paintings which still survive do, however, indicate the great popularity of topographical paintings of London in the second half of the eighteenth century and in the early nineteenth century.

While many later painters were content merely to make copies, others chose rather to base their own work on the Canaletto–Scott manner. One such was John Thomas Serres (1759–1825), son of the marine painter Dominic Serres, and himself active as both topographical and marine artist. He succeeded his father as Marine Painter to the King and is represented by six paintings in the Royal Collection, of which two are large views on the Thames painted in the 1790s.[1] The later of these, which is signed and dated 1798, is *The Thames at Windsor Bridge* (Plate 24A). The reproduction has here been placed among those of paintings by Scott to show how close this work is to his manner. J. T. Serres was typical of the many lesser topographical artists content to follow earlier styles and unaffected by contemporary developments.[2] While this is true of some working in London, it applies, of course, far more to those who were active in the provinces. Despite, or perhaps because of, the old-fashioned character of his work, J. T. Serres enjoyed considerable success. For a time he also practised as a painter of marine panoramas. In the later years of his career he was apparently persecuted by his wife, Olivia. This difficult lady was herself an amateur landscape painter, and, somewhat surprisingly, she was appointed Landscape Painter to the Prince of Wales in 1806. Olivia Serres is represented in the Royal Collection by two *Classical Landscapes* that are weak pastiches of Richard Wilson.[3]

To return to Samuel Scott, he appears to have kept in the background in the various movements among London's artists to form themselves into effective and powerful associations. Perhaps symptomatic of this is the fact that Scott was not one of the artists invited to execute topographical roundels for the Court Room of the Foundling Hospital, even though he was a governor. Largely through the activities of Hogarth, this was becoming an important meeting place for artists in the later 1740s. The earliest of the eight roundels are the two by Richard Wilson and another pair by E. Haytley (active 1745–61), which all date from 1746, the very year in which Canaletto first came to England. Apart from these two paintings Haytley is known only as a portrait painter. At this time Wilson was established in the same branch of painting and, as we shall see, only one landscape attributed to him that is probably earlier than his Foundling Hospital roundels is recorded today. Haytley's two roundels depict *Chelsea Hospital* (Plate 26) and *Bethlehem Hospital*, and although it could be suggested that they reveal a knowledge

1. O. Millar, *The later Georgian Pictures in the Collection of Her Majesty the Queen*, 1969, nos. 1077–8.

2. From Farington's *Diary* (16 November 1799)

we learn the interesting fact that in the winter of 1799–1800 Serres worked in the house where J. M. W. Turner had his lodgings.

3. Millar, *loc. cit.* nos. 1082–3.

of Canaletto's work, they are much closer to the work of the Dutch seventeenth-century townscape painters, such as Jan van der Heyden and the Berckheyde brothers of Haarlem. The same is true of the rather stiff contributions of Samuel Wale (d. 1786), who was to become a Founder Member of the Royal Academy and then its first Professor of Perspective. He made his name as an illustrator and history painter, and only rarely attempted landscape. Wale's three roundels, presented in 1748, show Christ's, Greenwich (Plate 27), and St. Thomas's Hospitals. The eighth roundel in the Court Room of the Foundling Hospital was contributed, also in 1748, by Gainsborough, who was only twenty-one at the time.

The inclusion of these small paintings in the rich decorative scheme of the Court Room, where they were hung beside large canvases with biblical subjects by Hayman, Highmore, Hogarth and Wills, may be taken as another indication that, despite the small number of established practitioners, topographical painting was much in vogue. It was a development in which the influence of Canaletto was certainly of great importance, though it was not to bear really significant fruit among British artists for some fifty years. But the time was ripe for the appearance of an English topographical artist of calibre, and the man who fulfilled this role admirably was already at the threshold of his career. This was Paul Sandby (1730–1809), who had come to London from his native Nottingham shortly before the arrival of Canaletto.

It should be remembered from the outset that Paul Sandby was much more than just a topographical artist in water-colours, and that his work was richly varied in subject, style and medium. It has, however, become customary to consider him only as a pioneer in the development of water-colour, and thus to neglect the other sides of his art. Though this aspect of his work cannot be discussed here, it is arguable that as a figure draughtsman alone he would deserve a high place in the annals of eighteenth-century British art. What does concern us closely is Sandby's considerable output in gouache or body-colours, a medium in which he showed more consistent confidence than he ever did in water-colours. Finally, in addition to producing numerous drawings for the engraver, Sandby himself developed great skill as an etcher, and he was largely responsible for the popularization of the new process of aquatint, in which he first worked in 1774. While it is included, chiefly for the sake of convenience, in the chapter on 'The Topographical Tradition', the following survey of Paul Sandby's art breaks new ground in attempting to discuss his work as a landscape artist as a whole. As a result it should become clear that he gained the leading position that he enjoyed among artists of the day because he was correctly considered by his contemporaries to be one of the formative figures in the development of British art in the second half of the eighteenth century, which was, of course, a period of unprecedented advances. We will shortly be studying the crucial importance of the contributions of Richard Wilson and Thomas Gainsborough to British landscape painting in this period; Paul Sandby stands beside these two masters, for, though in retrospect his achievement was not as distinguished as theirs, in his own time he was highly influential and he was instrumental in bringing to landscape art a new standing and importance.

36

Unfortunately Paul Sandby has been particularly ill-served by historians of British art, and the only full-scale study of him, which also includes his brother Thomas, was that published in 1892 by their 'descendant' William Sandby.[1] This is totally uncritical, and it is not altogether surprising that many of the drawings which William Sandby bequeathed on his death in 1904 to the British Museum, the Victoria and Albert Museum and other museums are well below the standard one would accept as the minimum for an artist of Paul Sandby's capability. William Sandby did not, in fact, inherit any of these drawings, but purchased them over a long period from a great variety of sources, and thus their provenance is no guarantee of authenticity. However, their inclusion in these readily accessible collections has led to the great proliferation of wrongly attributed drawings, and in many public and private collections Paul Sandby's work has now become inextricably mixed up with that of his pupils and followers, who have themselves become obscured in the process. Only one major collection of Sandby drawings, but that fortunately the largest in size and the best in quality, has been critically catalogued. This is the superb series in the Royal Collection at Windsor Castle, which was begun soon after the deaths of the brothers and has been consistently added to ever since. Because it is very largely devoted to drawings that are connected with Windsor and with activities of the royal family elsewhere, the collection provides a somewhat one-sided view of Paul Sandby's output. This emphasis is reflected in Paul Oppé's *Introduction* to his catalogue[2] of the series, which contains the only real attempt to achieve a chronological survey of Paul Sandby's development as an artist. As there are few gouache drawings at Windsor, that aspect of Sandby's art is largely ignored, with the result that he emerges once again as basically a topographical draughtsman who was also able to draw excellent figure studies.

Until quite recently it has been thought that Paul Sandby was born in 1725 or 1726,[3] and that he was already twenty-one when he was appointed a draughtsman on the Survey of the Highlands, set up under Colonel David Watson soon after the Jacobite rising of 1745. This had made it difficult to understand the inclusion of the words 'though very young' in the following passage from the *Memoir* written by his son, Thomas Paul Sandby, and published in the *Monthly Magazine* of 1 June 1811:[4]

'As circumstances are the great governors of men, and may in most instances be said to be the makers of them; perhaps the destination of Mr. Sandby to the Highlands was the source of his eminence as a landscape painter, at least in the formation of his peculiar style, as, though he there saw nature in her wildest form, the necessity under which he lay of attending to particular accuracy in filling up the plans, may be supposed

1. W. Sandby, *Thomas and Paul Sandby*, 1892.
2. P. Oppé, *The Drawings of Paul and Thomas Sandby at Windsor Castle*, 1947.
3. The correct birth date of 1730 was discovered by Dr. Johnson Ball and published in his doctoral thesis at Nottingham University. This discovery proves that Farington was correct in his *Diary*

entry on 4 January 1794, when he gave Paul Sandby's age as sixty-three.
4. P. Oppé, 'The Memoir of Paul Sandby by his Son', *Burlington Magazine*, LXXXVIII (1946), pp. 143–7. Here Sandby's date of birth is given as 1726.

37

to have formed in him that correct and faithful habit, with which he after viewed and delineated her...while in Edinburgh, though very young, his talents were discovered, and duly appreciated by many eminent persons in that city; ... at this time he made very many accurate views of Edinburgh and its vicinity and becoming acquainted with Mr. Bell, an engraver in that city, he got some insight into his mode of etching, and himself etched a number of scenes in the neighbourhood, which were done on the spot, upon the copper. At the same time also he took numerous sketches from nature, with surprising accuracy, and made many drawings of figures, in the costume, and of the habits and employments, of the inhabitants of Edinburgh, that are peculiarly interesting, and which mark a fertility of genius, that had only to select its path in art, to attain excellence. He chose landscape painting....'

At this time Sandby was very much under the influence of the work of Dutch artists; the drawings which he presented to the Board of Ordnance, as specimens of his skill when applying for the post of draughtsman to the Survey, are mostly competent copies after engravings by Abraham Bloemart.[1] The only landscape among them, the *East View of Edinburgh Castle*, a very precise pen-and-ink study difficult to distinguish from a copper engraving, is presumably also a copy, though its dating, 1746–7, may indicate that it was in fact completed on the spot. A remarkable water-colour and pencil view of *Leith* (Plate 28), which is signed and dated 1747, has recently come to light in Oxford.[2] In this vivid sunset scene Sandby more than proves his exceptional talents at this early date, and also shows his debt to the best in the Dutch landscape tradition. Unfortunately the spontaneous quality of this drawing was all too rarely equalled in the following sixty years of Paul Sandby's long career, and the more conventional line that much of his work was to follow is illustrated by another drawing of Leith in the same collection, which was executed only two years later (Plate 29). In this there is more concentration on detail, although there is still great freedom of technique in the foreground. On the whole, however, the spontaneity of the 1747 drawing is replaced by more care in composition aided by the *staffage* of the figures, bushes and weeds in the foreground. This second drawing of Leith was in fact etched by Sandby as one of a series of views in Scotland published in 1751, soon after his return from the Survey. The etching has rather more figures, and includes a coach on the left, going in the opposite direction to the one that is very lightly indicated in the drawing.

On his return from Scotland in 1751 Paul Sandby rejoined his brother Thomas (1723–98), who was on the staff of the Duke of Cumberland and was probably already living at Windsor at this time. Thomas Sandby was an architect, and was to become the first Professor of Architecture at the Royal Academy. He was also a skilled draughtsman, usually in a precise and detailed style. Outstanding examples of his work are the two large views from the terrace of Somerset House in the British Museum; in these the

1. L. Binyon, *Catalogue of Drawings by British Artists...in the British Museum*, vol. IV, 1907, p. 18, nos. 102–6. 2. L. Herrmann, 'Paul Sandby in Scotland', *Burlington Magazine*, CVI (1964), pp. 339–43.

strong influence of the similar composition by Canaletto is felt. In his early years in London the younger brother was clearly influenced by the elder and it is often difficult to be certain whether a drawing of this period is by Paul or by Thomas Sandby. It was at this time that Paul Sandby developed the qualities of 'accuracy' and of 'correct and faithful habit' named by his son, and these are to be seen in many of his drawings of Windsor, as for instance in the view of *Henry VIII Gateway from Castle Hill, with Houses to left and Salisbury Tower beyond* (Plate 30A).[1] This is among the most crisp and detailed of the drawings of the Castle, but, nevertheless, when compared with one of Thomas Sandby's thoroughly architectural drawings, such as the Royal Collection's *Old Somerset House, the Garden Front* (Plate 30B),[2] there can be no doubt whatever as to which of the brothers is the artist and which the architect. However, the collection at Windsor also includes a considerable number of much less finished drawings by Thomas Sandby, in which he uses bold and often colourful washes and very free outlines to great advantage.

Paul Sandby always retained a mastery of perspective, which, when added to his skill as a figure draughtsman and his understanding of the formation and foliage of trees (achieved by detailed and painstaking studies in Windsor Great Park), gives to his best topographical work an authority and conviction that is equalled by few of his contemporary artists in this field. Gradually, as can be seen in the *View of Strawberry Hill, Twickenham* (Plate 31A),[3] the character and technique of even his highly finished water-colour drawings grew somewhat freer, while in the more 'private' water-colour studies, such as the sparkling view from the back of his own house, *Paddington from St. George's Row* (Plate 31B),[4] we see him using the medium with the same spontaneity and naturalness as in the 1747 drawing of Leith. Paul Sandby's outstanding achievements in water-colours come on the rare occasions when those qualities are used successfully in compositions on an ambitious scale. There are several examples of this in the Windsor series in the Royal Collection. *A General View Westward from the Base of the Curtain of the Round Tower* (Colour Plate III and Plate 32) 'combines the utmost delicacy of a miniature with breadth and simplicity of colour and atmospheric truth',[5] to quote Mr. Oppé, who considered it the 'masterpiece' of the series. The more daringly composed '*Windsor, View of the Seat near the Terrace and a View of the adjacent Country*' (Plate 33)[6] displays even greater breadth and records with wonderful simplicity the character and atmosphere of the distant landscape; here he was 'painting' rather than 'drawing' with his water-colours. These masterpieces reveal Sandby as much more than a topographical artist, and show that at his best he had the qualities and instincts of the natural landscape painter.

It was as such that Thomas Gainsborough recommended him to a potential patron of his own, Lord Hardwicke, in the often quoted letter, written in about 1764, in which he himself declined to paint '*real Views* from Nature in this Country', and recommended

1. P. Oppé, *The Drawings of Paul and Thomas Sandby, loc. cit.* no. 25.

2. *Loc. cit.* no. 163.

3. This subject was engraved in ?1774 and published in Sandby's *The Virtuosi's Museum.*

4. Binyon, *loc. cit.* p. 7, no. 20.

5. Oppé, *loc. cit.* no. 37.

6. *Loc. cit.* no. 51.

Paul Sandby as 'the only Man of Genius...who has employ'd his Pencil that way'.[1] From 1760 Sandby exhibited regularly with the Society of Artists, and then from 1769 at the Royal Academy, of which he was a founder member. The titles given in the catalogues show that the bulk of these exhibits were topographical, but unfortunately the catalogue entries rarely indicate the medium of an exhibit. It seems likely that a large proportion of Sandby's exhibited work was in body-colours, and that there was also a considerable number of oil paintings, especially in his final years. Only a few of the latter are known today, and these are often disappointingly crude and naïve.

In his systematic work in water-colours Sandby was breaking new ground; in using gouache or body-colours he was joining a considerable number of artists of a variety of nationalities whose style and technique were closely linked in what became a cosmopolitan tradition. We have already seen that George Lambert was working in this medium and tradition in the 1740s; a few years later Paul Sandby was to become its principal British exponent. The most influential figure in the development of this gouache landscape tradition was undoubtedly the Italian artist Marco Ricci (1676–1730), who produced large numbers of classical, ideal and pastoral landscape compositions in body-colours, frequently on leather. Marco Ricci worked in England from 1709 to 1716, and it seems probable that during these years examples of his work in gouache were acquired by British patrons and collectors.[2] The important series in the Royal Collection[3] did not, however, come to this country until 1762, for it was part of the collection acquired by George III from Consul Smith. From his son's *Memoir* we learn that 'Mr. Sandby was a great admirer of the works of Marco Ricci, and studied them with fond attention; whenever one of Marco's pictures was to be met with, Mr. Sandby, if possible, became its purchaser; and, perhaps, he had the largest collection of that master extant in the country.'[4]

This passage from the *Memoir* and the evidence of many of his own drawings provide ample proof that Sandby was directly influenced by the work of Marco Ricci. Other exponents of body-colour working in England during Sandby's formative years must also have had an effect on him. Two of these artists were of French origin: John Baptist Claude Chatelain (1710–71) and Joseph Goupy (1689–1763). Both men were active as drawing-masters – Goupy had several royal pupils, including the future George III – and a fair number of fully authenticated landscape drawings in body-colours by each of them is known today. While those by Chatelain are mostly rather delicate classical compositions in a minor key, the drawings of Goupy are more forceful, and were certainly influenced by the tricks he had learnt in his considerable activity as a scene-painter. Another Italian artist who worked in body-colours was Francesco Zuccarelli (1702–88), who, as has

1. M. Woodall, *The Letters of Thomas Gainsborough*, 1963, pp. 87–91.

2. Several of Marco Ricci's followers and imitators were popular with English patrons and collectors. In 1742, for instance, William Windham of Felbrigg Hall brought back to England from his Grand Tour twenty-six gouache landscapes by Giovanni Batista Busiri (1698–?1757). See F. Hawcroft, 'The "Cabinet" at Felbrigg' in *The Connoisseur*, CXLI (1958), pp. 216–19.

3. Levey, *loc. cit.* 1964, nos. 591–622.

4. Oppé, *Burlington Magazine, loc. cit.* p. 147.

III Paul Sandby *Windsor, a General View Westward from the Base of the Curtain of the Round Tower* (detail)
The Royal Collection, Windsor Castle. (*Reproduced by gracious permission of Her Majesty The Queen*) *See page* 39
For whole drawing see Plate 32

IV Paul Sandby *The Waterfall*

Body-colour, 12 × 9½, 30·5 × 24·1
Castle Museum and Art Gallery, Nottingham. *See page* 42

already been said, was twice in England for considerable periods, from 1752 to 1762 and from 1765 to 1771. Zuccarelli's work and influence in England will be discussed in more detail in the next chapter, but he must also be mentioned at this point, for there is no doubt that Sandby's more pastoral and idealistic landscape compositions often owe much to his example. Indeed the J. Leslie Wright Collection, now at Birmingham, includes an *Italian landscape* by Sandby which is certainly correctly described as 'after Zuccarelli'.[1]

Sandby may also have been influenced in his use of body-colours by the example of William Taverner (1703–72), a lawyer by profession, who enjoyed, however, a high reputation as a landscape artist, practising in oils, water-colours and body-colours. Taverner is known to have been one of the circle of friends of William Sandby, the London book-seller who was a distant cousin of the Sandby brothers, whom he assisted during their early years in London. George Vertue thought very highly of Taverner and, in one of his Note Books, he sums up his considerable achievement as a pioneering figure in the development of British landscape art as follows: he 'has a wonderfull genius to drawing of Landskap in an excellent manner. adorned with figures in a stile above the common & paints in oil in a very commendable & masterly manner'.[2] Many of the surviving drawings by Taverner are very Italianate in style, but he also drew the English countryside with more liveliness and confidence than was usual at the time. His work is well represented in a group of water-colour drawings formerly in the Gilbert Davis Collection and now in the Huntington Library in California, and one of his most striking body-colour drawings is the *Sandpits, Woolwich*, in the British Museum.[3]

Though Sandby's work in body-colours drew inspiration from a variety of sources, it must be emphasized that he was no mere copyist or imitator, and that he developed a personal and varied manner in this medium, which he was using from his earliest years. In the British Museum's *Gate of Coverham Abbey, Coverdale, Yorkshire* (Plate 34A),[4] dating from 1752, water-colours and body-colours are both used and, just as the mediums are mixed, so are the styles, for the composition is an odd conglomeration of the antiquarian topographical and the more lively Italianate manner. It is interesting to compare this tentative excursion into the gouache tradition with a drawing that is firmly placed in it, and that might, indeed, be easily mistaken for the work of Marco Ricci. This is the *Stormy Sea with Castle Ruins and Figures in the Foreground* (Plate 34B), also at Birmingham,[5] which is in body-colours on panel. Unfortunately this rather unusual example of Sandby's practice in body-colours is not dated, and in the present state of our knowledge of his work it is impossible to be certain whether or not it is early, although this would seem likely.

Sandby also used body-colours for topographical compositions on a larger scale, and

1. *Masters of British Watercolours – The J. Leslie Wright Collection*, London, Royal Academy, 1949, no. 140.
2. 'Vertue Note Books – Volume III', *loc. cit.* p. 68.
3. M. Hardie, *Water-colour Painting in Britain*, vol. I, 1966, fig. 34.
4. Binyon, *loc. cit.* p. 9, no. 39.
5. *J. Leslie Wright Collection, loc. cit.* no. 125.

in these his powers of composition and of rendering atmosphere are often well displayed. Two quite early examples, each probably dating from the 1750s, are the Tate Gallery's colourful *Edinburgh Castle*[1] and the distant view of *Windsor Castle from the Back Fields at Eton*[2] in the Royal Collection. Both these ambitious drawings present a conventional view of their subject, but both are brought to life by the incorporation of a variety of incidents in the foreground and, especially in the case of the *Edinburgh Castle*, by a lively manipulation of the medium to provide convincing gradations of tone and light. In such works Sandby raises topography to a new level by incorporating in it qualities hitherto associated with idealistic and pastoral landscape painting.

A group of three important gouache landscape drawings, shown at an exhibition in London in 1969,[3] can be more firmly dated, for they are directly or closely connected with plates from the three pioneering series of aquatint views in Wales published in 1776 and 1777, and bearing the date 1775 in their dedications.[4] Two of the drawings are more or less conventional views of famous Welsh landmarks: Caernarvon Castle, and Benton Castle, Milford Haven, the latter seen against a fine sunset. The third drawing, and it is the one that is most closely related to the aquatint of the same scene, is of '*Pont y Pair over the River Conway above Llanrwst in the County of Denbigh*' (Plate 35B). This, the least conventional composition of the three, is, at the same time, the most successful in conveying something of the light and atmosphere of Wales, if without any indication of the time of day, which Sandby does frequently convey. The body-colour is freely applied and the high-lights are drawn with much abandon. These are qualities that are not normally associated with the use of body-colours, and it is clear that Sandby had totally mastered the medium. The aquatint of '*Pont y Pair*' retains the verve of the drawing to a remarkable degree, and again displays Sandby's mastery of what was then still a new technique. It also takes even further Sandby's interest in recording the actualities of nature, for the rays of the sun are clearly indicated. In *The Land Storm*,[5] a large gouache dated 1786 and exhibited at the Royal Academy in the following year, Sandby rendered most effectively the eerie feeling of a thundery sky suddenly lit by a flash of lightning.

Another example of the very free use of body-colours by Paul Sandby is *The Waterfall* (Colour Plate IV) at Nottingham, which is probably an imaginary landscape composition based on an Italian model. Sandby never travelled abroad, but numerous landscape compositions from his hand prove his ability to assimilate the characteristics of foreign scenery from the works of fellow-artists. Others show his skill in adapting the essential principles of the various modes and fashions of landscape art from the calm classicism of Gaspard Dughet to the wild romanticism of Salvator Rosa. In this context it should be remembered that Sandby himself formed a considerable collection of paintings, drawings and prints by earlier masters.

1. Tate Gallery, no. 1853.
2. Oppé, *The Drawings of Paul and Thomas Sandby*, loc. cit. no. 75.
3. Sabin Galleries Ltd, London, *The Cunning Hand*, October 1969, nos. 39–41.

4. J. R. Abbey, *Scenery of Great Britain and Ireland, 1770–1860*, 1952, no. 511.
5. Exhibited Spink & Son Ltd, London, *English Watercolours & Drawings*, April–May 1970, no. 4.

Unfortunately, as he grew older Paul Sandby tended to display less variety and spontaneity in his work in body-colours. The Whitworth Art Gallery's *The Timber Waggon* (Plate 35A), dated 1796, is reproduced here as one example of a considerable number of such artificial compositions on a large scale, many of which include a massive gnarled tree as their principal feature.[1] A closely related drawing, dating from two years earlier, is the Victoria and Albert Museum's *An Ancient Beech Tree*.[2] In this the tree's trunk is still more fantastic, and the drawing is even bigger as a whole. It is these exaggeratedly picturesque 'machines' that are usually considered typical of Paul Sandby's work in body-colours, but, as has been shown here, they form but one element of his practice in that medium. At the turn of the century Paul Sandby began to work more frequently in oils in a manner very similar to his later gouaches. The vogue for body-colours was passing, while Sandby's work in water-colours was now often feeble and outdated, especially in relation to the advances made by the new generation of artists, which included Girtin and Turner.

Although Sandby had outlived his popularity and influence, these had been considerable. From 1768 to 1797 he was the principal drawing-master at the Royal Military Academy at Woolwich, and during those years he also had numerous private pupils, including several of the young princes. At the time he had little difficulty in selling his drawings, and he further enhanced his reputation by his own work in etching and aquatint, and by the numerous engravings after his drawings. In that side of his work he was again in the van of fashion and taste, as is indicated by his Preface to *The Virtuosi's Museum*, a series of 108 'select views in England, Scotland and Wales' published between 1778 and 1781. In 'the choice of our subjects...we follow an illustrious example', wrote Sandby, 'the renowned Empress of Russia...has paid the highest compliment to the genius and taste of this country; by procuring, at an immense expence, views of all the noblemen and gentlemen's seats, and of every delightful spot throughout the kingdom, drawn on the spot, and painted upon setts of china dishes and plates. If these views appear so enchanting in the eyes of this Princess, surely it must afford the highest satisfaction to Britons themselves, to have in their possession complete representations of them on a better plan for preservation, and on much easier terms.'[3] These engravings

1. Such Salvator-Rosa-like ancient trees were popular with numerous British artists at this period. See, for instance, Benjamin West's vast *View in Windsor Great Park* in the Royal Collection (Millar, *loc. cit.* no. 1168, plate 118), which was probably exhibited at the Royal Academy in 1785.

2. G. Reynolds, *British Water-colours*, Victoria and Albert Museum booklet, 1968, plate 1.

3. In 1773 the Empress Catherine (the Great) of Russia commissioned from Josiah Wedgwood a vast cream-ware dinner and dessert service of some 1,300 pieces, on each of which was to be painted a different view representing 'British scenery'. The completed service was exhibited in London in June and July 1774, and this enterprising commission has rightly been considered as an important element in the progress of British topographical drawing (see J. L. Roget, *A History of the 'Old Water-colour Society'*, vol. 1, 1891, pp. 32–4). Iolo Williams (*loc. cit.* p. 249) drew attention to the fact that Paul Sandby's drawing of the *Gate of Coverham Abbey* (Plate 43A) was almost certainly the original of the design of one of the trial plates for this service.

range from conventional antiquarian topographical subjects, such as *Part of Wenlock Abbey*, which is plate 46, to pure landscapes like plate 73, the *View of Strath Tay, S.ᵗ Robert Menzies Seat*, where the house is a barely seen speck in the distance. Such collections of engravings became all the rage in the last decades of the eighteenth century, and work for the engravers was the mainstay of the majority of topographical artists. Another indication of the growing popularity of topographical drawings and engravings is to be seen in the changes, already referred to in Chapter I, made in the head-pieces of the Oxford Almanack at this time. When the series started in 1674 the subject of the illustrations was wholly allegorical; it was not until 1754 that the first purely topographical head-piece was printed, and the allegorical style was finally abandoned twelve years later.[1] Two of the artists still to be discussed in this chapter, Rooker and Dayes, made several drawings for the Oxford Almanack, as did J. M. W. Turner at the turn of the century.

In a letter written to Lord Nuneham in 1760, William Mason, friend of Joshua Reynolds and translator of Du Fresnoy's *The Art of Painting*, referred with enthusiasm to a picture by Sandby, and asserted that he would 'in a short time...be that Claude Lorraine that Browne assured him he was at Lord Scarbro's'.[2] Paul Sandby never fulfilled that promise, but for the following twenty years or more he was popularly accepted as the leading landscape artist of his day, despite the fact that he only rarely worked in oils. In 1811 Joseph Farington attended the sale of Paul Sandby's effects at Christie's. He wrote in his *Diary* on 2 May: 'There was a large Collection of drawings by the late P. Sandby, & I could not but sensibly feel the great difference between His works & those of Artists who now practise in Water Colour. – His drawings so divided in parts, so scattered in effect, – detail prevailing over general effect.' For the next two or three generations Paul Sandby's reputation suffered the fate of the pioneer whose achievements had been surpassed even in his own lifetime. However, if we look at such a drawing as the fluent study of 1802 entitled *In Windsor Park* (Plate 36),[3] we can see that Sandby did not entirely ignore the great advances in water-colour painting that took place in the last twenty years of his long life. This example of Sandby's work in old age would certainly not have disgraced the young Girtin and Turner at this time. Nevertheless Paul Sandby's pioneering contribution was a thing of the past, and we must not be confused by the fact that he lived and worked until 1809, by which time the majority of his pupils and followers in the topographical tradition were also dead.

In the present context it is not possible to be anything other than selective in discussing these followers and contemporaries. Three of the principal artists among them were all born in the 1740s. The eldest of these was Michael 'Angelo' Rooker (1743–1801), son of an engraver and a pupil of Paul Sandby, who became one of the first students at the Royal Academy Schools in 1769. He was elected A.R.A. in the following year, and

1. H. M. Petter, *The Oxford Almanack, 1674–1946*, 1946.

2. W. T. Whitley, *Artists and their Friends in England, 1700–1799*, vol. i, 1928, p. 169.

3. Binyon, *loc. cit.* p. 6, no. 15.

exhibited regularly at the Royal Academy. Though working both as an engraver and as a scene-painter, Rooker was also a prolific draughtsman, and a large number of his meticulous and highly detailed water-colour drawings are widely dispersed today. Most of them are of mainly antiquarian interest, but they are frequently enlivened by the incorporation of well-drawn and gracefully composed groups of figures. A typical example of such a drawing is *Buildwas Abbey, Shropshire* (Plate 37A) at the Ashmolean Museum. A larger version of the same composition, with some variations in detail, is in the Whitworth Gallery, and it is interesting to note that Rooker three times exhibited drawings of this picturesque ruin at the Royal Academy: in 1770, 1772 and 1800. Occasionally Rooker worked in oils, but in this medium his manner and colouring are just as careful and subdued as in his drawings. However, his ability to appreciate and record the landscape, as well as the buildings, of England, is seen in an upright composition at the Victoria and Albert Museum, *Godington, near Ashford, Kent*.[1] In this the trees and the simple country lane are given far more prominence than the house portrayed.

Thomas Hearne (1744–1817) was only one year younger than Rooker, and like him he started life as an engraver, being apprenticed to William Woollett. At the end of that apprenticeship he travelled to the Leeward Islands in 1771 as draughtsman to the newly appointed Governor. For the next five years he was engaged in making drawings out there, and, on his return, engravings from them. However, apart from the British Museum's series of fine water-colours of landmarks in Sicily, which are based on sketches made by Charles Gore, the remainder of Hearne's work was devoted to British topography and landscape, which he depicted with somewhat more freedom than Rooker. In these drawings he used water-colours with great delicacy, and he also frequently used straightforward grey washes with considerable effect. His outlines are usually stronger than those of Rooker, and his manner is altogether less finicky, although it is still far from bold. An outstanding series of drawings by him are views of Downton Castle and its surroundings, many of which are still at Downton, the Herefordshire seat of Richard Payne Knight, an important exponent of the picturesque. A fine example from this series, *Wooded Glen at Downton* (Plate 38A), is at the Victoria and Albert Museum. It is in ink and wash, and shows how splendidly Hearne was able to render the character and variety of English trees and woodland in his monochrome drawings. Another memorable example of this type of drawing is the *Trees in a Landscape*, formerly in the Bruce Ingram Collection.[2] The Victoria and Albert Museum's *Durham Cathedral, from the opposite Bank of the Wear*, dated 1783, is typical of Hearne's more deliberately composed, yet still reasonably naturalistic, landscapes.

Hearne's work was, however, more commonly devoted to antiquarian topography, and in that vein he made a large number of drawings for William Byrne's *Antiquities of Great Britain*, an ambitious series of plates published between 1778 and 1806. *The Nave and East End of St. Peter's in the East, Oxford* (Plate 38B), which is dated 1794 on the *verso*, was engraved in 1796 for the second volume of the *Antiquities of Great Britain*. Though

1. *Catalogue of Water Colour Paintings*, 1927, p. 456, fig. 38.　　2. Williams, *loc. cit.* fig. 83.

essentially simple and unassuming this drawing gives a pleasing and accurate impression of that lovely Oxford church.

The third of the topographical artists born in the 1740s is Thomas Malton, junior (1748–1804), whose father, another Thomas, was an architectural draughtsman. Most of the son's work was likewise devoted to architectural subjects, though he was also employed as a scene-painter at Covent Garden Theatre. His drawings show great accuracy of perspective and detail, as can be seen in the impressive composition, *St. Paul's Church, Covent Garden* (Plate 37 B), which was exhibited at the Royal Academy in 1787. This was engraved as plate 32 in Malton's *Picturesque Tour through the Cities of London and Westminster*, which he published in 1792. In the depiction of the buildings of London and other cities and towns, Thomas Malton was certainly the most gifted artist of his day, and he passed on the secrets of his skill to the most renowned of his pupils, J. M. W. Turner.

Compared to the highly professional draughtsmanship of Thomas Malton, that of the Swiss-born Samuel Hieronymous Grimm (1733–94) often appears rather crude. Grimm, who was both poet and artist, came to England in 1768, and showed four drawings at the first Royal Academy exhibition in the following year. He travelled extensively in the British Isles and produced a great quantity of drawings, mostly topographical, using wash, water-colours and body-colours. He enjoyed considerable patronage, including that of Gilbert White, for whose *Natural History of Selborne* he drew the vignette on the title-page. To the fashion set by Paul Sandby, Grimm added something of the naïvety of the Swiss topographical tradition, which was also thriving during these years.[1] Thus many of his drawings appear rather flat and two-dimensional, as can be seen in the *North Foreland Lighthouse* (Plate 39 B). On the other hand there is considerable depth in two small pen-and-wash studies dated 1789 of *St. Vincent's Rock, Clifton* in Bristol City Art Gallery.[2]

Similar qualities of flatness may frequently be found in the drawings of Anthony Devis (1729–1816), a member of a family of artists at Preston in Lancashire. However, Devis's outlines, often drawn in reed pen, are much looser than those of Grimm, and these combine with his almost invariable adaptation of basically classical compositions, to give his drawings qualities of grace and broadness. A typical example is the view of *Throstle's Nest* (Plate 39 A), in which Manchester is seen in the distance. In this drawing there are slight and pale water-colour washes; it is but on rare occasions that Devis uses this medium more strongly. He was active as an exhibitor and teacher in London from about 1760 to 1780, but despite all the possible influences to which he must have been exposed during these years he retained his own pleasing manner. A large selection of his drawings, as well as some oil paintings, may be seen at the Harris Art Gallery in Preston.[3]

The final artist to feature in this chapter is also by far the youngest, and his work,

1. See below, Chapter Three, pp. 80–82.
2. *Bristol Scenery, 1714–1858*, 1962 (Bristol City Art Gallery), nos. 3 and 4.
3. S. H. Pavière, *The Devis Family of Painters,* 1950.

while belonging in its essentials to the topographical tradition, forms a link with the developments in British landscape art which were to succeed it. As a man Edward Dayes (1763–1804) was difficult and disappointed (he took his own life); as an artist he was a sound draughtsman who made considerable innovations in the use of water-colours – innovations that were important in the development from the tinted drawing to the more spontaneous and atmospheric application of the pigment, which allowed the colour and texture of the paper to play their part in the final effect. Dayes's work can be very uneven in quality, but at his best he produced some of the outstanding water-colour drawings of the late eighteenth century. Among the most ambitious of these are such well-known compositions as the Victoria and Albert Museum's *Buckingham House, St. James's Park*, which is dated 1790 and was engraved three years later. In this, the elegant figures in the foreground are the principal feature, and the topographical element is essentially secondary. It is reminiscent of French drawings and engravings of the period, and also of the work of Thomas Rowlandson, and serves as a reminder that Dayes attempted several pure figure and historical subjects and also practised as a book illustrator.

However, Dayes's principal achievements were as a topographical artist, and an outstanding example of his work in this vein is the large water-colour of *Greenwich Hospital* (Plate 41), dated 1789. Though probably drawn with a ruler, the character and details of the buildings are convincingly rendered. The scene is enlivened by the variety of figures which are given more prominence than the conventional *staffage* groups, and the composition is balanced by the shipping on the left. It is much more of a 'picture' than Paul Sandby usually produced, and in addition the colouring is at once convincingly natural and harmonious. The same qualities are to be found in the four large drawings, all dated 1794, that Dayes executed for the Oxford Almanack, in which the colours are especially well preserved.[1] In drawings such as these Dayes sums up all that is best in the topographical tradition and it is not at all surprising that he had a great influence on the next generation of artists, especially Turner and Girtin, who was his pupil.

The influence of Dayes's less ambitious and more usual drawings was perhaps even stronger. He travelled widely in the British Isles sketching antiquarian and picturesque subjects, and also made drawings based on the sketches of others, such as the series of small water-colours of Scottish buildings in the Ashmolean Museum, for which the antiquarian James Moore made the outline drawings. When compared with the assurance of more imposing drawings, like the *Greenwich Hospital*, these works seem almost primitive, but they do display an effective individual style, in which the artist disguises his careful outlines by his skilful use of the water-colours. Both Girtin and Turner used this type of drawing by Dayes as a starting point for their own all-important developments of the topographical water-colour tradition.

Tintern Abbey (Plate 40), which is dated 1794, is a characteristic, and in no way exceptional, example of this kind of drawing by Dayes. When seen side by side, it is difficult to believe that these drawings of Greenwich and of Tintern are by the same

1. Now in the Ashmolean Museum.

47

artist – the black-and-white reproductions do, in fact, help to exaggerate the apparent difference in quality between them, for the colour and tones are essential elements of the drawing of Tintern. It is in this factor – the emphasis on colour and tone – that Edward Dayes made his vital contribution to the development of water-colour art. Some of his technical transformations in achieving this are to be seen in the *Tintern Abbey*, as for instance in the rendering of the calm water of the river by narrow parallel strokes of pigment with glimpses of the white paper between. Dayes also developed his new methods in monochrome drawings, in which he used blue or grey washes. He himself summed up his manner when he wrote, 'the student must distinguish between a glaring and a glowing color...for color is the attire of the art, and not the patches and paint of a courtezan'.[1]

1. 'Instructions for Drawing and Colouring Landscapes' in *The Works of the Late Edward Dayes*, 1805, p. 306.

CHAPTER THREE

The Discovery of Italy

ONLY A FEW of the British artists discussed so far travelled abroad, though, as has been seen, many foreign landscape artists worked in England. Some of the most influential of these were Italian, and the Italianate traditions in landscape were a vital force in the development of British landscape painting. Equally important was the impact that the scenery and art of Italy made on the British landscape artists who travelled there in increasing numbers from the middle years of the eighteenth century. One of the first to do so was Alexander Cozens (*c.* 1717–86), who was in Rome in 1746.

From the group of some fifty of Cozens's Italian drawings in the British Museum, and from the drawings and notes in a Roman Sketch-book published in *The Walpole Society* in 1928,[1] we have an unusually clear picture of Alexander Cozens's activities and plans while in Rome. We know that he worked in the studio of Claude-Joseph Vernet, and that he aimed to spend each summer morning sketching and outlining landscapes 'from life'. The surviving Italian drawings indicate both these activities. The majority of them reflect the influence of drawings and engravings by a variety of seventeenth- and eighteenth-century Italian, French and Netherlandish artists working in the classical landscape tradition. Others show him drawing from life, and reacting most sensitively to the scenery of Rome and its surroundings. Two of the British Museum's drawings which are on the same mount stand out in this category. One is a simple view of *A Farm*,[2] set in a broad landscape and depicted with the minimum of fuss and with the aid of a very little colour. The other is the much more dramatic *Landscape with Sun breaking through Clouds*[3] (Plate 42 A), which, again with great economy of line and only a few slight touches of colour, records with complete success the impact of such a dazzling moment when sun and scenery blend into a whole. The rays of the sun, the sky and the extensive view must surely have been drawn from nature, but the foreground *staffage* and the tree on the right are more deliberately drawn, and were very probably added in the studio. If this element of the drawing were omitted it would be an exquisite natural landscape; as it is it has all the properties of a classical landscape composition, and these are also to be found in the bulk of Cozens's more finished drawings throughout his career.

After his stay in Italy Alexander Cozens spent the rest of his life in England, but the evidence of his surviving drawings suggests that he very rarely drew from nature in this

1. A. P. Oppé, 'A Roman Sketch-book by Alexander Cozens' in *The Walpole Society*, XVI (1927–8), pp. 81–93.

2. L. Binyon, *Catalogue of Drawings by British Artists...in the British Museum*, vol. I, 1898, p. 267, no. 10a.

3. *Loc. cit.* p. 268, no. 10b.

country. Hardly any drawings of actual views or of a topographical character are known. One of the few recorded examples of this type of drawing is a *View of Greenwich*, which is dated 1766, and which is further exceptional in that it is a fully coloured water-colour drawing.[1] Despite the fact that it is in theory a topographical view and that it is coloured, this drawing is again in essence a classical landscape composition. The same may be said of the small number of oil paintings by Cozens recognized as such today; he exhibited a number of works in oil, and twenty paintings were included in the sale after his death.[2] A contemporary writer regrets that he did not more often paint in oils.[3]

From this and other evidence it is clear that what is known today of Cozens's work is representative of what he actually produced, and that he was, in fact, content and able to build up his reputation and patronage on the limited basis of monochrome landscape compositions, usually of an imaginative or idealized nature. Since their virtual rediscovery in the early years of this century, these drawings in brown, black or grey ink and washes have been regarded as a major achievement of British landscape art in the eighteenth century.[4] In the context of the work of British artists they stand out for their individuality and their consistency, but in the European context it is difficult not to see them as a deliberate and systematic attempt to emulate the manifold lessons of Claude Lorrain's rich and varied draughtsmanship. Drawings by Claude and prints after them[5] were popular with British collectors throughout the eighteenth century, and after leaving Italy Cozens would still have had ample opportunity to see examples. His Italian drawings do not show an especially strong debt to Claude; those which he executed after his return to England indicate that he considered the best way of expressing his Italian experiences was to re-echo the marvellous landscape drawings of that artist.[6]

It is true that Cozens developed an individual style, but it was a style that depended as much on the example and vision of Claude as on his own knowledge of, and feeling for, nature. In fact, just as later in the century artists and connoisseurs looked at landscape in a Claude Glass, so Cozens saw and recorded nature with Claude uppermost in his mind, as he must also have been when he was devising his endless 'systems' designed to aid himself and his pupils in achieving telling landscape compositions. These systems of drawing were a central factor in Cozens's life, and William Beckford was probably

1. F. Hawcroft, 'A Water-colour Drawing by Alexander Cozens', *Burlington Magazine*, CII (1960), pp. 486–9.

2. A. P. Oppé, 'A Landscape in Oil by Alexander Cozens', *Burlington Magazine*, XCVI (1954), pp. 21–2.

3. J. H. Pott, see below p. 61.

4. Burlington Fine Arts Club, London, 1916, *The Herbert Horne Collection of Drawings with Special Reference to the Works of Alexander Cozens*; Graves Art Gallery, Sheffield, and Tate Gallery, London, 1946, *Drawings and Paintings by Alexander Cozens*, arranged by Paul Oppé.

5. Such as the engravings published by Arthur Pond and Charles Knapton in the 1730s; Richard Earlom's mezzotint engravings of the *Liber Veritatis* were published in two volumes in 1777.

6. D. Howard in 'Some Eighteenth-Century English Followers of Claude' (*Burlington Magazine*, CXI (1969), pp. 726–33) suggests that Cozens would not have seen many of Claude's drawings from nature. Even if this suggestion is correct, this does not lessen the impact of those nature drawings by Claude which Cozens *did* see.

not exaggerating when he wrote from Fonthill in 1781, 'Cozens is here, very happy, very solitary, and almost as full of systems as the Universe.'[1] Cozens had considerable success as a drawing-master; he taught at Eton and in his last years some of the sons of George III were among his pupils. It is well known that many of those he instructed were encouraged to adopt his blot system in developing a composition. This system was outlined and illustrated in *A New Method of assisting the Invention in Drawing Original Compositions of Landscape*, which he published at the end of his life.[2] An essential feature of this method was that Cozens advocated the use of blots to stimulate a definite compositional idea already in the artist's mind. 'Possess your mind strongly with a subject' is the first instruction of Rule III, entitled 'To form a BLOT',[3] and in the introductory passage we read: 'An artificial blot is a production of chance, with a small degree of design.'[4] Here Cozens' method differs totally from the practice of some Chinese calligraphers and from the related suggestions of Leonardo, which are based firmly on the accidental nature of the blot or blemish. Cozens could not have advocated pure accident, for, as the final section of the book entitled 'Description of the various Kinds of Composition of Landscape' shows, he believed that the depiction of landscape must be based on the adherence to strict rules. These rules were, of course, based on the work of Claude.

Four pairs of drawings acquired by the British Museum in 1951 most effectively illustrate the deliberate aspect of Cozens' method in practice. Each pair consists of a blot and of the elaborately finished drawing which it inspired. As can be seen from the pair which is reproduced here (Plate 43), the 'blot' might equally well be described as a 'sketch', and would be accepted as such if it were from the hand of almost any other artist. The finished drawing is closely based on it; the main differences lie in the foreground plane of rocks and herbage. Just as in the Italian *Landscape with Sun breaking through Clouds* (Plate 42A), such an addition was needed to make of the drawing a true classical composition. However, Cozens was often able to achieve the same effect without such artificial appendages, as, for instance, in the lovely *View in a Wood* (Plate 42B), which is dated 1764. This sheet, and such drawings as the well-known *The Cloud* in the Oppé Collection,[5] are certainly the product of the observation and study of nature, but it is observation with an eye that is steeped in the style and methods of Claude Lorrain and his followers. There can be little doubt that Cozens' success in his own time was due to the similarity of his work to that of the vastly respected and cherished Claude. As a successful drawing-master he himself spread and enhanced the high reputation of his own preceptor.

While the actual impact of Italy on Cozens was outweighed by his discovery of the draughtsmanship of Claude, in the life and work of Richard Wilson (1713–82) the

1. 1946 Sheffield Exhibition Catalogue, p. 6.

2. It is reprinted as an Appendix in A. P. Oppé's *Alexander and John Robert Cozens*, 1952, pp. 165–87. Oppé devotes a chapter to Cozens' 'Systems', which also included illustrated guides to the depiction of trees and skies.

3. *Loc. cit.* p. 179.

4. *Loc. cit.* p. 169.

5. *Loc. cit.* pl. 21.

51

experiences of his own visit to Italy were decisive factors. Born in Wales, the son of a clergyman who gave him a sound classical education, he was sent to London in 1729 to become the pupil of Thomas Wright, a portrait painter about whom little is known. After six years under Wright, Wilson set up in practice as a portrait painter in London with some success, working in the accepted Kneller style of the day. There is little definite information concerning Wilson's life and work during these formative years in London, but there is a small group of dated canvases which prove beyond doubt that he was already painting landscapes in the years before he set out for Italy in 1750. Perhaps the earliest of these is the view of *Westminster Bridge*,[1] now in Philadelphia, which is dated 1745. This, and the view of *Dover*, of which several versions exist, one of which was engraved in 1747,[2] clearly show the influence of George Lambert. However, the two roundels, which Wilson painted for the Court Room of the Foundling Hospital in 1746,[3] display a more individual and sensitive approach. The two hospitals, St. George's and the Foundling Hospital itself, are shown in settings that have considerable atmosphere, and that display a knowledge of Dutch topographical painting.

The fact that he was asked to contribute these two works to the Foundling Hospital, and that they included the painting of the Hospital itself, seems to indicate that Wilson already enjoyed something of a reputation as a landscape artist. However, tradition has it that when he set out for Italy late in 1750 he had every intention of continuing primarily as a portrait painter. This is stated by Joseph Farington, who was his pupil from 1763 to 1766 in his *Biographical Note* on Wilson written in about 1805; he left England 'more with a view to improvement in that branch of art [portraiture] which he had hitherto professed, than with any intention of devoting himself to another'.[4] Wilson spent the first year or so of his time in Italy in Venice, and while there he certainly painted a number of portraits, including one of Francesco Zuccarelli,[5] who gave him a painting of his own in exchange for it. Zuccarelli was also the first owner of what is the earliest Italian landscape painting by Wilson known today. This is the *River and Farmhouse*[6] (Plate 44 B), now in the Victoria and Albert Museum, which has considerable affinities with the landscapes of Zuccarelli himself. It has been often repeated that it was Zuccarelli who persuaded Wilson to devote himself to the painting of landscape when they were together in Venice in 1751. This tradition probably has a basis of truth, unlike an alternative version of it which claims that Wilson had already been influenced by Zuccarelli when the Italian artist was supposed to have been in England in the early 1740s. There is, in fact, no evidence that Zuccarelli came to England at any time before 1752.[7] At the close of 1751, or early in the next year, Wilson moved on to Rome and here he was further encouraged and influenced in his development as a landscape painter by the French artist, Claude-

1. W. G. Constable, *Richard Wilson*, 1953, pl. 44 *a*. The present author has not seen this painting, which is now doubted by some authorities.

2. *Loc. cit.* pls. 38 *a* and *b*.

3. *Loc. cit.* pls. 43 *a* and *b*.

4. Farington's *Biographical Note* was printed on

pp. 10–14 of the *Catalogue* of the *Exhibition of Works by Richard Wilson*, held at the Ferens Art Gallery, Kingston-upon-Hull, in 1936.

5. Tate Gallery, London, no. 3727.

6. Constable, *loc. cit.* pl. 103 *a*.

7. See p. 54 below.

Joseph Vernet, who was just coming to the end of a long period in Italy. A remarkable canvas, that has not previously been published, reveals Richard Wilson painting a 'Vernet'. This is the *Italian Coast Scene with a Wreck* (Plate 46), which is signed and dated by Wilson. Without that signature this painting would easily pass as a work by Vernet himself, as indeed it was for long thought to be. Unfortunately the last figure of the date is very difficult to decipher, but it can be read as 1752, which would tally well with Wilson's contact with the French artist at the beginning of his own stay in Rome.

But, while the influences of the earlier masters – Claude, Dughet, Rosa and Marco Ricci – are found in Wilson's first Italian landscape paintings, he soon developed a manner of his own, in which he painted the scenery of Italy more seriously and realistically than either Zuccarelli or Vernet, or indeed than any artist working in Italy at this time. This personal style was rooted in his assiduous study of the outskirts of Rome and of the Campagna, where he made numerous drawings on the spot. The evolution of Wilson's art is impressively set out by Farington in the *Biographical Note* already referred to:

'By Studies made in Tivoli, Albano, Larici, Frascati, Terni and in the vicinity of Rome, Wilson formed his taste, and from the various matter which he found in those celebrated places he composed many pictures, and stored his mind with classical ideas which enabled him to form those beautiful compositions which are now the objects of general admiration. ...But wherever Wilson studied it was to nature that he principally referred. His admiration of the pictures of Claude could not be exceeded, but he contemplated those excellent works and compared them with what he saw in nature to refine his feeling and make his observations more exact; but he still felt independently without suffering his own genuine impressions to be weakened.'[1]

Although they have certain links with the draughtsmanship of other artists working in Rome in the mid-eighteenth century, particularly the Frenchmen Louis Gabriel Blanchet and Charles Michel-Ange Challe, the Roman drawings of Wilson have an individuality and effectiveness that make them a considerable achievement in their own right.[2] His on-the-spot studies have a nervous and subtle delicacy which conveys with great success the detail or the scene which he is recording. In his finished drawings, which, like his studies, are usually in black chalk heightened with white on grey paper,[3] the same delicate touch prevails, but the outlines of the major features are usually stronger, and elements of compositional *staffage*, drawn still more firmly, are added in the foreground and at the sides.[4] A beautiful view of Rome, inscribed by the artist '*The Vatican and Environs*' (Plate 44 A), combines all these characteristics. The distance and middle distance, certainly drawn from nature, are depicted with softness and subtlety; the group of trees and rocks in the right foreground are in a darker chalk and were probably added in the

1. *Biographical Note, loc. cit.* pp. 12–13.
2. See B. Ford, *The Drawings of Richard Wilson*, 1951; and D. Sutton, *An Italian Sketchbook by Richard Wilson*, 1968.
3. In his *Memoirs*, Thomas Jones stated that

Wilson 'did not approve of *tinted* Drawings' (*The Walpole Society*, XXXII (1946–8), p. 9).
4. The outstanding group of these is the well-known Dartmouth series, sixteen of which are reproduced in Ford, *loc. cit.*

studio. The same darker chalk has also been used to strengthen the outlines of some of the trees and buildings in the middle distance. As a whole this drawing wonderfully conveys form and tone, and these qualities are also to be found in Wilson's oil paintings of Rome and its surroundings.

Some of the first paintings which Wilson executed while in Italy are of historical or narrative rather than landscape subjects; these include *The Summons of Cincinnatus* and *The Departure of Regulus*,[1] which both date from 1752. In such compositions Wilson is still very much under the influences already discussed, but gradually the impact of the landscape itself begins to dominate his painting. In the Ashmolean Museum's *Pastoral Scene in the Campagna*[2] (Plate 45) it is the freely painted distant landscape that makes the greatest impact, while the carefully posed figures, sheep and ruin play a secondary role despite their apparent prominence. It is interesting to note that Wilson used this intimate scene with relatively minor changes as part of a broad landscape composition, the *River Mouth with Peasants dancing; Evening*,[3] of which several versions are known, all certainly painted some years after Wilson's return to England. The earliest known major landscape painted in Italy is the Earl of Dartmouth's *Rome from the Villa Madama*,[4] which is dated 1753. With its massive trees in the left foreground and the small figures beneath them, this has a somewhat Claudian character, but it already has that shimmering atmosphere which is a hallmark of Wilson's finest Italian landscape. This is even more in evidence in another distant view of Rome, dated 1754, the National Museum of Wales's *Rome and the Ponte Molle*[5] (Colour Plate V and Plate 47). Executed in thin, rather flat paint, in a very limited palette consisting largely of browns and yellows, it is a wonderful poem of evening light. The trees are dark and massive at their centre, but at their edges they vibrate with the sunlight breaking through the foliage. While basically a formal composition, with the traditional *staffage* elements of figures and masonry, this noble painting is essentially an evocation of mood – a deeply felt representation of the light and atmosphere of an evening in Rome.

While in Italy Wilson enjoyed considerable patronage, mostly from British travellers, and when he returned to England he had rather more money than when he had set out. The date of his leaving Rome is not certain, but it was probably in 1757 or early in the following year. It has been recorded by Wilson's first biographer that, soon after his return to England, the so-called 'Committee of Taste' resolved 'that the manner of Mr. Wilson was not suited to the English taste, and that if he hoped for patronage he must change it for the lighter style of Zucarelli'.[6] The Italian artist had come to England in 1752, and he stayed for some ten years. He returned for a second visit from 1765 to 1771, during which he became a founder member of the Royal Academy.[7] From the

1. Constable, *loc. cit.* pls. 15 *a* and *b*.
2. *Loc. cit.* pl. 105 *b*.
3. *Loc. cit.* pls. 104 *c* and 105 *a*.
4. *Loc. cit.* pl. 107 *a*.
5. *Loc. cit.* pl. 109 *b*.

6. T. Wright, *Some Account of the Life of Richard Wilson, Esq., R.A.*, 1824, p. 72.
7. M. Levey, 'Francesco Zuccarelli in England', in *Italian Studies*, XIV (1959), pp. 1–20.

large number of his works in so many of the old collections in this country, it is clear that he enjoyed widespread patronage, which included that of George III, who acquired a few of the canvases now at Windsor direct from the artist. There are not many variations in the landscape paintings of Zuccarelli, which are certainly 'light' in style and frivolous in content. Gaily clothed peasants and shepherds disport themselves in theatrically composed idyllic scenes, in which somewhat formless trees, rocks, rivers, lakes and mountains are assembled to provide a basically Italian background. Even on the few occasions when he was supposedly painting the scenery of England, as in the *View of Mrs. Clayton's House at Harleyford*,[1] there is no real change in the character of the landscape. Yet, if one remembers the prevailing, usually light-hearted, decorative styles popular in England in the second half of the eighteenth century, it is not in the least surprising that the prettiness of Zuccarelli's 'Arcadia' – so in tune with the pastoral poetry of the day – should have been more widely favoured than the much more demanding landscape painting of Richard Wilson. Thus Zuccarelli was called in to paint two idyllic overmantels as part of Robert Adam's most graceful decoration of the Long Gallery at Syon House. Among the artists more frequently employed by Adam when landscape panels were required were the Italian, Antonio Zucchi (1726–95), and his English pupil, William Hamilton (1751–1801), both of whom produced work which, though totally derivative, was pleasantly decorative.

At first Wilson himself found it difficult to record the English landscape without Italianate overtones. In some of the earliest English scenes painted after his return from Italy – such as *Croome Court, Worcestershire* (1758)[2] and the Tate Gallery's *Holt Bridge, the River Dee*[3] – not only the nature of the composition, but also the character of some of the trees and of other details, appear basically Italian. The latter's companion, *The Valley of the Dee*[4] (Plate 56), has the luminous, rather yellow, tonality of the landscapes of the Italo-Dutch artist Jan Both and some of his contemporaries. There are several other paintings by Wilson of views on the River Dee of which the earliest, that at Petworth, is dated 1760. It is probable that this was one of the pictures which he exhibited at the Society of Artists that year. At the exhibition he also showed the most important of his historical and literary landscapes, *The Destruction of Niobe's Children*, now in the Mellon Collection.[5] It was with such ambitious exercises in the Grand Manner that Wilson hoped to make his mark, and to regain the patronage which was already showing signs of being difficult to achieve. In these dramatic compositions Wilson is least himself and is most closely identified with the classical tradition of Poussin and Dughet. It might have been expected that this type of painting would have appealed especially to Sir Joshua Reynolds, the prime advocate in England of the Grand Manner, but it was, in fact, the *Niobe* that he was criticizing in the *Fourteenth Discourse* when he

1. Royal Academy, London, *Italian Art and Britain*, 1960, no. 168.

2. Constable, *loc. cit.* pl. 33a.

3. *Loc. cit.* pl. 35a.

4. *Loc. cit.* pl. 35b.

5. *Painting in England, 1700–1850*, Richmond, Virginia, 1963, no. 19, pl. 220.

said, 'Our late ingenious academician, Wilson, has, I fear, been guilty, like many of his predecessors, of introducing gods and goddesses, ideal beings, into scenes which were by no means prepared to receive such personages. His landscapes were in reality too near common nature to admit supernatural objects.'[1]

That so many of Wilson's landscapes were 'near common nature' is, of course, what has made them especially attractive to more recent generations. There is no evidence that Wilson sketched in oils from nature, though it has been suggested that the Ashmolean Museum's *Lago di Agnano*, with its subtle tonality, must have been painted on the spot.[2] However, the preliminary drawing for this composition has been recently rediscovered and presented to the Ashmolean;[3] this was certainly drawn on the spot and lacks the wooded cliff shown in the right foreground of the painting. Otherwise it has been closely followed in the painting. While there are many surviving *plein air* drawings done in Italy, those similarly executed in Britain are far less common, and no British sketch-book is known today. When Wilson returned to England the essential elements of his landscape style were formed, and it is not surprising that when seeking subjects in these islands he usually selected those which had something in common with the scenery of the Campagna. However, unlike most of his predecessors in the painting of the British scene, he was not just working in imitation of the earlier masters; he was using his own style, based on the greatest tradition of landscape painting, to record a narrow range of the scenery of his own country in a manner that was, in this context, as original as it was successful. This important achievement was brilliantly summed up by John Ruskin in one of his Oxford lectures: 'with the name of Richard Wilson, the history of sincere landscape art, founded on a meditative love of Nature, begins for England'.[4]

One of the few British drawings by Wilson is reproduced here as Plate 48 A. Now known as *A Welsh Valley*, it was, understandably enough, described as 'The Campagna, towards Albano', in an inventory of 1855.[5] This misconception was perhaps largely caused by the presence of the pine-like tree in the left foreground, but, as with the similar tree in the drawing of '*The Vatican and its Environs*' (Plate 44 A), it was probably added in the studio. The actual landscape, which is very freely drawn, has a definite Welsh air about it, which is even more strongly felt in the small oil painting based on this drawing, the *Welsh Valley with a Quarry* (Plate 48 B) in the Tate Gallery.[6] Here the framing tree is also retained, and seems just as out of place as it does in the drawing, but the character and feeling of the hillside and the valley are definitely not Italian.

The subject of the *Welsh Valley with a Quarry* did not impose any limitations of topographical accuracy on Wilson, but he might have been restricted by these in his

1. *Discourses*, ed. by Roger Fry, 1905, p. 385.
2. E. K. Waterhouse, *Painting in Britain, 1530–1790*, 1953, p. 165, pl. 140 a.
3. *Report of the Visitors*, 1967, p. 35.
4. *The Art of England*, Lecture VI 'The Hill-Side', given November 1883; *The Works of John Ruskin*, vol. XXXIII, 1908, p. 378.

5. The Inventory of the Chambers Hall Gift; archives of the Department of Western Art, Ashmolean Museum.
6. Constable, *loc. cit.* pl. 40 b.

V Richard Wilson *Rome and the Ponte Molle*, 1754 (detail) National Museum of Wales, Cardiff. *See page* 54
For whole canvas see Plate 47

VI Richard Wilson *Snowdon from Llyn Nantlle*

Canvas, 40½ × 49, 103 × 124·5
Castle Museum and Art Gallery, Nottingham. *See page* 57

VII Richard Wilson *On Hounslow Heath* (detail)

Tate Gallery, London. *See page* 58
For whole canvas see Plate 51

VIII Richard Wilson *River View: 'On the Arno'*, 1764 Canvas, 48⅝ × 41⅞, 123·5 × 105.9
City Art Gallery, Manchester (on view at Platt Hall) (*Reproduced by kind permission
of the Manchester City Art Galleries*) *See page* 60

painting of *Caernarvon Castle* [1] (Plate 49 B). However, in order to make of this familiar landmark a reasonable classical composition, Wilson has allowed himself considerable freedom with the topographical details. On the other hand the atmosphere and colouring are truly Welsh and, with its subtle use of pinks and its flatly painted distance, the misty light of the Western coastline is beautifully rendered. There is more accuracy in the topography of another painting at Cardiff, *Pembroke Town and Castle*, [2] in which Wilson has broken away from the classically balanced composition, and placed greater emphasis on the form of the buildings, for which he has used unusually thick paint. The mood of this picture is serious and dignified, and it is less immediately appealing than the more conventionally Italianate views of Caernarvon and Dolbadarn Castles. The same characteristics are to be found in another Welsh subject at Cardiff, where Richard Wilson's work is magnificently represented. This is the large and wholly successful painting of *Pistyll Cain, Merioneth* [3] (Plate 49 A), which combines an overall grandeur with beautifully painted detail, especially in the foreground. Like the painting of the quarry, this is, for the time, a remarkably realistic record of a straightforward natural scene, and Wilson's originality and success – in the context of British landscape painting – lies in rendering it as such. The figures are used in order to provide scale, and there is no element of artificiality or of posing; here we truly have Joshua Reynolds's 'common nature'.

For such pure landscapes Wilson found his greatest inspiration in his native Wales, which was to become one of the most popular of the British sketching grounds with the next generation of artists. It was the Welsh mountains that inspired Wilson in two of his masterpieces, the view of *Snowdon from Llyn Nantlle* [4] (Colour Plate VI) and *Cader Idris, Llyn-y-Cau* [5] (Plate 50). In the first, of which there are two versions, at Liverpool and Nottingham, Wilson's classical and natural instincts are combined in a wonderfully balanced and atmospheric rendering of Wales's principal mountain. This is most ingeniously given grandeur by being shown, as it were, through the keyhole of an opening in the hills surrounding the lake. The effect of the distance is beautifully painted, while the middle distance is much less strongly indicated. In his painting of distant views Wilson learnt much from Claude, but he developed a highly personal manner with the use of pinks, pale greens and white, which none of his followers was able to emulate with quite the same delicacy.

In the painting of *Cader Idris, Llyn-y-Cau*, now in the Tate Gallery, Wilson has effectively created a forceful composition based on a close-up view of a mountain, a concept of great originality when it was painted in the 1770s. The National Gallery *Catalogue* is certainly correct in stating that 'the topography is summary and the foreground invented', [6] but Thomas Pennant was equally truthful when he wrote in 1783 in the course of his account of the summit of Cader Idris that this scenery 'is so excellently expressed by the admirable

1. *Loc. cit.* pl. 32 b.
2. *Loc. cit.* pl. 48 b.
3. *Loc. cit.* pl. 52 b.
4. *Loc. cit.* p. 186.
5. *Loc. cit.* pl. 31 a.
6. M. Davies, *Catalogue of the British School*, 1959, p. 107.

pencil of my kinsman, Mr. *Wilson*, that I shall not attempt the description'.[1] Although it is not accurate in detail, this striking view of the tarn in a hollow at the foot of almost vertical crags gives one all that is needed to evoke the 'feel' of this rather grim mountain scenery. Equally effective in its rendering of atmosphere is another 'close-up' composition by Wilson, the view *On Hounslow Heath* in the Tate Gallery[2] (Colour Plate VII and Plate 51). Wilson exhibited *A view on Hownslow-Heath* at the Royal Academy in 1770, and at least two other versions of the composition are known today. It is somewhat unexpected that at such an early date this unpretentious and 'natural' view, with a humble clump of trees as its principal feature, should have been thought worthy of exhibition and of repetition. With its expanse of sky and the fine tones of the distance this canvas is, of course, a prediction of the vision of Constable, and it shows Wilson totally liberated from the shackles of Italianate classical landscape.

It has often been suggested that in his painting of country house 'portraits' Wilson introduced innovations into what had already become an established feature of the work of landscape painters in this country. In fact, Wilson's method of showing the house in its setting as part of a larger landscape was, as we have seen, already being practised by George Lambert, as for instance in the view of *Wotton Park* (Plate 9). There can be little doubt that in such paintings as that of *Croome Court, Worcestershire*[3] Wilson was again influenced by Lambert, as he had been in his few pre-Italian landscape paintings. However, to the novel formula introduced by Lambert, Wilson applied his greater skill in recording light and atmosphere. Thus, though following a precedent in their overall character, his house portraits break new ground in their beauty and effectiveness. The somewhat sketchy view of *Sion House from Richmond Gardens*[4] (Plate 52) is a wonderful rendering of a quiet summer's evening on the Thames, with the great house shown completely naturally in the middle distance. In the larger more finished version of this composition,[5] which shows the scene by afternoon light, the figures in the foreground are more prominent as they are not in shadow. There is also more light on the river and on the house, but this is again a relatively minor feature of the whole.

The same informality is seen in the well-known series of views of Wilton House,[6] and also in the splendid *View of Tabley House, Cheshire, the seat of Sir John Leicester*[7] (Plate 53), which was shown at the Royal Academy in 1780. This was Wilson's last exhibit, but it was suggested by a contemporary critic that it was 'an old picture, painted in his prime'.[8] This was certainly correct, for the painting was commissioned by Sir John's father, who died in 1770. It was probably of this painting that John Constable wrote to his friend Archdeacon Fisher after a visit to Sir John Leicester's collection in 1823: 'I recollect nothing so much as a solemn – bright – warm – fresh – landscape by

1. Constable, *loc. cit.* p. 171.
2. *Loc. cit.* pl. 39 *b*.
3. *Loc. cit.* pl. 33 *a*.
4. *Loc. cit.* pl. 54 *b*.
5. *Loc. cit.* pl. 54 *a*.

6. *Loc. cit.* pls. 58 *a* to 60 *b*.
7. *Loc. cit.* pl. 56 *a*.
8. W. T. Whitley, *Artists and their Friends in England, 1700–1799*, 1928, vol. I, p. 383.

Wilson, which still swims in my brain like a delicious dream.' In the same passage Constable described Wilson as 'one of the great appointments to shew to the world the hidden stores and beauties of Nature. One of the great men who shew to the world what exists in nature but which was not known till his time.'[1] Here Constable has summed up Richard Wilson's achievement as a painter, one important factor of which was his elevation of the country house 'portrait' from topography to landscape art.

A second traditional feature of British topographical painting – the panoramic view – was also revitalized by Wilson, as in *A View from Muswell Hill*,[2] which was exhibited at the Royal Academy in 1775. In this the somewhat featureless and flat area to the north-east of London, with Minchinden House (destroyed in the mid-nineteenth century) in its centre, is convincingly recorded, with an overall tone of mistiness typical of London and its surroundings. There is likewise a feeling of damp and haziness in Wilson's painting of the *Valley of the Mawddach, with Cader Idris*[3] (Plate 54), in which the Welsh valley, with its winding stream, rolling hills and backcloth of mountains, is truly shown as one of 'the hidden stores and beauties of Nature'.

That the Englishman's eyes and ears were already receptive to the beauties of nature is proved by the success of James Thomson's poem, *The Seasons*, of which the first part, *Winter*, appeared in 1726, and the collected volume – as already mentioned – in 1730. But while the description of natural phenomena was acceptable in poetry and prose, it still took several decades before their artistic value was recognized. It was no doubt in order to encourage that recognition that Wilson chose to illustrate a passage from *Summer* in his painting entitled *Solitude* (Plate 55), of which the earliest known version is dated 1762, a second 1768, and another ten years later.[4] This composition, which depicts movingly the 'solemn grove' described at some length by Thomson, was engraved by William Woollett and William Ellis, and published by the former in 1778. It was one of the most popular of Wilson's works in his own lifetime, and was, of course, breaking new ground in being based on a passage from the *Seasons*, which was soon to become a common source for inspiration in the painting of landscape compositions with a literary character. It is also a remarkable fact that, at a time when Wilson himself was finding it difficult to make a living by his painting, the engraver William Woollett (1735–85) was especially successful in the sale of his engravings after Wilson, which contributed handsomely to his considerable fortune. With the exception of the *Snowdon*, the paintings engraved by Woollett were all of an historical or literary nature, such as the *Niobe*, *Phaethon*, *Meleager and Atlanta*, and other subjects from Ovid. Here we have further proof

1. *John Constable's Correspondence*, ed. by R. B. Beckett, vol. VI, 1968, p. 117.

2. Constable, *loc. cit.* pl. 45 *b*.

3. *Loc. cit.* pl. 45 *a*.

4. See *loc. cit.* p. 169, where the canvas illustrated here is listed as version no. 10. The fact that this painting is signed with a monogram and dated

1762 is not recorded by Constable. See also W. A. Martin and Brian Sewell, London, *Paintings by Old Masters and English Artists*, November 1970 to January 1971, no. 20. The painting has recently been acquired by the Glynn Vivian Art Gallery, Swansea.

that Wilson was ahead of the fashion of the day in his painting of natural landscapes, only one of which Woollett thought it worth while to engrave.

It was no doubt as something of a compromise that Wilson devoted much of his time and energy in the last twenty-five years of his life to the painting of Italian landscapes, for which there was more demand than for his paintings of the British scene. One of his most successful 'stock' Italian subjects was a view of Lake Avernus, which is known today in a variety of versions and copies, all of which appear to have been painted in England. W. G. Constable illustrates five different 'patterns' of this view as well as two views of *Lake Avernus and the Island of Ischia*, and he lists over twenty versions of the former. With its mythological and historical connections, and its decorative ruins, Lake Avernus was a great attraction for visitors to Naples. Those who had been to Italy would have found a happy reminder in Wilson's composition; for those who knew Italy only by repute, such a painting of *Lake Avernus and the Island of Ischia*[1] (Plate 57) could provide a splendid substitute for the real thing. It was to fulfil these two requirements that Wilson continued to produce Italian views, and it is interesting to note that as his own memories of Italy receded further into the distance, his rendering of the Italian scene tended to become brighter and more colourful. The views which he painted while in Italy appear somewhat dark and sombre when compared with his later visions of Italy. The mellow tones and glowing light of the *River View: 'On the Arno'*[2] (Colour Plate VIII), which is dated 1764, are typical of the most successful of his 'English' Italian views. This noble composition was painted for an overmantel at Platt Hall, near Manchester, to which it has lately been returned. There are again a considerable number of variants and a great number of versions of this *River View*, most of which are horizontal compositions.

Another very fruitful source of compositions for Wilson was Tivoli, which his pupil Thomas Jones described as 'formed in a peculiar manner by Nature for the Study of the Landscape-Painter',[3] and which was one of the most popular sketching-grounds for artists of all nationalities. There is again a considerable variety in Wilson's compositions based on the features of Tivoli, in none of which great prominence is given to the famous waterfalls. In several of them an artist is shown sketching in the foreground, as in the National Museum of Wales's *A View at Tivoli*,[4] indicating that Wilson also remembered Tivoli as one of the favourite haunts of artists. With the temples on the cliff on the left, and the view down the gorge of the River Anio to the Campagna, this composition is built up with bold simplicity. The same effective simplicity of design is combined with subtlety of tone and colour in the small and poetic *The Vale of Narni* (Plate 58) in the Brinsley Ford Collection.[5] In paintings such as this Wilson truly achieved one of the landscape painter's principal purposes, the rendering of the spirit and poetry of a place.

1. Constable, *loc. cit.* pl. 69 *b*.

2. *Loc. cit.* pl. 101 *a*. For further details about the early history of the painting see E. Johnston, 'A Wilson for Manchester', *Burlington Magazine*, CXII (1970), p. 535.

3. *Memoirs, loc. cit.* p. 66.

4. Constable, *loc. cit.* pp. 222–3.

5. *Loc. cit.* pl. 90 *b*.

It is perhaps apt to close this discussion of Richard Wilson with a more detailed reference to *An Essay on Landscape Painting* which was published anonymously in 1782, the year of the artist's death. Here Wilson is described as 'a painter of great science'; to whom 'the finest effects of nature are familiar',[1] and he is listed as one of the six 'most eminent landscape painters of this country'[2] – the others being Lambert, Gainsborough, Barret, Marlow and Wright of Derby. The author of the *Essay*, who is thought to have been Joseph Holden Pott (1759–1847), at that time a young Cambridge graduate and later Archdeacon of St. Albans and then of London, incorporated these comments in his third chapter, which is entitled 'Hints for forming the Taste of an English School; with Remarks on the Landscape Painters of this Country'. Here he gives Wilson no credit of any kind for his painting of the English scene, though the chapter opens with a plea for 'the forming of an English school' of landscape:

'in this branch of the art particularly', he continues, 'our countrymen have contented themselves with imitating the ideas of other masters, when they should have copied nature only. In this country, the merely copying from nature, would of itself give a character to the landscapes of our painters, which would be peculiar, and would sufficiently establish the taste of an English school: for England has undoubtedly many unrivalled and peculiar beauties, many characteristic charms and graces worthy of the pencil. Every foreigner is immediately and powerfully struck with the beautiful verdure that prevails here through the year, owing perhaps to circumstances not so favourable to fogs and damps, to its insular situation.... The English park and forest, afford an infinite variety of character in its trees, and endless choice of foliage. We have also a great advantage over Italy itself, in the great variety and beauty of our northern skies; the forms of which are often so lovely and magnificent, where so much action is seen in the rolling of the clouds; all this is nearly unknown to the placid southern hemisphere.'[3]

That Joseph Pott makes no reference to Wilson's British paintings may well reflect the fact that little was seen of them in the last ten years of the artist's life: Pott was, of course, still a child when the best of them were being painted. On the other hand he was clearly familiar with the early landscapes of Gainsborough, which date from more than ten years before his own birth.

The artist picked out in the *Essay* as the 'only one of our painters who has given the genuine character of the countries he has lived in to his works'[4] was, not altogether surprisingly, George Barret (?1732–84). Pott considered him 'a great master of effect', while Wilson is reported to have described his fellow-artist's paintings as 'Spinach and Eggs'.[5] To the modern eye George Barret's paintings lack the subtle tonality and mood

1. *An Essay on Landscape Painting. With Remarks General and Critical on the Different Schools and Masters, Ancient or Modern*, London, 1782, pp. 67–8. The discovery of this then unrecorded publication in the British Museum was an important factor in the evolution of the present study.

2. *Loc. cit.* p. 65.
3. *Loc. cit.* pp. 53–6.
4. *Loc. cit.* p. 69.
5. Whitley, *loc. cit.* vol. 1, p. 381.

of Wilson's, though topographically and botanically they are usually more accurate. 'Every tree he paints is distinctly characterised', wrote Pott,[1] and there is certainly none of the possible confusion in Barret's work that exists in some of Wilson's as to whether the scene is British or Italian. Barret, whose work is discussed at this point because of its relationship to that of Richard Wilson, in fact never visited Italy. Having come to England from his native Ireland in 1762, he quickly established himself as a successful landscape painter, and found all the subjects he needed during his extensive travels in the British Isles.

Like Wilson, Barret was a founder member of the Royal Academy, where he exhibited with regularity. The majority of his exhibits were landscape paintings with specific titles indicating the exact place depicted. The rivalry between Wilson and Barret has certainly been exaggerated, but the Irishman did continue to enjoy considerable patronage in the years when Wilson was finding it difficult to find buyers for his work. It was in that period, for instance, that William Locke commissioned Barret (in about 1780) to decorate a large room at Norbury Park in Surrey with landscape paintings, depicting the mountainous scenery of Cumberland and Westmorland, but blending in perfectly with the actual landscape that surrounds this magnificently situated house. Barret was among the earliest painters to find inspiration in the Lake District, which was soon to become one of the most popular areas with artists and travellers in search of the picturesque. William Gilpin's *Tour of the Lakes* was compiled in 1772 and published in 1786.

George Barret's realism is well represented in a series of three large upright views in Dalkeith Park, which are now at Bowhill. The *View of Dalkeith Park with the Town in the Distance* (Plate 59) was probably exhibited at the Royal Academy in 1770; at the same exhibition Barret showed *Study from Nature on Lake Ullswater*, a title which implies that he occasionally painted on the spot. The *View of Dalkeith Park* illustrates his ability to make a balanced composition without resorting to any of the stock *staffage* items; on the other hand Barret's painting of *Llyn Peris with Dolbadarn Castle* (Plate 60) at Nottingham is flat and lifeless. In spite of touches of the tonality of Wilson, whom he imitated frequently in his later work, Barret has here produced little more than a theatrical back-drop for the lively group of figures and animals painted by his friend Sawrey Gilpin, with whom he often collaborated. In a pair of imaginary landscape compositions at Anglesey Abbey there is again strong evidence of the influence of Wilson, and here Barret is least himself for he is also trying to emulate the manner of Salvator Rosa and his followers. Professor Bodkin[2] and others have tried to revive the reputation of Barret, but with little success, for, despite a certain originality, his work on the whole appears somewhat mechanical and entirely lacks the authority and imagination of Wilson, who very aptly told a young patron towards the end of his life: 'depend upon it you will live to see my pictures rise in esteem and price...when Barret's are forgotten'.[3]

1. *An Essay, loc. cit.* p. 70. Edmund Burke, who persuaded the artist to come to England, thought Barret 'a wonderful observer of the accidents of nature'. (*The Works of James Barry*, 1809, vol. II, p. 89.)

2. T. Bodkin, *Four Irish Landscape Painters*, 1920.

3. Whitley, *loc. cit.* p. 381.

William Marlow (1740–1813) was another of 'the most eminent landscape painters' listed by Pott in 1782, although in the *Essay* only two sentences are devoted to his work, which was then at its prime, but which has been consistently underestimated since soon after the artist's death. While there is no great originality in the work of Marlow, this remains important for its successful assimilation of the influences of Canaletto and Samuel Scott on the one hand, and of Richard Wilson on the other. It has frequently been stated that Marlow was a pupil of Wilson, but there is no evidence for this. We do know that from 1756 to 1761 he worked in the studio of Samuel Scott, and like his master he devoted much of his energy to the painting of topographical views, especially of London. Indeed, were it not for Marlow's travels in France and Italy from 1765 to 1768, his proper place would be in the preceding chapter. However, the impact of those travels resulted in the production of Marlow's most characteristic and individual paintings.

One quality that is immediately apparent in Marlow's work is his firm and confident draughtsmanship.[1] He worked frequently in water-colours, drawing both figure and topographical subjects, and a fair proportion of his exhibits were drawings. To his firm outlines Marlow added subtle and delicate colouring, which gives his drawings remarkable qualities of light and tone. The more finished water-colours are usually neatly signed, and include both English and continental subjects. Thus at the Ashmolean Museum there is a large *Extensive View of London, from Temple Gardens*,[2] strongly reminiscent of Canaletto and Scott, and a delicate *Scene on the Rhône*, in which the river is seen flowing past a village with a tower on the far bank. A considerable number of Marlow's water-colours are of scenes in and around York, including a fine view of *The Old Ouse Bridge*, formerly in the collection of Sir Bruce Ingram,[3] of which at least one other version is known and which was also repeated in oils in a painting now at York Art Gallery.

It is probable that this painting and the drawings on which it is based all date from before Marlow's Continental travels. From 1762 to 1765 he was working in several parts of England, but it seems that he found his most consistent patronage in Yorkshire, and some of his best work is still to be seen in Yorkshire houses today. Among these is Burton Agnes Hall, where there are a number of overdoors painted by Marlow, as well as views of the house and of Barnston Hall, and the impressive *Distant View of Bridlington Bay and Flamborough Head* reproduced here (Plate 61). Though this shows some of Marlow's inherent weaknesses in the painting of landscape, for instance in its rather unconvincing trees, it does provide a telling record of the bleak Yorkshire coastline only a few miles from the house for which it was painted. There is also a great deal of atmosphere in the sky, which boldly takes up more than half the canvas. This broad view shows signs of the influence of George Lambert, and that artist's example is even more strongly felt

1. There is an album of Marlow's drawings of London in the British Museum (1877-8-11-21 . . . 110). These provide ample evidence of the qualities of Marlow's draughtsmanship, especially in his rapid sketches in pen and ink.

2. Sutherland Collection, large vol. IV, p. 25.

3. Messrs. P. & D. Colnaghi, *A Loan Exhibition of English Drawings and Watercolours in Memory of the Late D. C. T. Baskett*, 1963, no. 4.

in some of Marlow's house portraits such as those at Burton Agnes, and the rather grander views of Castle Howard,[1] dating from 1772 and still at the house today.

However, Marlow's house portraits stand out from those of Lambert because of the excellent drawing of the buildings, and the same quality differentiates his London views from those of his master, Samuel Scott. Probably one of the earliest of these is the *View of London Bridge* (Plate 62) in the Royal Collection,[2] in which St. Magnus's Church and Fresh Wharf are in the foreground. This may have been the painting of this subject which Marlow exhibited at the Society of Artists in 1762.[3] Here the lively depiction of riverside activity and the skilful drawing of architectural detail are successfully combined to make a telling composition, which is further enhanced by its pleasing tonality. The same subtle and luminous tones are to be found in most of Marlow's London paintings, as for instance in the pair of large oval compositions which belonged to David Garrick and which are now owned by the Corporation of London. Here Marlow has actually specified the times of day depicted; the *Blackfriar's Bridge and St. Paul's Cathedral* is a morning scene, and the view *Near Westminster* shows the evening light.[4] Another example of Marlow's interest in specific effects in his painting of London is his view of the City under snow, with the frozen Thames in the foreground, which is in the collection of the Duke of Rutland.

We know little in detail about Marlow's three years on the Continent (from 1765 to 1768), but from the surviving and exhibited paintings and drawings it is clear that he travelled quite extensively in Italy and in France. As most of his Italian and French views are very detailed, Marlow must have made a considerable number of on-the-spot drawings, but few of these are recorded today. The clear and crisp light of Italy and Southern France made an obvious impact on Marlow, and in his paintings he rendered it in sparkling silvery tones. He also painted the more mellow effects of the Italian scene, as in the *Italian Landscape* at the Fitzwilliam Museum (Plate 64). Here, like in the Italian painting by Wright of Derby reproduced on the facing plate, the treatment of the distance is reminiscent of the manner of Wilson, whose influence is often to be seen in Marlow's Italian views. But in the foreground, and particularly in the group of buildings on which the light is focused, Marlow had made use of his own sharper outlines and more positive tones. While in Italy Marlow also came under the influence of Vernet, whose coastal scenes he emulated as, for instance, in the *Bay of Naples* in the Mellon Collection.[5]

Where Marlow broke new and more original ground was in his paintings of France, the majority of which are devoted to scenes on that country's great rivers, thus anticipating by over half a century Turner's famous *Rivers of France* drawings and engravings. A composition which he repeated several times was the dramatic view of the *Pont du*

1. J. Steegman, *The Artist and the Country House*, 1949, pl. 26.

2. O. Millar, *The Later Georgian Pictures in the Collection of Her Majesty the Queen*, 1969, no. 936.

3. Three other versions are known; see Millar, *loc. cit.* and J. Hayes, *Catalogue of the Oil Paintings in the London Museum*, 1970, no. 73.

4. Guildhall Art Gallery, London, *An Exhibition of Paintings and Drawings by William Marlow*, 1956, nos. 9 and 15 (repr.).

5. *Painting in England*, *loc. cit.* no. 41, pl. 124.

Gard, Nîmes, of which an excellent version is in the Graves Art Gallery at Sheffield. Here Marlow found the ideal subject for combining his love of the painting of buildings with his ability to render the character and atmosphere of river scenery. Another favourite subject was the great palace at Avignon set on its rock above the Rhône, while at Lyons, further up the same river, he found a similarly 'bold and picturesque'[1] scene for his brush. It was a subject that he exhibited several times, and there is a fine painting of Lyons at Manchester City Art Gallery (Plate 63), of which another version has lately been on the London art market. This exemplifies beautifully the coolness and conviction of Marlow's French river scenes, which, like some of his Italian subjects, he repeated frequently on his return to England.

Thomas Jones recounts that when he himself was at the start of his career in 1769, 'There was Lambert, & Wilson, & Zuccarelli, & Gainsborough, & Barret, & Richards, & Marlow in full possession of Landscape business.'[2] Marlow was by far the youngest of these artists, and it is remarkable that he should have been included in such a list referring to the time immediately after his own return from the Continent. He had sent home some Italian landscapes for the exhibitions of the Society of Artists in 1767 and 1768, and he continued to show with that Society (of which he became Vice-President in 1778) until 1790, and at the Royal Academy from 1788 to 1796, making a single reappearance in 1807. While they included a few Italian subjects, a *View on the Alps* (1790), and one French scene, the majority of these exhibits were views in England, and of these the greater part were of London. Marlow never attempted to become a member of the Royal Academy, though he was on friendly terms with Sir Joshua Reynolds who was his neighbour in Leicester Fields. In 1788 Marlow moved to Twickenham, where Scott had also lived, and he remained there for the rest of his life. By the time of his move he had already been able to give up working on commissions and painted and drew only for his own pleasure.

It was some years after his 'retirement', in about 1795, that Marlow painted the remarkable *Capriccio: St. Paul's Cathedral and a Venetian Canal*, now in the Tate Gallery.[3] Though the Venetian element of this composition is apparently based on inferior engravings after Canaletto,[4] the skilful painting of the building and figures shows Marlow at his closest to that master, and it is not at all surprising that even in his own lifetime paintings by Marlow should have been passed off as the work of the Venetian.[5] On the whole Marlow's paint is broader and thinner than that of Canaletto, and he does not use the Venetian's slight dashes of paint to emphasize details and highlights. We have seen that Marlow owed a great deal to the examples of Canaletto, Scott, Lambert and Wilson, but at his best he was far more than just a gifted eclectic artist. The subtle rendering of light and a sensitive use of colour make much of Marlow's work stand out for its

1. T. Jones, *Memoirs, loc. cit.* p. 42.
2. *Loc. cit.* pp. 19–20.
3. No. 6213. The Tate Gallery has also recently acquired a pleasant *View on the Thames* by Marlow (T. 930).
4. F. J. B. Watson, 'Baudin, Canaletto, and Marlow', letter in *Burlington Magazine*, xcvii (1955), p. 391.
5. Whitley, *loc. cit.* vol. i, p. 206.

painterly qualities. Both as a draughtsman and as a painter Marlow ranks high among the British landscape artists of the second half of the eighteenth century.

The same cannot be said of John Inigo Richards (*c.* 1732–1810),[1] who, as we have seen, was also included in Thomas Jones's list of landscape painters, but of whom no mention is made by Joseph Pott. Richards, who was active as a scene-painter and succeeded his master, N. T. Dall, as principal scene-painter at Covent Garden in 1777, came under much the same influences as Marlow, but rarely, if ever, rose above them to do work with any individuality or originality. He seems not to have travelled abroad, but, nevertheless, painted occasional 'Italian' subjects, such as the very stagey *Roman Capriccio* at Cardiff, which is dated 1756. Two other paintings by Richards, also at Cardiff, illustrate the range of manner and quality in his work in oils. The *View of Halswell House, Somerset*,[2] which is dated 1764, is flat and naïve, while the *Chepstow Castle* (Plate 67) has a good effect of light, particularly in the sky, and shows strongly the influence of Wilson, both in the composition as a whole and in such details as the foreground trees. Richards also worked prolifically, and almost as unoriginally, in water-colours, and occasionally in gouache. Most of his subjects in these mediums are simple picturesque themes, many of which include a ruin as the central feature. Richards was a founder member of the Royal Academy, where he exhibited mostly landscapes. He was elected Secretary in 1788, a post which he retained until his death. His work as a scene-painter was highly regarded and popular in his day, and it must certainly have overshadowed his slender achievements as a landscape artist.

While Richard Wilson influenced many of his contemporaries he had only a few actual pupils who became professional artists. One or two of these studied under him in Italy, but of his London pupils only one later visited Italy. This was his fellow-Welshman Thomas Jones (1742–1803), who worked in Wilson's studio in Covent Garden from 1763 to 1765. Because of his invaluable *Memoirs*, published by the Walpole Society in 1951,[3] Thomas Jones's name is familiar to the student of eighteenth-century British art, but his own paintings and drawings are not widely known, though an excellent exhibition of his works was shown at Marble Hill House and in Cardiff in 1970.[4] From the *Memoirs* it is clear that Jones was himself disappointed by his relative lack of success as a landscape painter, though at the beginning of his career he won several Premiums at the Society of Artists. That he was intent on working from nature is revealed by a statement in his *Memoirs* referring to a three-week visit to Wales in the summer of 1772. Here, among the beautiful Welsh hills, he 'made a good many Studies in Oil on paper',[5] one of which, a view of a hillside at Pencerrig dated 1772, is in the City Art

1. The date of Richards's birth is uncertain, but Farington, in his *Diary* on 1 January 1794, gives his age then as sixty-two.
2. Constable, *loc. cit.* pl. 158*b*.
3. The whole of volume XXXII (1946–8) is devoted to the *Memoirs*, which were edited by A. P. Oppé.
4. Marble Hill House, Twickenham, June–August 1970, and National Museum of Wales, Cardiff, August–September 1970, *Catalogue* 'Introduction' by R. Edwards, and entries by J. Jacob.
5. *Memoirs, loc. cit.* p. 27.

Gallery at Birmingham (Plate 68 B). In its rendering of the rugged fields and the humid sky this small sketch shows a real feeling for landscape, as does another example in the Oppé Collection,[1] but in his larger oil paintings Jones's style is somewhat stiff and his technique is very tight. Though he is known to have copied and imitated the paintings of Wilson, his own finished paintings reveal little understanding of his master's sense of light and atmosphere, nor of his fluent use of paint. There is more evidence of the manner of J. I. Richards than of Wilson in the view of *Rousham House, Oxford* (Plate 66), which is still at Rousham today. Dated 1773, this was painted during Jones's long visit to Mr. Oldfield Bowles at nearby North Aston.[2] Here he was busy teaching his host, whose paintings and drawings often reflect the impact of Wilson more strongly than do those of Jones himself. Jones also painted nineteen pictures during his stay, which are listed in the *Memoirs*, and which include the view of Rousham (No. 12 in the list), and the ambitious composition, *The Bard*. This Jones thought 'one of the best' he had ever painted, and he presented it to his host.[3] Finally the artist was concerned with scene-painting for the amateur theatricals which were an important feature of life at North Aston Hall.

In 1776 Jones made further oil sketches in Wales,[4] and in September he paid another visit to North Aston. In the following month he set out for Italy, travelling overland, and reaching Turin early in November and Rome on the 27th of that month. Much of Jones's account of his journey to Rome is taken up with descriptions of people, inns and meals, but occasionally he reveals the impact that the landscape was making on him. Thus he remarks of the last stages of the approach to Turin: 'the most leading feature was the Range of Alps at a distance which like an immense broken Wall continued retiring to the left as we approached the City'.[5] His love of mountains is shown again by his comments on reaching the foot of the Appenines: 'The Scenery now was quite changed and I was almost in raptures at getting among Rocks precipices & Picturesque Mountains after having travell'd so long over the flat, insipid, tho' rich plains of Lombardy.'[6] After only a few days in Rome Jones set out for Genzano, skirting, on the way, the Lake of Albano and passing through Castel Gandolfo and Ariccia:

'This walk considered with respect to its classick locality, the Awful marks of the most tremendous Convulsions of nature in the remotest Ages, the antient and modern Specimens of Art, and the various extensive & delightful prospects it commands is, to the Scholar, naturalist, Antiquarian and Artist, without doubt, the most pleasing and interesting in the Whole World – And here I can not help observing with what new and uncommon sensations I was filled on my first traversing this beautiful and picturesque Country – Every scene seemed anticipated in some dream – It appeared Magick Land – In fact I had copied so many Studies of that great Man, & my Old Master, Richard Wilson,

1. 1970 Exhibition, *loc. cit.* no. 5.
2. *Memoirs, loc. cit.* pp. 27–33.
3. National Museum of Wales, Cardiff; 1970 Exhibition, *loc. cit.* no. 8.

4. 1970 Exhibition, *loc. cit.* nos. 11–14 and 16.
5. *Memoirs, loc. cit.* pp. 45–6.
6. *Loc. cit.* p. 50.

which he had made here as in Other parts of Italy, that I insensibly became familiarized with Italian Scenes, and enamoured of Italian forms, and, I suppose, *injoyed pleasures unfelt by my Companions.*'[1]

While Jones immediately felt 'at home' in Italy because of his intimate knowledge of the work of Wilson, he himself did not at once succeed in recording his own impressions with spontaneity and conviction. His early Italian sketch-books reveal a reasonably assured use of pencil outlines rather in the manner of Joseph Farington at the same period, while in his water-colour sketches he was clearly strongly influenced by Pars. The first finished Italian water-colours are stiff and hard, both in line and colour, but there are soon signs of a more successful and personal style. This, in its use of harmonious blues and blue-greens and in its softer and more balanced outlines, has something in common with the contemporary Italian drawings of J. R. Cozens, who was one of the English artists who welcomed Jones on his arrival in Rome in November 1776.[2] In May 1777 Jones returned to Genzano, and it was in these stimulating surroundings that he began to find himself. This process came to a happy climax in and around Naples, which Jones first visited in September 1778. Here, especially in his on-the-spot oil sketches, Jones made his outstanding achievements as a landscape artist. If he had not already painted such lively oil studies in his native Wales some years before his visit to Italy, it would be tempting to dismiss these Neapolitan examples as a flash in the pan, produced under the influence of some unknown fellow-artist.[3] As it is, however, these remarkable sketches can be considered as an outstanding personal achievement, though the temptation to make too much of them must be resisted. In the recent past their importance has been somewhat overemphasized, as, for instance, in the Introduction to the 1970 exhibition Catalogue, and in the Catalogue of the 1968 exhibition of 'Romantic Art in Britain' at Philadelphia. However, it cannot be denied that such sensitive studies as the Ashmolean's well-known *House with a Verandah* and the *Buildings in Naples*[4] (Plate 68 A) at Cardiff reveal a freshness and spontaneity of vision rare in landscape painting at this period.

In these oil sketches Thomas Jones was undoubtedly ahead of his time, but in his painting of finished landscape compositions he was very much of his time. Inside the very apartment from the roof of which he was making his vivid studies of the roof-tops of Naples, Jones was at work on his large *View of Lake Nemi*, one of the two compositions

1. *Loc. cit.* p. 55.

2. *Loc. cit.* p. 53.

3. One contemporary French artist who might have influenced Jones was P.-H. Valenciennes, by whom a number of pure landscape and sky studies in oils are known. Valenciennes and Jones could have met both in Rome and in Naples between 1777 and 1779. See L. Hawes, 'Constable's Sky Sketches' in *Journal of the Warburg and Courtauld Institutes*, XXXII (1969), p. 352 n. 28.

4. 1970 Exhibition, *loc. cit.* nos. 60 and 61. That the painting of oil studies from nature was a fairly common practice from the mid-eighteenth century onwards is shown by several written references (see, for instance, *Letters of Sir Joshua Reynolds*, 1929, ed. F. W. Hilles, p. 173). There are, however, very few survivals of this practice from these years.

which he painted for the Earl-Bishop of Derry in 1782.[1] This, like the similar *Bay of Naples* now at Cardiff,[2] is formal and stiff, showing little sense of place or of light. It was probably about works such as this that Joseph Farington was commenting in his *Diary* on 1 April 1798, when he wrote, 'Jones's landscapes very cold – like China'. After his return from Italy the majority of Jones's exhibits were Italian landscapes, and now his manner was often quite close to that of Wilson. A comparison between the *Classical Landscape* at Cardiff,[3] which is dated 1772, and the *Pastoral Landscape with a River*, dated 1794,[4] does not lead to the conclusion that the artist had spent several of the twenty years which divide these two works in Italy. Both before and after his own visit to Italy Jones often worked in the shadow of Wilson; while in Italy he appears to have tried to emulate the highly popular landscape style of Jacob More. On the whole Jones's efforts to achieve patronage were a failure, and he himself was mortified by the lack of recognition given to his work, both when he was in Italy and in the period immediately after his return to England in 1783. Having unexpectedly inherited his family estate in Radnorshire in 1787, Jones left London two years later to devote himself to his property. He soon became High Sheriff of the county and a magistrate, and he described his life as 'one uniform scene of domestick Retirement – at times, indeed, amusing myself with my beloved Art'.[5] Much of his late work is of an appallingly low standard, though there are occasional touches of his earlier powers, as in the water-colour of Pencerrig dated 1796 in the Brinsley Ford Collection.[6]

In the *Memoirs* Thomas Jones makes no mention of Thomas Patch (1725–82), an English artist who was resident in Italy from about 1747 until his death.[7] Best known today as a caricaturist, Patch also painted Italian landscapes in a variety of styles, ranging from that of Vernet, whose pupil he was in Rome, to that of Gaspard Dughet, in whose manner he painted several views of the falls at Terni.[8] He also painted numerous views of Florence, where he lived from 1755, of which three are in the Royal Collection, including an impressive distant view of the city set among its surrounding hills.[9] Some of these Florentine paintings are based on engravings, and the majority of them feature one or other of Florence's bridges; in most of them Canaletto's influence is to be seen, but Patch's adaptation of the Venetian's manner is hard and tight. Another British artist who was for long resident in Italy, and who is mentioned in the *Memoirs*, was Jacob More (1740–93). Born in Edinburgh he was apprenticed to the Norie family referred

1. *Memoirs*, *loc. cit.* p. 111; repr. pl. IV.

2. 1970 Exhibition, *loc. cit.* no. 44.

3. Norwich Castle Museum and Victoria and Albert Museum, London, *A Decade of English Naturalism 1810–1820*, 1969–70, no. 28, repr.

4. Hayward Gallery, London, *The Art of Claude Lorrain*, 1969, no. 139, pl. 38.

5. *Memoirs*, *loc. cit.* p. 142.

6. 1970 Exhibition, *loc. cit.* no. 90.

7. F. J. B. Watson, 'Thomas Patch; Notes on his Life, together with a Catalogue of his known Works' in *The Walpole Society*, XXVIII (1930–40), pp. 15–50.

8. A fine example, dated 1767, was shown as no. 14 (repr. pl. X) by Messrs. P. & D. Colnaghi, London, in their 1969 Exhibition of *Paintings by Old Masters*. It was acquired by the National Museum of Wales.

9. Millar, *loc. cit.* no. 977.

to in Chapter One, but rose far above their standard in his own landscape painting, as the impressive *The Falls of Clyde* (Plate 70) at Edinburgh proves. Possibly exhibited in 1771, this belonged to Sir Joshua Reynolds, who is reported as saying, 'More is the best painter of air since Claude.'[1] Though in essence a traditional classical composition the painting renders most effectively the liquid light effect and the awesomeness of its subject.

More went to Italy, where he remained for the rest of his life, in about 1773. He quickly achieved a high reputation as one of the leading landscape artists in Rome, and regularly sent Italian views to the London exhibitions. Working unashamedly in the tradition of Claude, and happy to be known as 'More of Rome', he painted impressively large but somewhat empty compositions featuring the principal sights in and around Rome. An outstanding example – *River Landscape: The Tiber Estuary*, which is signed and dated 1784 – belongs to St. Catharine's College, Cambridge.[2] A feature of this canvas is its glowing pink light, an element perhaps borrowed from the distances of Richard Wilson but here used to dominate the whole composition. The impact of Wilson is also to be seen in the much smaller *Flight into Egypt*, formerly in the Northwick Collection,[3] and in the backgrounds of a pair of large oval compositions, one of which is dated 1786, depicting the *Rest on the Flight into Egypt* and the *Rape of Deianira* (Plate 69A), which were in a London sale-room in 1962.[4] Here again there is that empty grandeur so typical of the paintings of Jacob More, and which must have been in Thomas Jones's mind when he was executing his own larger canvases, for More's standing was high, as were his prices. It was only to be expected that a newcomer to Rome would try to emulate such a successful fellow-artist in order to win approval for his own work. We learn from Jones's *Memoirs*[5] that More did draw (or paint) 'flying Sketches' on the spot when at Naples late in 1778 to witness an eruption of Vesuvius, and it is inferred that this was his usual custom. None of these are known today, and there is little evidence of study from nature in his finished works, such as the vast *Mount Vesuvius in Eruption* at Edinburgh, which is dated 1780.

Like most of the British artists who were long resident in Italy at this time, Jacob More acted as agent and dealer for several British collectors, including the Bishop of Derry (4th Earl of Bristol) and Thomas Harvey of Catton, who was John Crome's first patron. But More's own commissions were not confined to British collectors, and he is known to have painted landscapes for some of the most eminent Italian patrons, including the Pope and Prince Borghese. Today most of More's work is lost, and his former high reputation is a matter for surprise, though, as Colonel Grant has so aptly put it, 'More's great canvases are decorative objects enough, and lend mild dignity to hall or staircase.'[6]

While we know relatively little in detail concerning Jacob More's long residence in

1. Whitley, *loc. cit.* vol. II, p. 200.
2. Hayward Gallery, *loc. cit.* 1969, no. 138.
3. Sotheby's Sale, 25 June 1965, Lot 75.
4. Sotheby's Sale, 18 April 1962, Lot 120.
5. *Memoirs*, *loc. cit.* pp. 79–80.
6. M. H. Grant, *The Old English Landscape Painters*, vol. III, 1958, p. 215.

Rome, we are fully informed about the somewhat earlier activities in Rome of Jonathan Skelton (*c.* 1735–59), whose untimely death took place there after a stay of just over a year. This information is largely based on a series of letters written to his patron, William Herring, the first of which is dated from Rome, 11 January 1758.[1] The young English artist is full of hope and enthusiasm. Having complained about the lack of 'encouragement among the Italians for Painters of any kind nor indeed very little from any other Nation', Skelton proposes to send his pictures to England, and continues:

'As I propose to generally to introduce some particular Place about Rome into my Pictures, I flatter my self that they'll sell pretty well. I have already laid in two Pictures and going a second time over them, both partly Studies from Nature – The Weather now at times is so fine that I can draw in ye Fields without the Cold interrupting me. Here many Young People study Landscape – I think I may say without Vanity that I am the best Landscapepainter in Rome. I have taken a very handsome Lodging on the Trinita del Monte on one of ye Finest Situations about Rome it commands almost the whole City of Rome besides a good deal of ye Country. The Famous Villa Madama (where Mr. Wilson took his View of Rome from which I always thought his best Picture) comes into my View. I shall have the finest opportunity of painting Evening Skies from my Painting-Room that I could almost wish, – surely I shall be inspired as I am going to live in the Palace of a late Queen, and in the same Apartments that Vernet had (when he was here), and within 80 or 100 yards of ye House where those Celebrated Painters Nicolo and Gasper Poussin lived!'[2]

None of Skelton's oil paintings are known (or recognized as such) today, but some fifty of his Italian water-colours are widely dispersed in public and private collections. Though Skelton undoubtedly has 'the distinction of being the first English artist to make an impressive group of water-colours of the city (Rome) and its environs',[3] his early death, and the subsequent disappearance of his work, make him a curiosity rather than an important figure in the history of British landscape art. The other British landscape artists in Rome during Skelton's stay were all obscure figures; Robert Crone (1713–82) and John Plimmer (d. 1760/1761),[4] both pupils, but somewhat unsuccessful ones, of Richard Wilson, Solomon Delane (1727–after 1784), a Scotsman, and the Irish-born James Forrester (*c.* 1730–76). While in this company the work of Skelton appears outstanding, and though he is among the best documented of mid-eighteenth-century British artists in the present context, the temptation of dwelling too long on his water-colours must be resisted.

The surviving English drawings by Skelton, in which the influence of George Lambert,

1. 'The Letters of Jonathan Skelton written from Rome and Tivoli in 1758', ed. by B. Ford, in *The Walpole Society*, XXXVI (1956–8), pp. 23–84.
2. *Loc. cit.* pp. 34–5.
3. *Loc. cit.* p. 24.
4. Plimmer was patronized by Henry Hoare, of Stourhead, to whom he wrote in 1759: 'I have endeavoured to imitate Claude and Nature with as much care as I possibly could ever since Mr. Wilson left Rome and I have been my own master.' (K. Woodbridge, *Landscape and Antiquity*, 1970, p. 46.)

who may have been his teacher, can be detected,[1] show a high standard of draughtsmanship and a pleasing feeling for composition and colour. These skills provided a firm basis for the impact of Italy, which resulted in a considerable broadening and strengthening of his compositions and a heightened sense of colour and tone, all based on a more fluent and confident technique. Skelton's Italian drawings are immediately attractive and easily recognizable. They range from such formal compositions as the Victoria and Albert Museum's *Castle and Bridge of Sant'Angelo*[2] (Plate 72 A) to the more spontaneous *Villa of Maecenas, Tivoli*[3] (Plate 72 B) at Birmingham, which may be the drawing referred to in the following illuminating passage in a letter written from Tivoli on 20 August 1758. He describes a visit to his studio by three English visitors, of whom one thought that Skelton's work 'was something in Claude's Manner', while the second considered it 'something in Mr. Lamberts Manner' and the third, Lord Brudenell, thought his 'Manner very like Natures Manner'.

'They liked my Drawings in Water-Colours', continues the young artist; 'I think my Italian Drawings are better than those I made on Blackheath, and at Canterbury. I have now been at Tivoli a Month and I intend to stay 3 Months longer....I have painted a Picture here in Water-Colours from Nature, and succeeded rather better than I expected (as it is the first time) and particularly in a short Waterfall. I have half finished another in Oil from Nature, from the Window of my Bed-Chamber, I think I see my Manner altering in it; it is a Kit-cat size. In Figures I am not so much improved, as in Landscapes, however I purpose to try what this Winter will produce. I have spent the greatest part of this summer in drawing and painting after Nature.'[4]

A few months later Skelton was dead, but when his drawings were rediscovered in 1909 it was quickly realized that they represented a remarkable achievement and that they were considerably ahead of their time. It was not until the 1770s that larger numbers of talented British landscape artists were to find inspiration in Italy – Marlow had been one of the few British artist visitors in the 1760s. Four of these were primarily water-colour artists, of whom the earliest to reach Italy was William Pars (1742–82). As the first recipient of the Dilettanti Society's newly established grant to enable an artist to study in Rome, he left London for Italy in the summer of 1775. Pars was already an artist of established reputation – in 1770 he was one of the first to be elected an Associate of the Royal Academy – and he was also already an experienced traveller abroad, for he had been the artist appointed by the Society of Dilettanti to accompany their expedition to Asia Minor and Greece from 1764 to 1766. Pars's Greek drawings, of which there is a large group in the British Museum, were engraved to illustrate the second and third volumes (1789 and 1795) of Stuart and Revett's *Antiquities of Athens*, and the first and second parts (1769 and 1797) of the Society's *Ionian Antiquities*. In these Greek drawings

1. *Letters of Jonathan Skelton, loc. cit.* pp. 24–5 and 50–1.

2. S. Rowland Pierce, 'Jonathan Skelton and his Water Colours – A Check List', in *The Walpole Society*, XXXVI (1956–8), pp. 10–22, no. 41.

3. *Loc. cit.* no. 36.

4. *Letters of Jonathan Skelton, loc. cit.* p. 55.

Pars displays a combination of broad and telling composition with firmness of handling and a sensitive feeling for colour. Such qualities are also to be found in the remarkable drawings of Swiss scenery that Pars made on his second continental journey, on which he accompanied Lord Palmerston at some time between his return from Greece and 1771 – when he exhibited eight views in Switzerland and the Tyrol at the Royal Academy. Though a little stiff and over-detailed, these Swiss drawings show a sensitive reaction to the natural beauties of the Swiss mountains, but they do not, like those which J. R. Cozens and Francis Towne drew a few years later, capture their grandeur and awesomeness.

It was also in Lord Palmerston's company that Pars visited Ireland, where he made such successful drawings as *Killarney and Lake*,[1] one of six Irish subjects in the Victoria and Albert Museum. The breadth of composition that distinguishes many of Pars's drawings made in Greece, Switzerland and Ireland is rarely to be found in those which he made in Italy. Here he tended to choose more detailed and precise subjects, such as the *Italian Villa* in the Victoria and Albert Museum and the view of *The Temple of Venus, Rome* (Plate 73A) in the Mellon Collection. In this the plants in the foreground and the buildings beyond them are drawn with delicate precision, which is enhanced by the harmonious and natural colouring. From the *Memoirs* of Thomas Jones, who was on terms of close friendship with Pars, we know a great deal about his life and work in Italy, and it is clear that he took every opportunity of drawing and sketching from nature. An intimate knowledge of his subjects is reflected in many of his finished Italian water-colours, though his trees tend to be very stereotyped. It is an ironical fact that the illness which caused Pars's death was brought on by a cold caught at Tivoli while 'standing in the water' to make a drawing.[2]

The focal point of the long career of John 'Warwick' Smith (1749–1831) was his visit to Italy from 1776 to 1781. Though there are often close similarities between the Italian drawings of Smith and Pars, the former adhered more firmly to the topographical tradition in which he had been trained. However, in Italy Smith developed considerable strength and originality in his use of colour. It was this that chiefly impressed contemporary critics and patrons, by many of whom he was considered the outstanding and most influential figure of the growing British water-colour school at the turn of the century. In more recent years his reputation has been largely eclipsed by those of Towne and J. R. Cozens, and in the light of present taste it is difficult to be roused to enthusiasm by most of the numerous and similar drawings of 'Warwick' Smith. The more effective of these are those on a large scale, such as the British Museum's *The Temples of Saturn and Vespasian, Rome* (Plate 74A), in which the precision and stiffness of his smaller views are replaced by a reasonable rendering of atmosphere and tone. In such larger drawings Smith's colour is usually somewhat subdued, often with an overall pinkish tinge, while in those on a small scale the colouring is stronger and was considered naturalistic. A group of exceptionally well-preserved large water-colours of scenes in Cumberland and

1. M. Hardie, *Water-Colour Painting in Britain*, vol. i, 1966, fig. 62.
2. Whitley, *loc. cit.* vol. ii, p. 344.

Westmorland, shown in London in 1970,[1] display 'Warwick' Smith's ability to record his native landscape – he was born in Cumberland – with confident and effective economy; but even in these drawings there is a lack of variety.

Many of Smith's compositions were engraved, including a long series of *Select Views in Italy*. Typical of his small, rather tight drawings is the '*Tomb of the Plantian Family, near Tivoli, and Ponte Lucano*' (Plate 73B), engraved by J. Medland in 1795. The much larger study on which this highly finished drawing was based is also at the Ashmolean, and in this the outlines and colours are softer and more subdued, giving an effect of early morning which is altogether lost in the finished drawing.

'Warwick' Smith was active until 1823, and in addition to his Italian drawings he exhibited numerous topographical subjects in England and Wales. He was an early member of the Old Water-Colour Society, of which he was three times President. His influence, as exhibitor and teacher, was widespread, and already in 1799 J. M. W. Turner complained to Farington about 'the mechanically systematic process of drawing practised by Smith and from him so generally diffused'.[2] However, others judged 'Warwick' Smith very differently, and in 1812 a writer in Ackermann's *Repository of Arts* claimed that 'it may with truth be said, that with this artist the first epoch of painting in water colours originated'.[3] Just over a century after 'Warwick' Smith's death he was dismissed by Laurence Binyon as an artist who 'had no particular style, and our interest in him is faint'.[4] The reason for such contradictory opinions is perhaps to be found in the fact that 'Warwick' Smith was at heart a highly professional craftsman rather than an artist.

It is certainly the artistry and originality of his drawings that have made Francis Towne (*c*. 1740–1816) such a popular figure since the rediscovery of his work in the early years of this century.[5] During his own lifetime Towne met with only limited success, and throughout his career most of his patronage came from his native Devonshire, though he made repeated efforts to win recognition in London, including four attempts to be elected A.R.A. He exhibited quite frequently at the Society of Artists and at the Free Society from 1762 to 1773; between 1775 and 1815 he showed some thirty-five works at the Royal Academy, and he also exhibited at the British Institution. In 1805 he took the then unusual step of holding a 'one-man' exhibition at the gallery in Lower Brook Street in which the first exhibition of the Old Water-Colour Society was held later that year. He showed nearly two hundred drawings of 'the most picturesque scenes in the neighbourhood of Rome, Naples and other parts of Italy, Switzerland, etc., together with a select number of views of the Lakes, in Cumberland, Westmoreland and North Wales. The whole drawn on the spot....'[6] But all this was to be of little avail, for Towne's name only rarely features in contemporary records, and in 1919 A. P. Oppé could justly

1. Thos. Agnew & Sons, London, *97th Exhibition of Water-Colours and Drawings*, 1970, nos. 3, 7, 8, etc.

2. *Diary*, 16 November 1799.

3. Quoted by B. Long in 'John (Warwick) Smith', *Walker's Quarterly*, no. 24 (1927), p. 21.

4. L. Binyon, *English Water-Colours*, 2nd ed. 1944, p. 57.

5. A. P. Oppé, 'Francis Towne – Landscape Painter', in *The Walpole Society*, VIII (1919–20), pp. 95–126.

6. A. Bury, *Francis Towne*, 1962, pp. 118–22.

write, 'for almost a century after his death in 1816, the work of Francis Towne remained practically unknown'.[1]

Nothing definite is recorded about Towne's training as an artist, though he may have studied at Shipley's School in London in the mid-1750s. It seems possible that he was self-taught and thus developed that highly individualistic style which is to be found even in the earliest of his water-colours known today, one of which is the view of *Ivy Bridge in the County of Devon*, dated 1775.[2] Here already there are signs of that interest in the pattern and masses to be found in landscape which was to come to full fruition in the next decade. Towne carefully inscribed and dated the majority of his drawings, and the fact that none earlier than 1773 and very few before 1777 are known today indicates that in the first fifteen or so years of his career most of his work was in oils, which was certainly the medium of the bulk of his exhibits up to about 1800. Only a relatively small number of Towne's oil paintings is known today, and none of these display the genius and originality found in his water-colours. The view of *Exeter from Exwick*,[3] which was exhibited at the Society of Artists in 1773 and is now at the Royal Albert Memorial Museum in Exeter, is a large and somewhat empty classical composition with the Cathedral in the middle distance. The drawing on which this canvas is based shows much more understanding of the character of the scene, and expresses it with great simplicity.[4] Something of the same quality is found in the *View of Haldon Hall, near Exeter* (Plate 69 B), an oil painting recently acquired by the Tate Gallery. Dated 1780, this is in some ways a repetition of the classical landscape formula, with framing trees to left and right and figures in the foreground, but there is considerable feeling in the rolling fields of the middle distance and in the light skilfully focused on the house in the centre. The nervous and empty handling of the view of Exeter is here replaced by a simpler and more sincere use of the medium, which is also found in the Fitzwilliam Museum's *Hilly Landscape*, and in *The Valley of the Teign, Devonshire*, at Leicester, both of which are likewise dated 1780. In such paintings Towne's bold and flat use of oil-colours is reminiscent of the earlier Italian canvases of Richard Wilson, of which he may well have seen examples in various collections.

Because of the lack of surviving examples, Francis Towne's work in oils can only be given passing attention today, but as an artist in water-colours he stands out as one of the most original figures of the later eighteenth century. The first considerable group of drawings to show his own manner resulted from a tour in Wales in 1777. Though many of these Welsh drawings are still somewhat hesitant and weak, others reveal a further development in his understanding of the essential structure and character of a landscape scene. An outstanding example is the beautiful *Salmon Leap from Pont Aberglasllyn*,[5] drawn, as the full inscription on the *verso* informs us, on the spot by

1. Oppé, *loc. cit.* p. 95.
2. *Burlington Magazine*, cv (1963), p. 133 and fig. 41.
3. Bury, *loc. cit.* pl. XIX a.
4. *Loc. cit.* pl. XIX b.
5. Oppé, *loc. cit.* pl. LX. Formerly in the Oppé Collection, now in that of Miss A. H. Scott-Elliot.

'Morning Light from the Right Hand'. Another drawing made on this tour is that of *Pistyll Rhaiadr* (Plate 71), in the Spooner Collection. Here the highest waterfall in Wales is shown in its bare setting without any picturesque overtones. It is this concentration on essentials that Towne first reveals in the best of his Welsh drawings, most of which are designated as 'drawn on the spot', though the colour was certainly added at a later time – at the inn in the evenings or in the studio on his return home.

The next high point of Towne's career was his visit to Italy and Switzerland in 1780 and 1781. Here, as Paul Oppé has so aptly put it, Towne moved 'rapidly in the direction of greater boldness in handling, simplicity in design, picturesque selection of subject, use of colour for atmospheric and emotional effect, and generally in all the qualities which make a landscape painter'.[1] Though he was in contact with some of the other British artists then in Italy – Jones, Pars, and especially 'Warwick' Smith, in whose company he made the homeward journey through Switzerland in the autumn of 1781 – Towne was in no way influenced to abandon his own manner and technique. Indeed, he brought these to their greatest height during this period abroad, and some of his Italian and Swiss drawings rank among the finest British water-colours of the eighteenth century.

A magnificent series of Towne's Italian drawings – over seventy of them mounted in three albums – was presented to the British Museum immediately after the artist's death by his Executor and his residuary legatee, in compliance with Towne's own wishes. From these drawings it is possible to witness the development of Towne's style towards full maturity. It has been argued that in his earlier Italian drawings he was influenced by the work of his friend William Pars, who was also in Rome at this time. However, though this may be the case in a few details in one or two drawings, as a whole Towne's Italian works reveal a consistent evolution of his own manner of combining firm outlines with flat yet subtly graduated planes of colour. It is true that at first his reaction to the stimulating light and scenery of Italy and of Rome in particular appears somewhat hesitant, but he soon achieved a new and much bolder repertoire of colour, and once he had mastered this he was able to produce many of his finest drawings. When it is remembered that Towne was already about forty years old when he went to Italy, such an apparently rapid attainment of full maturity appears rather less remarkable.

Especially if it is compared with John 'Warwick' Smith's larger rendering of the same scene (Plate 74A), Towne's drawing of *The Temple of Saturn, Rome*[2] (Plate 74B) illustrates his concentration on the essential elements of light, form and colour, and his ability to render the details of the scene convincingly and with the minimum of fuss. Smith's drawing appears more laborious, though it has, in fact, little additional detail in it; he shows rather more of the building in the right background and in front of it a corner of the Temple of Vespasian is to be seen through the trees, which are sparser than those in Towne's composition. Towne has made full use of the dark mass of these trees to emphasize the elegance of the columns of the temple, and has used the

1. *Loc. cit.* p. 109.
2. Binyon, *Catalogue of Drawings by British Artists*, vol. IV, 1907, p. 201, no. 2 (16).

light-reflecting surface of the tall building behind further to embolden this effect. With its strong colours Towne's drawing of this familiar Roman scene is a carefully conceived work of art, in which even the line of washing plays its part; 'Warwick' Smith's is no more than a pleasing topographical composition. As has already been suggested, such a comparison illustrates the great advances made by Towne in his highly personal contribution to the *art* of landscape, and again reveals 'Warwick' Smith as little more than a craftsman. It is, however, understandable that while Towne's work was largely ignored, that of Smith was greatly sought after, for Towne was far ahead of his time.

The methods that Towne used so successfully in Rome itself enabled him to produce even more rewarding drawings in the surrounding countryside and in the area around Naples. Some of these drawings – such as the remarkable *In the Villa Barberini*,[1] drawn by the light of the 'evening sun from the right hand', and showing the statue of an ox on a pedestal bathed in light beneath a mass of very dark trees through which there is a glimpse of the sky – continue his use of bold, dark colouring. On the whole, however, his palette becomes lighter and more subtle, as in the fine study of trees and distant landscape entitled *Near Naples*[2] (Colour Plate IX and Plate 75A). Here the pattern and tones of the trees in the foreground are magnificently contrasted with the more generalized and distant features on the right, which include a glimpse of the Bay of Naples, seen largely in shadow. The link between these two elements of the composition is to be found in the soft clouds and gentle blue of the sky. Again, despite the basically classical character of the composition, this is a drawing of place and mood, and, as we shall see, it is on a par with similar drawings by J. R. Cozens, who was at this time also breaking away from the classical and topographical traditions, but along quite different lines. Another aspect of Towne's grasp of the character and mood of the scenery around Naples is shown in the unusually delicate and sensitive drawing of *The Bay of Naples*, now in the Ashmolean Museum.[3] With only a few pen-and-ink lines and a flat grey wash, this achieves a consummate rendering of this famous spot on a day of complete calm and considerable heat.

It was on his journey home through Switzerland that Francis Towne's novel vision achieved some of its outstanding results. He had left Rome with 'Warwick' Smith in August 1781, and spent only a short time among the Alps, but it was a time during which the advances that he had made in Italy enabled him to produce what are undoubtedly his outstanding drawings. Though the best of these marvellous mountain compositions have been frequently reproduced in recent years, a survey such as this cannot be complete without yet another reproduction of at least one of them. Calm, severe and harmonious, these drawings reveal Towne's total understanding of the grandeur and strength of the Swiss mountains, though it is possible that this understanding owes something to the example of the Swiss artist, Caspar Wolff, whose work will be discussed below.[4] There

1. *Loc. cit.* p. 202, no. 2 (22).
2. *Loc. cit.* p. 202, no. 3 (2).
3. *Exhibition of English Drawings purchased from* the Collection of the late Sir Bruce Ingram, 1963, no. 92.
4. See below, p. 80.

is no element of picturesqueness or narrative in *The Source of the Arveiron; Mont Blanc in the Distance* (Plate 76), which relies absolutely on its rendering of form, colour and atmosphere, as does the second, even starker, drawing of this awesome scene, in the Oppé Collection.[1] Some of Towne's other Alpine drawings appear quite commonplace when compared to these two masterpieces, but there are a few further examples of such powerful mountain scenes, including the view of *The Mer de Glace from Montanvert*, in the collection of Mrs. John Carleton.[2]

Towne's work was never again to reach such heights, and in later years his highly individual style tended to become somewhat mannered and laboured, as is seen in a series of four views in Oxford, all dating from 1813, in the Ashmolean Museum. Though pleasingly composed and well drawn, these lack the conviction and sense of place of the Italian and Swiss drawings. Three of them are inscribed with the time of day when the drawing was executed, but this seems to have had no effect on Towne's rendering of the light and colour, and the latter has no specific relevance to Oxford, though it produces a perfectly satisfying effect as such. A large number of Towne's later drawings of scenes in the British Isles have reappeared in recent years, and while these usually have an instantly pleasing effect, they tend quickly to decline into mere shadows of the artist's earlier work. There are, of course, many exceptions to this generalization, notably the drawings which Towne executed while on a visit to the Lake District in 1786. Here he was once more inspired to use his particular talents to record this remarkable scenery, though again without the boldness of his continental drawings. Two typical examples of these lakeland drawings are the *Lake of Grasmere*, formerly in the collection of Miss Buckingham,[3] and the rather smaller *Raven Crag with Part of Thirlmere*,[4] in the Fitzwilliam Museum. In both these compositions conventional foreground planes of trees are used to lead the eye to the hills which form the principal feature of the scene.

Such conventionality is fortunately lacking in a group of three striking drawings of a waterfall dating from the 1786 visit to the Lakes. These all show *The Cascade at Ambleside* from almost precisely the same close point of view, and without any inclusion of foreground detail or of sky. It is instructive to compare one of these drawings — that in the Ashmolean Museum is reproduced here (Plate 77) — with *The Source of the Arveiron*. In the latter line is of relatively little importance, while in the other the waterfall and its immediate surroundings are rendered as an intricate pattern of lines. In both compositions, however, it is the rendering of tone and environment that are of primary importance, and this Towne has achieved as convincingly in the spacious composition of the mountain scene as in the more intimate and detailed view of the waterfall.

Like the majority of Towne's drawings, *The Cascade at Ambleside* has a long inscription in the artist's hand on the *verso*, including the frequently repeated words *drawn on the Spot*. We are also told the exact date — 10 August 1786 — and on many other sheets even

1. Bury, *loc. cit.* pl. XL (colour).
2. *Royal Academy Bicentenary Exhibition*, 1968–9, no. 672.

3. Oppé, *loc. cit.* pl. LXV.
4. Bury, *loc. cit.* pl. VIII.

the exact time when the drawing was made is recorded. All these practices were unusual for a landscape artist working in the later eighteenth century, and we associate them more readily with the name of Constable. They show, as do the best of his drawings, that Towne was, in fact, pursuing the same aims as Constable began to do about a quarter of a century later. He was recording landscape for its own sake and not because of its topographical content or classical characteristics. His interest in trees was as great as that in mountains and hills, and they are the primary feature of many of his compositions. Francis Towne undoubtedly ranks among the first of the natural landscape artists.

Despite the fact that he exhibited regularly in London, and that he held his own one-man exhibition there in 1805, Towne seems to have had little impact on the artistic world of the capital. Although they were for a time neighbours in Queen Anne Street West, there is no record of any contact between Towne and Turner, and the only well-known artist who appears to have been influenced by Towne's work was J. S. Cotman. In his native Devonshire, however, Towne had a following of friends and pupils, and, according to Farington,[1] amassed a considerable fortune. With one exception little is known today of the work of his pupils. That exception is John White Abbott (1763–1851), a prolific draughtsman who faithfully adhered to the more obvious elements of the style and technique of his master.[2] Abbott, who practised for many years as a surgeon, spent all his life in Devonshire, of which he was made Deputy-Lieutenant in 1831. The works which he exhibited at the Royal Academy between 1794 and 1821 were probably all (or at least mostly) oil paintings, but today his reputation, which has grown rapidly with that of Towne, rests almost entirely on his drawings.[3] Most of these are as immediately pleasing as the later drawings of his master, but like them they lack depth and sincerity. However, at his best Abbott shows considerable feeling for the structure and pattern of a landscape scene, as in the large drawing of *Trees at Peamore Park, Exeter*, dated 1799, in the Spooner Collection.[4]

In the work of Francis Towne we have seen the first real independence from previous landscape traditions, an achievement all the more remarkable considering the relative isolation of the artist. As has already been indicated, the same achievement is also found in the drawings of John Robert Cozens (1752–97) who, as the son of Alexander Cozens, was very much at the centre of matters artistic. Yet J. R. Cozens was, in his way, as isolated as was Towne, and though his work has never been forgotten, especially among artists, the wider appreciation of it dates only from the last fifty years. J. R. Cozens was twice on the Continent, from 1776 to 1779 and in 1782 and 1783, and much has been made of the possibility that, in his remarkable development as a water-colour artist, he

1. *Diary*, 11 November 1810.
2. See A. P. Oppé, 'John White Abbott of Exeter', in *The Walpole Society*, XIII (1924–5), pp. 67–84.
3. Six oils, three of them signed, are in the City of Exeter Art Gallery; see *Paintings and Drawings by Francis Towne and John White Abbott in the collection of the Exeter Museums and Art Gallery*,

1971, pp. 33–4. A small group of canvases formerly ascribed to Gainsborough will be attributed to J. White Abbott by J. Hayes in his forthcoming book, *The Landscape Painting of Thomas Gainsborough*.
4. Courtauld Institute, London, *The William Spooner Collection and Bequest*, 1968, no. 37, pl. 1.

was strongly influenced by the example of some of the Swiss and Italian artists also working in water-colours at this time. It would be as well, therefore, to examine the work of some of these artists at this stage, bearing in mind that Francis Towne may likewise have come under the influence of some of them during his travels in Italy and Switzerland.

Caspar Wolff (1735–83) has been justifiably claimed as 'the real artistic discoverer of the Alpine world',[1] a world which had lately been revealed and analysed in literature by Jean-Jacques Rousseau. Having studied under P. J. de Loutherbourg[2] in Paris in 1770 and 1771, Wolff returned to Switzerland and immediately began work on a large number of paintings and water-colours of the Alps for the publisher Wagner of Berne, who produced prints of many of them. Wolff's depiction of Alpine scenery is outstanding for its realism and starkness; fine examples are the tempera study and the oil painting of the *Rhône Glacier seen from the Bottom of the Valley above Gletsch*, both in the Aargauer Kunsthaus, Aarau.[3] The painting is dated 1778, and in its unadorned depiction of the glacier and the surrounding snow-capped peaks it anticipates Towne's two famous drawings of the Arveiron of three years later. The possibilities of a connection cannot be ignored, while some of J. R. Cozens's early Alpine scenes, such as Mrs. Cecil Keith's *Between Chamonix and Martigny: The Aiguille Verte*,[4] also appear remarkably similar.

In his water-colour drawings and coloured etchings Johann Ludwig Aberli (1723–86), the leading figure of the Berne School, depicted the mountain scenery with far more grace and conventionality than did Wolff, and like the work of most of his followers and pupils, that of Aberli is in accord with the topographical traditions of the day. The aim of these artists was to produce acceptable *vedute* for the growing number of tourists, and only occasionally did they succeed in depicting convincingly and naturalistically the grandeur of their theme. An exception was, of course, Caspar Wolff.

The work of the Swiss-born draughtsman, S. H. Grimm, who came to this country in 1768, has already been briefly discussed,[5] and it should also be remembered that a number of other later eighteenth-century topographical artists working in Britain — among them Francis Grose, J. A. Gresse, Jacob Schnebbelie and the rather better known John Webber, R.A.[6] — were of Swiss parentage. A Swiss artist whose work was popular with British patrons, but who never himself visited England, was Abraham-Louis-Rodolphe Ducros (1748–1810). Ducros is scarcely mentioned in the annals of European landscape art, but in recent years he has become an important figure in accounts of the development of British water-colour painting. As early as 1917, in the fifth volume of *The Walpole Society*, C. F. Bell put forward the suggestion that one factor in the great advances made by British artists in the later years of the eighteenth century may have been their contact with various Swiss artists also working in Rome at this time.[7] Eleven

1. Arts Council, London, etc., *Le Voyage Pittoresque*, 1968–9, 'Introduction' by E. Gradmann.
2. See below, Chapter Four, pp. 113–6.
3. *Le Voyage Pittoresque*, London showing only, nos. 94 and 95, both repr.
4. C. F. Bell and T. Girtin, 'The Drawings and Sketches of John Robert Cozens', in *The Walpole Society*, XXIII (1934–5), no. 8, II.
5. Above, Chapter Two, p. 46.
6. See below, Chapter Four, p. 131.
7. 'Fresh Light on some Water-colour Painters of the Old British School, etc.', pp. 47–83.

IX Francis Towne *Near Naples,* 1781 (detail)

British Museum, London. *See page* 77
For whole drawing see Plate 75A

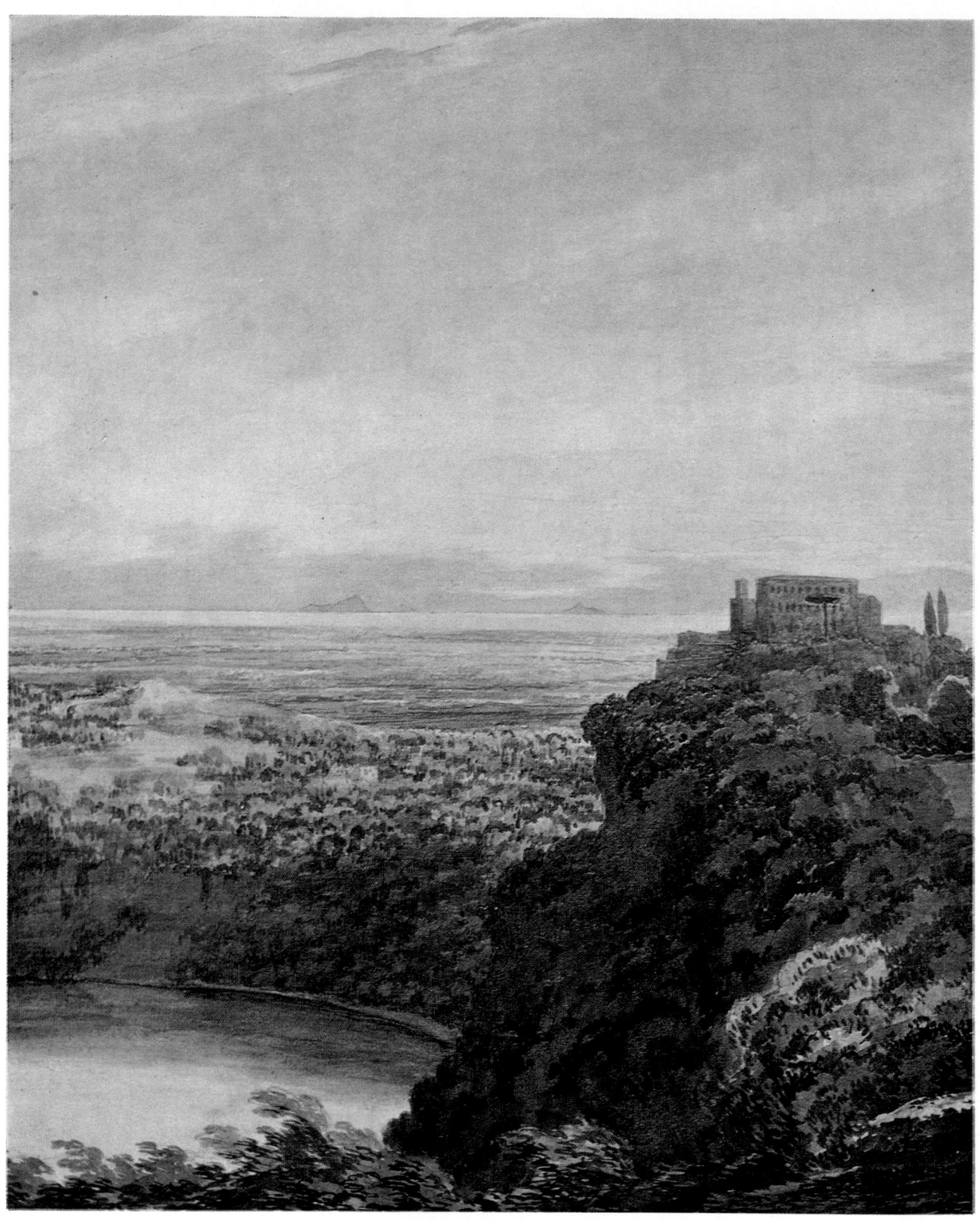

X John Robert Cozens *The Lake of Nemi, looking towards Genzano* (detail)

Whitworth Art Gallery, University of Manchester. *See page* 87
For whole drawing see Plate 80

years later William T. Whitley, in his invaluable *Artists and their Friends in England*,[1] published some fascinating evidence which supported this surmise. This was part of that now well-known passage from page 82 of the first volume of Sir Richard Colt Hoare's *History of Modern Wiltshire* (1822), in which this patron and amateur artist discussed 'designs in water-colours, which have made, within these few past years, a most astonishing progress'. After mentioning as outstanding examples the drawings of Salisbury made for him by J. M. W. Turner, Sir Richard continues, 'this rapid improvement in water-colour drawing has taken place within my own memory; for during my younger days, Paul Sandby was the monarch of the plain, and esteemed the best artist in this line. The next marked improvement in colouring was recognized in the drawings of Mr. John Smith, now living, and to whom, as an instructor, I owe the little I do know of drawing: but the advancement from *drawing* to *painting* in water-colours did not take place till after the introduction into England of the drawings of Louis du Cros, a Swiss artist, who settled at Rome; his works proved the force, as well as the consequence that could be given to the unsubstantial body of water-colours, and to him I attribute the first knowledge and power of water-colours. Hence have sprung a numerous succession of Artists in this line. . . .'

In his introduction to Volume XXIII of *The Walpole Society*, which is devoted to J. R. Cozens, C. F. Bell quotes the whole of the relevant passage, and in a lengthy footnote he discusses the eleven drawings by Ducros acquired by Sir Richard and still at Stourhead today; two of these are reproduced in the same volume.[2] Mr. Bell also draws attention to some unpublished passages in Farington's *Diary* in which the drawings of Ducros are highly praised, thus confirming Sir Richard's opinion.

Apart from the examples at Stourhead, drawings by Ducros, who settled in Rome in about 1770, some fifteen years before Sir Richard Colt Hoare's first contact with him, are to be seen in several other British collections, including the Whitworth Art Gallery and the Spooner Collection. While most of the examples at Stourhead are rather heavy and dark in colouring, the *Harbour Scene* at Manchester has a relatively light palette of pale greys, greens, blues and pinks, resulting in pleasing effects of light and reflection, though the foreground details are somewhat stiff and heavy. This drawing is dated 1778, and thus belongs to the very period when J. R. Cozens could have been in contact with Ducros. The example in the Spooner Collection – *Ariccia, near Rome*[3] – dates from 1784, and here too there is a reasonably delicate effect of light in the distance and middle distance, contrasting with the dark and heavy details of the large tree and herbiage in the foreground. On the whole the highly finished drawings of Ducros, which are usually on a large scale, adhere to the more conventional landscape formulae of the day, though in their colouring they are stronger and more varied than the normal water-colours of the time, and resemble landscapes executed in body-colours or even in oils.

1. Vol. II, p. 363.
2. Bell and Girtin, *loc. cit.* pp. 12–14, and pls. XXXV and XXXVI. The same two drawings and two more by Ducros are reproduced by Woodbridge, *loc. cit.* pls. 31 *a* and *b*, 32 *a* and 40.

3. *The William Spooner Collection and Bequest*, *loc. cit.* no. 33, pl. 4.

As we shall see J. R. Cozens's colouring, while it became stronger during his second Italian journey, remained highly individual in character, and it is impossible to locate any real signs of contact with Ducros. It is also difficult to accept Mr. Bell's very positive assertions of the impact of Ducros's drawings at Stourhead on some of Turner's work in water-colours at the close of the century.

The drawings and reputation of this Swiss artist have been discussed here at some length because of the role that he has been given in recent literature as a result of C. F. Bell's theories. But while it may be said that Mr. Bell has tended to exaggerate the importance of Ducros, there is little doubt that not enough has been done to follow up his hints as to the possible influence of other 'foreign' artists on the British water-colour school. An exhibition held in London by Mr. John Manning in 1960[1] was devoted to one hundred drawings by Carlo Labruzzi (1748–1817), and his work has since reappeared regularly in numerous dealers' exhibitions. An album of his drawings had been acquired by the British Museum some years earlier. However, no attempt has yet been made to assess the possible impact of Labruzzi's work on British artists. As has been shown by F. J. B. Watson in his excellent Introduction to the catalogue of the exhibition, Carlo Labruzzi was one of the few *Italian* artists popular with British visitors to Rome in the penultimate decade of the eighteenth century, before a stop was put to the Grand Tour by the French Revolution and the Napoleonic Wars. Once again the patron who concerns us here was Sir Richard Colt Hoare, for it was he who took Labruzzi with him on a journey along the Via Appia in the autumn and winter of 1789. It was on that journey that Labruzzi made the water-colour studies of the principal monuments and scenes on the route, of which a large number were shown in the 1960 Exhibition. Executed on white paper in bright, usually rather pale, water-colour washes applied with great freedom and fluency over soft and rapid pencil outlines, it can be presumed that these are 'on-the-spot' drawings, though on occasions the colour may have been added in the evenings. In a few of these sheets the outlines are drawn with the point of the brush in dark grey wash, and in most of them abundant use is made of the white of the paper to obtain effects of highlight and light. In the context of their time these spontaneous and vigorous drawings stand out as well in advance of the normal practices of the day.

From these 'on-the-spot' studies Labruzzi made more finished sepia drawings, of which two hundred and twenty-six (now in the Vatican Library) were retained by Sir Richard, who planned to publish an account of the Via Appia illustrated by engravings after Labruzzi's drawings. In the event, probably owing to political developments, only twenty-four plates were published, without any text, under the title *Antiquities of the Via Appia*. Mr. Watson has suggested most plausibly that the albums containing the British Museum and Manning water-colours 'were sent from Rome for inspection by potential English purchasers of the Via Appia book', and that they were to be seen at the Strand premises of W. Palmer,

1. The Manning Gallery, London, *Carlo Labruzzi – An Exhibition of Fine Watercolour Drawings of the Appian Way*, June–July, 1960. F. J. B. Watson's 'Introduction' to the exhibition catalogue provides full details of the history of these drawings. Nothing new has been added to this by K. Woodbridge in *Landscape and Antiquity*, 1970.

the print-seller who sold the engravings in London. Thus Labruzzi's drawings, which would certainly have intrigued and inspired any receptive British artist of the day, were to be seen in London as well as in Rome. It is probable that the drawings of many other Italian, Swiss, Austrian, German and French landscape artists would likewise have been available to their British contemporaries, and it is certain that the development of the British water-colour school, and the impact of Italy on that development, will be most fruitfully judged in the future when considered in the broader context of European landscape art of the eighteenth century.

A German artist who held a commanding position among the landscape painters working in Italy in the last decades of the century was Jacob Philipp Hackert (1737–1807) who, having studied in Berlin and after a period in Paris, was in Italy from 1768 onwards. Like Jacob More, whose work has already been discussed,[1] Hackert's standing became one of great eminence, although his painting and drawing of landscape added little or nothing to the conventional practices of the time, being a stiff amalgam of Italianate classical and Netherlandish traditions. The position and work of Hackert are neatly summed up by Thomas Jones in the following, somewhat acid passage from his *Memoirs*, written at Naples on 2 December 1782:

'I was greatly surprised by a Visit from the great Mr. Hackaert of Rome – the more so, as he never once deigned me that honour all the while I remained in that City – He told me that "in the course of his Correspondence with the Earl of Bristol, having signifyed his Intention of going to Naples in Order to Execute a Considerable Commission for the King, he had been desired by that Nobleman to call and see how I went on with his Pictures" – He was pleased to pay many Compliments on my progressive Improvement in paying due attention to the *Detail* – that is to say, minute finishing, which by the bye, was more congenial to his own taste, who like most German Artists, study more the *Minutiae* than the grand principles of the Art – He promised to communicate to his Lordship these favourable Sentiments of my works, and, I believe, kept his Word, though at the Time, I took all as commonplace Compliment; for, some time afterward, I received Letters from his Lordship which contained the warmest professions of friendship and future patronage. I may here observe that there never was, perhaps, a man who was more endued with the Talent of making People believe that he was the greatest Genius that ever existed, and as he made others think so, and thought so himself – his behaviour was in Character – He had the Address to insinuate himself into the good graces of half the Princes in Europe, from some of whom he received Pensions, particularly the Empress of Russia, and King of Naples – by the former he was employed to paint her Sea Victories over the Turks, and a Russian frigate was absolutely blown up at Leghorn, that Mr H. might study the Effect of the Explosion – He had likewise been honoured with the Rank of Colonel in her Imperial Majestys Service – By the King of Naples he was employ'd to paint his Royal Hunts – Posterity will more impartially judge of his real merit – to whom – I refer – '[2]

1. See above, pp. 69–70. 2. *Memoirs*, *loc. cit.* pp. 117–18.

Despite the fact that Goethe edited Hackert's posthumous autobiography,[1] and re-soundingly sang the praises of his work, posterity thinks none too highly of Hackert's formalized and exact landscape compositions, though his drawings, which combine minute observation with a feeling for atmosphere conveyed with considerable delicacy, are again sought after today. However, in his own time J. P. Hackert could hardly have been more successful, and his example, like that of Jacob More, was certainly very influential among those artists who placed worldly success before artistic satisfaction. The German artist frequently collaborated with his short-lived younger brother, Johann Gottlieb Hackert (1744–73), who exhibited his work in London at the Society of Artists and at the Royal Academy in the last years of his short life.[2]

There is no record that the landscapes of the Swiss artist Salomon Gessner (1730–88) were known in England, and it was as a writer on landscape painting that his name would have been familiar to British artists.[3] Two editions of the English translation of Gessner's *A Letter to M. Füslin on Landscape Painting*, which had appeared in German in 1770, were published, the first in London in 1776, and the second in Edinburgh in 1798. The M. Füslin of the title was Johann Caspar Füssli, a minor artist, whose much more famous son, Johann Heinrich, settled in England in 1764, and became known as Henry Fuseli. It was very probably through his influence that this fascinating book was translated into English, preceding Joseph Pott's *Essay*[4] by six years. Gessner outlines his approach to landscape painting as follows:

'My natural inclination led me to landscapes... I determined to draw after nature. But I soon found, that this great and sublime master does not explain himself clearly but to those who have learnt to comprehend him. My precision in following him every where led me astray.... My first progress, therefore, was to discern what I was not able to perform; the second was, to have recourse to the great masters [he modelled himself on Waterloo, Swanefeld, Berchem, etc.]....Like the bee I search'd honey from many flowers. I consulted, I imitated, and returning to nature, wherever I found a tree, a trunk, or foliage that attracted my regard, that fix'd my attention, I made a sketch of it, more or less finish'd. By this method, I join'd to facility the idea of character, and I form'd a manner that became more personal to me....But the two Poussins, and Claud Lorrain, at last possessed me entirely. It was in their works I found dignity and truth united.'

Gessner goes on to refer to Rosa, Rubens, Wouvermans, Everdingen, and other artists, and recommends that one should not only look at their work but should also read the history and lives of the artists – and the *best* poets. 'The poet and the painter,' he continues, 'friends and rivals, draw from the same source; they both borrow from nature, and

1. *Philipp Hackert – Biographische Skizze*, 1811.
2. A. Graves is probably mistaken in attributing exhibits some years after his death to J. G. Hackert; the 30 drawings shown at the Society of Artists in 1790 and 1791 must have been by J. P. Hackert.

3. Salomon's son Konrad (1764–1826) exhibited landscapes at the Royal Academy from 1797 to 1803, giving as his addresses various places in London.
4. See above, p. 61.

84

communicate their riches, by rules which are analogous. Variety without confusion. That is the grand principle of all their compositions.'[1]

In his fluent prose, Salomon Gessner, who was both poet and painter, sums up simply and convincingly the creed and methods that lay behind most of the landscape painting that was being executed in Europe, and in Italy in particular, in the second half of the eighteenth century. We have already examined the work of several British landscape artists who would not have agreed with such a conventional creed, and who, by breaking away from it, ensured the progressive development of landscape art. After this long digression we must turn again to the drawings of one of the greatest of these – J. R. Cozens. Very little is known about his work before his departure for the Continent in the summer of 1776. Earlier that year he had exhibited an oil painting – *Hannibal in his march over the Alps, showing to his army the fertile plains of Italy* – at the Royal Academy, and he was an unsuccessful candidate for associate membership. Much has been written about this painting, though it has still to be rediscovered; another oil painting, apparently authentically signed and dated 1791, was published in 1909.[2] This is, however, an uninspiring idyllic landscape displaying a variety of influences, including that of French and Italian eighteenth-century artists.

Before showing the *Hannibal* at the Royal Academy Cozens had exhibited a few drawings at the Society of Artists, but these are also lost today. The earliest drawings by him which are known today are those which he executed in Switzerland in the late summer and autumn of 1776. It is probable that he was travelling in the company of Richard Payne Knight (1750–1824), then a young man of twenty-six on his second journey to Italy, and later to become well known as a collector, writer and critic. The bulk of the surviving early Swiss drawings, of which a fine series is now in the British Museum, originally belonged to Payne Knight. It has been generally supposed that these drawings, which are mostly completed with monochrome washes, were Cozens's on-the-spot studies, but it is difficult to uphold this theory, especially if the character of Cozens's later pencil studies from nature is borne in mind. However, it is safe to assume that the drawings, several of which are specifically dated, were made at stopping-places during the journey. Despite their economy of line and rare and tentative use of colour, most of them convey with great subtlety the feeling and character of the Alpine scenery. There is a marvellous sense of clouds floating among wooded mountains in the drawing of *Mont Blanc and the Arve near Sallanches* (Plate 78), which is dated 27 August 1776.[3] Drawn in pen and ink over pencil, and with washes that are mostly grey and grey-brown, this composition owes much of its effect to liberal use of the white of the paper. The tiny figures on the river-bank provide a scale, and emphasize the grandeur of the scene. While the influence of his father's teaching is in evidence throughout these drawings,

1. S. Gessner, 'A Letter to M. Füslin on Land-scape Painting', in *New Idylles by Gessner*, translated by W. Hooper, London 1776, pp. 90–101.

2 Anon. (? C. J. Holmes), 'An Oil-painting by J. R. Cozens', *Burlington Magazine*, XIV (1908–9), pp. 304–7. The painting is now in the collection of Martin Holmes.

3. Bell and Girtin, *loc. cit.* no. 5.

they already show glimpses of J. R. Cozens's own style, and, as Paul Oppé has pointed out, they readily lent themselves to elaboration and enlargement in that style without any major alteration.[1]

By the end of November Cozens was sufficiently settled in Rome to be one of the English artists assembled at the 'English Coffee-house' at the time of Thomas Jones's first visit there.[2] Otherwise there are scant factual details about Cozens's first stay in Italy, whence he 'set off...for England' on 8 April 1779.[3] However, there is a considerable body of drawings executed during these years, and they make it clear that this was a vital period in the formation of J. R. Cozens's style. One essential factor of that style is that it is based on an interest in the scenery rather than the architecture of the country. Though buildings do feature in many of Cozens's compositions, they usually play a subsidiary role, being included not for their own sake but as a focal point in the composition of the landscape. A superb example of this is Miss H. Barlow's *The Colosseum from the North*,[4] in which the great building is shown in silhouette as a harmonious feature of the overall sunset effect. Dated 1780, this must have been executed soon after Cozens's return from Italy. Thus Cozens truly breaks away from the topographical tradition that was still dominant at this time. Another equally important aspect of his break with tradition is seen in his highly personal and extremely limited use of colour. In a sense this remains monochromatic, though in his subtle blending of blues, greys and occasional greens, he achieves effective rendering of the light and tones of Italian scenery. His drawings were made neither for exhibition nor for the engraver, and were usually destined for the portfolios of private patrons and collectors. It is remarkable that so many of these were sufficiently far-sighted to find such unusual drawings acceptable. Though all too few facts are known about Cozens's life before he became insane, it appears that, for an artist of such limitations and originality, he achieved a surprisingly high reputation. This is reflected in the brief comments on his work made by Edward Dayes: 'The works of this draughtsman are marked with originality. His colouring is sombre and grand, though sometimes bordering on heaviness: his distances are carried off into a fine tone of air. His forms are often defective, and his trees lumpy and ill-shaped; but this defect is compensated by great breadth in the *chiaro-oscuro*.'[5]

The chronology of the finished work executed by Cozens during his first visit to Italy is confused, and this confusion is added to by the fact that he often made several versions of his most effective compositions, frequently at intervals of a number of years. Further uncertainty arises because Cozens's second visit to Italy followed quite closely on his first, for he set out with William Beckford (author of *Vathek* and builder of Fonthill) in May 1782, arriving in Naples on 6 July. This second visit was shorter than the first, for Cozens was back in London in November of the following year. For the second Italian

1. A. P. Oppé, *Alexander and John Robert Cozens*, 1952, p. 130.
2. *Memoirs, loc. cit.* p. 53.
3. *Loc. cit.* p. 87.
4. Bell and Girtin, *loc. cit.* no. 116.
5. 'Professional Sketches of Modern Artists', in *The Works of the late Edward Dayes*, 1805, pp. 324–5.

journey there is more detailed evidence of Cozens's movements, largely owing to the fortunate rediscovery by C. F. Bell in the late Duke of Hamilton's Collection of 'seven sketch-books filled by Cozens when travelling as draughtsman in the suite of Beckford through the Tyrol, in Italy, and on his road home by way of Mont Cenis, between June 4, 1782, and October 27, 1783'.[1] These sketches and the drawings based on them make it clear that during this visit to Italy Cozens's development reached full maturity – a maturity which achieved some of its finest results in the drawings executed from the Italian sketches in the ten years of activity left to the artist after his final return to England.

During his earlier period in Italy Cozens paid several visits to Lakes Albano and Nemi in the Alban Hills. From the sketches that he made at this time he developed some of his most frequently repeated subjects, among which is *The Lake of Nemi, looking towards Genzano*[2] (Colour Plate X and Plate 80). Bell and Girtin list six versions of this composition, of which two, including the one illustrated here, are in the Whitworth Art Gallery.[3] More recently Francis Hawcroft has rejected one of these drawings and has added two further versions.[4] In all of these Cozens has made good use of the magnificently situated Palazzo dei Cesarini and its surrounding trees to give emphasis on the one hand to the lake sunk in its crater, and on the other to the expanse of the plain and the sea beyond. In this beautifully balanced landscape the extensive sky plays an important role, as it does in so many of Cozens's finished Italian drawings. It should, however, be observed that very few of the studies in the Hamilton sketch-books include any references to the sky whatever. For his depiction of skies J. R. Cozens must therefore have relied largely on his memory and imagination, which makes the effectiveness of some of his sunsets and storms all the more remarkable.

The far-reaching plain is again a principal feature in the *View on the Galleria di Sopra, above the Lake of Albano* (Plate 75 B), which belonged to Sir George Beaumont, who gave it to John Constable. Of this composition, with its striking pattern of wind-bent trees, there are three known versions, including the beautiful unfinished drawing in the Oppé Collection.[5] The trees in this 'close-up' study of a scene near Lake Albano have much in common with those in the centre of the well-known view of *The Lake of Albano and Castel Gandolfo*, of which there are nine known versions, including those in the Tate Gallery, the Ashmolean Museum, the Fitzwilliam Museum and the Whitworth Art Gallery.[6] In that composition, with its strong Claudian overtones, the plain is seen in the background on the right, but standing out against it on its hill-top is the castle, while a corner of the lake is shown in the right foreground. The weight of these features on the right is balanced by an area of light among the dark trees on the left, in which a goat-herd

1. Bell and Girtin, *loc. cit.* p. 4.
2. This is based on no. 9, inscribed *Gensano*, in the book of *28 sketches by J. Cozens of Views in Italy 1776–78* in the Sir John Soane's Museum.
3. Bell and Girtin, *loc. cit.* no. 141.
4. Whitworth Art Gallery, Manchester, and

Victoria and Albert Museum, London, *Watercolours by John Robert Cozens*, March to May 1971, no. 25.
5. Bell and Girtin, *loc. cit.* no. 154, pl. xv *a*.
6. *Loc. cit.* no. 147, pl. xiv *b*.

is shown driving his flock down the hill. Like Claude (and Marco Ricci), Cozens frequently makes use of small figures to provide scale or balance in his landscape compositions. These also are rendered with a minimum of colour, though occasionally they become vehicles for the reflection of sunlight, which is otherwise usually largely absent from the foreground of these essentially sombre drawings.

There is no such relief in the foreground of the *View from Mirabella* (Plate 79) in the Victoria and Albert Museum.[1] This is in the deep shadow of evening light, and provides an effective contrast to the few streaks of light in the far distance of the plain and the glow of the setting sun on the horizon and in the lower portions of the otherwise darkening sky. There are stronger variations of light in the Ashmolean Museum's superb *Sepulchral Remains in the Campagna*,[2] in which there is also greater variety of colour, a quality which becomes more prevalent in Cozens's later work. This startlingly simple drawing is described by Paul Oppé as 'perhaps the most poignant of all English landscapes'.[3] Though that may be considered a somewhat excessive claim, it is drawings such as this, the *View from Mirabella*, and their not infrequent peers, that place J. R. Cozens among the outstanding British landscape artists. While the possible influence of artists such as Hackert and Ducros cannot be ignored, Cozens's development is surely striking enough to be considered as essentially personal, and it is one of the most original achievements in the story of British landscape painting. In addition it was an achievement which, as we shall see, was to have a very great influence on the next generation of landscape artists.

In the last years of his career J. R. Cozens devoted most of his energies to working up drawings based on his continental sketches. He also made drawings of a few English subjects. Several of these are of scenes in the Lake District, which could easily be mistaken for weak Alpine views. Two unmistakably British scenes are *An English Country House in a Park* in the Royal Collection,[4] and the striking *Windsor Castle from the South-West*[5] (Plate 81) in the Cecil Higgins Museum. This retains the same blues, grey-greens and greys that are predominant in the Italian drawings, but with its lovely, somewhat humid, distance and its lush foreground trees, it is surely as successful in rendering the character of the famous Thames Valley scenery as are the best of the drawings of Paul Sandby. Another very successful English drawing is the *View of London and the Thames from Greenwich* in the Spooner Collection at the Courtauld Institute.[6] Most of the English drawings mentioned here are relatively recent rediscoveries, and it is to be hoped that more may be found in future years. The rare examples now known suggest that in his final years – he became incurably insane in 1794 and died three years later – J. R. Cozens was beginning to find himself as an artist of the English scene. However, it was only a beginning, and his high reputation must rest on his drawings of Switzerland and Italy.

For Joseph Wright of Derby (1734–97) the 'discovery' of Italy had also meant the real start of his work as a landscape painter. When he set out for Italy in the late autumn

1. *Loc. cit.* no. 216, pl. XVIII *b*.
2. *Loc. cit.* no. 370, pl. XXVIII *b*.
3. Oppé, *loc. cit.* p. 148
4. 1971 Exhibition, *loc. cit.* no. 99, repr.
5. *Loc. cit.* no. 98, repr.
6. *Loc. cit.* no. 94, repr.

of 1773 he 'had had little experience of landscape painting...(and) only one pure landscape dating from before the Italian journey is known'.[1] This is a remarkable study of *Rocks with Waterfall*[2] which is painted with considerable dash and feeling in a manner also found in the landscape backgrounds of some of Wright's pre-Italian-subject pictures. The immediate impact of the scenery of Italy is shown by the fact that, even on his journey southwards to Rome, Wright was making numerous landscape drawings, in pencil, pen, wash and occasionally water-colours. In their manner these are strongly influenced by the draughtsmanship of seventeenth-century Dutch Italianate artists such as Breenbergh. During their journey to Rome the Wrights were accompanied by the young John Downman (1750–1824), who was to become well known as a portrait draughtsman. The Oppé Collection includes a group of striking landscape drawings made by Downman while in Italy, many of which are reminiscent of the Italian drawings of Joseph Wright. It has always been taken for granted that it was the older man who led the way, but the possibility that in fact it was the other way round cannot be ignored, for several of Downman's studies, especially those of trees, are imbued with remarkable freshness.

Having recorded his first impressions of various scenes between Nice and Rome and in Rome itself, Wright concentrated most of his landscape energies during the rest of his stay in Italy on two themes – the Girandola (firework display) in Rome and the eruption of Vesuvius. The choice of these subjects is not in the least surprising for a painter of candlelight scenes, but on the whole his painting of such spectacular open-air light effects was less successful than his rendering of interiors seen in artificial light. The full story of the Vesuvius and Girandola compositions is traced in detail by Mr. Nicolson, who makes it clear that only the preliminary studies and a small number of finished paintings were executed while Wright was in Italy.[3] The only other landscape paintings dating from the Italian visit are of two grottoes on the Gulf of Salerno, in which he has recorded telling effects of morning and evening light.

On his return to England in September 1775 Wright tried unsuccessfully to set up as a portrait painter in Bath, but after less than two years he gave up the unequal struggle and returned to his native Derby, where he remained for the last twenty years of his life. From then on he turned more and more to the painting of landscape – producing versions of various Italian themes, and also finding new subjects in Derbyshire and, at the very close of his career, in the Lake District. During the same years many of his portraits and subject pictures feature landscape backgrounds; notable among these are the superb portrait of the recumbent Brooke Boothby in the Tate Gallery,[4] and the haunting *Indian Widow* at Derby.[5] The importance of Wright's landscape painting is reflected by the fact that already in 1782 he features among the six 'most eminent landscape painters' in Joseph Pott's list.[6]

1. B. Nicolson, *Joseph Wright of Derby*, 1968, vol. I, p. 75.
2. *Loc. cit.* no. 328, pl. 112.
3. *Loc. cit.* pp. 76–81.

4. *Loc. cit.* no. 20, pls. 219 and 219a.
5. *Loc. cit.* no. 243, pl. 247.
6. See above, p. 61.

In all his landscape drawings and paintings Wright's chief interest lies in the qualities of light, and while in his early Italian subjects he pursued that interest with little subtlety, his English work demanded and produced greater originality and sensitivity. This is already to be seen in one of the earliest of the post-Italian English landscapes, the view of *Matlock High Tor, by Moonlight*, at Leicester.[1] Unfortunately it is in very poor condition, but enough remains to show how effectively he has rendered the shivering moonlight reflected on the water of the river and the craggy surfaces of the rocks, and echoed in the tiny stars peppering the otherwise quiet sky. Similar mysterious qualities are retained in the slightly later painting of the same spot shown from a different view-point, now in the Mellon Collection[2] (Plate 82). In a painting of the same scene by daylight, the *Matlock Tor* in the Fitzwilliam Museum,[3] Wright has mellowed and formalized his composition, and the influence of Richard Wilson is clearly to be seen. Though that influence was to dominate much of Wright's later landscape painting, his interest in unusual light effects is maintained and continues to give his work an individual quality. In the Fitzwilliam *Matlock Tor* this is expressed in the soft light cast by the sun breaking through the clouds; in the spacious *Albano*[4] (Plate 65) at Cardiff (at one time attributed to Wilson) great heat and absolute calm are rendered in thin flat paint that itself seems to glow with the very effect that it is evoking.

One of the last achievements in English landscape by Wright – and there are many less successful landscapes from the years preceding it – is the luminous *Landscape with a Rainbow* at Derby[5] (Plate 83). This is probably also a Derbyshire subject, but the interest is focused not on the actual scene but on the rainbow that illuminates it in such a spectacular way. This almost theatrical moment is subtly framed in a foreground of sturdy trees, which give great emphasis to the momentary nature of the rainbow and its light. The experience which led to this composition brought out the best in Wright of Derby, despite pain and illness at this stage of his life; the scenery of the Lake District, of which he made several paintings in the last two years of his life, did not have the same effect. There is little poetry or grandeur in Wright's paintings of Derwentwater or Ullswater – these are conventional exercises in the picturesque with theatrical under-tones, and only in the close-up view of *Rydal Waterfall*[6] in Derby Museum do we again see evidence of that mastery of light and mood which singles out the best of Wright of Derby's landscape.

1. *Loc. cit.* no. 307, pl. 212 and fig. 107.
2. *Loc. cit.* no. 308, pl. 217.
3. *Loc. cit.* no. 310, pl. 248.
4. *Loc. cit.* no. 260, pl. 315.
5. *Loc. cit.* no. 298, pl. 347.
6. *Loc. cit.* no. 324, pl. 352.

CHAPTER FOUR

The Tradition of the Netherlands, and the Rise of the Picturesque

AS HAS ALREADY been discussed in the opening chapter, the majority of the foreign landscape artists working in this country in the seventeenth and early eighteenth centuries came from the Netherlands. However, in the 1740s their impact and influence were overshadowed by the landscape tradition of Italy, and most of the British landscape painters of the middle years of the century worked under that influence rather than under that of the Netherlands. The outstanding exception to this generalization was Thomas Gainsborough (1727–88), who drew and painted landscape from his earliest days, and always preferred this side of his work to the painting of portraits, by which he made his living and his name. At the outset of his career he had hopes of setting up as a landscape artist, but he soon found that his commissions were 'chiefly in the Face way',[1] and it is as a portrait painter that he has been principally studied until quite recently. However, thanks very largely to the current researches and writings of John Hayes, a great deal of material has now been assembled on which to base a survey of Gainsborough's achievements as a landscape artist.

These achievements were certainly recognized by many of Gainsborough's contemporaries. In 1782 Joseph Pott listed him among the six 'most eminent landscape painters of this country',[2] and stated that he felt 'strong inducements to give him the preference to all his predecessors or contemporaries in this country'.[3] In his famous *Fourteenth Discourse*, delivered four months after Gainsborough's death, Sir Joshua Reynolds makes numerous references to his painting and drawing of landscape, and discusses them as an essential element of Gainsborough's overall achievement. He judged him most fairly as a natural and instinctive artist, whose 'grace was not academical or antique, but selected by himself from the great school of nature'.[4] Though Gainsborough undoubtedly broke most of the rules proposed by Reynolds, the latter declared that he was 'more captivated with the powerful impression of nature, which Gainsborough exhibited in his portraits and landscapes'[5] than by the artificial works of some of the more recent Roman artists who were all the rage at the time.

As was to be the case with Constable, Gainsborough's instinctive feeling for landscape developed out of a combination of the impact of the Suffolk scenery in which he was born, and of his knowledge of the works of earlier landscape artists – in Gainsborough's case principally of the Netherlandish School. To these influences were added the experience

1. Letter to Mr. Robert Edgar, written from Ipswich on 13 March 1758, in *The Letters of Thomas Gainsborough*, ed. M. Woodall, 1963, p. 61.
2. *An Essay on Landscape Painting, etc.* p. 65.
3. *Loc. cit.* p. 72.
4. *Discourses*, ed. R. Fry, 1905, p. 383.
5. *Loc. cit.* p. 376.

of close contact with the contemporary Rococo style, especially as practised in London by the French artist Hubert Gravelot, in whose studio Gainsborough was employed in the early 1740s, and as advocated by William Hogarth, whose theories were summed up in the *Analysis of Beauty*, published in 1753. From these varied sources Gainsborough quickly developed an individual landscape style, which then underwent a number of very positive changes as he himself came under different influences. It should, however, be stressed that Gainsborough was never a pasticheur. The essential elements of all his landscape work were his characteristic verve and intuition, to which he added his powers of assimilation as and when this seemed necessary.

In his earliest days Gainsborough made landscape drawings from nature. These range from delicate and somewhat hesitant pencil studies, of which there are numerous examples in the British Museum, to such confident and effective drawings, often in black chalk, as the well-known *Burdock Leaves*,[1] also in the British Museum. In nearly all these early sheets the example of various Netherlandish artists can be traced. Though probably mostly drawn on the spot, they are in no way topographical in character. While some of them show an interest in the structure and minute details of the landscape, others already reveal that ability to select and synthesize which characterizes the majority of Gainsborough's landscape paintings and drawings. As his technique grew broader and bolder, the subjects of his landscape drawings became more generalized. In about 1747 he was still drawing such relatively tight compositions as the Whitworth Gallery's pencil and black chalk copy of Ruisdael's painting *La Forêt* in the Louvre,[2] in which the effect is much enhanced by skilful use of white highlighting. Some ten years later his draughtsmanship had reached greater individuality, as in Sir John Witt's *Country Road at the Edge of a Wood*.[3]

The development in Gainsborough's early drawings is paralleled by that in his landscape paintings. Gravelot left London in October 1745, by which time Gainsborough had probably already set up his own studio, where 'his first efforts were small landscapes, which he frequently sold to the dealers at trifling prices'.[4] One of the earliest of these to survive is the very Dutch *Animals Crossing a Ford* at Upton House.[5] Owing an overall debt to Jan Wijnants, this tiny canvas lacks form and depth, except in the distance on the right, which is surprisingly effective. There is firmer handling in the unfinished *Path through the Woods*, belonging to Sir Alfred Beit.[6] Here, as Dr. Hayes has pointed out, there are close similarities with the technique of Watteau, whose work could certainly have become familiar to Gainsborough while he was in London in the 1740s.[7] Another strong influence in these first landscape paintings is that of Jacob Ruisdael, which brought more naturalism into Gainsborough's compositions, as is seen in the fine canvas

1. J. Hayes, *The Drawings of Thomas Gainsborough*, 1970, no. 86.

2. *Loc. cit.* no. 80.

3. *Loc. cit.* no. 233.

4. *The Morning Chronicle*, 8 August 1788; quoted Hayes, *loc. cit.* p. 2.

5. E. Waterhouse, *Gainsborough*, 1958, no. 877.

6. *Loc. cit.* no. 876.

7. J. Hayes, 'Gainsborough's Early Landscapes', *Apollo*, LXXVI (1962), p. 667. Gainsborough could also have gained experience of Watteau's style from his contacts with P. Mercier.

at Vienna, *A sandy Lane through Woods with Cottage and Donkeys*.[1] It has always been thought that Gainsborough must have seen the landscapes of Ruisdael, Wijnants and other Dutch artists, in collections in East Anglia, but recent research has made it clear that he could just as easily have studied such paintings while he was in London from about 1740 to 1748, for during those years numerous examples passed through the sale-rooms.[2]

A recognized masterpiece of this first London period is the National Gallery of Scotland's *Landscape with a distant View of Cornard Village*[3] (Plate 84), which dates from about 1747. At first sight this appears to be a combination of a Wijnants, in the sandy bank in the foreground, and of a Ruisdael, in the beautiful distance on the right. But once this 'art historical' impression is forgotten, the individuality of the composition, so definitely based on the 'idea' of the scenery and sky of Suffolk, comes into its own. This is especially true of the right half of the canvas, with the river winding past the village into the distant landscape, which merges marvellously into the sky. Another outstanding work dating from the end of these years in London has already been referred to briefly in Chapter Two. This is the circular view of *The Charterhouse*,[4] which was Gainsborough's contribution to the Court Room of the Foundling Hospital. George Vertue tells us that of the eight roundels this was 'tho't the best and masterly manner'.[5] Various influences – of Dutch artists such as Jan van der Heyden, of Hogarth, and of Rococo grace – are to be identified in this small composition, but again it reveals a personal feeling for problems of light and atmosphere as well as an original development of the topographical tradition. *The Charterhouse* is exceptional in Gainsborough's *oeuvre* in being a painting of an actual and identified place; as he later made absolutely clear in his well-known letter to Lord Hardwicke, written in about 1764 and already quoted from on page 39, he was not interested in painting '*real views* from Nature'.

Late in 1748 Gainsborough, by then a married man of twenty-one, returned to Sudbury, in the hope, which proved to be a vain one, of establishing a practice there. During this period in Suffolk his landscape painting made rapid strides forward, as is seen in two outstanding canvases in the National Gallery. We know from one of Gainsborough's own letters that *Gainsborough's Forest* ('*Cornard Wood*') (Plate 85)[6] was painted at Sudbury in 1748. The artist, writing in the last year of his life, himself refers to it with some pride 'as an early instance (of) how strong my inclination stood for Landskip', and he thought it 'worth remark' that 'the touch and closeness to nature in the study of the parts and *minutiae* are equal to any of my latter productions'.[7] Once again this large canvas, with its muted greens and dark sky, shows an overall debt to the Dutch School,

1. Waterhouse, *loc. cit.* no. 859; Hayes, *loc. cit. Apollo*, fig. 4.

2. Hayes, *loc. cit.* p. 671.

3. Waterhouse, *loc. cit.* no. 840, where it is dated to the earlier 1750s. Hayes (*loc. cit.* fig. 3) dates this canvas more convincingly to *c.* 1747.

4. Waterhouse, *loc. cit.* no. 861.

5. 'The Vertue Note Books – Volume III' in *The Walpole Society*, XXII (1933–4), p. 157.

6. Waterhouse, *loc. cit.* no. 828; National Gallery, no. 925, *British School Catalogue*, 1959, pp. 36–7.

7. *Letters, loc. cit.* p. 35.

and especially to Jacob Ruisdael, but its rendering of tone and colour bears witness to Gainsborough's sincere reaction to the scenery of his native Suffolk. The dual nature of the landscapes of the 1740s and early 1750s is well summed up by Joseph Pott in his *Essay* of 1782 as follows: 'At his outset in life he appears to have studied and preferred the Flemish style, and particularly to have imitated Wynants in the breaking of his grounds and choice of his subjects; in these pictures, however, he gives a faithful representation of English nature. His churches, cottages, figures, hamlets are all English, and are painted with strict attention to truth.'[1] The happy informality of *Gainsborough's Forest*, with its light-hearted distribution of the figures, is yet another example of the artist's debt to French painting.

The National Gallery's second great landscape of this Sudbury period forms part of the famous double portrait of *Mr. and Mrs. Andrews*[2] (Colour Plate XI and Plate 86), which was probably painted in the autumn of 1750.[3] The recently married young squire and his wife are portrayed quite naturally in the setting of their own land. She sits a little stiffly on a bench, against which he is leaning in a more relaxed pose. Behind them is the trunk of a large tree, beyond which are further trees through a gap in which a church tower, identified as that of St. Peter's, Sudbury, is seen. All this would make a complete picture in itself, but Gainsborough, with true genius, has gone further. He has adapted the compositional device which he had already used quite frequently in such works as the *Landscape with a distant View of Cornard Village* at Edinburgh (Plate 84), and has balanced the mass of the figures (here replacing the sandy bank of the Edinburgh picture) by the landscape on the right. In place of the winding river, we have the lines of stubble and the corn stooks to lead our eye into the distance, with the delicate mauve of the wooded hill on the skyline. As well as forming an essential element of the whole composition, the landscape part of *Mr. and Mrs. Andrews* stands on its own as 'perhaps the most beautiful yet painted by any English artist'.[3] It was certainly the most successful that Gainsborough had yet painted, and clearly shows his outstanding ability as an instinctive and original landscape artist.

In the autumn of 1750 Richard Wilson, still set on practising as a portrait painter, was preparing for his journey to Italy; Paul Sandby was working as a draughtsman on the Survey to the Highlands; and George Lambert, *the* established landscape painter of the day, was becoming stiffer and ever more conventional in his work. Seen against this contemporary background Gainsborough's achievements at Sudbury, and later at Ipswich, where he moved in 1752, seem all the more remarkable. He did not find any sale for his pure landscapes, and had to resort to the painting of portraits to make a living. However, his brilliant compromise, in the development of which he was certainly indebted to Watteau, of portraying his sitters in landscape settings, gave Gainsborough the chance to make the best of both worlds, and gave to English eighteenth-century art one of its most charming contributions to the development of European painting. *Mr. and*

1. *An Essay, loc. cit.* p. 72. 3. *National Gallery Acquisitions 1953–1962*, pp. 28–9.
2. Waterhouse, *loc. cit.* no. 18.

Mrs. Andrews is the masterpiece among these early Suffolk portraits; another fine example in the National Gallery is that of *John Plampin*,[1] who is shown lounging against a tree in a very Watteauesque pose, which is also seen in the portrait of *Philip Thicknesse* at St. Louis (now attributed to Francis Hayman).[2] In these Gainsborough canvases the landscape setting is usually essentially Suffolk, with Dutch overtones; however, in the delightful double portrait of *Heneage Lloyd and his Sister*[3] at the Fitzwilliam the background with its lake and its balustrade is more Rococo and artificial.

The growth of a similar element of artificiality can be seen in the 'pure' landscape compositions which Gainsborough painted in his later Suffolk years. In the *View near the Coast*[4] (Plate 87), at Ipswich, the position of the cattle and their numerous attendants on the bank in the centre seems precarious and unlikely, and the church tower, with its small spire, rising behind the trees on the right would have had to be a very tall one. Such criticisms could also be made of the *Woody Slope with Cattle and felled Timber*[5] at Minneapolis, which is essentially a decorative arrangement of trees and tree-trunks. This increasingly decorative element in his landscapes was probably adopted by Gainsborough because of the prevailing taste of his time. As has already been noted in Chapter Three, when Zuccarelli came to England in 1752, he quickly gained popularity with his highly stylized pastoral landscape compositions.

One of the few landscape commissions which Gainsborough received while in Ipswich was from the Duke of Bedford, who in 1755 acquired two overmantels,[6] which are still at Woburn today. In these the figures play an important role and are highlighted to stand out against the relatively dark landscape. On the other hand, in a pair of broader compositions painted a year or two later, possibly for the artist Francis Hayman, the exquisitely painted figures merge more happily into the whole. In one of them, *Country Road with Farm Cart, Milkmaid and Cows*,[7] belonging to L. H. Wilson, the composition springs to life with its lovely jewel-like details, which include such familiar Rococo features as a half-dead tree and a tree-trunk beside it on the ground. This canvas is executed in unusually brilliant colours, both in these details and in the fine distant landscape with its mauve hills on the skyline. However, despite these qualities the composition is still essentially a decorative one, and it lacks the realistic sense of place which distinguished some of the earlier Suffolk landscapes.

Disappointed by the continued lack of patronage in Ipswich, Gainsborough moved to Bath in 1759. This move was to have an immense effect on his career, and also on the development of his work, both in portraiture and in landscape. He quickly built up a flourishing practice as a portrait painter, finding an ample supply of sitters among the fashionable visitors to the spa. His portrait style became more mature and assured, and his landscapes also were painted with greater verve and conviction, and usually on a larger

1. Waterhouse, *loc. cit.* no. 546.
2. *Loc. cit.* no. 659. The convincing attribution to Hayman was first proposed by John Hayes.
3. *Loc. cit.* no. 452.

4. *Loc. cit.* no. 838.
5. *Loc. cit.* no. 830.
6. *Loc. cit.* nos. 829 and 833.
7. *Loc. cit.* no. 857.

scale than those of his Suffolk period. One which dates from soon after the move to Bath, and which is said to have been painted for Gainsborough's great friend, Samuel Kilderbee, is the *Wooded Landscape with a mounted Farmboy leading a Horse and a Woodman returning*[1] (Plate 88). Here the technique is already much broader and freer than in the Ipswich paintings, and the composition, with its framing trees on both sides, is essentially in the Grand Manner. As a whole the painting has great rhythm and movement, and a Claudian element has been added to the more usual Netherlandish influences.

These changes can be attributed to two principal factors. Firstly the very different character of the West Country scenery, which is more varied and picturesque than that of East Anglia, certainly influenced Gainsborough's approach to landscape. The second factor was the new range of earlier landscape paintings which he was able to see in collections within reach of Bath. Most important among these were the rich and atmospheric landscape compositions of Rubens, of which he could have studied one or two actual or supposed examples, at Wilton and elsewhere.[2] As we have seen, Gainsborough's own manner and technique were already becoming broader and freer, and it comes as no surprise that he was greatly attracted and influenced by the bold brushwork and flowing compositions of Rubens's landscapes, which had previously made little impact on British artists.

The Tate Gallery's almost square *Sunset: Carthorses drinking at a Stream*[3] is an early and relatively tight example of Gainsborough's painting under the influence of Rubens, in which reminiscences of Watteau are, however, also still to be found. With its vibrant colours and sunset light – this is one of the first examples of such a specific light effect in Gainsborough's landscapes – it is a compact composition in which a multitude of detail and a harmonious overall effect are successfully combined. Within three or four years Gainsborough had broken away almost totally from the discipline of detail, and was able to paint such a bold masterpiece as the Barber Institute's *The Harvest Waggon*[4] (Colour Plate XII).

A comparison between this wonderfully fluent canvas, with its delicate tones, and the much more deliberate *Sunset* scene at the Tate, can be usefully paralleled by a similar comparison between two such well-known portraits as that of *Mrs. Portman*,[5] formerly on loan to the Tate Gallery, and that of *Countess Howe*[6] at Kenwood. The former, which is contemporary with the *Sunset*, is firm and precise in technique and character; the slightly later portrait of the Countess is a masterpiece of flowing Rococo design and execution. The same Rococo qualities are uppermost in *The Harvest Waggon*, which was probably exhibited in London at the Society of Artists in 1767. Here the debt to Rubens is twofold, for it lies not only in the vigorous nature of the landscape as a whole, but also in the tension of the superbly composed group of figures on the wagon. This debt is a direct

1. *Loc. cit.* no. 910.
2. J. Hayes, 'Gainsborough and Rubens', *Apollo*, LXXVIII (1963), p. 90.
3. Waterhouse, *loc. cit.* no. 897.
4. *Loc. cit.* no. 907.
5. *Loc. cit.* no. 552.
6. *Loc. cit.* no. 387.

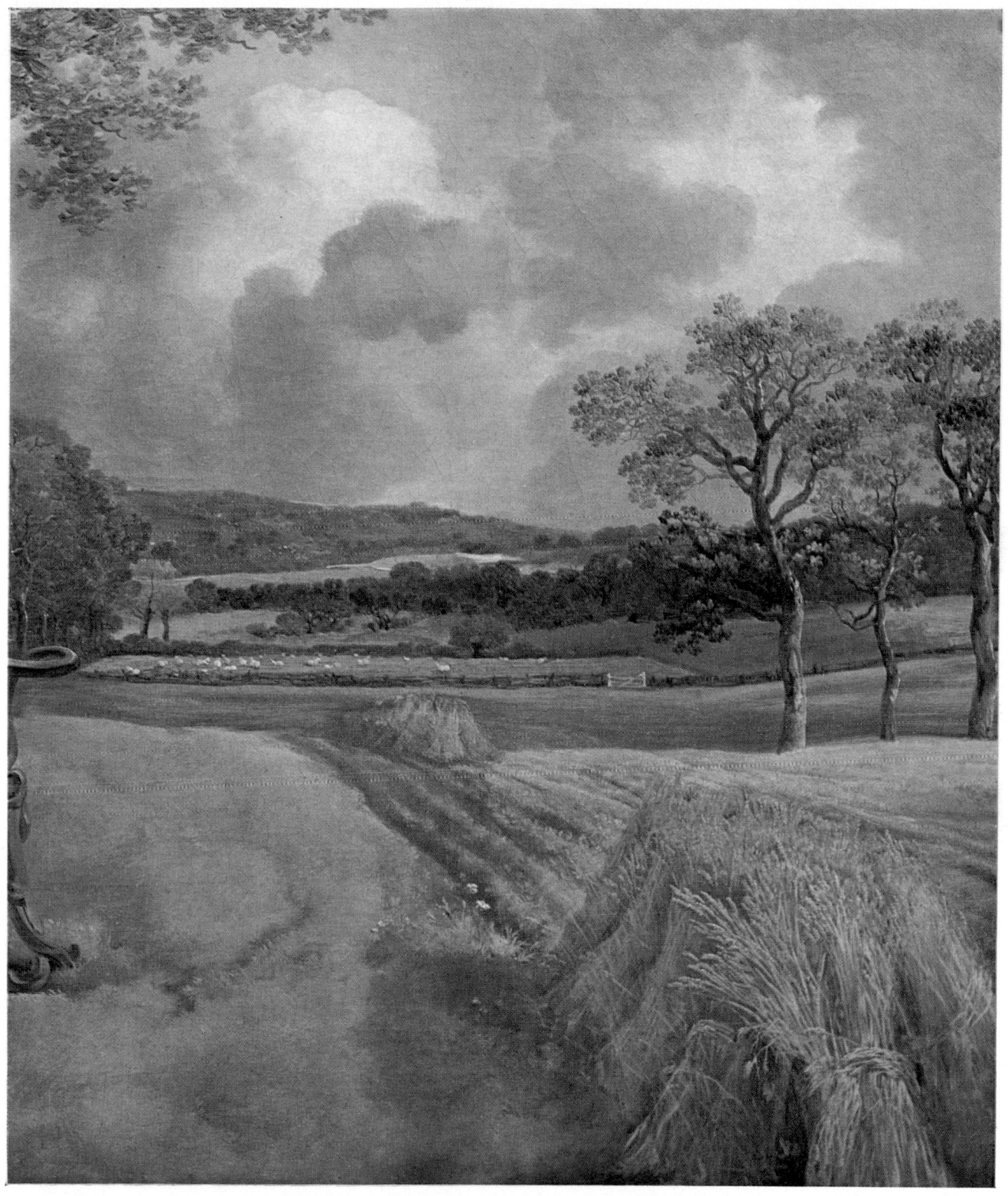

XI Thomas Gainsborough *Mr. and Mrs. Andrews* (detail)

National Gallery, London. (*Reproduced by courtesy of the Trustees, the National Gallery, London*) *See page* 94

For whole canvas see Plate 86

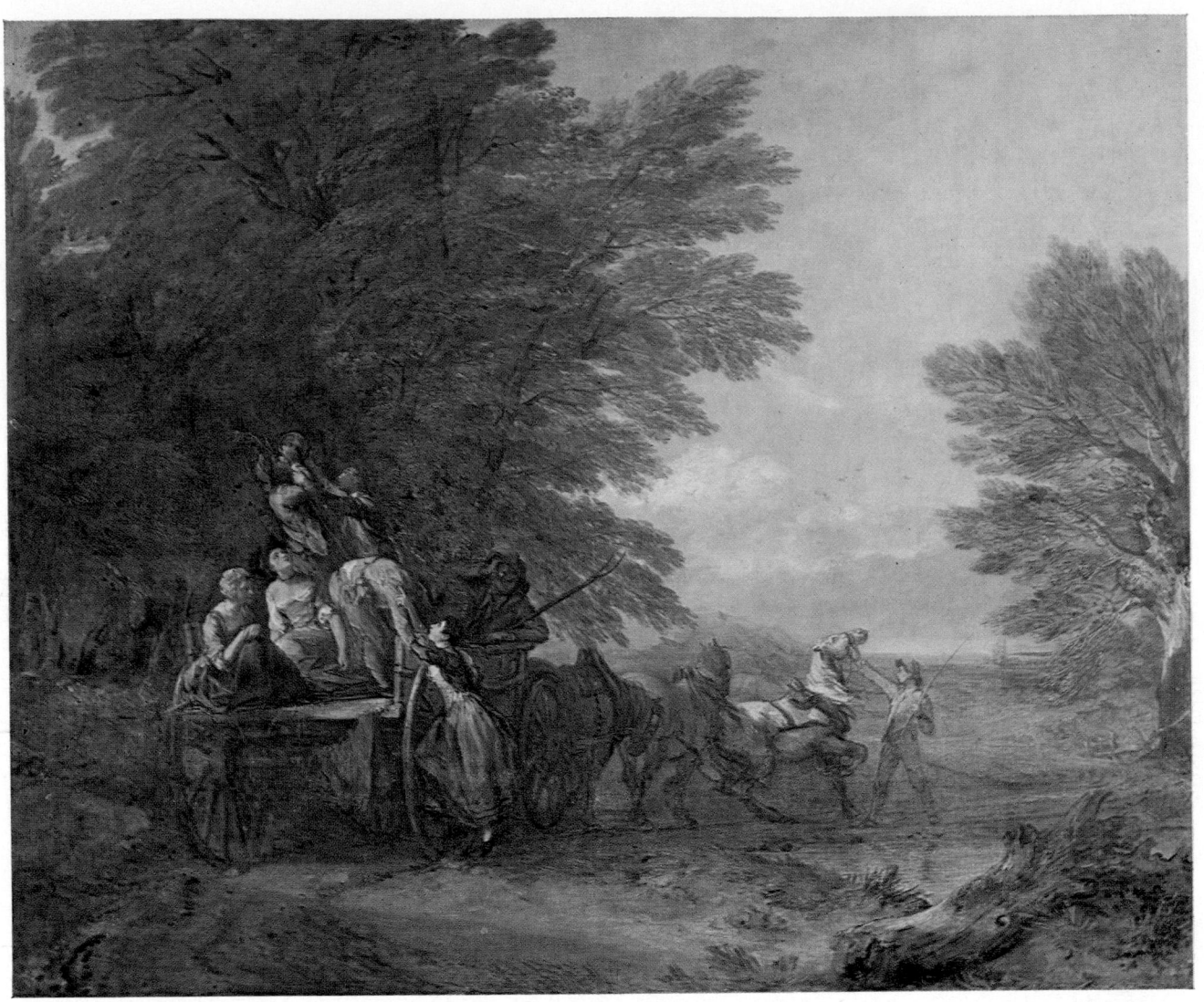

XII Thomas Gainsborough *The Harvest Waggon* Canvas, 47¼ × 57, 120 × 144·8
The Barber Institute of Fine Arts, University of Birmingham. *See page* 96

one, for, as Dr. Hayes has demonstrated, there is a close relationship with Rubens's *Descent from the Cross* at Antwerp.[1] Gainsborough's familiarity with this masterpiece could have come through the preliminary study for the central panel which was then at Corsham;[2] there is an unfinished copy of the *Descent* by Gainsborough, in reverse and presumably based on an engraving, though probably aided by his memories of the Corsham panel.[3]

The Harvest Waggon is but the first of a considerable number of similar landscape masterpieces of the Bath period. The theme of country folk moving through a landscape continued to exercise Gainsborough. Of much the same date as the Barber picture is *The Road from Market*[4] at Toledo, in which a line of mounted peasants is riding along a woodland track in warm evening light. In contrast the cool light of morning dominates the more open composition of *Going to Market*[5] (Plate 89) at Kenwood. This is a somewhat sleepy, disorganized 'cavalcade', in which three of the mounted men are outlined against the sky in the centre of the composition. There is even more concentration on the figures in the graceful *Peasants going to Market: Early Morning*[6] at Royal Holloway College, in which they are just reaching the top of a hill and rising, as it were, from the morning mists of the valley below. This is probably the last of the artist's variations on this theme at that time.

Most of Gainsborough's landscapes painted during the second half of his Bath period are evocative of mood and atmosphere. One of the most successful, with its rhythmic rendering of an extensive view, is the *River Landscape with Figures in a Boat*[7] (Plate 90) at Philadelphia. This echoes the influence of the later Rubens landscapes, more open and less peopled, such as the National Gallery's *A Landscape with a Shepherd and his Flock*. There is a strong feeling of repose and rural calm in the *River Landscape*, and this is even stronger in Lord Camrose's *Wooded Landscape with rustic Lovers and Cattle*,[8] which was also painted towards the end of the Bath period. In this large canvas the influence of Claude can be seen, and it is one of Gainsborough's grandest and most successful classical compositions.

In his drawings also, Gainsborough, during the 1760s and early 1770s, was increasingly turning to compositions in the classical manner, which were to continue for the rest of his career. An example dating from the early 1760s, and identified by John Hayes as a preliminary study for a recently rediscovered painting of the same period, is the Ashmolean Museum's *Wooded Landscape with Figures and distant Mountain*[9] (Plate 92 A), a dramatic composition with an especially effective stormy sky. This is one of a pair of drawings in water-colour and body-colour on brown paper, an unusual technique for Gainsborough, and he has made the fullest use of the coloured paper in executing this

1. Hayes, *loc. cit.* p. 92.
2. Now in the Lee Collection at the Courtauld Institute, London, no. 75.
3. Waterhouse, *loc. cit.* no. 1027; collection of the Hon. Michael Astor.
4. *Loc. cit.* no. 906.
5. *Loc. cit.* no. 912.
6. *Loc. cit.* no. 911.
7. *Loc. cit.* no. 945.
8. *Loc. cit.* no. 922.
9. Hayes, *Drawings*, no. 265.

rather Italianate subject in the manner of the Italian *gouache* artists. There is also something of a classical element in Major Michael Ingram's *Wooded Landscape with Herdsman and Cattle*[1] (Plate 92 B), which probably dates from a few years later, though in this case the subject speaks more of the countryside around Bath. With a considerable element of colour, a relatively rare feature in Gainsborough's drawings, this small sheet shows the artist at his freshest and gayest, and once again it reveals his instinctive and sensuous reaction to the actual scenery around him.

As Reynolds records in the *Fourteenth Discourse* Gainsborough 'had a habit of continually remarking to those who happened to be about him whatever peculiarity of countenance, whatever accidental combination of figure, or happy effects of light and shadow, occurred in prospects, in the sky, in walking the streets, or in company'.[2] In 1774 Gainsborough finally left Bath for London, and his opportunities for the direct experience of landscape were clearly diminished. But, as Reynolds also tells us, he overcame this problem in the following manner: 'from the fields he brought into his painting-room, stumps of trees, weeds, and animals of various kinds; and designed them, not from memory, but immediately from the objects. He even framed a kind of model of landscapes on his table; composed of broken stones, dried herbs, and pieces of looking-glass, which he magnified and improved into rocks, trees, and water.'[3] He had already used these methods while in Bath, but it seems reasonable to suppose that when living in London he made more constant use of such sources of inspiration. We know that he did much of his drawing in the evenings, by candlelight, and it comes as no surprise that his later landscape drawings became even more generalized, both in subject and in handling. Black chalk, wash and stump were now his favourite mediums, and he often used coloured paper to enhance his effects.

In these late drawings, of which, fortunately, a very considerable number has survived, Gainsborough has brought together all his own experience as a landscape artist and his knowledge of the landscape art of others.[4] From these sources he has created his very personal later style. Of the many examples that could be cited to illustrate this aspect of Gainsborough's achievement, only a few can be selected here. Two fairly specific drawings of these years are Lord Eccles's beautiful *Wooded Landscape with Rustic Lovers and Cow*,[5] an upright composition radiating a wonderful effect of light, and the magically economical *Clump of Trees with four Cows*[6] in the National Gallery of Scotland. The majority of these sheets are, however, much broader and more imaginative in subject and composition, as in the *Wooded mountainous Landscape with Sheep*[7] (Plate 93 A), a powerful black chalk and stump drawing of the mid-1780s. Drawn with even more rapidity and vigour is the *Wooded Landscape with Packhorses descending to a Pool*[8] (Plate 93 B) at Bedford. In this

1. *Loc. cit.* no. 273, where it is suggested that 'the treatment and tonality are strongly influenced by Van Dyck's landscape sketches'.

2. *Discourses, loc. cit.* p. 377.

3. *Loc. cit.* pp. 377–8.

4. See, for instance, J. Hayes, 'Gainsborough and the Gaspardesque', *Burlington Magazine*, CXII (1970), pp. 308–11.

5. Hayes, *Drawings*, no. 499.

6. *Loc. cit.* no. 799.

7. *Loc. cit.* no. 639.

8. *Loc. cit.* no. 759.

very late example we have a composition that is at once 'grand' and 'pastoral'; it is the quintessence of Gainsborough's deeply felt landscape vision.

Gainsborough's move to London led to an increased use of his imagination in the execution of his landscape drawings, and his landscape paintings were, of course, similarly affected. The stage of development which they had reached in his final years at Bath made this an easy change to assimilate. Fired by the inspiration of Rubens, Gainsborough's landscape art had already reached maturity, as might be expected of a man in his later forties. During the remaining years of his life, all of which were spent in London, he continued to devote much of his time to the painting of landscape, though the demand for portraits was not abated. In 1777 he received his first portrait commissions from the Royal Family, and in that year he again showed at the Royal Academy, of which he had been made a founder member in 1768 but with which he had quarrelled in 1773. His return to the Exhibition was a triumphant one; among the portraits were two of his masterpieces, *The Honourable Mrs. Graham*,[1] now at Edinburgh, and *Carl Friederich Abel*,[2] in the Huntington Gallery at San Marino. The only landscape he showed on this occasion was equally spectacular. This was the National Gallery's *The Watering-Place*[3] (Colour Plate XIII and Plate 91), which Horace Walpole described at the time as 'in the style of Rubens, and by far the finest landscape ever painted in England, and equal to the great masters'.[4] An unidentified Italian artist, in a letter to a colleague in Rome, wrote of it as follows: 'His large landscape, No. 136, is inimitable. It revives the colouring of Rubens in that line. The scene is grand, the effect of light is striking, the cattle very natural. But what shall I say of the pencilling? I really do not know; it is so new, so original, that I cannot find words to convey any idea of it.'[5]

Despite its obvious qualities, *The Watering-Place* was not sold, and indeed Gainsborough only rarely found buyers for any of his landscapes, which, as we know from Sir William Beechey, 'stood ranged in long lines from his hall to his painting-room, and they who came to sit to him for their portraits...rarely deigned to honour them with a look as they passed them'.[6] These were the very years during which Richard Wilson was having such difficulty in selling his work, but, unlike his less fortunate colleague, Gainsborough was making an excellent living from his portraits, and could afford to paint landscape for his own pleasure.

Shortly before leaving Bath he had written to his great friend William Jackson, a composer and organist: 'I'm sick of Portraits and wish very much to take my Viol da Gamba and walk off to some sweet Village when I can paint Landskips and enjoy the fag End of Life in quietness and ease.'[7] In addition to the painting and drawing of landscape, music was a great solace of Gainsborough's life. The painter was a more

1. Waterhouse, *loc. cit.* no. 323.
2. *Loc. cit.* no. 1.
3. *Loc. cit.* no. 937.
4. W. T. Whitley, *Artists and their Friends in England 1700–1799*, 1928, vol. I, p. 322.
5. *Loc. cit.* p. 323.
6. G. W. Fulcher, *Life of Thomas Gainsborough, R.A.*, 1st ed. 1856, p. 114.
7. *Letters, loc. cit.* p. 115.

than adequate performer on the viola da gamba, and he included many influential musicians among his closer friends; C. F. Abel, composer and professional viola da gamba player, Johann Christian Bach (known as 'the English Bach'), J. C. Fischer, composer and famous performer on the oboe, who married Gainsborough's younger daughter in 1780, and Jackson were among them. Gainsborough moved among some of the leading and most advanced exponents of music in England, and he himself often incorporated musical qualities of rhythm and harmony in his landscapes. Gainsborough would surely have agreed that these, as C. P. E. Bach wrote of contemporary music, 'must, first and foremost, stir the heart'.[1]

In 1780 the Royal Academy held its first exhibition in its new rooms at Somerset House, and on this special occasion Gainsborough showed no less than sixteen paintings, of which six were landscapes. Among the portraits was the Royal Collection's superb full-length of J. C. Fischer,[2] who had recently become the artist's son-in-law. It is difficult to identify any of the landscapes with certainty, for they were merely described in the Catalogue as *Landscape* or *A Landscape*, but it seems probable that the version of *The Cottage Door*[3] (Plate 94) now in the Huntington Collection in California was one of them. The sentimental theme of the pretty mother and ragged children of a peasant family assembled at the door of their humble woodland cottage, awaiting or witnessing the return of the family bread-winner, was one that engaged Gainsborough throughout the last years of his life, both in drawings and in paintings. Indeed the last landscape that he painted,[4] now belonging to the University of Southern California at Los Angeles, is a powerful variant of this subject. In the large Huntington canvas the ancient forest trees seem to swirl and vibrate around the calm and peaceful family gathering in their midst, and this contrast emphasizes the artificiality of the scene, which was, however, in keeping with the contemporary Londoner's feeling of nostalgia for rural life. This was expressed more frequently in the poetry and literature of the day. In *The Idler* Dr. Johnson referred to the 'homely quiet and blameless simplicity'[5] of life in the country, and an anonymous satirist wrote in 1762 in *The St. James's Magazine* of

'Trim poets from the City desk
Deep vers'd in rural picturesque....'[5]

Another of Gainsborough's 1780 landscapes, of which only fragments survive today,[6] was even more of a rural idyll. Depicting *The Country Churchyard*, it was published in 1790 as an aquatint, with the first sixteen lines of Gray's *Elegy* printed below the picture.

In 1781 Gainsborough exhibited three more landscapes, all of which can be identified. These show entirely different uses of his skills than had been seen in the sentimental subject pictures of the preceding year. In one of them, the oval composition of a *Peasant*

1. Hayes, *Drawings*, p. 8.
2. Waterhouse, *loc. cit.* no. 252.
3. *Loc. cit.* no. 941.
4. *Loc. cit.* no. 1011.

5. A. R. Humphreys, *The Augustan World*, 1964, p. 39.
6. Waterhouse, *loc. cit.* no. 942.

on Horseback driving Cattle over a Bridge,[1] Gainsborough is at his most Rococo. This decorative painting, which the artist is said to have given to Oldfield Bowles of North Aston, in exchange for a violin, is, to cite Professor Waterhouse, 'perhaps closer to Fragonard in mood than any other of Gainsborough's'.[2] The British artist's knowledge of his contemporary French colleague would probably have been based on prints; Gainsborough's experience of new and different landscape styles was also benefiting at this time from his regular visits to the London sale-rooms, which were part of his own activities as a collector of paintings.

It may well have been the work of Dutch marine artists seen in the sale-room that inspired Gainsborough to try his hand at coastal scenes, and two of the works which he showed in 1781 were in that category.[3] The first was a storm scene, and could have been either the *Fishermen setting out* at one time in the collection of Sir John Leicester, or the *Coast Scene: Selling Fish*[4] (Plate 96) belonging to the Duke of Westminster. The latter, with its beautifully painted squally sea – in which thick paint is used for the 'white horses' – and its windswept sky, is full of movement. This is emphasized by the sails of the vessels at sea and by the wind-blown clothing of the women on the shore. In contrast the second shore-scape at this exhibition, the *Coast Scene with Fishermen dragging Nets*[5] at Anglesey Abbey, shows a calm sea, which in its turn is re-echoed in the solid rocks and ruin close to the water, all painted almost in monochrome. Despite their qualities both these compositions are somewhat theatrical, and they lack the conviction of Turner's early sea-scapes of a generation later.

Apart from the possible inspiration drawn from Dutch marine painting, these coastal scenes certainly owe a debt to the influence of Philip James de Loutherbourg, the French painter who came to London in 1771 and whose work will be discussed in greater detail later in this chapter. What concerns us at this point is Loutherbourg's *Eidophusikon*, a remarkable pictorial entertainment which he launched in February 1781, and which quickly became one of London's most popular spectacles. For Loutherbourg this was a long-considered development of his work as a scene painter, and he himself claimed that 'by adding progressive motion to accurate resemblance a series of incidents might be produced which should display in the most lively manner those captivating scenes which inexhaustible Nature presents to our view at different periods and in different parts of the globe'.[6] Gainsborough was captivated by the *Eidophusikon* with its splendid dramatic effects, which for him must have put even Rubens in the shade, and we are told that 'he passed his evenings at that exhibition in long succession'.[7] With its moving painted scenes, enhanced by remarkable light and sound effects, and accompanied by suitable music, the *Eidophusikon* brought the arts together in a novel manner. Gainsborough

1. *Loc. cit.* no. 959.
2. *Loc. cit.* p. 31.
3 Gainsborough actually bought a painting by Backhuysen in December 1781, in a mixed sale at Christie's; see J. Hayes, 'Gainsborough's Later Landscapes', *Apollo*, LXXX (1964), p. 24.

4. *Loc. cit.* nos. 954 and 955.
5. *Loc. cit.* no. 956.
6. Whitley, *loc. cit.* vol. II, p. 352.
7. Ephraim Hardcastle (i.e. W. H. Pyne), *Wine and Walnuts*, 1823, vol. I, p. 296.

was moved to devise his own pictorial entertainment, the so-called 'peepshow box', which is now in the Victoria and Albert Museum. For this he painted a series of transparencies on glass,[1] which were inserted in the box in front of a group of candles, the flickering light from which was diffused through a coloured silk screen. Viewed through a magnifying lens in the front of the box these simple landscapes must have appeared dramatically alive, or at any rate 'different'.

The experiences of the *Eidophusikon* and of his own 'peep-show box' are strongly felt in Gainsborough's later landscape paintings and drawings. These become more fluent and more concerned with the rendering of atmosphere and mood. As in his drawings, details and specific features become less important in his landscape paintings, which concentrate on the essence of the subject. This quality is seen in the National Gallery of Scotland's *Rocky Mountain Landscape*[2] (Plate 100), which was exhibited at the Royal Academy in 1783, and in the Tate Gallery's much smaller *Woody Landscape with a Bridge*.[3] Both these compositions feature mountains, and in both of them the figures play a minor role. In their overall character they can be considered at once picturesque and romantic, and in these late landscapes Gainsborough must certainly have had the current vogue for 'The Picturesque' in mind. Like other late eighteenth-century exponents of that vogue he was anticipating the romantic qualities which grew out of it. This aspect of Gainsborough's work will become clearer in conjunction with the brief discussion of the Picturesque later in this chapter. Suffice it to say here that proof of Gainsborough's awareness of the growing taste for the sublime and picturesque can be found in the fact that in the summer of 1783 he made a journey to the Lake District. Before setting out he wrote to a friend: 'I'm going along with a Suffolk Friend to visit the Lakes in Cumberland and Westmorland; and purpose when I come back to show you that your Grays and Dr. Brownes were tawdry fan-Painters. I purpose to mount all the Lakes at the next Exhibition, in the great stile.'[4] In these acid comments Gainsborough couples the name of the poet Thomas Gray, whose journal of a tour to the Lakes was first published in 1780, as an appendix to the second edition of Thomas West's *Guide to the Lakes*, with that of Dr. John Brown, Vicar of Newcastle, whose *Description of the Lake and Vale of Keswick* had been published in 1767. Here we have proof that Gainsborough was aware of the growing picturesque literature of his day.

However, Gainsborough did not take the Academy by storm with his lakeland landscapes in 1784, for at that year's exhibition the artist had his final disagreement with the Royal Academy. He withdrew all his pictures and never showed at Somerset House again. A few months later he opened the first of his own exhibitions at his gallery in Schomberg House. That exhibition included only one landscape that could have been the result of his visit to the Lakes, the *Upland Valley with Sheep*, now in a private collection.[5] Gainsborough never really broke away from his theatrical approach to the painting of mountain

1. Waterhouse, *loc. cit.* nos. 970–81. 4. *Letters, loc. cit.* p. 125.
2. *Loc. cit.* no. 966. 5. Waterhouse, *loc. cit.* no. 992.
3. *Loc. cit.* no. 984.

scenery, and even such a beautiful canvas as the *Mountain Landscape with Peasants crossing a Bridge*,[1] at Washington, does not reveal a true feeling for the grandeur and strength of mountains. Nevertheless such works are outstanding in the context of their own time. We may remember that Constable, another East Anglian, was no more successful in the painting of mountains.

There is no doubt that Gainsborough, like Constable, excelled at peopled landscapes, in which figures and natural scenery are skilfully blended to create a harmonious whole. This was what Gainsborough achieved in such masterpieces as *The Harvest Waggon* (Colour Plate XII) and *The Cottage Door* (Plate 94). He does, of course, use a similar method in many of his most successful whole-length portraits, uniting his sitters with superb background landscapes. Innumerable examples of this could be cited, among them *Countess Howe*, which has already been referred to, and *Mrs. Sheridan*,[2] shown at the Royal Academy in 1783 and now in Washington. In the latter the hair and clothing of the beautiful sitter are blown by the same breath of wind that is sweeping through the tree beneath which she sits and wafting the grass at her feet. Gainsborough's interest in the fusion of human beings with landscape resulted in the development of his 'fancy pictures', the first of which, shown in the exhibition of 1781, was *A Shepherd*.[3] This was destroyed in a fire in 1810, but is known through the mezzotint engraving of R. Earlom.

In the following year Gainsborough showed two such pictures, one of which was the *Girl with Pigs*[4] (Plate 98), now at Castle Howard. This was bought at the exhibition by none other than the President, Sir Joshua Reynolds. Gainsborough in a brief letter of thanks wrote: 'I may truly say I have brought my Piggs to a fine market.'[5] Reynolds referred to it at the time as 'by far the best picture he ever painted, or perhaps ever will'.[6] The pensive mood of the little girl watching over her young pigs is reflected in the sombre and dark landscape behind them, and the two elements of the composition are perfectly balanced. In the majority of the fancy pictures – there are less than twenty of them in all – the central figures are children. Here we see the effect of a new influence on Gainsborough, that of Murillo's paintings of beggar children. Despite their name, Gainsborough's fancy pictures have an air of truth and reality, and we know that he painted the children from live models – poor London children whom he brought into his studio. Another probable influence in these works can again be found, as in Gainsborough's earliest days, in contemporary French art, notably that of Greuze. The fancy pictures provided Gainsborough with a perfect vehicle for combining his love of landscape and his skill as a figure painter, and they were warmly received by the critics. Most of them also quickly found buyers.

In the last years of his life Gainsborough made further experiments in the combination of landscape and figure painting. An outstanding example is *The Mall*[7] in the Frick

1. *Loc. cit.* no. 1008.
2. *Loc. cit.* no. 613.
3. *Loc. cit.* no. 797.
4. *Loc. cit.* no. 799.
5. *Letters, loc. cit.* p. 127.
6. Waterhouse, *loc. cit.* p. 36.
7. *Loc. cit.* no. 987.

Collection, which dates from 1783. In this a gathering of elegant ladies and gentlemen is strolling in a park, and there is perfect balance between the groups of figures, with the ladies in their full flowing dresses, and the back-cloth of varied trees and the sky glimpsed through them.[1] That Gainsborough was making other experiments in his development of landscape subject pictures, and that he was, in fact, touching on history painting, we know from two late, unfinished works. These are the *Musidora* in the Tate Gallery, and the *Diana and Actaeon* (Colour Plate XIV)[2] in the Royal Collection. Recent cleaning has revealed the latter as a masterpiece in which perfect harmony between the figures and the landscape has been achieved. Despite the obvious rapidity of the execution of this large sketch, the composition was carefully evolved, for there are several preliminary drawings for it. In the *Diana and Actaeon* Gainsborough was certainly close to his final solution of the problem of combining figure and landscape painting.

In some of the works of his last years Gainsborough was content to continue and improve upon methods and themes of which he had already made use. *The Cottage Door*[3] (Plate 99), now on loan to the Victoria and Albert Museum, which was painted in the summer of 1786, is a fascinating combination of three different aspects of Gainsborough's landscape art during his last period in London. In its overall character and theme it belongs to the sentimental peopled landscapes which begin in the later 1770s; in the wild and romantic nature of the distant scenery it is reminiscent of such paintings as the *Rocky Mountain Landscape* of Plate 100; in its principal figures it is directly linked with two of the fancy pictures, for it repeats, with slight variations, the title-role group of the *Girl with Pigs*, and the young woman sweeping of the unfinished *The Housemaid*[4] in the Tate Gallery. All these elements are here successfully united to achieve one of Gainsborough's most pleasing late landscape compositions, basically classical in character and painted with great fluency.

This *Cottage Door* was immediately purchased by Wilbraham Tollemache, who was also the first owner of another canvas on loan to the Victoria and Albert Museum, *A Country Cart crossing a Ford*,[5] which is executed with even more freedom and with marked economy of colour. This is in contrast to the strong, deep colours of a canvas of much the same date, *The Harvest Waggon*[6] at Toronto, which was painted in about 1784–5, and is a fascinating development of the much earlier *Harvest Waggon* (Colour Plate XII) at Birmingham. The light-hearted Rococo qualities of the latter are here replaced by a calmer and more earnest mood, which is, of course, reflected in the colours. This same mood of calm and serenity pervades what is perhaps the greatest of Gainsborough's late landscape paintings, the Tate Gallery's *The Market Cart*[7] (Plate 95), which was finished in December 1786. Here there is no longer any feeling of experiment;

1. Gainsborough apparently never completed *The Richmond Water-walk*, a projected companion-piece to *The Mall*, which is discussed by J. Hayes in *The Burlington Magazine*, cxi (1969), pp. 28–31.
2. *Loc. cit.* nos. 814 and 1012.

3. *Loc. cit.* no. 1001.
4. *Loc. cit.* no. 811.
5. *Loc. cit.* no. 948.
6. *Loc. cit.* no. 993.
7. *Loc. cit.* no. 1002.

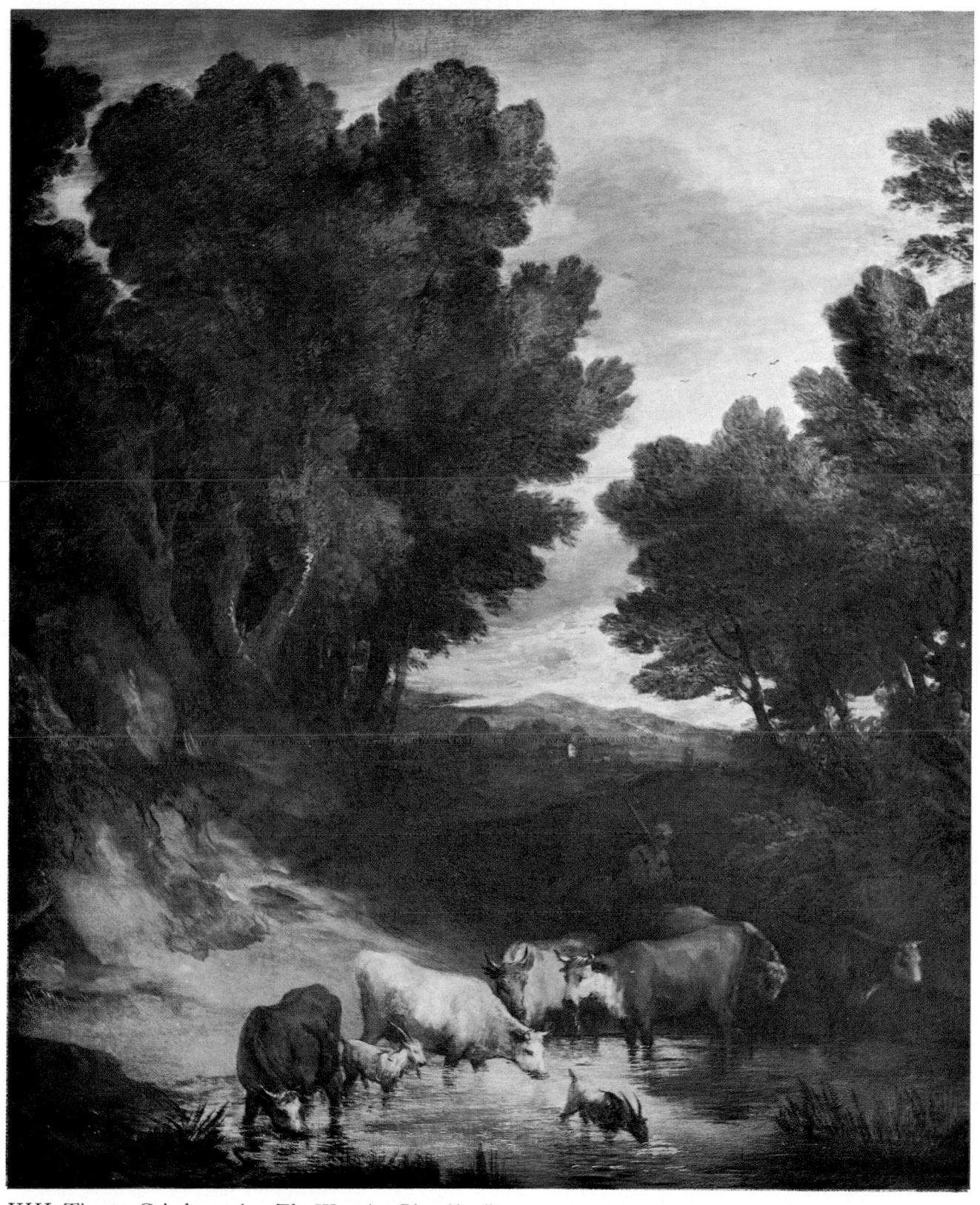

XIII Thomas Gainsborough *The Watering-Place* (detail)
National Gallery, London. (*Reproduced by courtesy of the Trustees, the National Gallery, London*) *See page* 99
For whole canvas see Plate 91

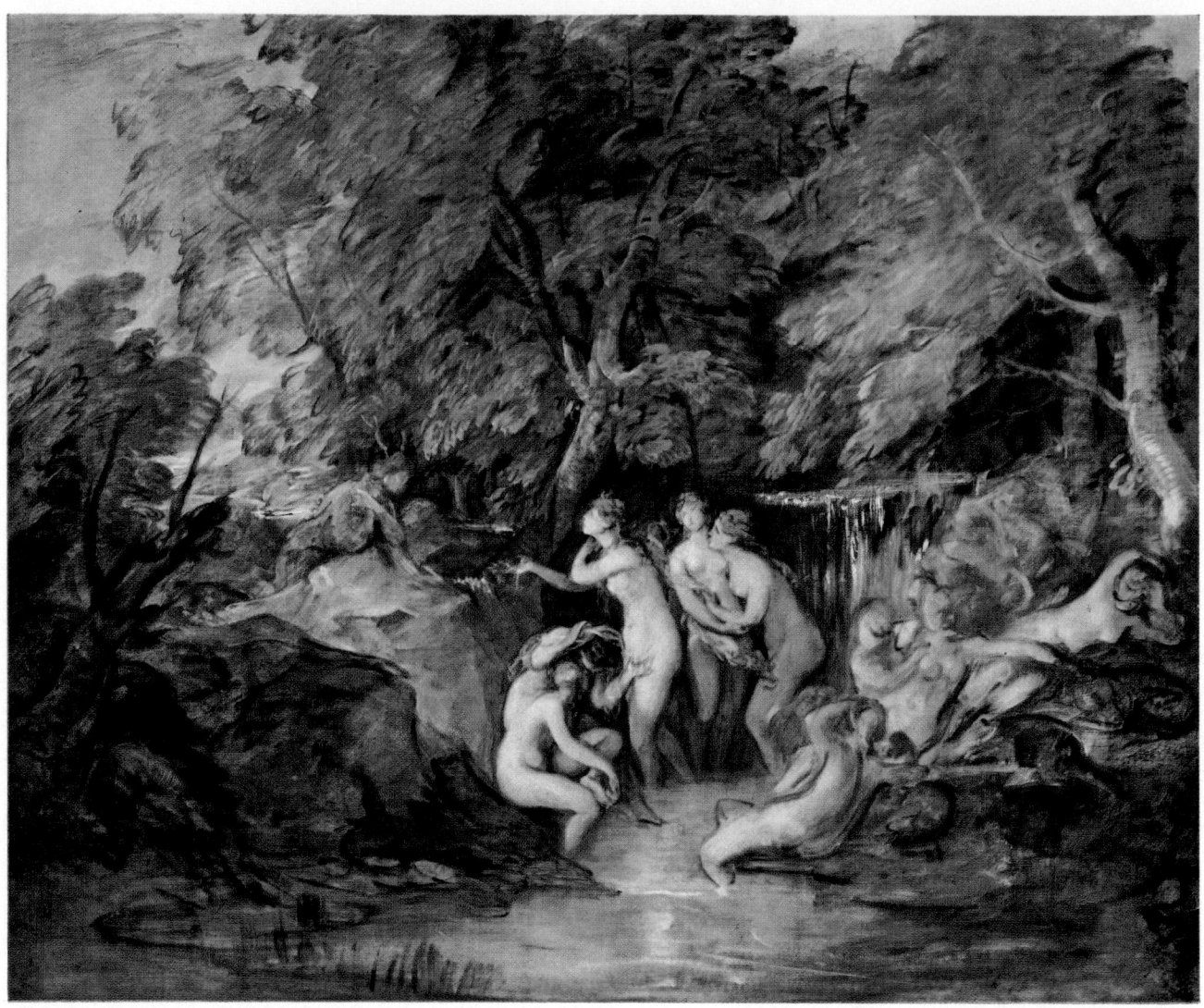

XIV Thomas Gainsborough *Diana and Actaeon* Canvas, $62\frac{1}{4} \times 74$, $158 \cdot 1 \times 188$
The Royal Collection, Windsor Castle. (*Reproduced by gracious permission of Her Majesty The Queen*) *See page* 104

this harmonious composition is complete and assured, and it is only a short step to some of the masterpieces of Constable, such as *The Cornfield*. Once again *The Market Cart* is a peopled rustic scene, but, with its fluently painted trees and its subtle lighting, this is also a grand and total landscape. Here, as in its companion, the *Cottage Door with a Peasant smoking* at Los Angeles,[1] which was the artist's last important landscape composition, Gainsborough reveals his complete mastery and authority in the branch of painting that had constantly exercised, and most delighted him throughout his life.

Gainsborough never left these shores, and despite the many foreign influences on his work, this was, on the whole, essentially English. His death, in August 1788, came just less than a year before the outbreak of the French Revolution, which heralded the beginning of the end of the eighteenth century. Thus Gainsborough still belonged wholly to this notable century in British culture and art, though like all great artists he was a pioneer who looked beyond his own time. In the story of British landscape painting he stands out, with Richard Wilson, as a vitally influential figure in the further development of this art in the nineteenth century.

In this discussion of Gainsborough's landscape painting there have been several references to his portraits, and in particular to those with a landscape background. This would, therefore, seem to be an appropriate place to outline the use of landscape backgrounds by British portrait and animal painters in the eighteenth century. The painting of portraits with a landscape element dates from the earliest days of this genre, both in Italy and in the North. Some of the first examples in England are to be found among the miniatures of Tudor times, and in the portraiture of the Stuart period, so firmly based on the example of Anthony van Dyck, landscape backgrounds are a frequent occurrence. But in most cases these are essentially backgrounds, repeating accepted formulae, and with little merit on their own account. One would be hard put to it to find a landscape in the portraits of Lely and Kneller that is anything more than a decorative space-filler, and the same is true of much of the work of their successors in the first half of the eighteenth century.[2] Not altogether surprisingly it was an animal painter, Francis Barlow (?1626–1704), who was the first British figure artist to show a more genuine feeling for landscape, both in his paintings and in his drawings. As far as we know Barlow did not paint any pure landscapes, unlike his follower John Wootton, whose work has been discussed in Chapter One.

When Gainsborough was painting his first outdoor portraits in the 1740s, Philip Mercier (1689–1760), who came to London in about 1716, had already been portraying his sitters in conversation pieces with semi-topographical landscape settings for some twenty years. From the artistic point of view few of these conversation pieces achieve unity between the sitters and the landscape, but it is often clear from the character of the latter that Mercier was, in fact, painting these family groups in their proper setting, that is in their own park or garden, with a sight of the family home in the background.

1. *Loc. cit.* no. 1011.
2. Even when a specific building is shown in the background, this is rarely assimilated into the picture as a whole.

An early example of this, dating from 1725–6, is the group of *Viscount Tyrconnel with his Family*,[1] in which various members of the Brownlow family are posed around a swing, set amid trees, with the façade of Belton House, the family seat, beyond them.

A considerable number of British artists adopted this kind of conversation piece, best known among them being Arthur Devis (1711–87), whose younger brother, Anthony, has already been briefly referred to as a landscape draughtsman.[2] Arthur Devis's interiors are usually noticeably empty and stiff; his landscape backgrounds are also stiff, but are often crowded with detail, as in the group of *Arthur Holdsworth, Thomas Taylor and Captain Stancombe conversing by the River Dart* in the Mellon Collection.[3] In the more formal portrait of the Atherton Family in the same collection[4] the foreground is taken up with two tree stumps surrounded by carefully studied weeds and other plants, which are more convincingly painted than any other features of the landscape setting, with its 'cardboard' house in the distance. This tradition of portrait groups in a landscape setting was developed in the second half of the eighteenth century by such artists as John Hamilton Mortimer, Francis Wheatley, Joseph Wright of Derby,[5] whose beautiful *Mr. and Mrs. Thomas Coltman*[6] is one of the outstanding works in this vein, and Johann Zoffany (1735–1810). This German-born artist came to England in 1760, and with his immaculate and detailed style he raised the genre of the conversation piece to new heights of fashion. Zoffany also made frequent use of a landscape setting, as in the group of *The Drummond Family* in the Mellon Collection,[7] but, though accurate and even naturalistic, his painting of landscape tends to be hard and colourless. In that splendid composition of *The Sharp Family making Music on the Thames at Fulham*[8] the landscape in the background, showing Fulham Church and its surroundings, is rather crude. The same quality pervades most of the landscape settings in the paintings of Francis Hayman (1708–76), whether they be conversation pieces or decorative and literary compositions. In this aspect of his easel painting Hayman was certainly influenced by his experience as a scene-painter, for he began his London career in that capacity at Drury Lane.

Apart from Wright of Derby and Francis Wheatley, whose painting of landscape will be discussed below, there is, in fact, no other British painter of conversation pieces who reveals any of the true feeling for landscape, and the ability to convey it on canvas, which we have seen in Gainsborough. Again with the exception of these artists, can we discover any other portrait painter of the century whose landscape backgrounds have such qualities? It is certainly not to be found in the work of Sir Joshua Reynolds (1723–92), whose landscape backgrounds are never much more than decorative, though

1. *Philip Mercier Exhibition*, City Art Gallery, York, and Iveagh Bequest, Kenwood, 1969, no. 12 (repr.).

2. See above, Chapter Two, p. 46.

3. *Painting in England, 1700–1850*, Richmond, Virginia, 1963, no. 224, pl. 71.

4. *Loc. cit.* no. 227, pl. 84.

5. Wright of Derby's landscape painting has

already been discussed in Chapter Three, pp. 188–199.

6. B. Nicolson, *Joseph Wright of Derby*, 1968, no. 41, pl. 91.

7. *Painting in England, loc. cit.* no. 235, pl. 229.

8. *Johann Zoffany Exhibition*, Arts Council, London, etc., 1960–1, no. 13, pl. VIII.

occasionally, as in the early *Commodore Keppel* [1] at Greenwich, and in the late *Lord Heathfield* [2] in the National Gallery, they are splendidly evocative of mood. One of Reynolds's most successful backgrounds is the snow scene in the delightful child portrait of *Lady Caroline Scott as 'Winter'* at Bowhill. [3] There are a few rather formalized landscape studies among Reynolds's sketch-books and other drawings, and a small group of landscape paintings is attributed to him, including the Tate Gallery's *The Thames from Richmond Hill*. [4] This is very thinly painted, with little colour, and shows strong Italianate influences, as does the *Landscape with Goatherd* traditionally attributed to Reynolds, which is in York City Art Gallery. [5]

Benjamin West (1738–1820), Reynolds's successor as President of the Royal Academy, also painted the occasional landscape, including the vivid small study of the *View from the Terrace at Windsor*, dated 1791, in the Tate Gallery, where there is also another bigger and less convincing Windsor landscape. [6] The largest and most ambitious of West's landscapes known today is the sadly darkened *A View in Windsor Great Park* in the Royal Collection, [7] which was very probably exhibited at the Royal Academy in 1785. With its huge gnarled trees framing the distant view of the castle, this is a very stagy composition in keeping with the landscape backgrounds of West's portraits and history pictures.

None of the other leading eighteenth-century English portrait painters, such as Romney, Beechey and Hoppner, made use of anything more adventurous than stock backdrop landscapes in their portraits, though by Hoppner there are a number of quite effective landscape drawings in the style of Gainsborough. In Scotland Allan Ramsay (1713–84) rarely used landscape backgrounds, though he drew some landscape studies while in Italy. His much younger colleague, Sir Henry Raeburn (1756–1823), showed a more forceful attitude towards the use of landscape in his portraits. His beautiful double portrait of *Sir John and Lady Clerk*, [8] which dates from 1792, is an example of this at its best. The couple are shown standing beneath a tree with a broad hilly landscape behind them, towards which the Baronet is pointing. It is sensitively painted, and in its grey colouring and character it is, in some ways, reminiscent of John Crome's famous painting of about ten years later, the *Slate Quarries* in the Tate Gallery. Another fine example of Raeburn's ability to convey the atmosphere of landscape in his backgrounds is the National Gallery of Scotland's small full-length portrait of *The Reverend Robert Walker, skating on Duddingston Loch*. [9] According to tradition this marvellous work was painted by Raeburn in 1784 for his own entertainment; in it he conveys with the minimum of effort the atmosphere of crisp winter cold and ice.

1. E. K. Waterhouse, *Reynolds*, 1941, p. 39, pl. 27.

2. *Loc. cit.* p. 79, pl. 281.

3. *Loc. cit.* p. 68, pl. 184.

4. No. 5635.

5. City of York Art Gallery, *Catalogue of Paintings*, vol. II, 1963, p. 73, no. 987, pl. 28.

6. Nos. 5310 and 5620 respectively.

7. O. Millar, *The Later Georgian Pictures in the Collection of Her Majesty the Queen*, 1969, no. 1168, pl. 118.

8. *Royal Academy Bicentenary Exhibition*, London, 1968–9, no. 190.

9. National Gallery of Scotland, *Catalogue of Paintings and Sculpture*, 1957, p. 215, no. 2112.

But, despite their relative quality, Raeburn's landscape backgrounds cannot really vie with those of Gainsborough and of Wright of Derby. We have to look again to an animal artist, in this case George Stubbs (1724–1806), for a painter who can join these two masters in that aspect of his work. In Stubbs's painting the landscape forms an essential element. Often it is of great beauty on its own account; invariably it enhances the credibility of the animal or animals portrayed. Many of these backgrounds are certainly based on actual scenery, as, for instance, in the large canvas of *The Grosvenor Hunt*, dated 1762, in which the horsemen and hounds are shown in a landscape representing 'the scenery of the Country from the saloon of Eaton Hall'.[1] In the famous compositions of 'Mares and Foals', which also belong to the 1760s, the peaceful, very English, landscape settings, depicted in the fullness of summer, reflect the lazy calm and contentment of the horses. For the skies of these masterpieces Stubbs has chosen quiet, cloudy effects that are also typical of the English summer.[2] The same realistic qualities are found in the backgrounds of many of the less ambitious horse portraits, such as *Pumpkin with a Stable Lad* in the Mellon Collection,[3] which is dated 1774. Here the landscape, with its lake below the level of the foreground, is reminiscent in character and colouring of some of the contemporary country-house portraits of Richard Wilson. On the other hand two of the later 'Mares and Foals' compositions are set against imaginary landscapes in a romantic vein, showing Stubbs once again in step with the most up-to-date styles of his day.[4]

The remarkable quality of Stubbs's landscape painting is seen most clearly in the small study of *The Rubbing-down House, Newmarket*[5] (Plate 104A), in which there is no figure of any kind. Assigned by Basil Taylor to the mid-1760s, this must rank as one of the first British landscape paintings that is truly naturalistic. It reveals no debts to any earlier landscape tradition or artist, and it proves Stubbs's direct reaction to the scenery in which he was working, and his ability to create a work of art out of a relatively featureless landscape. The rubbing-down house is shown again, on a much larger scale, in the famous *Gimcrack with a Groom, Jockey and Stable-lad, on Newmarket Heath*,[6] and in the considerably later *Hambletonian, rubbing down*.[7] In their different ways both these vast compositions largely depend for their effect on Stubbs's successful rendering of the flat and monotonous open spaces of the heath. In contrast to this, with its close-up view of part of Welbeck Abbey, is the portrait group of 1767 of the 3rd Duke of Portland, mounted on a white horse and accompanied by a groom leading a second horse, a huntsman, and two hounds.[8] This group of people and animals is effectively shown framed between trees and set off against the dark background of the house. This detail gives a considerable air of dignity to an otherwise simple composition.

1. *Stubbs in the 1760s*, Thomas Agnew & Sons, London, 1970, no. 3.

2. *Loc. cit.* nos. 4–8.

3. *Painting in England, loc. cit.* no. 319, pl. 184.

4. *Stubbs in the 1760s, loc. cit.* photographs C and D.

5. *Painting in England, loc. cit.* no. 318, pl. 176.

6. *George Stubbs Exhibition*, Whitechapel Art Gallery, 1957, no. 18, pl. XI.

7. *Loc. cit.* no. 29, pl. I.

8. W. Shaw Sparrow, *British Sporting Artists*, 1922, pl. 40.

There are many further examples of Stubbs's clever use of his landscape background to provide atmosphere. In one of his subject pictures, *The Farmer's Wife and the Raven* of 1786, which is also in the Mellon Collection,[1] the discomfiture of the unfortunate farmer's wife is splendidly re-echoed in the mournful aspect of the weeping willow immediately behind her stumbling white horse. The raven sits on the branch of a dark, sparsely leaved tree, seen sharply set against the light on the extreme right of the composition. From this subject picture it is an easy move to Stubbs's own brand of peopled landscape, the farming scenes which he was painting between 1779 and 1795. There is evidence that the various versions in this series were worked up from a group of studies from nature, though none of these drawings or sketches are known today. In these scenes Stubbs never succeeds as Gainsborough did in wholly integrating his figures with the landscape. This is largely because he never quite managed to break away from a frieze-like arrangement of the former. The Mellon Collection's version, dated 1795, of *The Reapers*[2] (Plate 104 B), which is painted in enamel colours on an oval Wedgwood plaque, shows this very clearly. However, if we forget the comparison with Gainsborough, there is in these harvesting scenes a wonderful combination of realistic rural figures and animals with naturalistic landscape. This is achieved in an entirely matter of fact way, as it was by Bruegel, and lacks the sentimental character of Gainsborough's rustic idylls.

Finally we must look at the landscape backgrounds of Stubbs's paintings of wild and exotic animals. Again there are ample illustrations of this aspect of his work in the Mellon Collection, including the early *Zebra* and *Tiger*.[3] Both these animals, with their distinctive hides, are shown in the light against shady backgrounds; a dense forest in the case of the zebra, and a dark rocky cavern in that of the tiger. In the *Horse frightened by a Lion*,[4] the great, powerful cat is shown at the mouth of a similar dark cavern, while behind the quivering grey horse is a vapid rolling landscape. Between the two animals are a group of solid rocks and more delicate herbage, further emphasizing, as does the landscape, the great differences between the terrified horse and the prowling lion. But despite the symbolic and romantic character of this animal subject and of the landscape that accompanies it, the latter still manages to be realistic. The same is true of Stubbs's other lion-and-horse paintings, and of that masterpiece recently acquired by the Manchester City Art Gallery, *A Cheetah with two Indians*.[5] These works all display elements that could be interpreted as 'picturesque' or 'sublime' or 'romantic', but for Stubbs this was certainly just the *right* way of tackling such subjects.

For many of his contemporaries, however, there were no doubt other reasons for the increased use of 'picturesque' and 'sublime' landscape backgrounds, for the interest in and appreciation of actual landscape had rapidly become widespread. By the mid-eighteenth century, as we have seen, the classical, the topographical and the Netherlandish naturalistic

1. *Painting in England*, loc. cit. no. 323, pl. 185.
2. *Loc. cit.* no. 327, pl. 183.
3. *Loc. cit.* nos. 315, pl. 164, and 316, pl. 175, respectively.
4. *Painting in England 1700–1850*, Royal Academy, London, 1964–5, no. 263.
5. *National Art Collections Fund 67th Annual Report*, 1970, p. 33, pl. VIII

landscape traditions were all familiar to British artists and connoisseurs. The strong bias of fashion was towards the classical, for this originated in Italy, the land of promise and inspiration to all interested in art. However, only the wealthy on their Grand Tour, or the really dedicated student, were likely to achieve a first-hand experience of Italy, and with the rapid growth of a culture-loving middle class the majority of those interested had to make do with second-hand impressions, or had to discover substitutes that were within their reach. Thus worthwhile features and qualities were discovered in the landscape of Britain, putting it on a par with that of Italy, or at any rate with the Italian landscape as recorded in paintings, drawings and prints. The origins of the interest in the picturesque qualities of British scenery go back much further than this social development of the middle years of the century. A great deal has already been written, and will continue to be written, about this very British contribution to European aesthetics, and this is not the place to add materially to that literature. The earliest signs of the picturesque movement – whether they be found in the work of architects and garden designers at the very beginning of the century,[1] or in the writings of such descriptive and 'natural' poets as James Thomson, or in Edmund Burke's *Philosophical Enquiry into the Origin of our Ideas of the Sublime and Beautiful*, which appeared in 1757, or anywhere else – do not directly concern us here. Though they may be said to have established the right climate, they did not immediately affect British landscape painting.

The first evidence of the impact of the picturesque on the painting and drawing of landscape coincides with that aspect of the 'movement' which resulted in a growing interest in the actual scenery of these islands. Partially as a result of the improved inland travel facilities more and more connoisseurs of the middle class were encouraged to follow in the footsteps of the pioneers among them who had 'discovered' the beauties of England. Thus the movement quickly gathered momentum, and it came to a head when all, even the richest, were largely denied travel on the Continent for nearly a quarter of a century as a result of the French Revolution and the Napoleonic Wars. It is true that many of these travellers were searching for the most Italianate aspects of British scenery and thus made considerable use of their Claude Glass;[2] suitably 'Claudian' compositions were selected and these were often also sketched. There were several variations on this instrument, which achieved wide popularity in the later eighteenth century.

The rapid development of travel for the sake of seeing the scenery of Great Britain is reflected in the growing number of tours, travel-journals and guides that were written from about 1760 onwards, rising to considerable numbers in the years around the turn of the century. Works of that class had, of course, been published long before this period, but these earlier examples, such as the writing of John Leland in the sixteenth century

1. N. Pevsner, 'The Genesis of the Picturesque' in *Studies in Art, Architecture and Design*, vol. 1, 1968, pp. 79–101.

2. See above, Chapter One, p. 26.

and of William Stukeley early in the eighteenth, were largely concerned with topographical and antiquarian interests. From 1740 onwards, as John Harris has summarized in a recent article,[1] another increasingly popular reason for touring in this country, and for the publication of guides, was 'the innocent pastime of making the round of country houses', and, it should be added, of their gardens, many of which had, of course, recently been altered to emulate the landscape painting of Claude and his followers.

All this is succinctly summed up by the Rev. William Gilpin (1724–1804), that assiduous pioneer of picturesque travel, in the first of his tours to appear in print, that of *The River Wye and Several Parts of South Wales*. This *Tour*, made in the summer of 1770, was first widely circulated in manuscript and then published, on an experimental basis, in 1783 (though dated 1782 on the title-page).[2] The opening paragraph reads as follows: 'We travel for various purposes – to explore the culture of soils, to view the curiosities of art, to survey the beauties of nature, and to learn the manners of men, their different politics and modes of life.'[3] But in his 'little work' Gilpin 'proposes a new object of pursuit; that of examining the face of a country *by the rules of picturesque beauty*; opening the sources of those pleasures which are derived from the comparison'.[3]

The success of the *Wye Tour* encouraged Gilpin to undertake the publication of what had already been his most popular tour in manuscript, and it was to remain the most popular in print. This was entitled, *Observations on Several Parts of England particularly the Mountains and Lakes of Cumberland and Westmoreland, relative Chiefly to Picturesque Beauty*, which appeared late in 1786. The temptation to quote at length from the Preface and opening section of this '*Tour of the Lakes*', as it has come to be called, must, alas, be avoided. In the former, William Gilpin outlines the rewards and problems involved in the closer observation of landscape, stressing especially the variations caused by changes of weather and by the effects of time. The latter presents 'a slight view of those great features of the country (England), on which its picturesque beauty, in general, so much depends'.[4]

Having briefly surveyed the coastline of these islands, Gilpin continues:

'If we leave the coast, and take a view of the internal parts of the country, we find the *southern* counties much varied with hill and dale. The *western* rather approach the mountainous character; almost the whole of Wales is in that style of landscape. But in the *mid*-land, and *eastern* parts, we scarce find any elevation that deserves to be mentioned: they are generally level; till we arrive near the centre of the island.

'In Derbyshire the first mountainous country begins. There the high lands forming themselves by degrees into a chain of mountains, direct their course towards the north-west. They first divide Lancashire from Yorkshire: then entering Westmoreland, they spread themselves over the whole of that county, and a part of Cumberland. Again

1. J. Harris, 'English Country House Guides, 1740–1840', in *Concerning Architecture – Essays . . .presented to Nikolaus Pevsner*, 1968, pp. 58–74.

2. C. P. Barbier, *William Gilpin*, 1963, p. 71.

3. *Observations on the River Wye*, etc., 5th ed. 1800, p. 1.

4. *Tour of the Lakes*, 3rd ed. 1808, p. 1.

contracting themselves into a chain, and forming the limits between Cumberland, and Northumberland, they continue their course northward; and enter Scotland. — It is in the various parts of this vast combination of mountains, to which we may add those of Wales, that the admirers of the beautiful and sublime in English landscape are chiefly gratified.'[1]

Wales, Derbyshire, and above all the Lake District provided the chief attractions for travellers in search of the picturesque, and the artists quickly followed in their train producing illustrations for the books which guided them, and records of the scenery they had admired, to hang on their walls or to keep in their portfolios. But it was not only the increased demand for depictions of specific scenery that affected the British artist, it was much more the change in climate of the overall attitude towards landscape. No longer was it sufficient to paint Italianate classical compositions like those of George Lambert, or naturalistic landscape scenes in the Netherlandish tradition, like the early work of Gainsborough, or purely topographical scenes in the manner of Canaletto and his followers. What was now wanted — to use the words of Sir Joshua Reynolds in his *Thirteenth Discourse*, delivered in 1786 — was landscape painting which made 'an impression on the imagination and the feeling' and which could 'produce a pleasing effect upon the mind'.[2] Gilpin would certainly have considered these qualities as essential elements of the 'picturesque', which he at first defined, in 1768, as 'expressive of that peculiar kind of beauty, which is agreeable in a picture',[3] and then, some thirty years later, as 'that kind of beauty which *would look well in a picture*'.[4] If we add to these definitions the quality of 'roughness' which Gilpin considered essential to the picturesque, we have to seek no further to account for the popularity of the mountainous regions of Wales, Derbyshire and the Lakes, with tourists and artists alike. Gilpin himself produced hundreds of pen-and-wash drawings, such as the *Lakeland Scene* reproduced here (Plate 102 A), that were largely generalized impressions of such scenery, and some of these were used to illustrate his *Tours*. Gilpin may well have used his Claude Glass when he devised his compositions.

In the closing years of the eighteenth century there was considerable controversy, in which Gilpin, naturally, was involved, as to what was truly 'picturesque', and that controversy has been re-echoed in recent times by the many differing theories concerning the rise and influence of 'the picturesque'. The verbose combat between the two Herefordshire squires, Richard Payne Knight and Sir Uvedale Price, was largely concerned with the impact of landscape painting on the 'improvers' of actual landscape — that is the landscape gardeners and designers — and thus does not concern us here. There is little evidence that landscape painters were really involved in this controversy on points of detail; they were, however, greatly concerned with the fact that this controversy reflected a growing interest in landscape as such. And thus, to return at last from this long diversion to the

1. *Loc. cit.* pp. 2–3.
2. *Discourses*, ed. R. Fry, 1905, p. 365.
3. *An Essay on Prints*, 5th ed. 1802, p. xii.

4. *Observations on the Western Parts of England, etc.*, 2nd ed. 1808, p. 328.

subject of landscape backgrounds in later eighteenth-century portrait and figure painting, the increasing use of these can certainly be attributed to the developments outlined in this brief discussion of 'the picturesque'. In addition there was also an important social reason for an increased use of landscape. It had become even more the practice than in earlier generations for those who succeeded in commerce to acquire landed property, and to indulge in the active cultivation of rural pursuits. These interests were, of course, reflected in the art patronage and collecting of such new members of the landed gentry.

An artist whose landscape painting strongly reflects all these developments was Philip James de Loutherbourg (1740–1812), the creator of the *Eidophusikon*, which has already been discussed earlier in this chapter. He was born in Strasbourg, the son of a miniature painter of Polish origin, and trained in Paris under Carle van Loo and the battle painter François Casanova, who also taught Vernet. Loutherbourg quickly established a reputation in Paris with battlepieces, land- and seascapes in the styles of Berchem and Vernet, and idyllic compositions under the influence of Boucher; in 1766 he became a member of the Académie. Five years later Loutherbourg settled in London, where he soon became a leading figure in the world of artists. He arrived with an introduction to David Garrick, and in 1773 became his stage and scenery designer; he continued with this kind of work for some ten years. He exhibited regularly and profusely at the Royal Academy, being elected A.R.A. in 1780 and R.A. in the following year. Professor Waterhouse has succinctly summed up Loutherbourg as 'an extremely capable professional artisan',[1] and when discussing his paintings and drawings it is tempting to use such terms as 'slick', 'shallow' and 'artificial'. However, whatever his shortcomings in the eyes of much later critics, in his own time Loutherbourg was extremely successful and influential. A high point of his career came in 1806, when he was a candidate, albeit an unsuccessful one, for the Presidency of the Royal Academy.

This painter's French origins gave him a special position among his fellow-artists, rather like that enjoyed by Lucien Pissarro, eldest son of Camille, when he came to England in the late nineteenth century. Loutherbourg used his great energy and his natural qualities of showmanship to make the most of that position, and in the last years of his life it was further enhanced by the fact that he was virtually the only major practitioner of landscape painting who had already been active in the formative years of the eighteenth century, and who continued to work with success and vigour in the early years of the new century. J. M. W. Turner, who was his neighbour at Hammersmith from 1807 to 1811, is the best known among the many rising young artists who looked to Loutherbourg for guidance and advice.

Two principal characteristics stand out in Loutherbourg's painting; his effortless eclecticism and his ability to produce up-to-date work in accord with the fashion of the moment. To these qualities he added that inventiveness and liveliness which was essential for his theatrical work. In this he broke away from the decorative and architectonic

1. *Painting in Britain: 1530–1790*, 1954, p. 223.

'Baroque' stage-set tradition, and used the same qualities of realism blended with picturesqueness that were such a marked feature of his own *Eidophusikon* and of the other contemporary pictorial entertainments quickly devised in imitation of it.

In 1772, the year after his arrival in London, Loutherbourg showed two paintings and five drawings at the Royal Academy. Horace Walpole praised one of the paintings, no. 139 – *A Large Landscape with Figures*, and thought the drawings 'excellent'.[1] At this time there were relatively few landscapes at the Royal Academy, and Loutherbourg's contributions must certainly have made their mark, bringing to the walls at Pall Mall competent examples in the manner of such popular artists as Berchem and Vernet. Most of his landscape exhibits in the next ten years continued to have generalized titles, with occasional intimations of weather, season and time of day, as in no. 177 at the 1773 Exhibition, which was entitled *A landscape, representing an Evening, with innocent rural amusements*. It was bought by David Garrick. There were also a number of subject pictures and military scenes, including the impressive *Warley Camp: the mock Attack* (1779, no. 182) and *Warley Camp: the Review* (1780, no. 15), painted for George III and now at Buckingham Palace.[2]

In 1784, when Loutherbourg showed ten paintings, all of them landscapes, there was a sudden change to specific titles in all but one of them. Two depicted scenes in Derbyshire and seven in Cumberland and Westmorland. There could be no clearer sign of the impact of picturesque travel, which, as we have already seen, had also influenced Gainsborough to visit the Lakes in 1783. But while Gainsborough did not, for reasons already explained, 'mount all the Lakes at the next Exhibition', Loutherbourg more than filled the breach. Two large mountainous landscapes with cattle, one at York City Art Gallery[3] and the other at Castle Ashby, may well be examples of the Lakeland and Derbyshire scenes shown at this exhibition, for both are signed and dated 1784. He continued to paint and exhibit views in the Lakes throughout the rest of his career, and a typical example is the Tate Gallery's *Lake Scene in Cumberland: Evening* (Plate 101), which is dated 1792. With its sharp division into coulisses and its carefully graduated light effect, this composition exemplifies the theatrical qualities that are usual in Loutherbourg's picturesque landscapes. These came to include several Welsh subjects, and views of other popular beauty spots like Tintern Abbey, shown in the large composition, *Tintern Abbey on the River Wye* (Plate 102 B), dated 1805, at the Fitzwilliam Museum. Here again Loutherbourg displays his theatrical thinking, for by including only a small section of the ruin, and by making the most of its dramatic setting on the banks of the River Wye, he has produced a splendidly evocative scene. A continental composition with all the qualities of a stage set is the Victoria and Albert Museum's *The Falls of the Rhine at Schaffhausen*. Thinly painted but with considerable detail, and betraying the influence of the two principal French landscape painters of the time, Hubert Robert and Vernet, this large canvas has

1. Whitley, *loc. cit.* vol. II, p. 387.
2. Millar, *loc. cit.* nos. 932–3, pls. 83–4.

3. *Catalogue of Paintings*, vol. II, 1963, p. 63, no. 995, pl. 24.

recently been shown to date from the artist's first recorded visit to Switzerland in 1787 and 1788.[1]

In 1805 Loutherbourg published *The Romantic and Picturesque Scenery of England and Wales*, a series of coloured aquatint engravings after his drawings, with a text in both English and French, a surprising feature at that date. This publication includes a variety of scenes, among which is a fiery view of the *Iron Works, Colebrook Dale*. A number of Loutherbourg's sketches of such industrial subjects as iron works, mills, and lime kilns, mostly in Wales, forms part of the Turner Bequest, having been acquired by J. M. W. Turner from Dr. Monro's Collection.[2] Loutherbourg was far from being the only artist of his day to find inspiration in industrial scenes (some others were Wright of Derby, Sandby, Rooker, Cotman and Ibbetson), but his rendering of them was exceptionally realistic and convincing.

There is a marked lack of atmosphere in the *Fishermen launching their Boat*[3] (Plate 97), which Loutherbourg painted in 1784 for the 1st Earl Grosvenor, as a companion to the *Coast Scene* (Plate 96) which Gainsborough had executed for that nobleman some three years earlier. Somewhat monotonous in tone and with little atmosphere in the sea or tension in the figures of the fishermen striving to launch their boat, this does not compare favourably with the movement and excitement in Gainsborough's composition. If the Loutherbourg is compared with another of his own shorescapes, the dramatic *The Shipwreck* of 1793 at Southampton[4] (Plate 103B), it again becomes clear that it is the stagy element that makes the greatest impact in Loutherbourg's landscape painting. Though flatly and thinly painted, the Southampton canvas has considerable force, which is achieved by its very exaggeration. In the more natural *Fishermen launching their Boat*, the artist's clumsiness and shortcomings are all too obvious.

Loutherbourg was essentially a creator of effects – on the stage, in his *Eidophusikon*, and on canvas. This is seen in both versions of a well-known and influential composition dating from late in his career, *An Avalanche in the Alps*. The version illustrated here (Plate 103A and Colour Plate XV) is dated 1803, and was quite recently acquired by the Tate Gallery from the Northwick Park Collection.[5] It was no. 116 at the Royal Academy of 1804, and had the title *An avalanche or ice fall, on the alps, near the Scheideck, in the Valley of Lauterbrunnen*. The other, probably slightly earlier, version is at Petworth,[6] where it was noticed by Waagen, and was the only one of the many works by Loutherbourg that he must have seen which he mentioned in his *Treasures of Art in Great Britain*.[7] Both these compositions with their tiny figures and huge rocks make a tremendous dramatic impact and clearly demonstrate Loutherbourg's place as a pioneer in the

1. See J. H. Kunin, 'The Date of Loutherbourg's "Falls of the Rhine at Schaffhausen"', *Burlington Magazine*, CXIV (1972), p. 554.

2. A. J. Finberg, *Inventory of the Drawings of the Turner Bequest*, vol. II, 1909, no. CCCLXXII.

3. *R.A. Bicentenary Exhibition*, loc. cit. no. 58.

4. *Pictures from Southampton*, at Messrs. Wildenstein, London, 1970, no. 20.

5. Christie's Sale, 25 June 1965, lot 88.

6. C. H. Collins Baker, *Catalogue of the Petworth Collection of Pictures*, 1920, no. 362.

7. G. F. Waagen, *Treasures of Art in Great Britain*, vol. III, 1854, p. 38.

landscape painting of the Romantic Movement. The same claim can, of course, be made for many of his earlier works, such as the *Travellers attacked by Banditti* of 1781, which is also in the Tate Gallery. This is again a dramatic theme handled with great vigour; that Loutherbourg was equally well able to convey romantic qualities in scenes of peace and quiet has already been shown by the *Tintern Abbey on the River Wye* (Plate 102 B) of 1805. In the same year he painted the Mellon Collection's *The Evening Coach*,[1] which was shown at the Royal Academy in 1806. In this, the distant view of the City of London is beautifully contrasted with the detailed foreground in a way that foreshadows some of the Hampstead scenes of John Constable.

Loutherbourg's influence on artists much younger than himself has already been referred to; we must now turn to his impact on artists who were active in his own lifetime. Among these was that shadowy figure Sir Francis Bourgeois (1756–1811). Born in London, of Swiss descent, he started his successful career as a landscape painter as the pupil of Loutherbourg. Elected A.R.A. in 1787 and R.A. in 1793, he was appointed landscape painter to George III in the following year. In 1791 he had been appointed painter to Stanislaus, King of Poland, who conferred on him the honour of knighthood; George III sanctioned the artist's use of that title in England. Bourgeois exhibited over 100 works at the Royal Academy between 1779 and 1810, but today his landscapes are rarely seen, and he is unrepresented in most of our public collections. The one place where his work can be studied – there are some twenty of his paintings – is the Dulwich College Picture Gallery, of which he was, of course, the founder.[2] The landscapes among these paintings reveal the strong influence of Loutherbourg on his pupil, though Bourgeois was also directly influenced by some of the same Netherlandish artists as his master. Thus nos. 135 and 325 at Dulwich, both entitled *Landscape with Cattle*, owe a great deal to Cuyp, while the example of Berchem is seen in some of the other compositions. Most of these canvases are quite freely painted and the artist makes much use of not very subtle highlights. In the majority of the compositions the figures and animals play a vital role, as in the *View on the Sea-shore* (no. 335, Plate 106 B), in which there is not only a 'frightened' horse close to the sea, but there are also horses and a cart seen against the sky at the top of a cliff.

None of these works display an individual artistic personality and it is difficult to account for Bourgeois's success. In 1790 Sir Joshua Reynolds paid £100 for a large landscape with cattle shown by Bourgeois at that year's Academy. The newspaper that reported this stated that 'although it was painted in four days Sir Joshua insists that it is one of Bourgeois' best productions'.[3] One would have expected the President to be a better judge, for, according to W. T. Whitley, it was Bourgeois's own aim 'to attain Mr. Loutherbourg in execution, Mr. Gainsborough in colouring and Mr. Wilson in

1. *Painting in England*, Richmond, Virginia, *loc. cit.* no. 42, pl. 122.

2. Bourgeois bequeathed to Dulwich College the considerable collection of paintings which he had

himself been left a few years earlier by the dealer Noel Joseph Desenfans.

3. Whitley, *loc. cit.* vol. II, pp. 374–5.

forms and grandeur'.[1] Another unexpected aspect of Bourgeois's career is his friendship with J. M. W. Turner, who was much affected by his friend's death in 1811.[2] On the other hand most of the art-historical source books of the period omit any mention of Bourgeois, who, despite his royal appointment, is not today represented in the Royal Collection. However, Bourgeois did not escape the acid pen of Edward Dayes, who declared that 'like most imitators, he has caught the worst part of his master, without adding anything of his own: and never having studied from Nature, his style has become so vicious, as to look like painting run mad'.[3]

For a time Francis Wheatley (1747–1801) enjoyed a success that surpassed that of Bourgeois, but the last years of his life were dogged by ill health and misfortune, which adversely affected his work and quickly lowered his reputation. Wheatley was an artist of great variety, and his paintings comprise small-scale portraits and conversation pieces, most frequently with landscape backgrounds, straightforward landscapes, rural fancy pictures, and theatrical and other subject pieces, including several somewhat sentimental contributions to Boydell's Shakespeare Gallery. In much of his work he was influenced by Zoffany, but in his painting of landscape, whether as background or for its own sake, he showed a much more sensitive reaction to British scenery than did the German-born artist. The earliest known, and by far the most impressive, landscape painting by Wheatley is *The Harvest Waggon*[4] (Plate 105) at Nottingham. Dated 1774 this is a straightforward variant on Gainsborough's *Harvest Waggon* (Colour Plate XII) of about 1767 at the Barber Institute. More deliberately and broadly painted than Gainsborough's masterpiece, Wheatley's *Harvest Waggon* is in its own right a telling representation of British landscape depicted in strong and harmonious colours. Painted two years later is the somewhat traditional composition of *The Medway at Rochester* in the Mellon Collection,[5] which is reminiscent of the work of William Marlow.

Much more personal in manner is the fine landscape in the *Family Group*, formerly known as 'The Browne Family', also in the Mellon Collection,[6] which is dated to about 1778. The mother and father, surrounded by their five children, are seen fishing and sketching on the bank of a river, with trees behind them and a distant landscape beyond the river on the left. The figures fit harmoniously into the landscape, as they do in the glowing composition of *Nymphs Bathing, a View of the Salmon Leap at Leixlip*, which is dated 1783.[7] Wheatley had eloped to Ireland in 1779 with the wife of another artist, and he spent some four years there. The chief products of these years were several ambitious conversation portraits with successful landscape backgrounds. He also painted a number of pure landscapes, both in oils and in water-colours, among them the *Seashore at Howth* in Southampton Art Gallery.[8] Here Wheatley has used the paint directly and

1. *Loc. cit.* p. 142.
2. W. T. Whitley, *Art in England, 1800–1820*, 1928, p. 181.
3. 'Professional Sketches of Modern Artists', in *The Works of the Late Edward Dayes*, 1805, p. 322.
4. M. Webster, *Francis Wheatley*, 1970, no. 3.
5. *Loc. cit.* no. 13.
6. *Loc. cit.* no. 27.
7. *Loc. cit.* no. 45.
8. *Loc. cit.* no. 44.

broadly to produce pleasing effects of light and colour. The same direct and colourful technique characterizes this artist's fancy pictures, of which he showed the first in 1785 and which were to be his most popular works. Included among them were the famous *Cries of London*, the paintings of which were shown at the Royal Academy between 1792 and 1795.[1] In the majority of these compositions Wheatley introduced landscape backgrounds.

Most of the known landscapes of Wheatley's later years are in water-colours, and in these also we find his characteristically broad and harmonious colouring used to produce pleasingly straightforward effects, with the minimum of outlines. This is well exemplified by the Ashmolean Museum's small *Lake Windermere* (Plate 106 A), which was engraved by S. Middiman for his *Select Views in Great Britain*, published in 1787. Wheatley's art has qualities of grace and elegance rather than of action and drama; his rustic world is relaxed and calm, and has no intellectual pretensions. The same is true of his landscapes, in which the sun is always shining, the water is placid and the colours are those of high and fruitful summer.

Though his work shows few signs of the direct influence of Loutherbourg, Francis Wheatley has been discussed at this point because he himself had some impact on two of the painters who were the principal followers of that artist – George Morland and Julius Caesar Ibbetson. Close to each other in age, comparable in their work, and almost on a par in the apparent wretchedness of their lives, these two artists achieved great successes in the closing years of the century. George Morland (1763–1804) was the son of the portrait and genre painter Henry Robert Morland, to whom he is said to have been apprenticed at the age of ten. The father made use of his son's precocious talents to further his own business as a restorer of and dealer in Old Masters, particularly landscapes of the Dutch School. When he set up independently in 1784 George Morland had thus had considerable experience in copying and faking in a wide range of styles. This, added to his own natural facility of touch, resulted in a style that was mature and fluent, and Morland quickly made his mark as a painter of peopled landscapes and rustic genre scenes, usually on a small and intimate scale. For the twenty or so years of his active career Morland alternated between periods of all-engrossing dissipation – in keeping with the fashionable Rousseauesque vogue of the day – and of feverish activity. During these latter he produced large numbers of paintings and drawings, many of which were engraved, so that his work was widely dispersed and known. He rarely painted for specific commissions, but relied on the growing number of dealers and galleries to sell his work. His remarkable popularity rested more on his genre scenes and animal subjects than on his landscapes, but these obviously also found buyers, for Morland produced them in large numbers throughout his years of activity.

The landscapes range from totally placid subjects, like the delightful pair of *Quarry Scenes* (Plate 107 B) in Lady Altrincham's Collection, to such a dramatic composition as *The Wreckers* at Southampton.[2] In the latter Morland has relied on his usual pastelly

1. *Loc. cit.* pp. 81–5. 2. *Pictures from Southampton, loc. cit.* no. 21.

colours and has found it difficult to create with them a scene of storm and tension in emulation of Loutherbourg. In this canvas Morland's sea is insubstantial and suggestive of cotton-wool; on the other hand, in his many peaceful shore scenes, such as Leicester Museum's *Calm off the Coast of the Isle of Wight*,[1] sea, cliffs and sky are all convincingly depicted, though the overall effect is rather empty, as that of an actual uneventful coast scene so easily can be. That same correct atmosphere of emptiness is found in the painting of *A Gipsy Encampment* (Plate 107 A) at York,[2] which is in striking contrast with the careless lushness of the untidy forest scene in the large composition of a *Gipsy Encampment with seated Man breaking Firewood* at Detroit.[3] In his landscapes Morland is working within the picturesque tradition of Gainsborough and Loutherbourg, and the same tradition pertains in his popular animal subjects, such as the *Inside of a Stable* of 1791 at the Tate Gallery,[4] the *Pigs* at Birmingham,[5] and the *Bargaining for Sheep*, dated 1794, also at Leicester.[6] In addition to their picturesque characteristics these compositions frequently display something of the moralizing quality which pertains in Morland's peasant and middle-class genre scenes.

In these different aspects of his painting Morland's appeal is immediate, but a second impression often conveys an element of artificiality, and of clumsiness also. This may be accounted for by the fact that Morland's work is basically an amalgamation of technical and stylistic knowledge taken from other artists, with only rare references to nature. Morland's success, despite using such methods, rests largely on his ability and skill in the manipulation of paint, which gives his landscapes a personal character. He was a natural painter, who was too idle or too preoccupied to make use of his talents in anything other than an eclectic manner, and who was, in any case, aiming to produce work with popular appeal. As final examples of this characteristic dual nature of Morland's painting we should remember his charming *Winter Landscapes*, such as the two in the Mellon Collection.[7] These are directly in the Netherlandish tradition, but with their cloudy grey skies and their stark snow-covered trees they also belong to Morland's individual vision of the untidy English rural scene peopled by essentially 'picturesque' peasants.

In his rendering of the British landscape Julius Caesar Ibbetson (1759–1817) had higher ambitions, but he largely lacked the personal touch and facility of Morland. Despite their eclecticism the genuine landscape paintings of Morland cannot be mistaken for the work of other artists; on the other hand those of Ibbetson are often so mistaken, and in particular attributions to Richard Wilson are common. Born in Leeds, Ibbetson was at first apprenticed to a ship painter in Hull, where he was further employed in scene-painting, which he also practised in other Yorkshire towns. In 1777 Ibbetson moved to London, where his first work was with a picture-dealer and restorer. Thus he

1. Leicester Museums and Art Gallery, *Collection of Paintings*, 1958, no. 105.
2. *Catalogue of Paintings*, loc. cit. p. 68, no. 45, pl. 38.
3. *Romantic Art in Britain*, Detroit and Philadelphia, 1968, no. 100.
4. No. 1030.
5. City Museum and Art Gallery, Birmingham, *Catalogue of Paintings*, 1961, p. 105, no. 956' 87.
6. *Collection of Paintings*, loc. cit. no. 106.
7. *Painting in England*, loc. cit. no. 50, pl. 137, and *Painting in England*, London, 1964–5, no. 35.

gained that same cosmopolitan experience which benefited Morland, and like him he also produced a large body of painting in the manner of earlier masters, especially of the Netherlandish School. Even as late as 1799, the date on the *Evening Landscape* at York,[1] he was still producing essentially Dutch work, in this case in the manner of Nicholas Berchem. The York canvas is competent and assured, and is in line with Edward Dayes's relatively friendly criticism of Ibbetson, whose 'own manner' he thought 'clear and firm, but sometimes a little hard; and his colouring has too much of a clayey hue'.[2] In comparison with the York canvas much of Ibbetson's work is naïve and crude. It is their variability in quality that makes it difficult to assess the paintings and water-colours of this artist, as is clearly shown by the view of *Ludlow Castle* (Plate 108 A), which is dated 1792, at Manchester. Thinly painted, but with sparkle, and successful as a composition, this does, however, have considerable weaknesses, as in the depiction of the river and its formless banks. There are similar weak points in the small panel of *Beeston Castle, Shower of Rain* (Plate 108 B), which is dated 1793 and is at Nottingham.

Both these paintings were presumably the result of Ibbetson's 1792 tour of Wales in the company of the Hon. Robert Fulk Greville, a popular courtier of the day. The artist had already been to South Wales in 1789, and he visited country houses in various other areas, including the Isle of Wight. Ibbetson was far more interested in the authentic scenery of this country than Morland, and though, like those of Morland, the majority of his landscapes include figures, many of them are primarily topographical views. It was as a topographical draughtsman that he joined the ill-fated mission to China which set out in 1787 under the Hon. Charles Cathcart, but which got no further than the East Indies owing to the death of its leader. Most of Ibbetson's records of this voyage consist of crude water-colours, but in 1789 he exhibited at the Royal Academy an imposing canvas, *Landing the remains of the Honourable Col. Cathcart for interment at Angere Point in the Island of Java*.[3] This shows Ibbetson at his best both in the painting of figures and of landscape, and these two elements are harmoniously combined in an evocative composition. However, in his small-scale portraits, which are similar to those of Wheatley, Ibbetson usually fails to achieve this harmony, and the figures stand stiffly in an unrelated landscape. Examples of this are the portrait of *George Biggin* (dated 1783) in the Mellon Collection,[4] and the *Portrait of a Young Man* (dated 1790) at Leeds.[5]

From 1799 to 1804 Ibbetson lived largely in the Lake District, and in the following year he returned to his native Yorkshire, where he remained in semi-retirement for the rest of his life. In these later years his landscape painting took on a new grandeur and breadth, and it adheres more closely to the picturesque style of Loutherbourg and Wheatley. Typical of his lakeland scenes is the peaceful view of *Ullswater from the Foot*

1. *Catalogue of Paintings, loc. cit.* p. 54, no. 17, pl. 39.

2. *Works, loc. cit.* p. 333.

3. *The First Hundred Years of the Royal Academy,* Burlington House, London, 1951–2, no. 55.

4. *Painting in England*, Richmond, Virginia, *loc. cit.* no. 271, pl. 136.

5. R. M. Clay, *Julius Caesar Ibbetson*, 1948, pl. 105.

XV Philip James de Loutherbourg *An Avalanche in the Alps*, 1803 (detail) Tate Gallery, London. *See page* 115
For whole canvas see Plate 103A

acing p. 120

XVI William Hodges *Tomb and distant View of Rajmahal Hills*, 1782 Canvas, 24½ × 28½, 62·2 × 72·5
Tate Gallery, London. *See page* 130

of Gowbarrow Fells (Plate 109A) in the Fitzwilliam Museum. This is dated 1808, and must therefore have been painted in Yorkshire, as were several other similar lakeland landscapes, including the fine pair of *Grasmere* and *Ullswater* (a variant of the Fitzwilliam composition) dated 1806 in the collection of Mr. J. E. Brennan.[1] A very large view of Ullswater, which was exhibited at the Royal Academy in 1801, is now at Leeds.[2] This has a rather empty foreground, in which members of the artist's family are seen seated on a rock; it is thought to have been Ibbetson's largest landscape painting.

In the summer of 1800 Ibbetson spent some time in Scotland, where he taught the daughters of Lady Balcarres in 'painting from nature'. A striking record of this visit North of the Border is the successful upright composition featuring a foaming waterfall, entitled *North Esk: A Sketching Lesson*.[3] The artist, watched by the two young ladies, is shown sketching; all three are perched somewhat precariously on a rock at the head of the waterfall. Another memorial of this connection with the Balcarres family is Ibbetson's dedication to Lady Elizabeth Lindsay, one of his Balcarres pupils, of his strange book, *Painting in Oil*, which was published in 1803. The full title of this work is *An Accidence, or Gamut, of Painting in Oil, for Beginners; in which is shewn the most easy way of imitating Nature, by means of a simple system, the result of many years' practice; with a Landscape painted in oil, by the Author, and all the tints in patterns.* Ill-written and full of technical verbiage, this is a somewhat flippant work, which seems to have had little influence except on those who were already familiar with Ibbetson and his methods. However, it did appear in a second edition in 1828, and the patient reader can discover in it much that clarifies Ibbetson's own uneven methods, including the recipe for his 'gumtion',[4] of which the collector and amateur artist Sir George Beaumont was a regular user.

The majority of Ibbetson's landscape compositions are calm and peaceful. A notable exception, which was painted in 1798, is *A Phaeton in a Storm* at Leeds.[5] This wild and romantic scene, reminiscent of some of the 'effects' of Loutherbourg, records an actual happening during Ibbetson's Welsh tour with the Hon. Robert Greville. The canvas, which is somewhat thinly painted for such a dramatic scene, is based on a more placid water-colour of this adventure,[6] in which the element of the storm is entirely omitted. In making the changes in the painting, Ibbetson was clearly influenced by the prevailing romantic mood of the closing years of the century. There is also such a mood in many of Ibbetson's later Yorkshire landscapes, though these are usually of entirely quiet scenes, like the beautiful *The River Ure at Masham*,[7] dated 1816, at Bradford. In some aspects, though not in its quality, this is reminiscent of Constable's work at this time. However, such forward-looking work is unusual for Ibbetson, and the more normal traditional and eclectic character of his painting is seen in the *Landscape with Figures: Masham Castle*

1. *Loc. cit.* pls. 81 and 82.
2. Leeds City Art Gallery, *Catalogue of Paintings*, Part I, 1954, p. 41, no. 11.
3. Clay, *loc. cit.* pl. 74.
4. *Loc. cit.* p. 138.
5. *Loc. cit.* pl. 34; Leeds, *Catalogue, loc. cit.* p. 39, no. 6.
6. Clay, *loc. cit.* p. 36.
7. *Loc. cit.* pl. 123.

(Plate 109 B) at Leicester.[1] Dated 1811, this very 'Netherlandish' Yorkshire scene features a group of scantily clad and pretty young washerwomen, who, one suspects, are more likely to be based on the figures of such an artist as Cornelis van Poelenburgh, than on the young women of Ibbetson's own Yorkshire. But one might agree with Edward Dayes (who said it of the artist's cattle) that they 'are touched with great smartness and spirit'.[2]

The same qualities of 'smartness and spirit' are predominant in the numerous drawings of Thomas Rowlandson (1756–1827). While the majority of these are figure drawings recording or caricaturing the customs and events of the day, there is also a considerable number of landscape drawings which reveal Rowlandson as a sensitive and original artist in that vein. These have frequently been neglected in judgements of Rowlandson, though an exhibition entitled *Thomas Rowlandson – Drawings from Town and Country* was shown at the Reading Museum and Art Gallery in 1962. Many of Rowlandson's finest landscape studies were made in the West Country, and especially in Cornwall, where the artist was a frequent visitor at the house of his friend and patron, Matthew Michell, the banker, who owned Hengar House at St. Tudy. A fine example of these Cornish drawings, in which the colouring is unusually strong, is the Ashmolean Museum's *A Farm House at Hengar, Cornwall* (Plate 110A), which is dated 1803. The subject was etched by Rowlandson in reverse in 1812 for his series of *Views in Cornwall*. Though a pleasing record of country folk and animals in their proper setting, as a composition this drawing has many weaknesses, especially in its emptiness in the foreground.

This weakness of composition is frequent in Rowlandson's more ambitious landscape drawings, though it was triumphantly overcome in the famous masterpiece, *Vauxhall Gardens*,[3] shown at the Royal Academy in 1784 and now in the Victoria and Albert Museum. With its harmonious combination of architecture, trees and figures, this is undoubtedly indebted to the example of Gainsborough in such works as *The Mall*, which that artist exhibited at Schomberg House in the same year. A more direct link between Rowlandson and Gainsborough lies in the younger artist's successful copies from Gainsborough in his *Imitations of Modern Drawings*, published in 1788. Here Rowlandson has captured the spirit and character of Gainsborough's landscape drawings, and has added to them something of his own calligraphic line. For it is by his use of rapid, often broken, pen outlines, ranging from the black and deliberate to the most delicate of touches, that Rowlandson brings such life to his drawings. In his landscapes his use of colour washes is usually economical and tentative, and in the majority of cases considerable areas of the white of the paper remain exposed. The artist's rare pencil drawings display his equally lively mastery of that medium.

Rowlandson travelled widely in the British Isles and occasionally on the Continent, and on these travels he made numerous on-the-spot landscape studies, some of which take on the air of caricature by their very rapidity. An example is the small sketch of

1. *Collection of Paintings*, loc. cit. p. 29, no. 84.
2. *Works*, loc. cit. p. 334.
3. A. P. Oppé, *Thomas Rowlandson – His Drawings and Water-Colours*, 1923, pl. 5.

The Logan Rock at Leeds; this much drawn (and now photographed) rocking stone on the southern tip of Cornwall is given great character with strong effects of light and shade. Rowlandson achieved similar qualities of vivacity in many of his small studies of Welsh scenery now in the National Library of Wales at Aberystwyth. These date from his 1797 tour of Wales, and some were subsequently used for one of the best known of Rowlandson's topographical publications, the *Remarks on a Tour to North and South Wales*, which appeared three years later. Many of these Welsh views are essentially simple and depict straightforward scenes, as, for example, in *Pont Aberglaslyn* (Plate 110B), in which there is a head-on view of the road crossing the bridge, with the frothing stream in the right foreground. Beyond are the steep sides of the gorge, with just a tiny glimpse of sky between them. This is not a carefully composed record of a potentially picturesque scene; it is a direct sketch which achieves great effect by its brisk realism. Rowlandson was not impressed by current picturesque theories, and caricatured their begetters and followers mercilessly in his drawings for William Combe's well-known *Tours of Dr. Syntax in Search of the Picturesque*, first published in book form in 1812.

Rowlandson was also highly successful in the drawing of town and harbour scenes, and at their best these subjects have that same spontaneity as the rural landscapes. All three aspects of his landscape are combined in some of his Isle of Wight sketches, of which there is a large group in the Huntington Library, California,[1] and also in such inland drawings as his views of Chepstow, of which there were two examples in the Bruce Ingram Collection. On the other hand, some of the compositions in which buildings appear seem peculiarly stiff, and in these Rowlandson was probably copying from the prints of other artists. An example of this practice is to be found in the *Radcliffe Square, Oxford*,[2] in the Ashmolean Museum. The architectural section of this drawing, which compares most unfavourably with the vigour of the figures in the foreground, was clearly copied from the head-piece of the Oxford Almanack for 1790, which was engraved by Isaac Taylor after D. Harris. Rowlandson was the most prolific of artists, and such lapses are only to be expected. As a whole, however, his landscapes deserve to be more seriously considered than hitherto, though it must be remembered that, apart from more consistent weaknesses, the drawings of 1820 differ very little from those of 1780. Having found his style, Rowlandson was happy to continue working in it, and utterly ignored the developments introduced by such contemporary draughtsmen as Girtin and Turner.

Despite his close contact with many younger artists, among them Girtin and Turner, and his own strong influence on them, the same lack of development is to be found in the surviving work of Joseph Farington (1747–1821). Now, because of his invaluable *Diary*, rediscovered in 1921, Farington's is a household name among all interested in the history of British art. However, in the century between his death and the finding of the *Diary*, his career and work had been largely forgotten, though it should be pointed out that F. Gordon Roe's '*Dictator of the Royal Academy*' – *An Account of Joseph Farington, R.A.*

1. R. R. Wark, *Rowlandson's Drawings for a Tour in a Post Chaise*, 1964.

2. A. Hamilton Gibbs, *Rowlandson's Oxford*, 1911, colour plate facing p. 74.

was published as no. 5 of *Walker's Quarterly* a few weeks before the Puttick and Simpson sale at which the *Diary* and large numbers of Farington's drawings were sold. These drawings are now widely dispersed in collections throughout the world, but even today only a handful of oil paintings by Farington is known. Between 1765 and 1813 he showed over a hundred works at the Society of Artists – some of the earliest were views in Wales – and at the Royal Academy, and the great majority of these were certainly in oils. The Royal Academy retains Farington's Diploma Work (he was elected R.A. in 1785), a dull and stiff *Coast Scene*, which is signed and dated, 1786. Another smaller *Coast Scene* is at Southill. While the Diploma picture, with its hefty rocks, is somewhat theatrical and reminiscent of Loutherbourg, the Southill painting concentrates far more on the figures and is essentially Dutch in character. A third signed oil, of *Cardiff Castle*, passed through the London sale-rooms in 1964.[1] This again is theatrical and stiff, a crowded composition with sharp uprights in the manner of John Inigo Richards; a similar work is the painting of *Little Malvern Church*, formerly in Colonel Grant's Collection,[2] for which there is a squared drawing, dated 1791, in the Witt Collection at the Courtauld Institute.[3]

All these canvases make it difficult to understand how Farington achieved the reputation that he did, and none of them show any sign of his having been one of the most favoured pupils of Richard Wilson. There is, however, one small painting, *The Oak Tree*[4] in the Tate Gallery (Plate 112), which is in an entirely different category. Though not signed, the attribution to Farington and the dating *c.* 1785–90 both seem wholly feasible, and we have here at last a work in oils which, especially in its misty middle distance and its fine distant landscape on the left, speaks strongly of the influence of Wilson, as does the way in which the paint has been applied in depicting the central tree. Furthermore, this, in its general character, is related to several of Farington's studies of trees, such as the Victoria and Albert Museum's *The Lady Oak, near Cressage, Shropshire*, a large pen-and-wash drawing dated 1789.[5] It is to be hoped that more paintings by Farington of this quality may come to light; at present, however, his standing as a painter of landscapes in oils can only be low.

Quite the reverse is true of his achievements as a landscape draughtsman, for here Farington developed a successful personal style. While a pupil of Richard Wilson he made copies of his master's drawings, of which there are examples in some of the sketchbooks in the Victoria and Albert Museum. During these years he exhibited drawings with some success, for in 1764, 1765 and 1766 he was awarded Premiums for his landscape drawings by the Society of Arts. Many of his early drawings are, however, stiff, as for instance a small pencil study of *The Logan Rock*,[6] which, especially when compared

1. Sotheby's sale, 26 February 1964, lot 112.

2. M. H. Grant, *History of the Old English Landscape Painters*, vol. IV, 1959, fig. 282.

3. *Hand-list of the Drawings in the Witt Collection*, 1956, p. 18, no. 442.

4. No. T. 786.

5. Victoria and Albert Museum, *Catalogue of Water Colour Paintings*, 1927, p. 198, no. 44-1895.

6. Christie's sale, 12 November 1968 (Elizabeth Richardson Simmons Collection), lot 53.

with the fluent Rowlandson drawing of the same subject referred to on page 123, makes this Cornish landmark appear lifeless. In these earlier drawings the influence of the Netherlandish topographical tradition is strongly felt, but at a later date Farington turned to a technique in pen and ink and wash that owed much, especially in its broken line, to the example of Canaletto. He also made frequent use of a style of composition that is essentially classical, with broad, distant views framed by foreground features, usually trees. These characteristics are seen in the fine pen and ink and wash drawing of *Carlisle* (Plate 111 B) in the Whitworth Art Gallery. This was engraved in 1790, and belongs to that period of Farington's career when his draughtsmanship was at its best and large numbers of his drawings were being reproduced in aquatint and other media.

The earliest of the volumes of topographical engravings after Farington's drawings had been published in 1789 and was devoted to *Views of the Lakes, etc., in Cumberland and Westmoreland*. Farington spent some years in the Lake District in the later 1770s, and his first Academy exhibits between 1778 and 1782 were all of lakeland subjects. The surviving Lake District drawings and the engravings show that his approach to the beauties of this area was not that of the artist in search of the sublime and the picturesque, but rather of the topographical draughtsman able to produce well-balanced and succinct compositions. However, the formality of Farington's finished drawings is entirely absent in the rapid pen or pencil studies of landscape details and compositions which are found in some of his sketch-books. These no doubt represent his direct reactions to nature, and their existence makes it all the more remarkable that Farington could have been so unadventurous when painting in oils and when drawing some of his straightforward topographical subjects.

The most successful of Farington's series of topographical engravings were the seventy-six plates aquatinted by J. C. Stadler as illustrations for Boydell's *History of the River Thames*, published in two volumes in 1794. The view of *Great Marlow* (Plate 111 A) in the Ashmolean Museum, which is signed and dated 1792, is one of the drawings belonging to this series. With its fluent line and delicate wash this shows Farington at the height of his technical powers, while the simple yet monumental composition is of an equally high quality. There are several further examples of these Thames drawings, not all of them engraved, in the Ashmolean, and another fine group is in the Royal Collection, including the splendid view of *Windsor Castle and Town from St. Leonard's Hill*,[1] in which the framing trees are lightly indicated with considerable subtlety. It is in such broad landscape compositions that Farington's draughtsmanship is at its most appealing. In his architectural topographical subjects, like the drawing of the *Town Hall at King's Lynn* dated 1787 in the British Museum,[2] his technique is stiffer and his approach more stereotyped.

If Farington's surviving work is judged as a whole, it becomes difficult to understand

1. A. P. Oppé, *English Drawings at Windsor Castle*, 1950, no. 255, pl. 51.

2. L. Binyon, *Catalogue of Drawings by British Artists...in the British Museum*, vol. II, 1900, p. 129, no. 1.

how he achieved a high place among the artists of his day, and it must be presumed that this was, in fact, largely due to his presence and his personality. His own *Diary* and other contemporary sources leave no doubt that he was a leading figure among the artists in London, and that he was one of the most powerful members of the Royal Academy. This was true to the end of his life, even though in his later years he rarely exhibited – his last contributions to the Exhibition were made in 1813.

Farington was highly critical of the work of many of his fellow-artists, and of none more so than Alexander Nasmyth (1758–1840), the Scottish landscape painter, whose studio he visited while in Edinburgh in September, 1801. He thought Nasmyth's paintings 'defficient in style & in colouring & executed in a puerile and feeble manner . . .they do not look like the works of a master learned in the art, but are likely enough to please people not conversant with superior art and to be esteemed as such as pleasing furniture. I cannot but think if such pictures were sent to a London Exhibition they wd. be thought very indifferent by the Professors.'[1] In fact, Nasmyth began to show his work in London a few years later and continued to do so until the year before his death; most of his London exhibits were of Scottish subjects.

Alexander Nasmyth, whose own reputation has been eclipsed by that of his short-lived son, Patrick, to be discussed in the second part of this work, has frequently been dubbed, with some justice, as 'the father of Scottish landscape painting'. He began life as a portrait painter, having been apprenticed to Allan Ramsay from 1774 to 1778, but after a visit to Italy (1782–4) he was attracted by the painting of landscape, and this gradually became his chief occupation, though he also worked as a landscape gardener, architect and engineer. A large Claudian composition of the *Ponte Molle, near Rome* is at Manchester, and this shows a traditional reaction to the scenery of Italy

In his painting of landscapes Nasmyth leant heavily on both the Netherlandish and the classical traditions. His paint is usually thinly and nervously applied, and his compositions often seem forced and artificial. These failings occur in some of his views of Edinburgh, such as that of the Castle, in the National Gallery of Scotland, dated 1824,[2] and the more distant view of the city of two years earlier, which was lately on the London art market.[3] In both these canvases the foregrounds are strongly Dutch in character and colouring, though there is greater individuality in the painting of the middle distance and distance. Alexander Nasmyth also painted London, as, for instance, in the large composition of *Waterloo Bridge and the City from Whitehall Stairs* exhibited in Edinburgh in 1827 and now in Lord Inchcape's Collection. This shows the new bridge, opened in 1817, and was painted from much the same viewpoint as Constable's famous composition of the opening ceremony, exhibited in 1832. The two vast canvases are almost identical in size; Constable's is a masterpiece of the nineteenth century – Nasmyth's (apart from the anachronism of the bridge) might well belong to the mid-eighteenth.

1. *Diary*, 23 September 1801.
2. *Catalogue of Paintings and Sculpture, loc. cit.* p. 181, no. 2104.

3. Messrs. Oscar and Peter Johnson, London, *The Nasmyth Family*, 1964, no. 13.

Nasmyth is just as backward-looking in his less ambitious compositions, such as the *Rocky wooded Landscape with ruined Castle by a Loch* (Plate 115) at Glasgow. Dated 1817, this is again a mixture of various influences; that of Richard Wilson may be detected in the luminous distant view on the left. Here Nasmyth has chosen a subject that is essentially picturesque, and he found many other similar scenes in his native Scotland. Yet, as in this case, his technique was frequently too mild and hesitant to be effective, and we have to wait for his pupil, the Rev. John Thomson, for really evocative renderings of Scotland's wealth of picturesque subjects by a native artist.

Thomas Barker (1769–1847), known as 'Barker of Bath', lived on even longer into the nineteenth century than did Alexander Nasmyth, and was in many ways equally old-fashioned. The strongest influence in his work was certainly the example of Gainsborough, though, like Nasmyth, Barker's painting is basically an amalgam of Netherlandish and Italian influences. Barker used paint much more freely and vigorously than Nasmyth, but his compositions lack the discipline of the Scottish artist and are often rather empty. Barker's characteristic combination of spirited brushwork with an inadequately thought-out composition is seen in the Mellon Collection's *Mountainous Landscape with a Watermill*,[1] which lacks the depth needed to make it a telling picturesque scene. In such a painting Barker was presumably trying to give the impression of working from nature, something in which he is far more successful in the Tate Gallery's *Landscape, near Bath*[2] (Plate 114), which is thought to date from about 1796. Despite its lack of any central feature, this stretch of moorland scenery is represented as an effective composition in which the greys and greens of the landscape are subtly contrasted with the blue sky – a contrast made all the more forceful by the hard straight skyline.

In such naturalistic landscapes Barker is at his most individual (though there are certainly strong debts to Richard Wilson in the Tate's canvas); he loses his personality in those works which attempt to fit into accepted traditions, such as the very Italianate *Landscape* (Plate 113), also in the Tate Gallery.[3] This lakeside scene with its 'Marco Ricci' trees and its 'Gaspard Poussin' hills was certainly painted in England, though the inspiration for it probably dates from Barker's years in Italy, where he was sent by his Bath patron in about 1789. He returned to England in 1793 on the death of his father, an animal painter, and he spent the remainder of his life in Bath, though he was a fairly regular exhibitor in London up to 1847. Barker achieved his greatest success with his rustic fancy pictures, such as *The Woodman*, of which a version is in the Tate Gallery.[4] In this early work, dating from about 1787, the debt to Gainsborough is pre-eminent; in the *Gipsy Encampment*, in the Ashmolean Museum,[5] the artist's style and his vigorous handling of paint come into their own. This monochrome sketch is a preliminary study for a painting exhibited at the British Institution in 1815, and it proves that Barker could at times produce work more in keeping with the romantic

1. *Painting in England, loc. cit.* no. 49.
2. No. 4196.
3. No. 2987.
4. No. 792.
5. Ashmolean Museum, *Report of the Visitors*, 1961, p. 57.

fashion of the day. However, on the whole he is essentially an artist of the eighteenth century.

Numerous other artists painting landscape in England in the first years of the nineteenth century were unmoved by the changes then being introduced, and continued happily to follow one or more of the modes of the century in which they were born. As is to be expected, these more traditional artists enjoyed considerable patronage. In this context it is interesting to note that the Flemish Hendrik de Cort (1742–1810) spent the last twenty or so years of his life in England, successfully painting and exhibiting views of cathedrals, country houses and the like, in a style that is often more reminiscent of his seventeenth-century than of his eighteenth-century predecessors. Examples lately on the London art market included stiff views of Canterbury Cathedral (dated 1809) and of Chatsworth. The Nottingham City Art Gallery has two views of Wollaton Hall and its park which are typical of de Cort's precise and lifeless manner, which must certainly have appealed to the more antiquarian-minded lovers of the picturesque.

One more aspect of the growing vogue for the picturesque has yet to be discussed: this is the work of those British artists who accompanied and followed the explorers and the empire builders of the later eighteenth century. Initially the reason for their employment was largely scientific; just as some noblemen and gentlemen in the eighteenth century and before took artists with them on their travels to paint and draw what they had seen, so the ambassadors and explorers were occasionally accompanied by artists to record their experiences and discoveries – botanical and zoological as well as topographical. Thus, when Captain Cook set out from Plymouth in August 1768 on his first voyage to the Pacific, there were two artists on board the *Endeavour*. These were Alexander Buchan, a topographical draughtsman who died on the voyage out, and Sydney Parkinson, a botanical artist, who, owing to the death of his colleague, also made some crude topographical drawings. On that voyage the scientific work was in the capable hands of (Sir) Joseph Banks, who was likewise concerned in drawing up the plans for Cook's second voyage on board the *Resolution*. For this Banks included four artists in his party, among them none other than Johann Zoffany. But the naturalist fell out with the Navy Board because of accommodation problems and withdrew from the whole enterprise. Zoffany was to gain his experience of the Far East some years later, for he was in India from 1783 to 1789. During his visit he was chiefly engaged in the painting of portraits, but he also made some rather run-of-the-mill topographical drawings. The artist who was on board the *Resolution* when she set sail in July 1772 was William Hodges (1744–97), and the paintings and drawings which he made on this voyage set a new standard for future British artist travellers,[1] but it was a standard which few were able to attain.

By training – at William Shipley's School and as an apprentice of Richard Wilson for at least five years from 1757 or 1758 – Hodges was just the right person to approach the task with the latest techniques at his fingertips. By temperament this artist clearly

1. For an excellent discussion of Hodges's work on this voyage see B. Smith, *European Vision and the South Pacific 1768–1850*, 1960 and 1969, to which the present author is indebted for much of the information given here.

sympathized with the enterprising scientific methods of his companions on board the *Resolution*. In the remarkable series of paintings and drawings executed during the long voyage, Hodges combined the influences of his scientific environment with his artistic experience to produce pictures that were authentic and naturalistic records as well as being satisfying landscape compositions. The *Resolution* was anchored outside Cape Town for nearly a month, and during that time Hodges painted a large canvas of *The Cape of Good Hope* (Plate 116), which is now in the National Maritime Museum at Greenwich. While this composition retains some of the qualities of an accurate 'profile drawing' of the coastline, a more important element is its effective rendering of atmosphere and weather. As Professor Smith has pointed out, the *Resolution*'s log-book shows that the weather was squally throughout most of the month,[1] and this fact is wonderfully recorded in the flickering light effects on the rocks. It is likely that Hodges worked on this canvas on deck, and it stands out as a remarkable example of early *plein air* painting.

From the Cape, *Resolution* sailed through the Antarctic, and Hodges was faced with a different challenge in the rendering of light and tone. Again he succeeded remarkably well in his series of wash drawings, now preserved in the Public Library of New South Wales, which record the keen light and sharp outlines of this desolate area. In the Pacific the problems were again very different: here all was lushness and sunshine, but the artist (who had never been to Italy) found that he had the necessary qualities to make paintings that satisfied the scientists' requirements of accuracy as well as the taste of the connoisseurs. However, in one aspect – their very broad and free technique – these Pacific compositions received considerable criticism, as, for instance, from Edward Edwards, who wrote: 'Educated as he was under a master not over careful in finishing his pictures, like too many of those pupils who endeavour to imitate their masters, he copied more of Wilson's defects than of his perfections; in consequence of which, his works in general have too much the appearance of that neglect, which has been considered as the effects of slovenliness united with the affectation of mastery.'[2] This lack of 'finish', which was later to be one of the chief faults in the eyes of his contemporaries of Constable's work, is clearly seen in the *Monuments on Easter Island* (Plate 117), also at Greenwich. Basically this is a conventional composition with picturesque overtones; but in addition Hodges has achieved a remarkable rendering of environment and scale, with – and this is the painting's chief quality in modern eyes – a minimum of fuss and detail, or, as the eighteenth century would have named it, 'finish'. These same qualities are pre-eminent in the romantic *Crater in the Pacific* at Brighton,[3] which in its stark rendering of a natural phenomenon was much ahead of its time. On the other hand in some of his more conventional Pacific scenes, such as *Tahiti Revisited* at Anglesey Abbey, which was painted after Hodges's return to England in 1775, directness and conviction are largely lost in the artist's attempt to produce an acceptable Academy piece.

Despite such efforts Hodges failed to gain adequate patronage and recognition, and

1. *Loc. cit.* 1969, p. 42. 2. E. Edwards, *Anecdotes of Painters*, 1808, p. 244.
3. *Romantic Art in Britain*, 1968, *loc. cit.* no. 74.

he was not elected R.A. until 1787. In the meantime he had spent about four years in India, where he sailed under the patronage of Warren Hastings in 1780. Before his departure he had supervised the engraving of some of his drawings and paintings as illustrations for the official record of Captain Cook's voyage, published in two volumes in 1777. Unfortunately the economy and naturalness of his painting are largely lost in the engravings, and the same is true of his Indian aquatints, which he published in 1786 under the title of *Select Views in India*. That Hodges could succeed as well in India as he had done in the Pacific in capturing the essentials of the region's character is proved by the Tate Gallery's superb canvas, *Tomb and distant View of Rajmahal Hills* (Colour Plate XVI), which is dated 1782. Here again we have an example of the artist's ability to achieve his effect by the simplest of means. It is truly a stroke of genius to have given to a largely conventional landscape composition those qualities of mystery and 'difference' that make it appear essentially Indian, by the inclusion at just the right place of one stark palm tree.

While Hodges's exotic Pacific and Eastern scenes, and his publication of some of them, indicate that the search for picturesque subjects had opened up vast new fields of interest, the fact that he himself failed to achieve success as an artist – he was to retire in 1794 and committed suicide three years later, having failed as a banker – is evidence that, in general, taste in landscape painting was still attuned to the conventional, a truth which his master, Richard Wilson, had also discovered. That Hodges, to whom we shall return at the close of this chapter, himself often adhered to the conventional is shown by his own Diploma work, *The Ghauts at Benares* (Plate 119), which, apart from the architecture of the buildings and the details of the boats, could be a scene on any European river. Similarly conventional characteristics invest most of the paintings and drawings of Thomas Daniell (1749–1840) and his nephew William Daniell (1769–1837), who were in India from 1786 to 1793. Both uncle and nephew – there is often little to distinguish their work – were essentially topographical artists. They were content to record (frequently with the aid of a *camera obscura*) the architecture and other details of the exotic scenes they saw on their travels without any attempt to render the character of the country. Hundreds of their drawings survive today, including over four hundred in the India Office Library,[1] of which the large water-colour of the *Ghauts at Benares*[2] (Plate 118) is a typical example.

The Daniells were as prolific as they were conventional, and continued to exhibit their characteristic Indian subjects for many years after their return to England. They must rank as among the least distinguished artists to achieve full membership of the Royal Academy – Thomas in 1799 and William in 1822; on the other hand their depictions of India – accurate and informative as far as architecture went – were immensely popular, and also influential in the fast-growing taste for things Indian. Between 1795 and 1808 they issued in six parts their imposing *Oriental Scenery*, a series of 144 coloured aquatint

1. M. Archer, *British Drawings in the Indian Office Library*, vol. II, 1969, pp. 574–99.
2. *Loc. cit.* p. 577, no. 168.

plates, which sold for a total of £210. This was followed in 1810 by the much smaller *A Picturesque Voyage to India by the Way of China*, in which there were fifty coloured aquatints. The Daniells (and we must not forget William's younger brother, Samuel (1775–1811), who travelled in Africa) also published numerous other topographical works, among them William's ambitious *A Voyage Round Great Britain* (1814–25) with over 300 plates. The members of this hard-working family were highly successful in adapting their skills as topographic artists to the demands created by the vogue for picturesque subjects.

Many other artists travelled far afield in the later years of the eighteenth century on the hunt for picturesque subject-matter. Among them was William Alexander (1767–1816) who was in China from 1792 to 1794 as draughtsman on Lord Macartney's embassy. While the bulk of his published illustrations are concerned with the costume and manners of China, he also made delicate and evocative landscape drawings, of which there are examples in numerous collections. Alexander had trained under Pars and Ibbetson, and their teaching is often in evidence in his drawings of China. Similarly the Swiss antecedents and training of John Webber (1750/2–93) are felt in that artist's paintings and drawings of scenes in the Pacific. Webber, who was born in London of Swiss parentage, returned to his father's country to study under J. L. Aberli,[1] and the hard Swiss topographical style is evident in most of his work. Webber was the draughtsman on Captain Cook's third and last voyage to the Pacific, which set out in 1776. His paintings and drawings made on and after the expedition lack the fluency of those of William Hodges, and are usually more concerned with the rendering of detail than of atmosphere. This is seen in Webber's *View of Macao* (Plate 120), which was painted for the Admiralty after his return, and was exhibited at the Royal Academy in 1785. Here, except for the details of figures, boats and architecture, there is nothing specifically Oriental, and this large and conventional composition misses that quality of place which Hodges so often achieved.

In the end, to return to Hodges, that artist was himself forced to try to achieve a compromise between the accepted conventions and his own direct approach to landscape painting. In 1790 he had undertaken yet another long journey in search of material, this time in Europe, and he travelled as far as Russia. But again his paintings met with little success, and finally Hodges, like Gainsborough in his fancy pictures, tried to develop a different and higher 'class' of landscape painting. At the end of his career he held a special exhibition in Old Bond Street of two paintings, which were entitled *The Effects of Peace* and *The Effects of War*. In these, as Edwards records, he 'made a vain attempt to produce what might be called a didactic style of landscape'.[2]

Edwards quotes at length from Hodges's own printed explanation of his intentions, and, as this provides a valuable insight into some of the problems facing the British landscape painter at the end of the eighteenth century, the most relevant passages must be quoted again here:

1. See above, Chapter Three, p. 80.　　　　2. *Anecdotes, loc. cit.* p. 246.

'The branch of painting, towards which my studies have been principally directed', wrote Hodges, 'is landscape. These studies were begun under the greatest modern master of that art, Wilson. I must be permitted to value myself upon such an advantage, which I hope very extensive travels through various countries must have improved.

'Upon maturely reflecting on the nature of my profession, I have been led to lament a defect, and humbly to endeavour at a remedy. I found in the ancient and in many of the modern masters of landscape, the grandest combinations of nature, and the most exact similitude, the happiest composition, and pencilling governed by the hand of Truth. But I confess there seemed very rarely to me any moral purpose in the mind of the artist. The storm has been collected over the peaceful trader, or the brilliant skies of Italy have illumined merely the forms of inanimate nature. We have seen foliage frowning on one side, and the blasted trunk exhibiting its dreary defoliation on the other; but the whole has evinced only the ordinary progress of life, and the effects of elemental war.

'It could not escape me, that the other branches of the art had achieved a nobler effect – History exhibited the actions of our heroes and our patriots, and the glory of past ages – and even Portrait, though more confined in its influence, strengthened the ties of social existence. To give dignity to landscape painting is my object.'[1]

The exhibition was a failure, and the two paintings have long since disappeared, though Edwards states that they were in the collection of Sir John Soane.[2] But in the context of the history of British landscape painting their actual execution and their place in the chequered career of William Hodges invest them with exceptional interest. Hodges's instinctive approach to landscape painting as the accurate rendering of scenery, light and atmosphere was far ahead of its time; it was not, in fact, to become acceptable until the end of Constable's career in the 1830s. Hodges's rendering of conventional and picturesque landscape subjects also failed because his technique was too free, and his canvases lacked that necessary quality of 'finish', which even Turner was usually forced to adopt until the 1820s. Hodges's attempt at 'didactic' landscape failed because it was probably too realistic, lacking the soothing qualities of Gainsborough's fancy pictures or the theatrical characteristics of such artists as Loutherbourg. Great advances had been made in landscape painting in the eighteenth century, but it was not until well on into the following century that artists could achieve public support if they advanced still further.

1. *Loc. cit.* pp. 246–7.
2. I am indebted to Sir John Summerson for checking that there is no other record of their having been in Soane's collection.

SELECT BIBLIOGRAPHY

References to books on individual artists, articles in periodicals, and museum, collection and exhibition catalogues, are given in the footnotes

ABBEY, J. R., *Scenery of Great Britain and Ireland, 1770–1860*, London, 1952

BINYON, Laurence, *English Water-Colours*, London, 1933 and 1944

BUCKERIDGE, Bainbrigg, *An Essay towards an English School of Painters*, 3rd edition, London, 1754; reprint, London, 1969

CLARK, Kenneth (Lord), *Landscape into Art*, 1st edition, London, 1949

DAYES, Edward, *The Works of the Late Edward Dayes*, London, 1805; reprint, London, 1971

EDWARDS, Edward, *Anecdotes of Painters*, London, 1808; reprint, London, 1970

FARINGTON, Joseph, *The Farington Diary*, a selection in 8 volumes edited by J. Greig, London, 1922–8. A copy of the typescript is deposited in the British Museum Print Room, and a new, full printed edition is in preparation

GESSNER, Salomon, 'A Letter to M. Fuslin on Landscape Painting', in *New Idylles by Gessner*, translated by W. Hooper, London, 1776

GRANT, Colonel M. H., *A Chronological History of the Old English Landscape Painters*, 2nd edition, 8 volumes, Leigh-on-Sea, 1957–61

HARDIE, Martin, *Water-Colour Painting in Britain*, 3 volumes, London, 1966–8

HIPPLE, W. J., *The Beautiful, The Sublime, and The Picturesque in Eighteenth-Century British Aesthetic Theory*, Carbondale, Illinois, 1957

HUSSEY, Christopher, *The Picturesque*, London, 1927; reprint, London, 1967

HUSSEY, Christopher, *English Gardens and Landscapes, 1700–1750*, London, 1967

JONES, Thomas, 'Memoirs of Thomas Jones', edited by A. P. Oppé, in *The Walpole Society*, volume XXXII (1946–8), London, 1951

LEMAÎTRE, Henri, *Le Paysage Anglais à l'Aquarelle, 1760–1851*, Paris, 1955

MANWARING, Elizabeth Wheeler, *Italian Landscape in Eighteenth Century England*, New York, 1925; reprint, London, 1967

OGDEN, Henry V. S. and Margaret S., *English Taste in Landscape in the Seventeenth Century*, Ann Arbor, Michigan, 1955

POTT, Joseph Holden (published anonymously), *An Essay on Landscape Painting. With Remarks General and Critical, on the Different Schools and Masters, Ancient or Modern*, London, 1782

PYNE, W. H. (under pseudonym of Ephraim Hardcastle), *Wine and Walnuts*, 2 volumes, London, 1823

REDGRAVE, Samuel, *A Dictionary of Artists of the English School*, 2nd revised edition, London, 1878

REDGRAVE, Samuel and Richard, *A Century of Painters of the English School*, 2 volumes, London, 1865; 2nd revised edition, 1 volume, London, 1890; illustrated and corrected reprint, edited by Ruthven Todd, London, 1947

REYNOLDS, Sir Joshua, *The Discourses*, first collected edition, London, 1797; edition with Introduction and Notes by Roger Fry, London, 1905; edition by Robert R. Wark, San Marino, California, 1959

ROGET, John Lewis, *A History of the 'Old Watercolour' Society*, 2 volumes, London, 1891

STEEGMAN, John, *The Rule of Taste from George I to George IV*, London, 1936; reprint, London, 1968

STEEGMAN, John, *The Artist and the Country House*, London, 1949

VERTUE, George, 'The Vertue Notebooks' published in 6 volumes in *The Walpole Society*, volumes XVIII (Vertue I, 1930), XX (Vertue II, 1932), XXII (Vertue III, 1934), XXIV (Vertue IV, 1936), XXVI (Vertue V, 1938), XXIX (Index, 1947), and XXX (Vertue VI, 1955)

WALPOLE, Hon. Horace (Earl of Orford), *Anecdotes of Painting in England*, 4 volumes, Strawberry Hill, 1765–71; edited by Ralph N. Wornum, 3 volumes, London, 1849 and revised edition 1862. A fifth volume of unpublished

material, edited by F. W. Hilles and P. B. Daghlian, New Haven, 1937

WATERHOUSE, Ellis, *Painting in Britain, 1530 to 1790*, 1st edition, London, 1953

WATERHOUSE, Ellis, *Three Decades of British Art, 1740–1770*, Philadelphia, 1965

WATSON, J. R., *Picturesque Landscape and English Romantic Poetry*, London, 1970

WHINNEY, Margaret and MILLAR, Oliver, *English Art, 1625–1714*, Oxford, 1957.

WHITLEY, William T., *Artists and their Friends in England, 1700–1799*, 2 volumes, London, 1928

WILLIAMS, Iolo A., *Early English Watercolours*, London, 1952; reprint, Bath, 1970

PLATES

The majority of the measurements given here are taken from the relevant museum and exhibition catalogues. Measurements are in inches and centimetres, height preceding width. Where the definite date of a painting or drawing is known this is included immediately after its title.

135

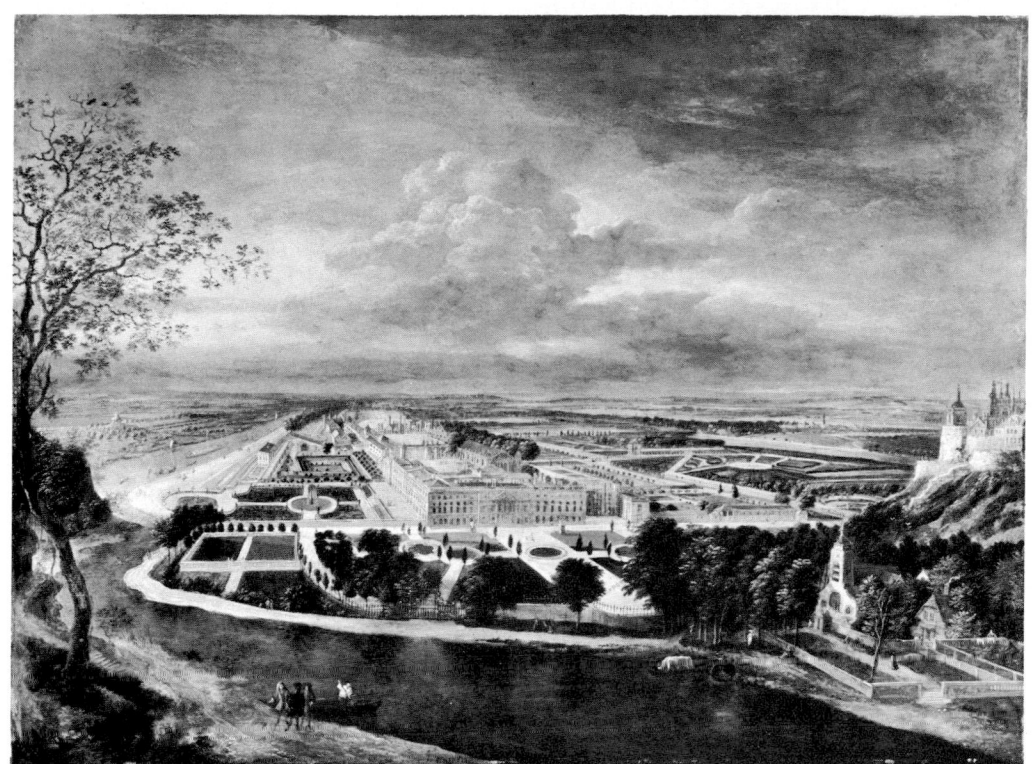

1 A Jan Griffier *View of Hampton Court Palace* Copper 15 × 19⅞, 38·1 × 50·5
Tate Gallery, London. *See page* 13

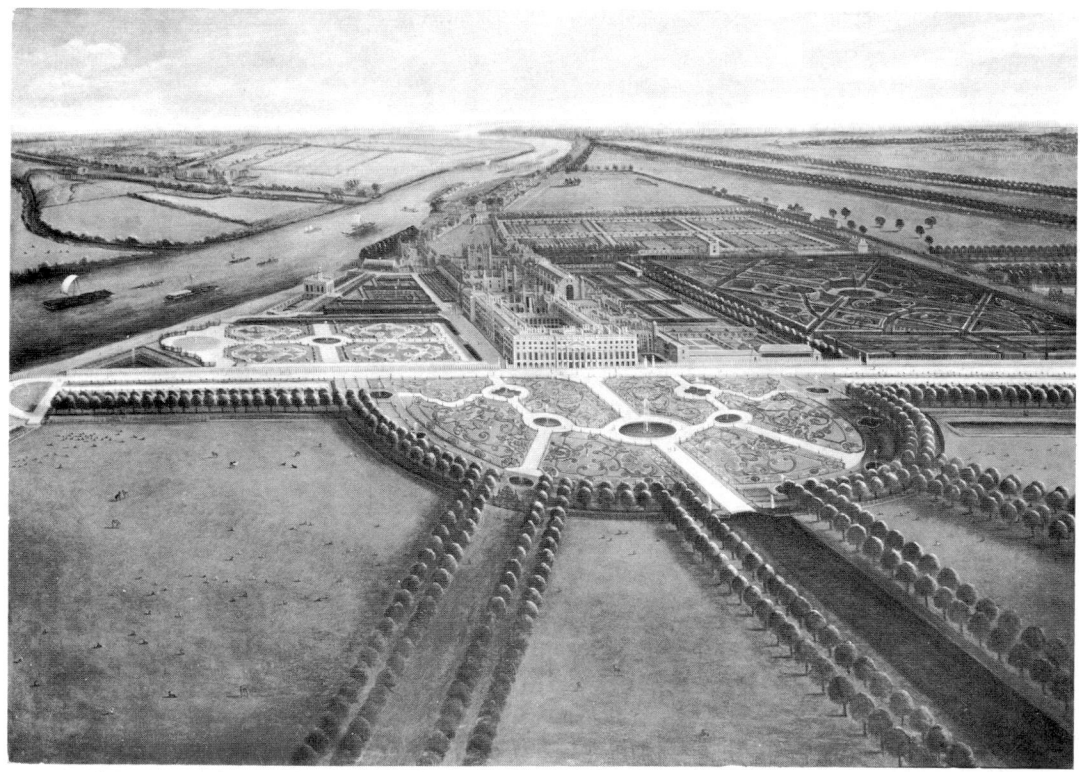

1 B Leonard Knyff *A View of Hampton Court* Canvas 60¼ × 85¼, 153 × 216·5
The Royal Collection, Hampton Court.
(*Reproduced by gracious permission of Her Majesty The Queen*) *See page* 13

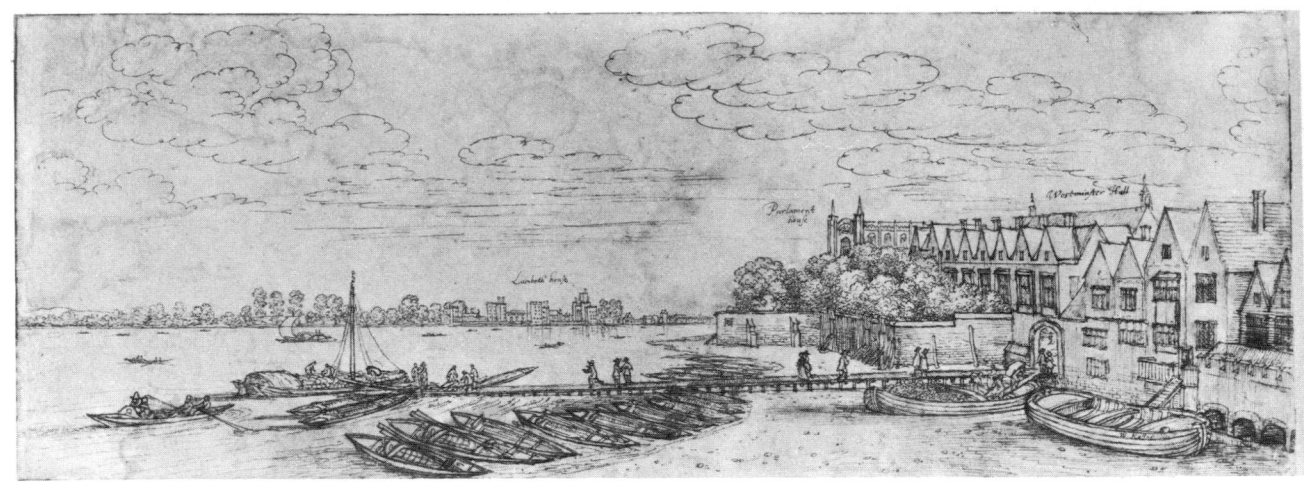

2A Wenceslaus Hollar *A View of the Thames below Westminster Pier* Pen and ink 5½ × 15¾, 14 × 40
The Barber Institute, University of Birmingham. *See page* 14

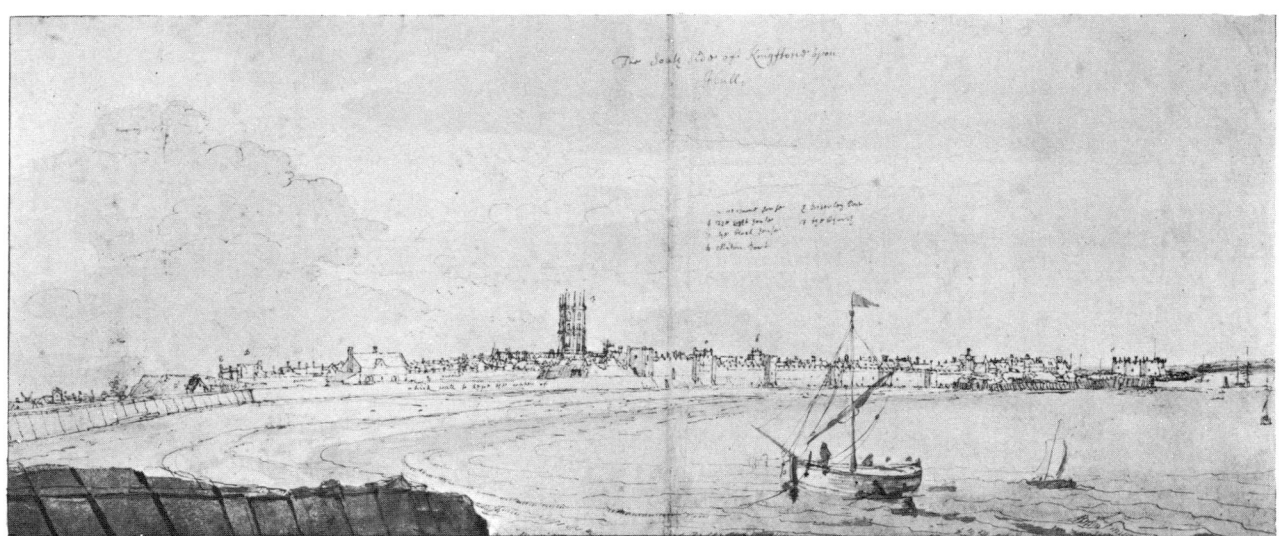

2B Francis Place *Kingston Basin, Hull* Pen and brown ink, with washes of grey and blue 7⅛ × 17½, 18·2 × 44·6
British Museum, London. *See page* 15

2C Leonard Knyff *View from Richmond Hill* Pen and brown ink, with grey wash 8¾ × 30, 22·2 × 76·2
Private Collection. *See page* 16

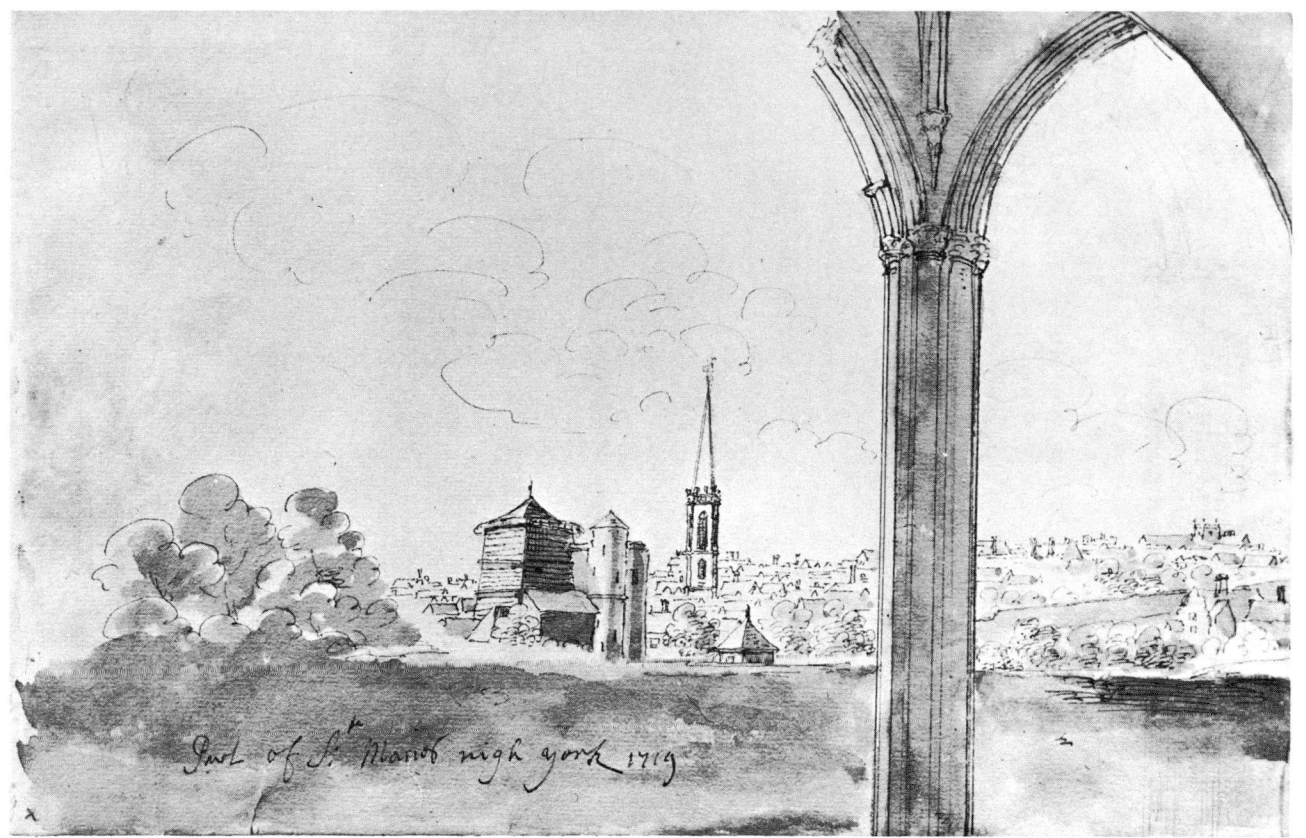

3A Francis Place '*Part of St. Maries nigh York 1719*' Pen and ink and wash 6×9¼, 15·2×23·6
City Art Gallery, York. *See page* 16

3B Pieter Tillemans '*From my Turit in Blackfriars Lambeth*'

Water-colours on a pink preparation 7⅞×14½, 19·9×37
Ashmolean Museum, Oxford. *See page* 16

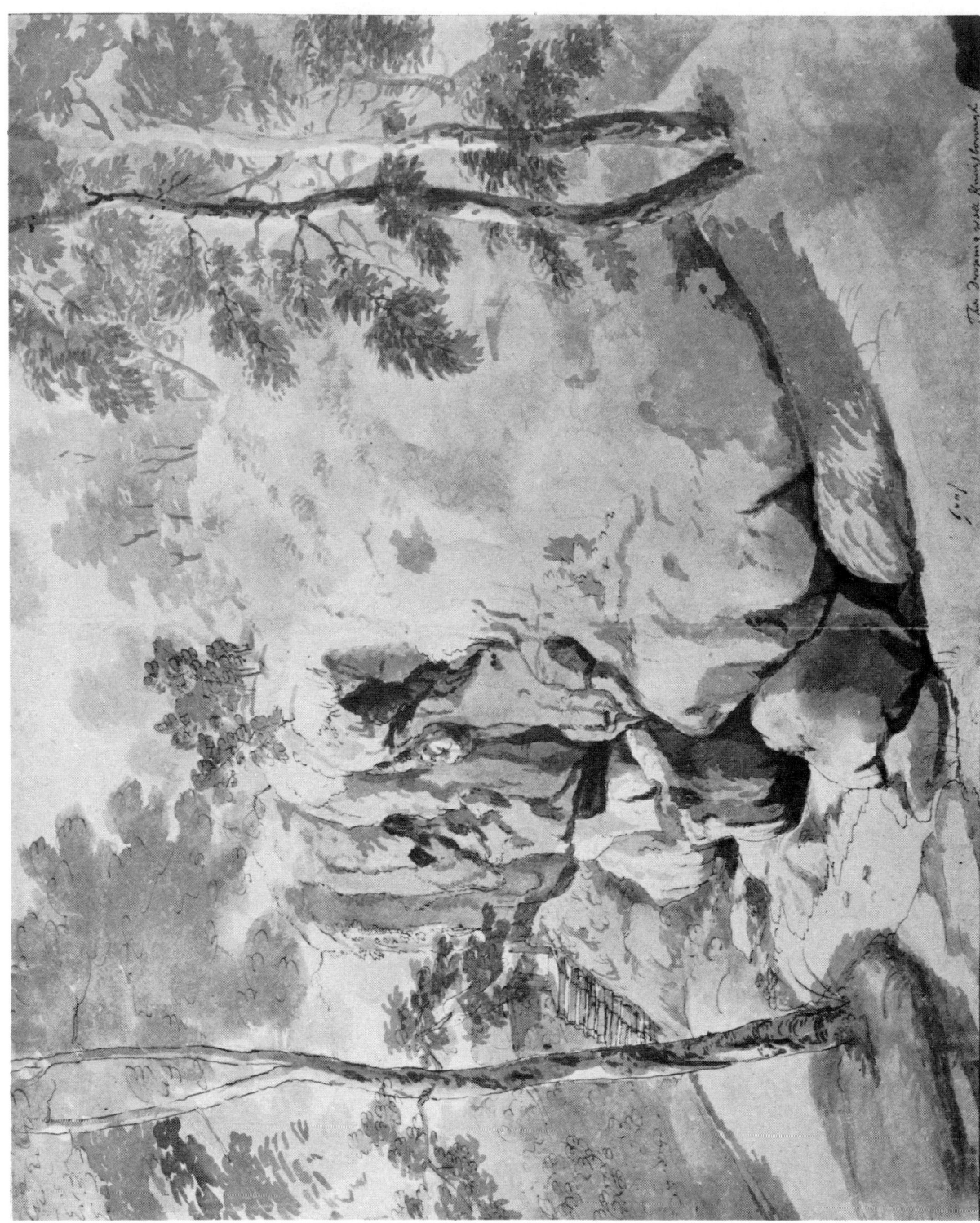

4 Francis Place *The Dropping Well, Knaresborough* Grey wash, partly outlined with pen and brown ink $12\frac{5}{8} \times 16$, $32 \cdot 1 \times 40 \cdot 6$
British Museum, London. *See page* 15

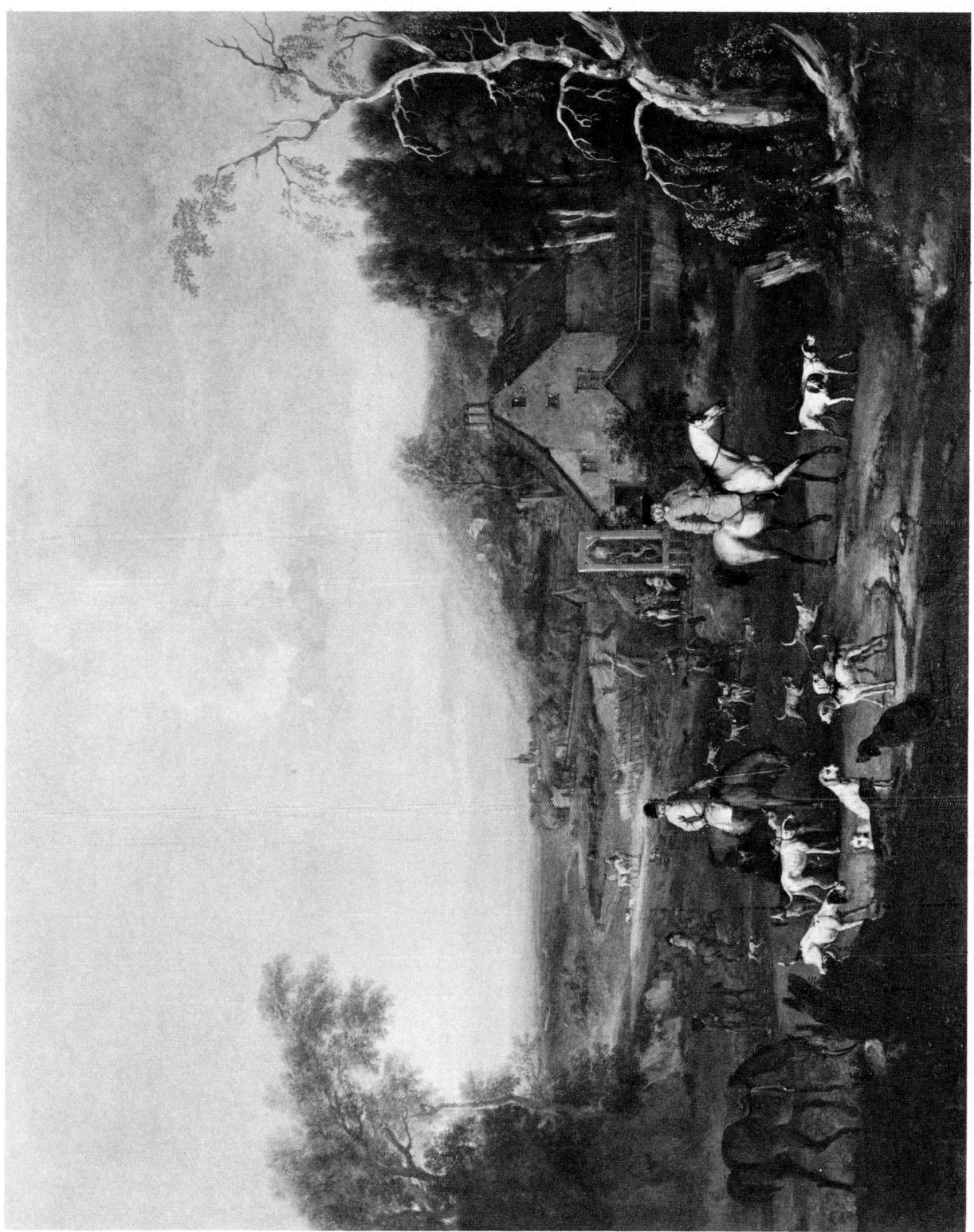

5 Pieter Tillemans *Mr. Jemmet Browne at a Meet of Foxhounds* Canvas 38½ × 48½, 97·75 × 123·25
Mr. and Mrs. Paul Mellon, Oak Spring, Virginia. *See page 17*

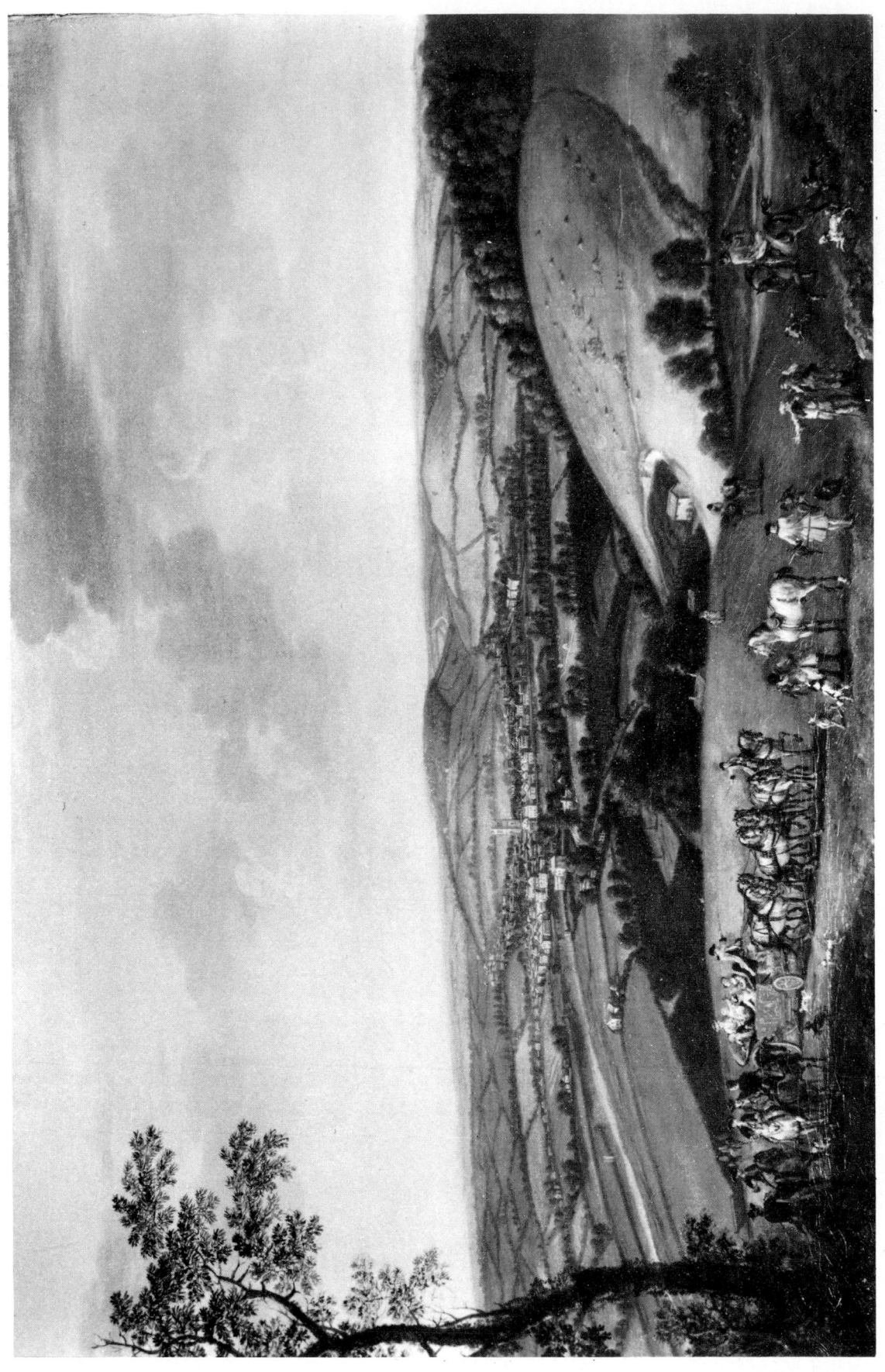

6 John Wootton *Distant View of Henley-on-Thames* Canvas $39\frac{3}{4} \times 61\frac{1}{2}$, $101 \times 156 \cdot 2$

The Royal Collection, Windsor Castle. (*Reproduced by gracious permission of Her Majesty The Queen*) *See page* 17

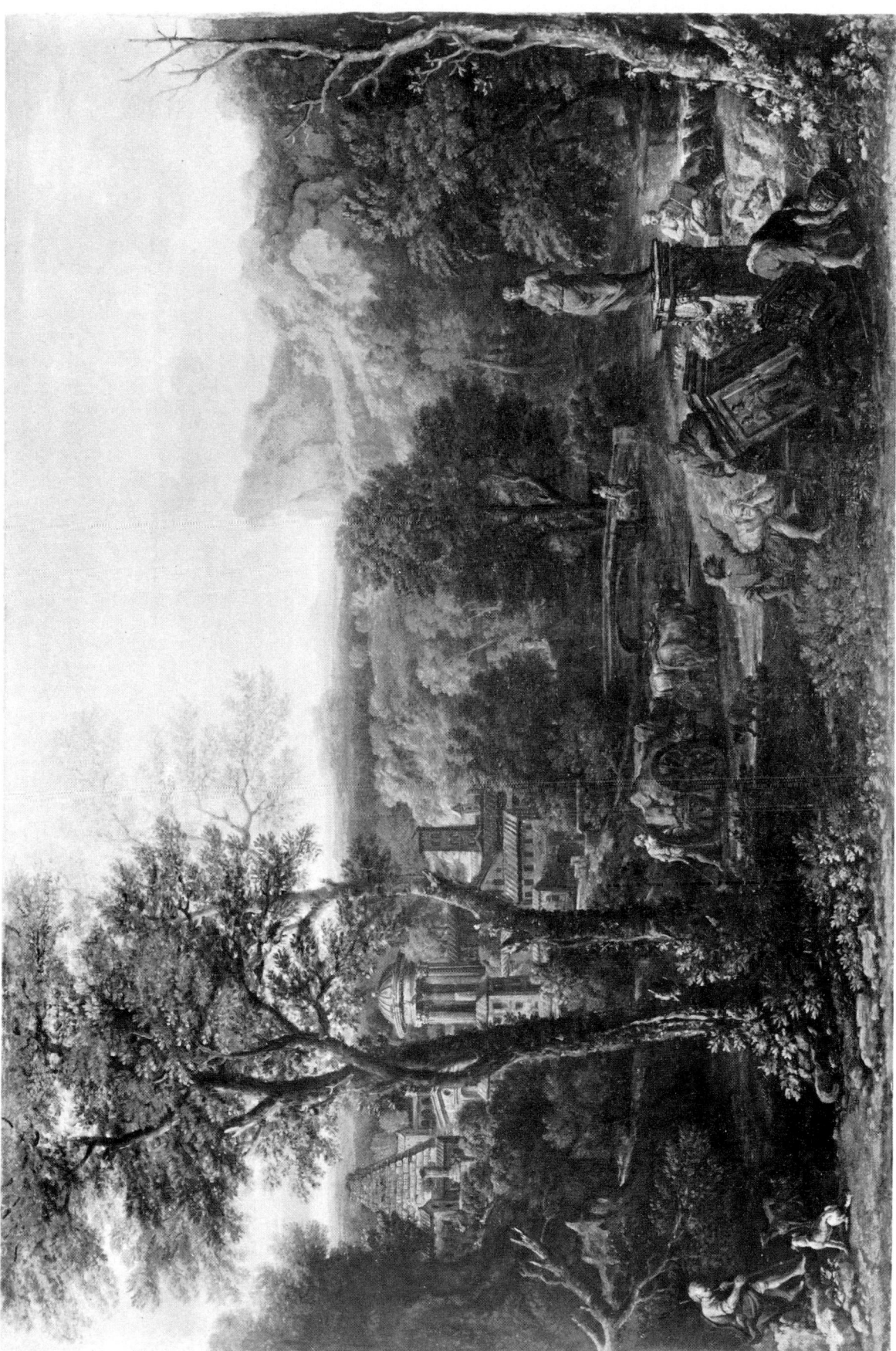

7 John Wootton *Classical Landscape*

Canvas 47×72, 119·4×183
Whitworth Art Gallery, Manchester. *See page* 18

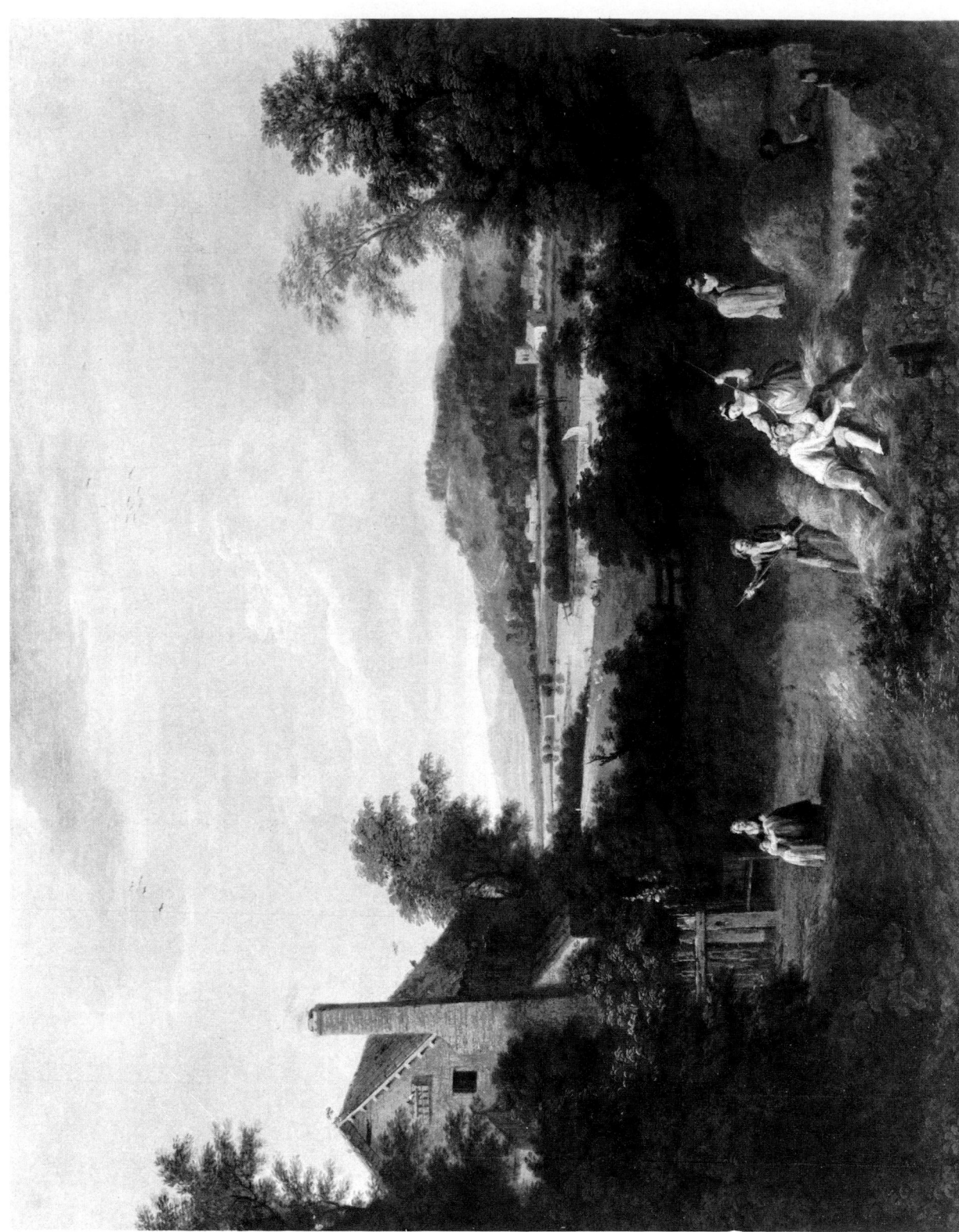

8 George Lambert and William Hogarth *Landscape with Farmworkers* Canvas 40×50, 101·5×127
Mr. and Mrs. Paul Mellon, Oak Spring, Virginia. *See page 22*

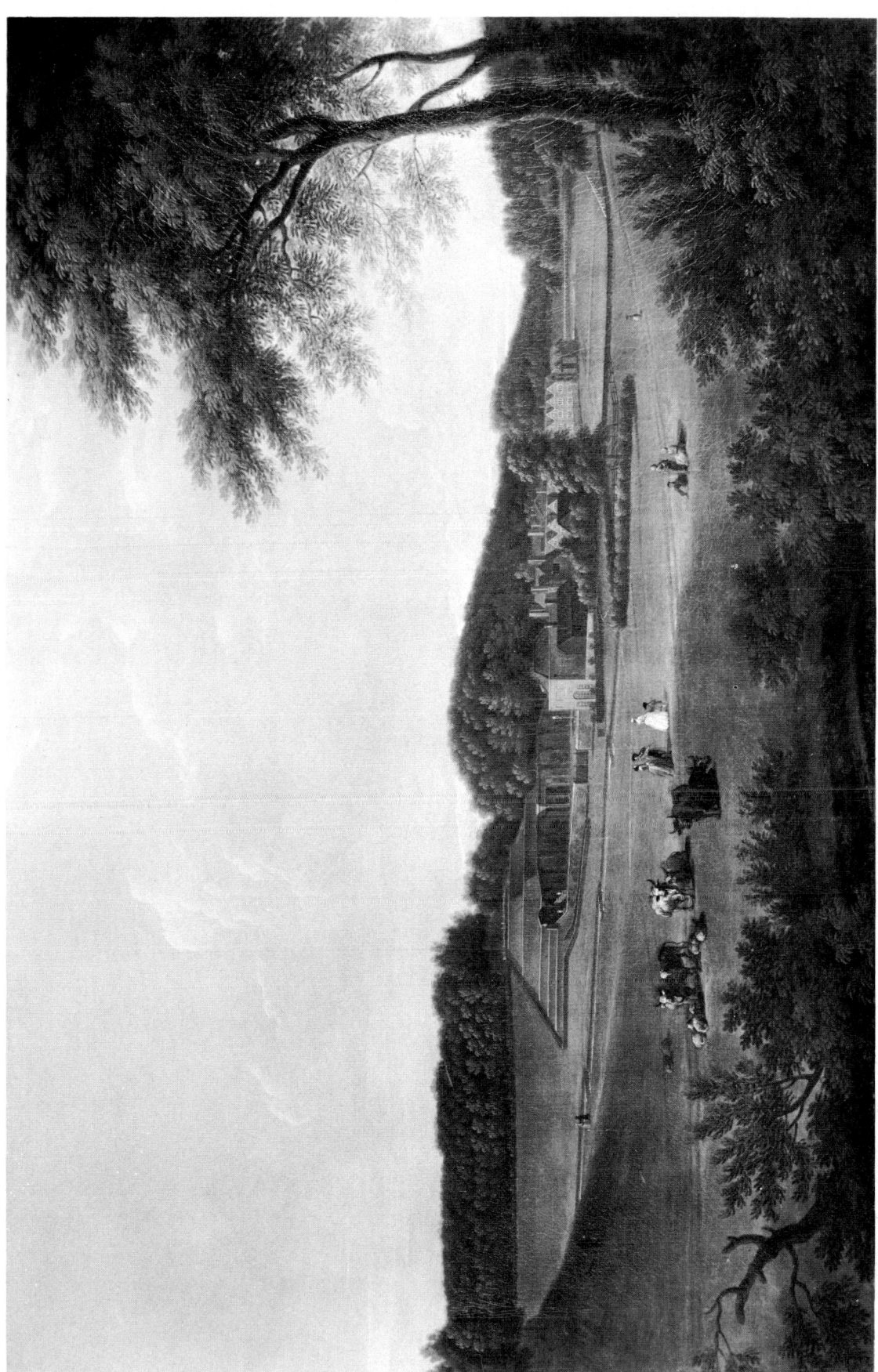

9 George Lambert *Wotton Park, Surrey*, 1739 Canvas $23\frac{1}{2} \times 43\frac{3}{4}$, 59.7×111.2
The Lord Camoys, Stonor Park, Henley-on-Thames. *See page 22*

10 George Lambert *Landscape with a Coastal Inlet*, 1763 Canvas 48×54, 122×137·2
National Museum of Wales, Cardiff. *See page* 23

11 George Lambert *Classical Landscape*, 1745

Canvas 40¾×46, 103·5×117
Tate Gallery, London. *See page* 23

12A James Norie *Classical Landscape with Architecture*, 1736 Canvas $25\frac{1}{2} \times 52, 64 \cdot 8 \times 132$
National Gallery of Scotland, Edinburgh. *See page 23*

12B George Smith (of Chichester) *Classical Landscape* Canvas $12 \times 17, 30 \cdot 5 \times 43 \cdot 2$
Tate Gallery, London. *See page 24*

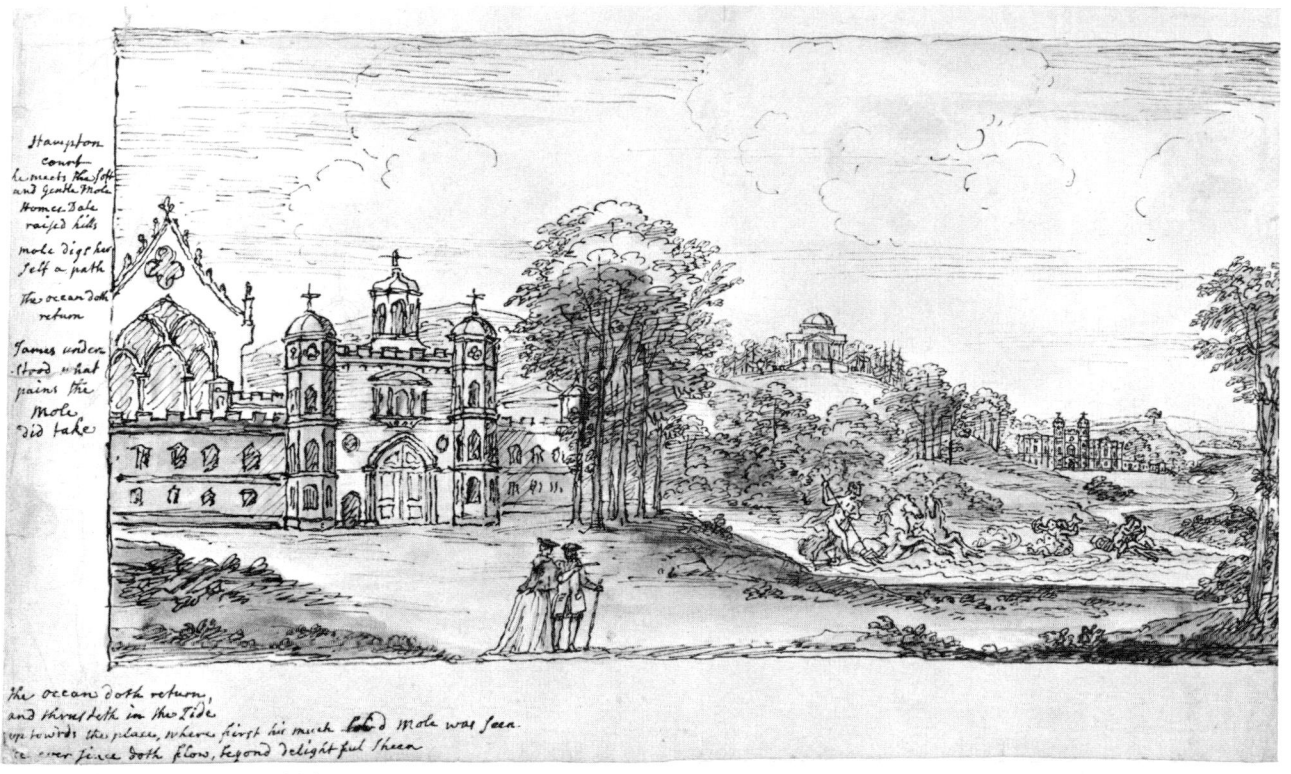

13A William Kent *Fanciful Landscape with Hampton Court and Esher Place*

Pen and brown ink and wash $7\frac{1}{4} \times 12\frac{1}{4}$, $18 \cdot 1 \times 31 \cdot 2$
British Museum, London. *See page 26*

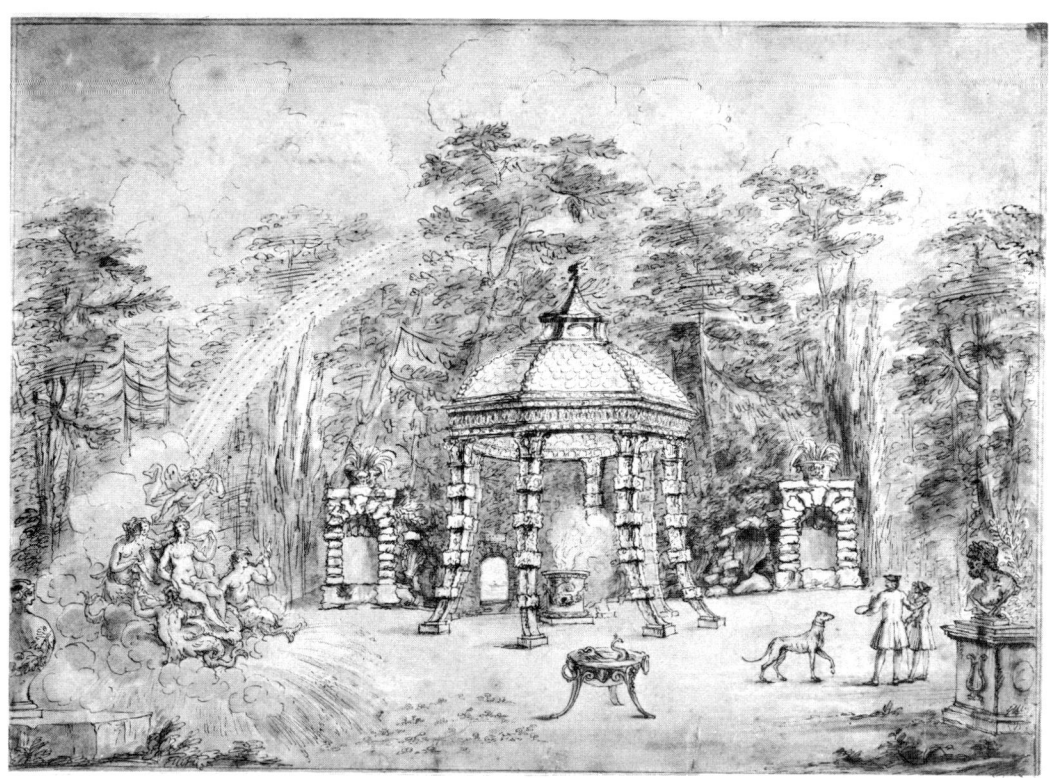

13B William Kent *A View in Pope's Garden, Twickenham*

Pen and ink and brown wash $11\frac{3}{8} \times 15\frac{5}{8}$, $29 \times 39 \cdot 7$
British Museum, London. *See page 26*

14 Bernard Lens *View of Gloucester* Pen and ink and grey wash 14⅞ × 37¼, 37·8 × 94·6
Ashmolean Museum, Oxford (Sutherland Collection). *See page 27*

THE NORTH EAST PROSPECT OF RICHMOND, IN THE COUNTY OF YORK.

15 Samuel and Nathaniel Buck 'North East Prospect of Richmond, in the County of York', 1745 Pen and ink and grey wash $10\frac{5}{8} \times 31\frac{1}{4}$, 26.9×79.5
Ashmolean Museum, Oxford (Sutherland Collection). *See page 27*

16 Giovanni Antonio Canaletto *Whitehall and the Privy Garden from Richmond House*

Canvas 43 × 47, 109·2 × 119·4
The Duke of Richmond and Gordon, Goodwood, Chichester. *See page* 29

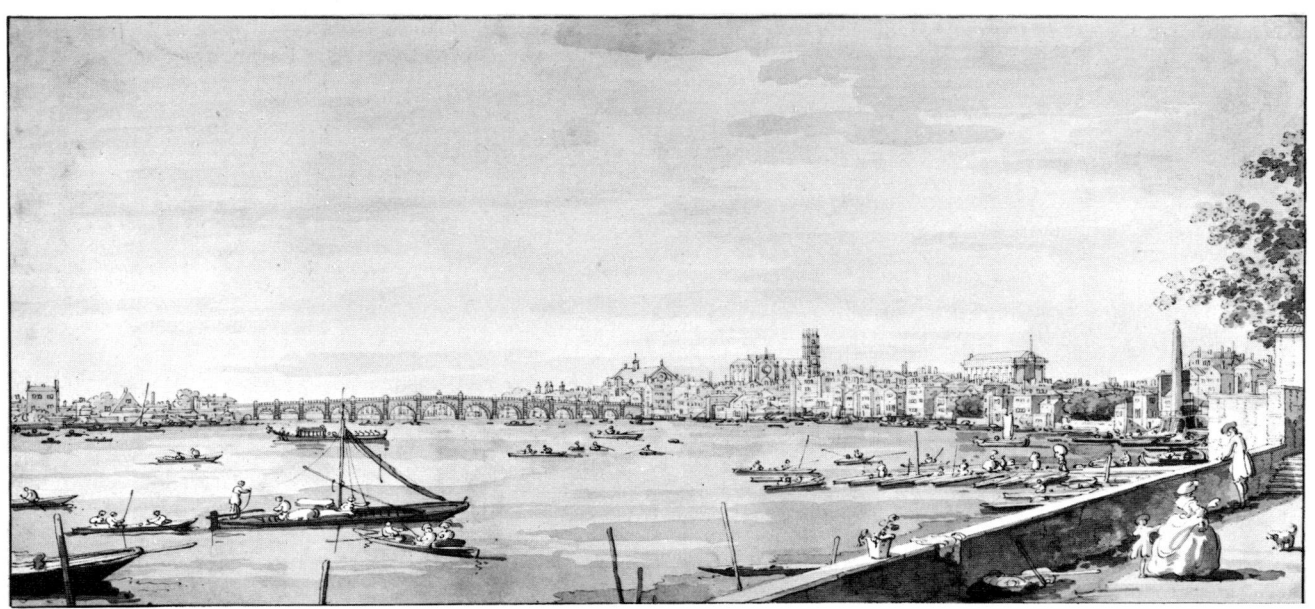

17 A Giovanni Antonio Canaletto *View of Westminster from the Terrace of Somerset House*
Pen in black/greyish ink with grey wash over pencil $10\frac{3}{4} \times 19\frac{1}{8}$, $27\cdot4 \times 48\cdot6$
The Royal Collection, Windsor Castle. (*Reproduced by gracious permission of Her Majesty The Queen*) *See page* 29

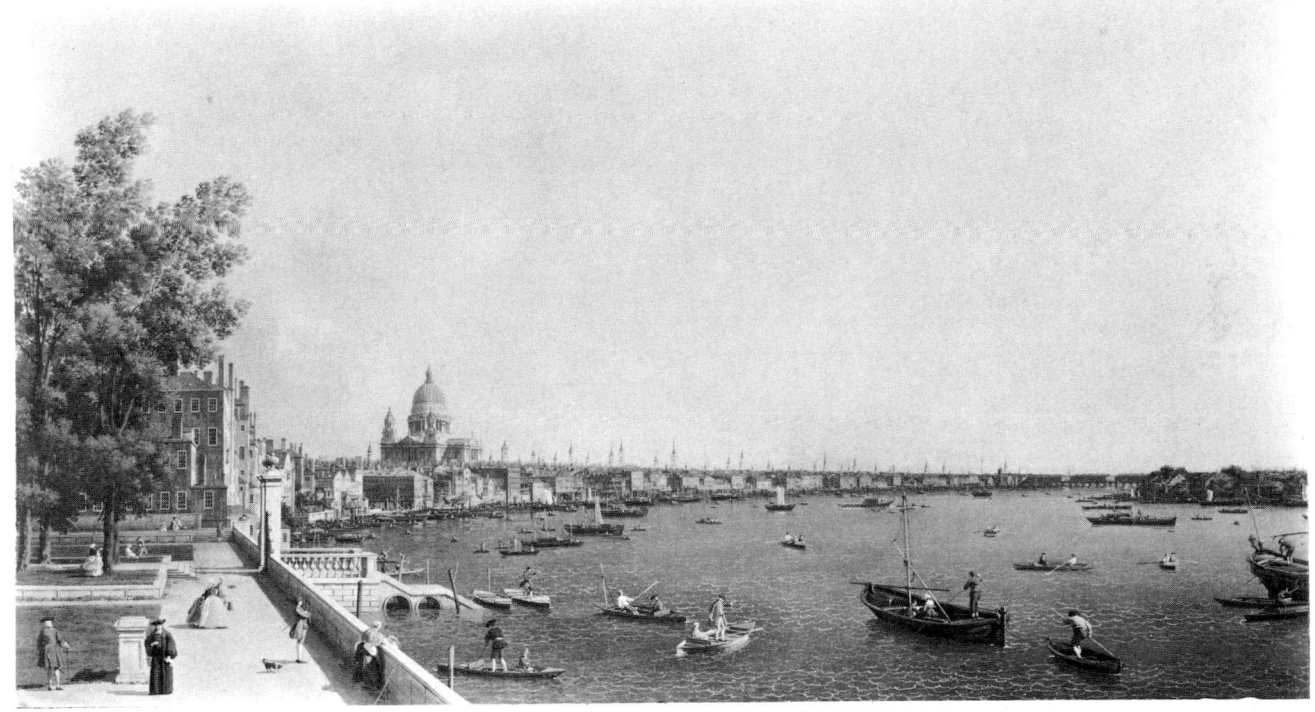

17 B Giovanni Antonio Canaletto *The Thames from Somerset House Terrace towards the City*
Canvas $42 \times 73\frac{5}{8}$, $106\cdot7 \times 187$
The Royal Collection, Windsor Castle. (*Reproduced by gracious permission of Her Majesty The Queen*) *See page* 29

Canvas 18¼×29¼, 46·4×75
Dulwich College Picture Gallery. *See page 30*

18 Giovanni Antonio Canaletto *Old Walton Bridge*

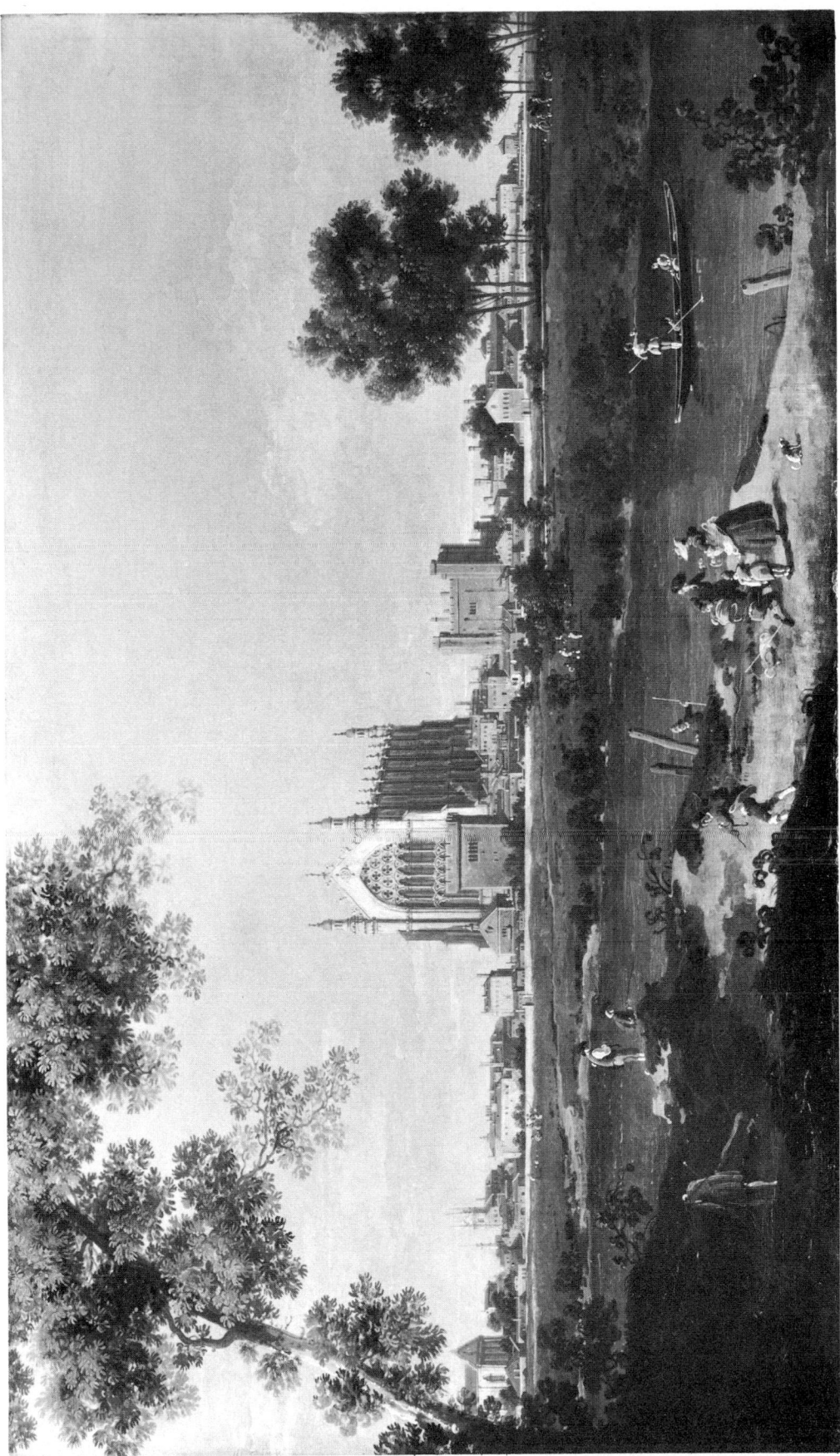

19 Giovanni Antonio Canaletto *Eton College*
Canvas $24\frac{1}{4} \times 42\frac{3}{4}$, $61 \cdot 6 \times 107 \cdot 7$
National Gallery, London. *See page 30*

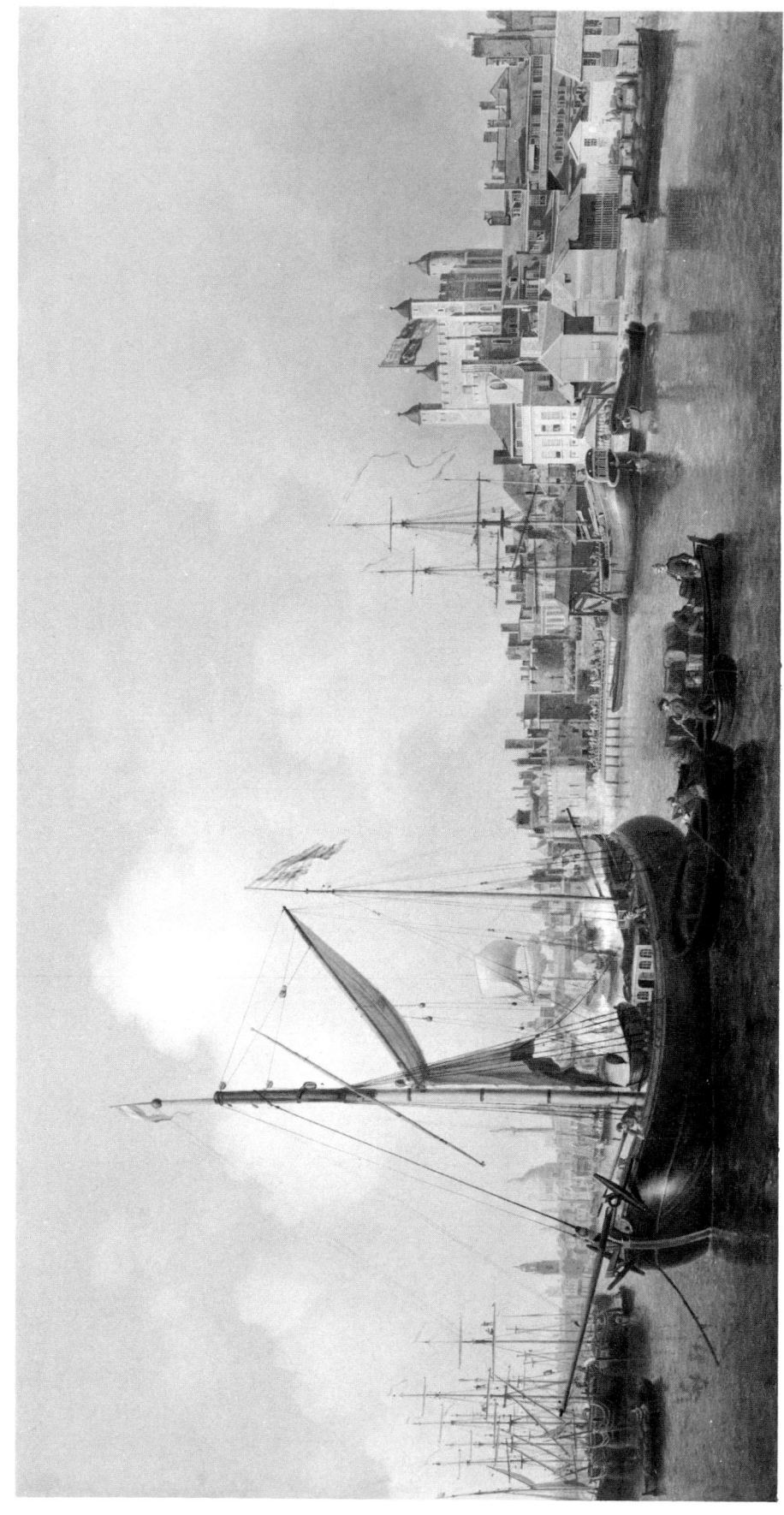

20 Samuel Scott *The Thames and the Tower of London on the King's Birthday*, 1771

Canvas $39\frac{3}{4} \times 76$, 101×193

Mr. and Mrs. Paul Mellon, Oak Spring, Virginia. *See page 32*

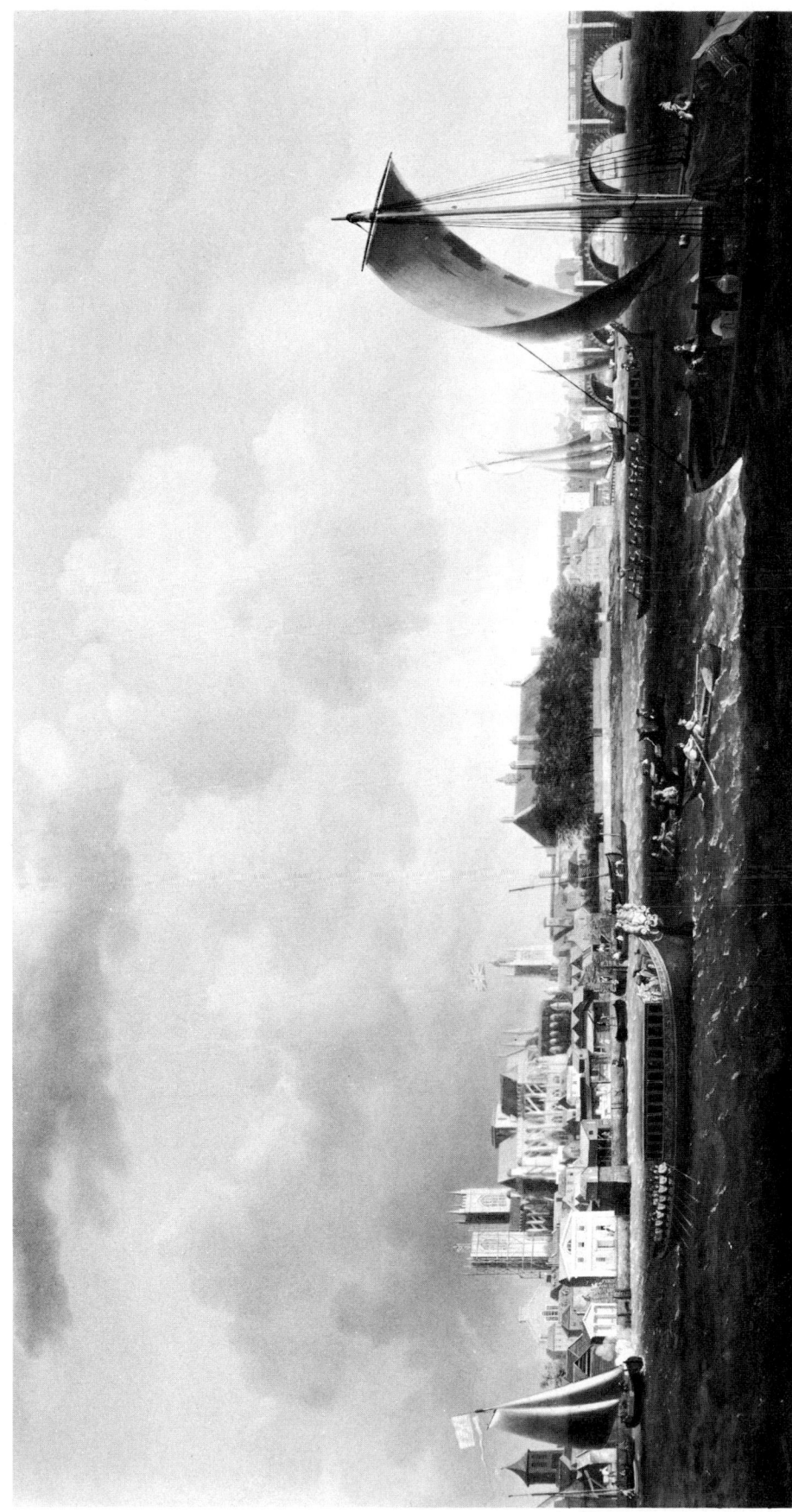

21 Samuel Scott *A View over the River towards Westminster*

Canvas $31\frac{1}{4} \times 59\frac{1}{4}$, 79.4×150.5
Mr. and Mrs. Paul Mellon, Oak Spring, Virginia. *See page 32*

22 Samuel Scott *Westminster Bridge*

Canvas $41\frac{3}{8} \times 46\frac{1}{2}$, $105 \times 118 \cdot 1$
Mr. and Mrs. Paul Mellon, Oak Spring, Virginia. *See page 32*

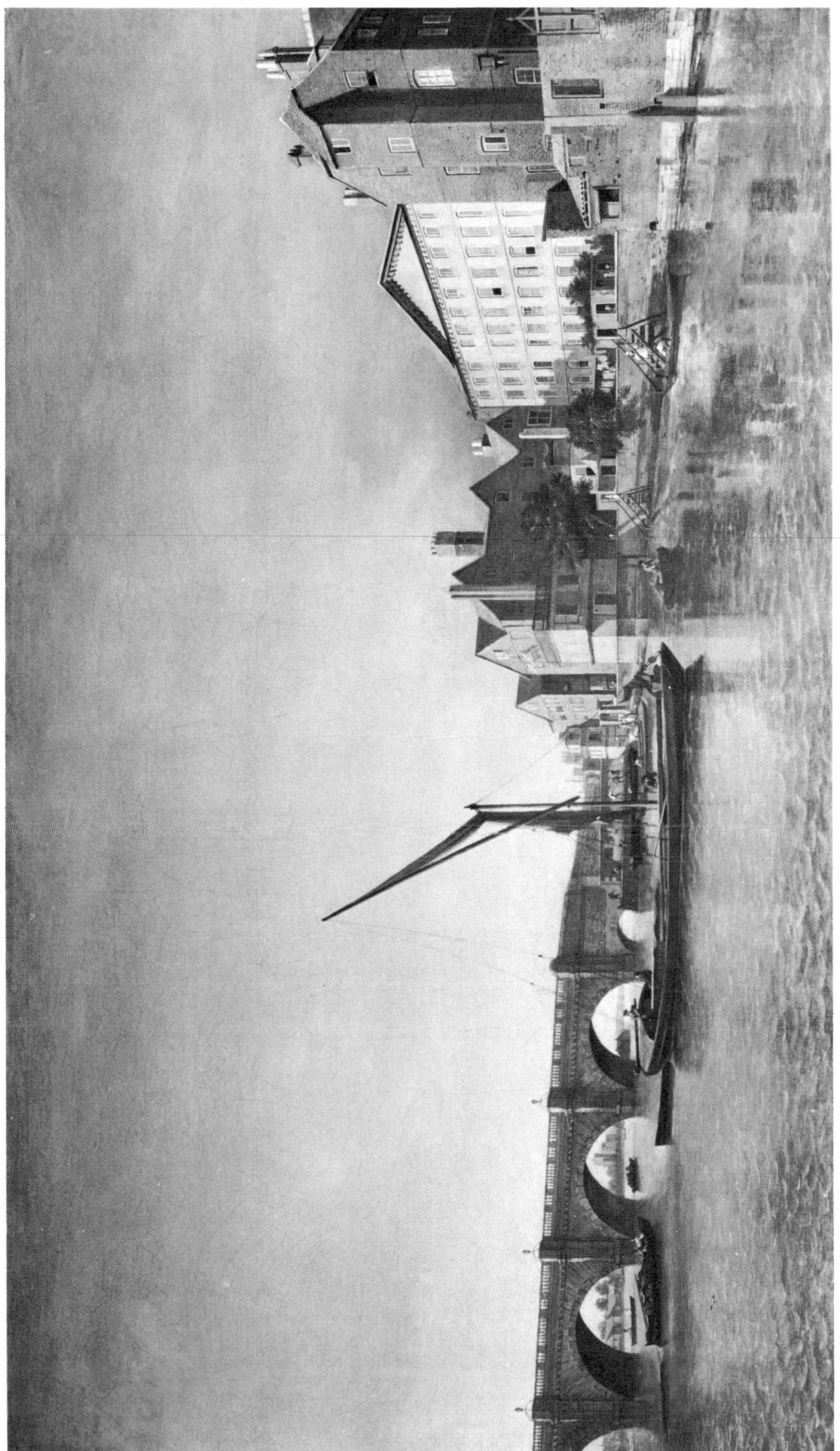

23 Samuel Scott *Westminster Bridge*, 1747

Canvas 27 × 45, 68·5 × 114·3
The Worshipful Company of Fishmongers, London. *See page 32*

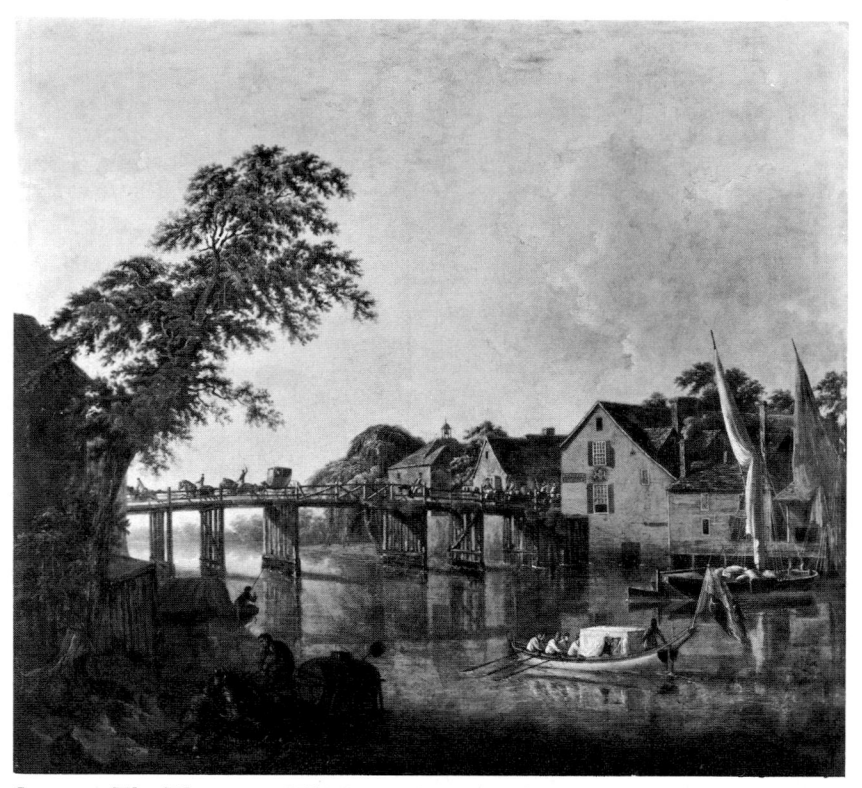

24A John Thomas Serres *The Thames at Windsor Bridge*, 1798 Canvas $43\frac{1}{8} \times 48$, $109 \cdot 5 \times 121 \cdot 9$
The Royal Collection, Windsor Castle. (*Reproduced by gracious permission of Her Majesty the Queen*) *See page 35*

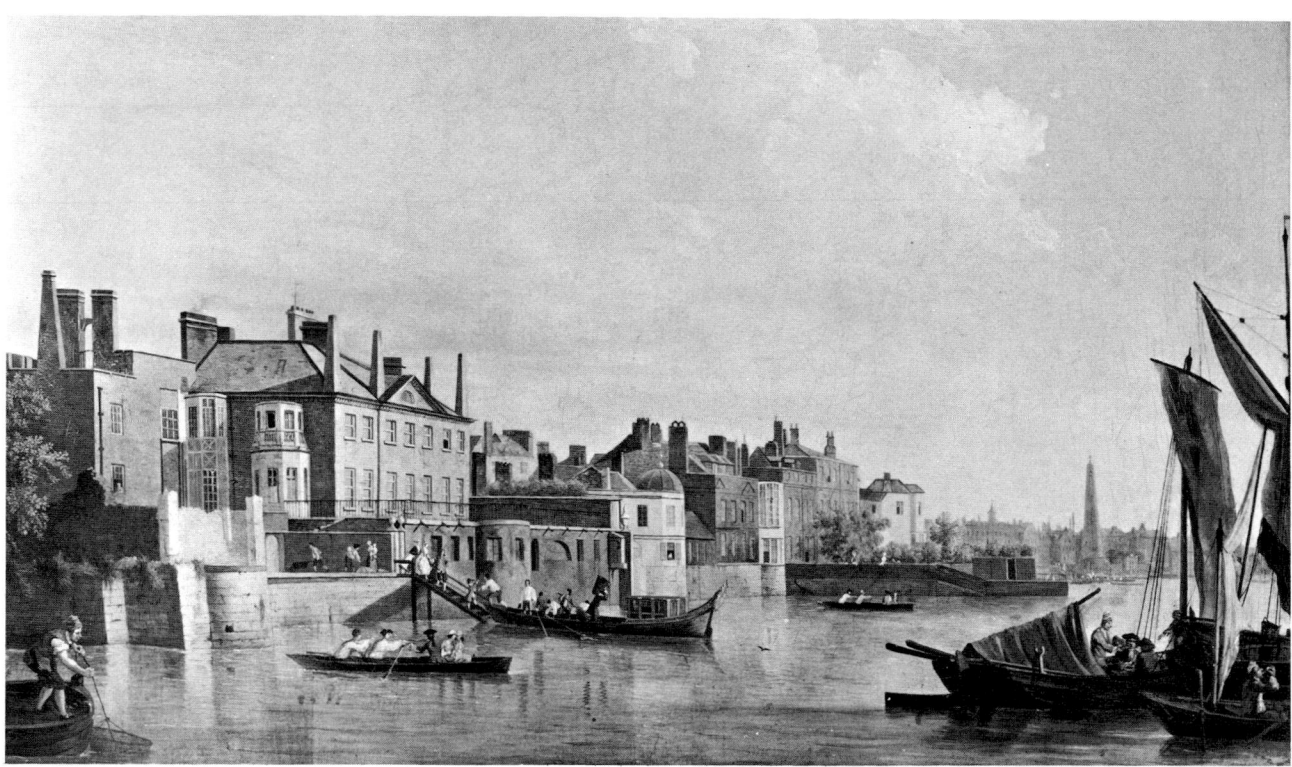

24B Samuel Scott *View on the Thames from a Point close to Westminster Bridge* Canvas $27 \times 46\frac{1}{2}$, $68 \cdot 5 \times 118 \cdot 1$
Guildhall Art Gallery, London. *See page 32*
For detail see Colour Plate II

25 A Samuel Scott *Study of Buildings by the Thames at Deptford* Pencil and grey wash 6¼ × 13⅛, 15·9 × 33·3
The Huntington Art Gallery, San Marino, California. *See page* 33

25 B Samuel Scott *The Thames at Deptford* Canvas 20½ × 37¾, 52·1 × 96
Tate Gallery, London. *See page* 33

26 E. Haytley *Chelsea Hospital*, 1746

Canvas 22, 55·9, diameter
Thomas Coram Foundation for Children, London. *See page* 35

27 Samuel Wale *Greenwich Hospital*, 1748 Canvas 21, 53·3, diameter
Thomas Coram Foundation for Children, London. *See page* 36

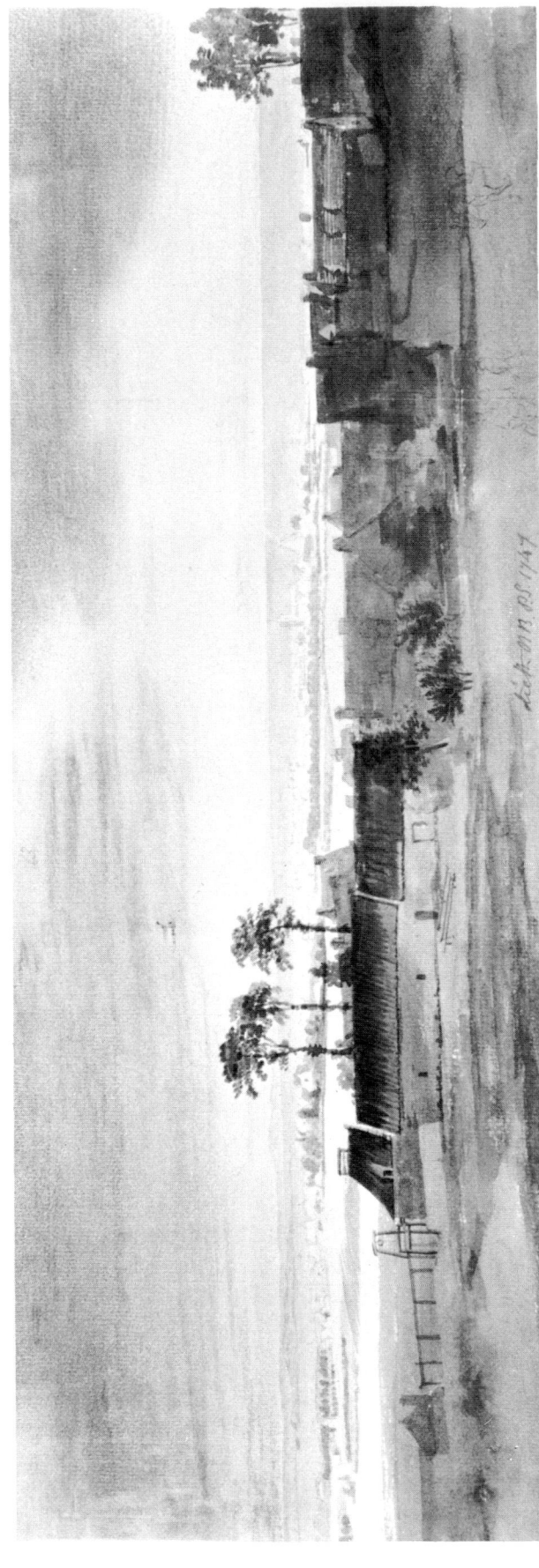

28 Paul Sandby *Leith*, 1747

Water-colours and pencil 6⅜ × 17⅞, 16·2 × 45·3
Ashmolean Museum, Oxford (Sutherland Collection). *See page 38*

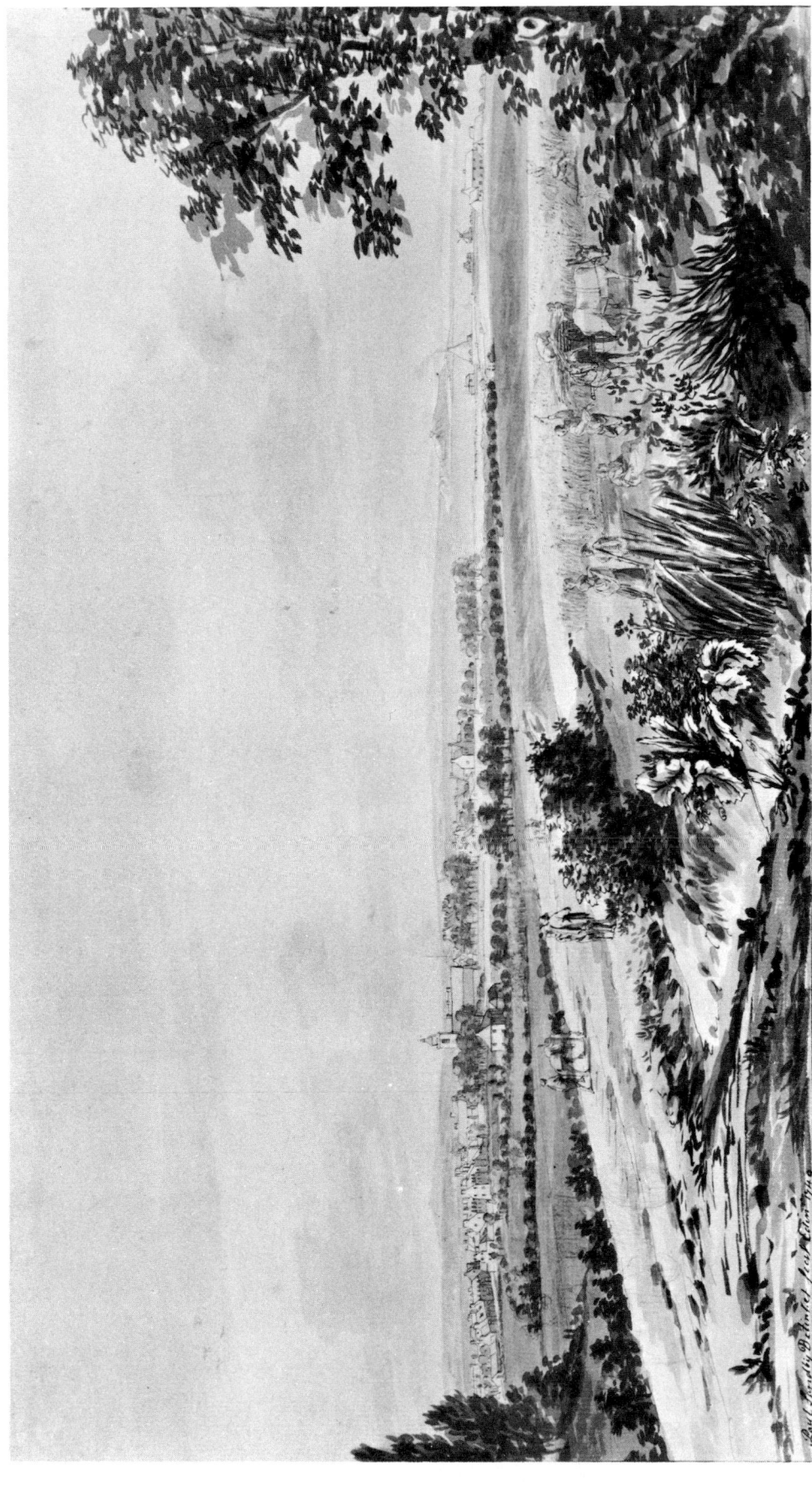

29 Paul Sandby *South Prospect of Leith*, 1749

Water-colours, pen and ink, and some indications in pencil $8\frac{5}{8} \times 15\frac{3}{8}$, $21\cdot9 \times 39\cdot1$
Ashmolean Museum, Oxford (Sutherland Collection). *See page* 38

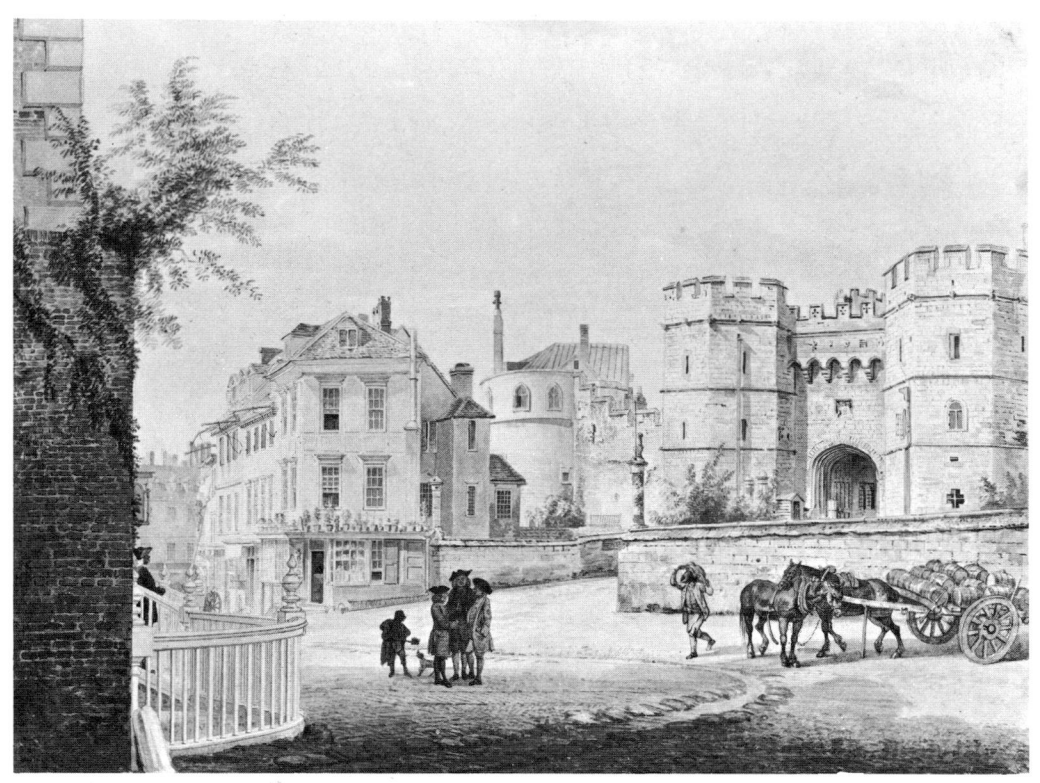

30 A Paul Sandby *Henry VIII Gateway from Castle Hill, with Houses to left and Salisbury Tower beyond*
Pencil, pen and water-colours, some gouache $12 \times 15\frac{3}{4}$, 30.5×40
The Royal Collection, Windsor Castle. (*Reproduced by gracious permission of Her Majesty The Queen*) *See page* 39

30 B Thomas Sandby *Old Somerset House, the Garden Front* Pen and water-colours $20\frac{7}{8} \times 29\frac{1}{2}$, 53×75
The Royal Collection, Windsor Castle. (*Reproduced by gracious permission of Her Majesty The Queen*) *See page* 39

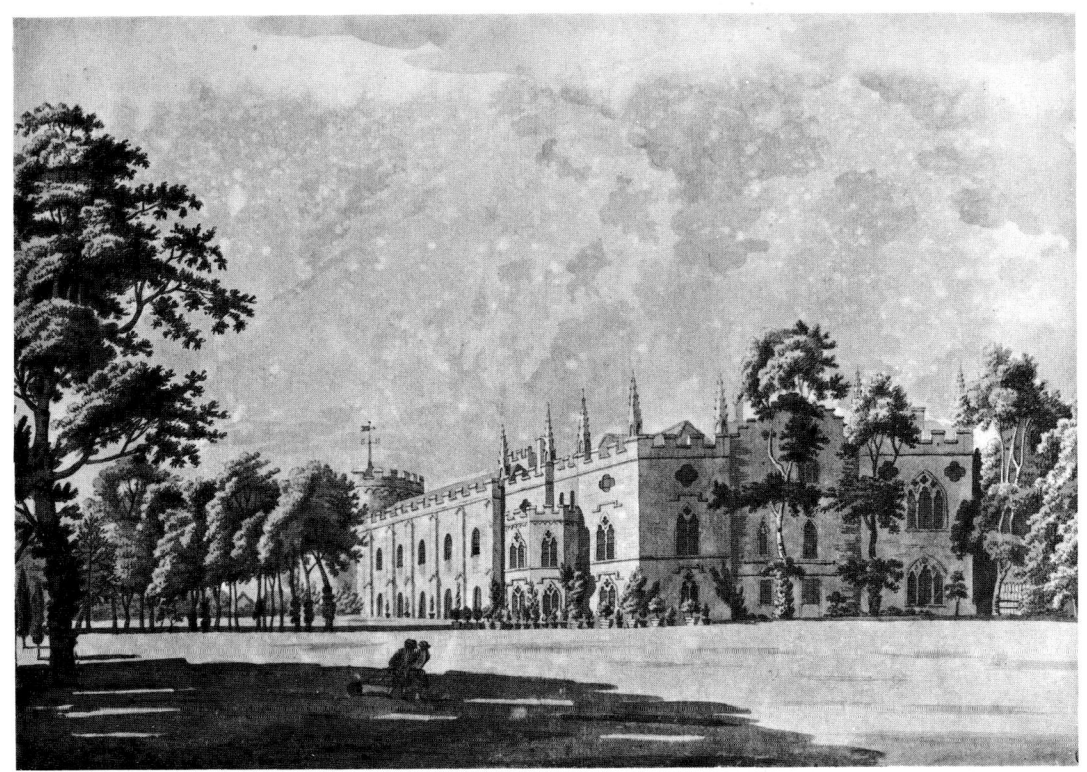

31 A Paul Sandby *View of Strawberry Hill, Twickenham* Water-colours and pen and ink 10 × 14, 25·4 × 35·5
Castle Museum and Art Gallery, Nottingham. *See page* 39

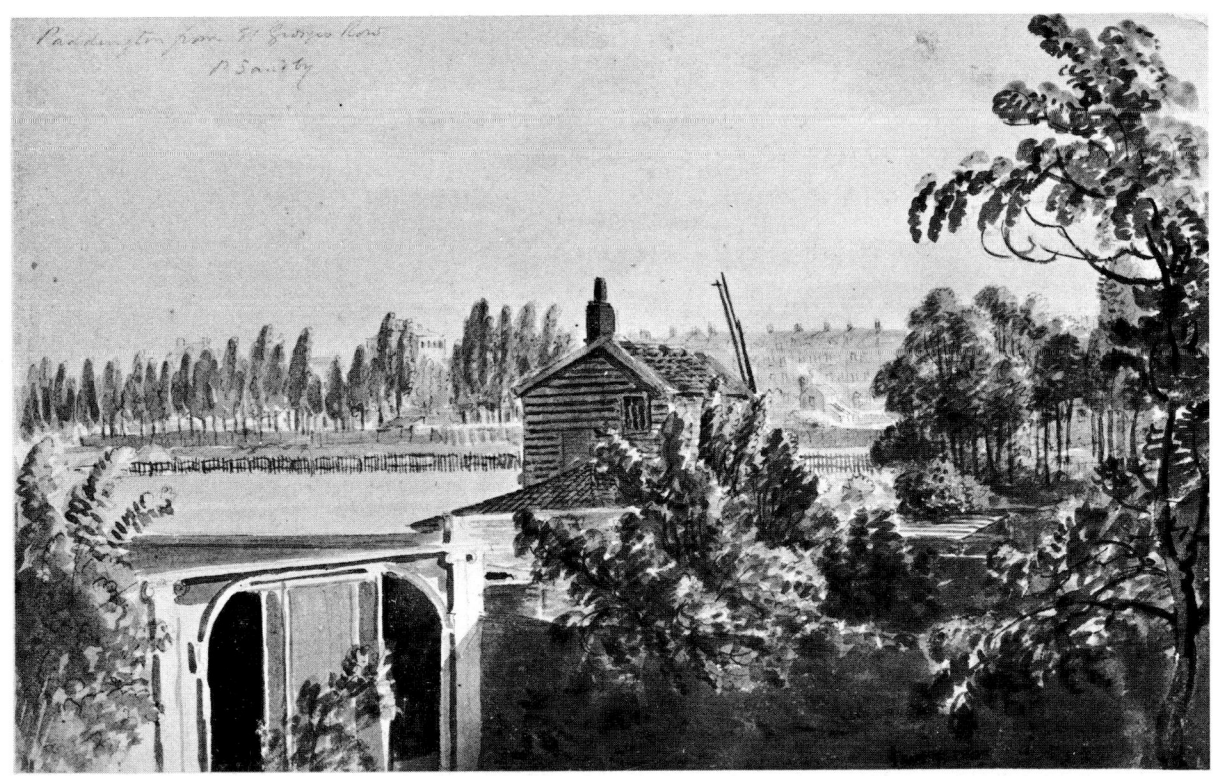

31 B Paul Sandby *'Paddington from St. George's Row'* Water-colours 7 × 11¼, 17·8 × 28·5
British Museum, London. *See page* 39

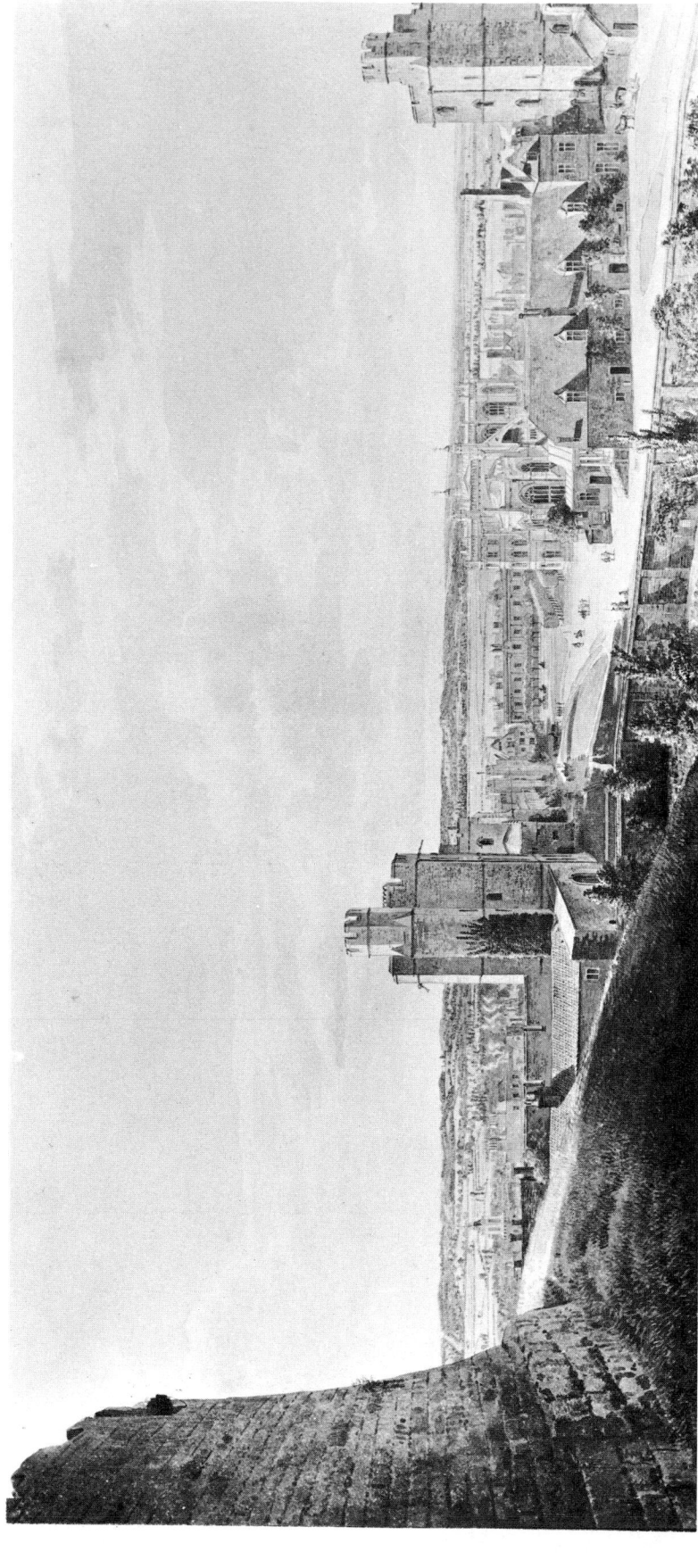

32　Paul Sandby　*Windsor, a General View Westward from the Base of the Curtain of the Round Tower*　Pencil, pen and water-colours　$11\frac{1}{4} \times 24$, $28\cdot5 \times 61$
The Royal Collection, Windsor Castle. *(Reproduced by gracious permission of Her Majesty The Queen) See page 39*
For detail see Colour Plate III

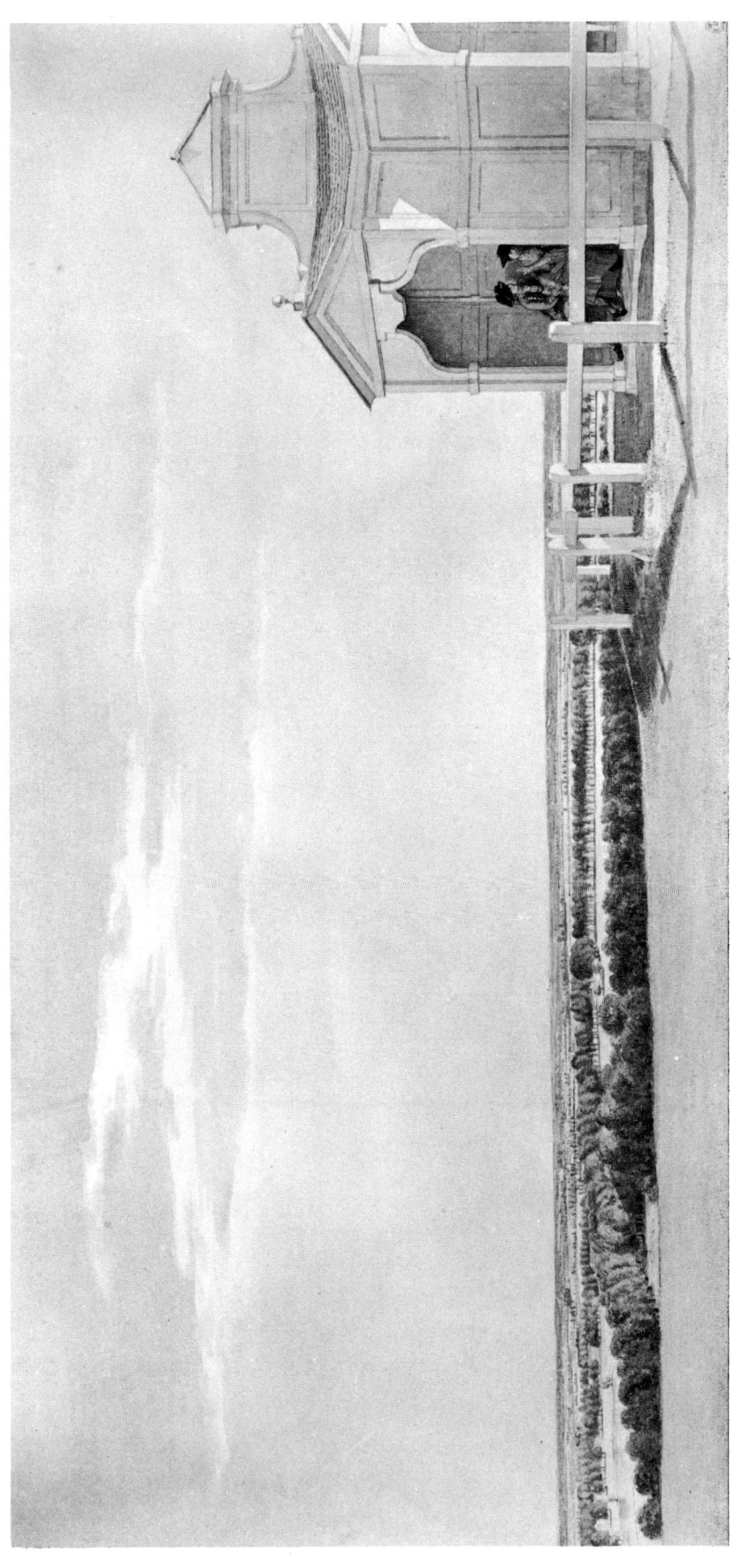

33 Paul Sandby 'Windsor, View of the Seat near the Terrace and a View of the adjacent Country'
Pencil and water-colours, with some body-colour $10\frac{7}{8} \times 22\frac{1}{2}$, 27.7×57.1
The Royal Collection, Windsor Castle. (Reproduced by gracious permission of Her Majesty The Queen) See page 39

34 A Paul Sandby *Gate of Coverham Abbey, Coverdale, Yorkshire, 1752*

Water-colours and body-colour $10\frac{3}{8} \times 15\frac{1}{4}$, $26\cdot4 \times 38\cdot8$
British Museum, London. *See page* 41

34 B Paul Sandby *Stormy Sea with Castle Ruins and Figures in the Foreground* Body-colour $11\frac{3}{4} \times 17\frac{3}{4}$, $29\cdot9 \times 45\cdot1$
City Art Gallery, Birmingham. *See page* 41

35 A Paul Sandby *The Timber Waggon*, 1796

Body-colour 26½ × 36¼, 67·3 × 92·1
Whitworth Art Gallery, Manchester. *See page* 43

35 B Paul Sandby '*Pont y Pair over the River Conway above Llanrwst in the County of Denbigh*'

Body-colour 7¾ × 10¾, 19·8 × 27·5
Mr. and Mrs. Paul Mellon, Oak Spring, Virginia. *See page* 42

36 Paul Sandby *In Windsor Park*, 1802 Grey wash and water-colours, over pencil 11¾ × 9½, 29·9 × 24·2
British Museum, London. *See page* 44

37 A Michael 'Angelo' Rooker *Buildwas Abbey, Shropshire*
Water-colours $8\frac{3}{8} \times 11\frac{1}{2}$, $24 \times 29\cdot3$
Ashmolean Museum, Oxford. *See page* 45

37 B Thomas Malton, junior *St. Paul's Church, Covent Garden*, 1787
Water-colours $12\frac{1}{2} \times 18\frac{5}{8}$, $31\cdot8 \times 47\cdot3$
Whitworth Art Gallery, Manchester. *See page* 46

38A Thomas Hearne *Wooded Glen at Downton, Herefordshire*
Pen and ink and wash 12⅝ × 13¾, 32·1 × 34·9
Victoria and Albert Museum, London. *See page* 45

38B Thomas Hearne *The Nave and East End of St. Peter's in the East, Oxford*, 1794
Water-colours over pencil 7½ × 10, 19 × 25·3
Ashmolean Museum, Oxford. *See page* 45

39 A Anthony Devis *Throstle's Nest, with Manchester in the Distance*

Water-colours over pencil $9\frac{7}{8} \times 11\frac{7}{8}$, $25 \cdot 1 \times 37 \cdot 7$
City Art Gallery, Manchester. *See page* 46

39 B Samuel Hieronymous Grimm *North Foreland Lighthouse*

Water-colours and pen and ink $9\frac{5}{8} \times 14\frac{3}{8}$, $24 \cdot 4 \times 36 \cdot 5$
Victoria and Albert Museum, London. *See page* 46

40 Edward Dayes *Tintern Abbey*, 1794 Water-colours over pencil 9¼×15½, 24·1×39·4
Whitworth Art Gallery, Manchester. *See page 47*

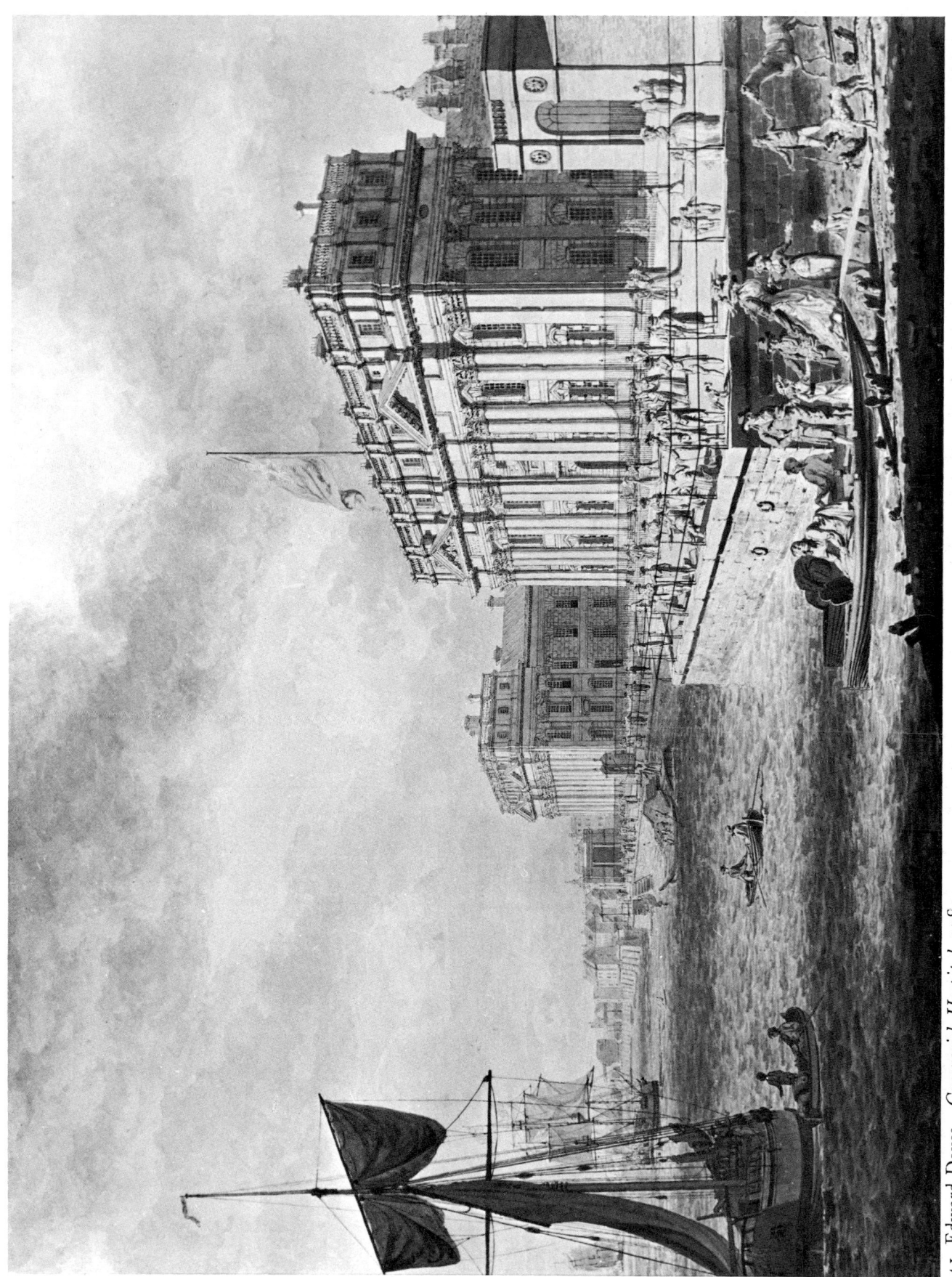

41 Edward Dayes *Greenwich Hospital*, 1789

Water-colours and pen and ink $17 \times 23\frac{3}{8}$, $43 \cdot 2 \times 59 \cdot 4$
Whitworth Art Gallery, Manchester. *See page 47*

42A Alexander Cozens *Landscape with Sun breaking through Clouds*
Grey, brown and greenish washes with black ink $8\frac{3}{8} \times 11\frac{1}{8}$, 21·3 × 28·2
British Museum, London. *See page 49*

42B Alexander Cozens *View in a Wood*, 1764
Pen and brown wash, on tinted paper $4\frac{1}{2} \times 6$, 11·4 × 15·2
The Huntington Art Gallery, San Marino, California. *See page 51*

43A Alexander Cozens *Ruin on a wooded Hill* (blot)
Dark grey ink $6\frac{1}{8} \times 7\frac{5}{8}$, 15·6 × 19·3
British Museum, London. *See page* 51

43B Alexander Cozens *Ruin on a wooded Hill*
Pen and ink and brown wash (slightly varnished) $6\frac{1}{4} \times 7\frac{5}{8}$, 16 × 19·3
British Museum, London. *See page* 51

44 A Richard Wilson '*The Vatican and Environs*'

Black chalk and stump on grey paper, heightened with white $11\frac{7}{8} \times 20\frac{3}{4}$, $30 \cdot 3 \times 52 \cdot 7$
Private Collection. *See page* 53

44 B Richard Wilson *River and Farmhouse* Canvas $16\frac{1}{4} \times 20\frac{1}{4}$, $41 \cdot 3 \times 51 \cdot 5$
Victoria and Albert Museum, London. *See page* 52

45 Richard Wilson *Pastoral Scene in the Campagna*

Canvas 27⅛ × 20⅛, 69 × 51
Ashmolean Museum, Oxford. *See page* 54

46 Richard Wilson *Italian Coast Scene with a Wreck*

Canvas $27\frac{1}{2} \times 42\frac{1}{2}$, 76·9 × 108
Private Collection. *See page 53*

47 Richard Wilson *Rome and the Ponte Molle*, 1754 Canvas 38 × 53, 96·5 × 134·6
National Museum of Wales, Cardiff. *See page 54*
For detail see Colour Plate V

48 A Richard Wilson *A Welsh Valley*

Pencil, black chalk and stump, on white paper $9\frac{3}{8} \times 14\frac{5}{8}$, $23 \cdot 8 \times 37 \cdot 2$
Ashmolean Museum, Oxford. *See page* 56

48 B Richard Wilson *A Welsh Valley with a Quarry*

Canvas $16\frac{1}{2} \times 20\frac{1}{2}$, 42×52
Tate Gallery, London. *See page* 56

49 A Richard Wilson *Pistyll Cain, Merioneth*
Canvas 68 × 66, 172·7 × 167·6
National Museum of Wales, Cardiff. *See page* 57

49 B Richard Wilson *Caernarvon Castle*
Canvas 24 × 48½, 61 × 123·2
National Museum of Wales, Cardiff. *See page* 57

50 Richard Wilson *Cader Idris, Llyn-y-Cau*

Canvas 19⅝ × 28⅜, 49·8 × 72·1
Tate Gallery, London. *See page 57*

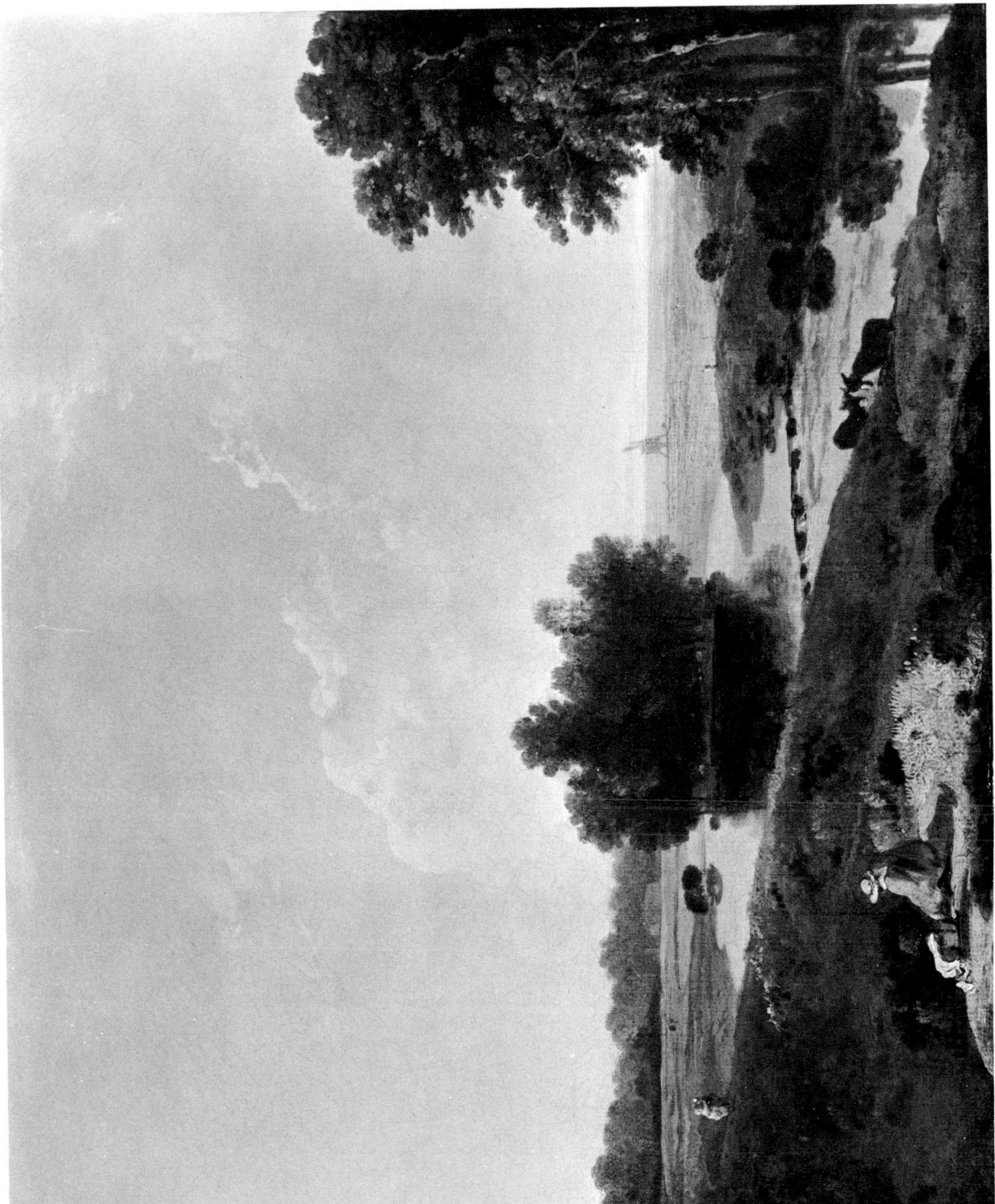

51 Richard Wilson *On Hounslow Heath*

Canvas $16\frac{3}{4} \times 20\frac{3}{4}$, $42 \cdot 5 \times 52 \cdot 7$
Tate Gallery, London. *See page* 58
For detail see Colour Plate VII

52 Richard Wilson *Sion House from Richmond Gardens*
Canvas 13½ × 16¾, 34·3 × 42·1
Brinsley Ford Collection, London. *See page 58*

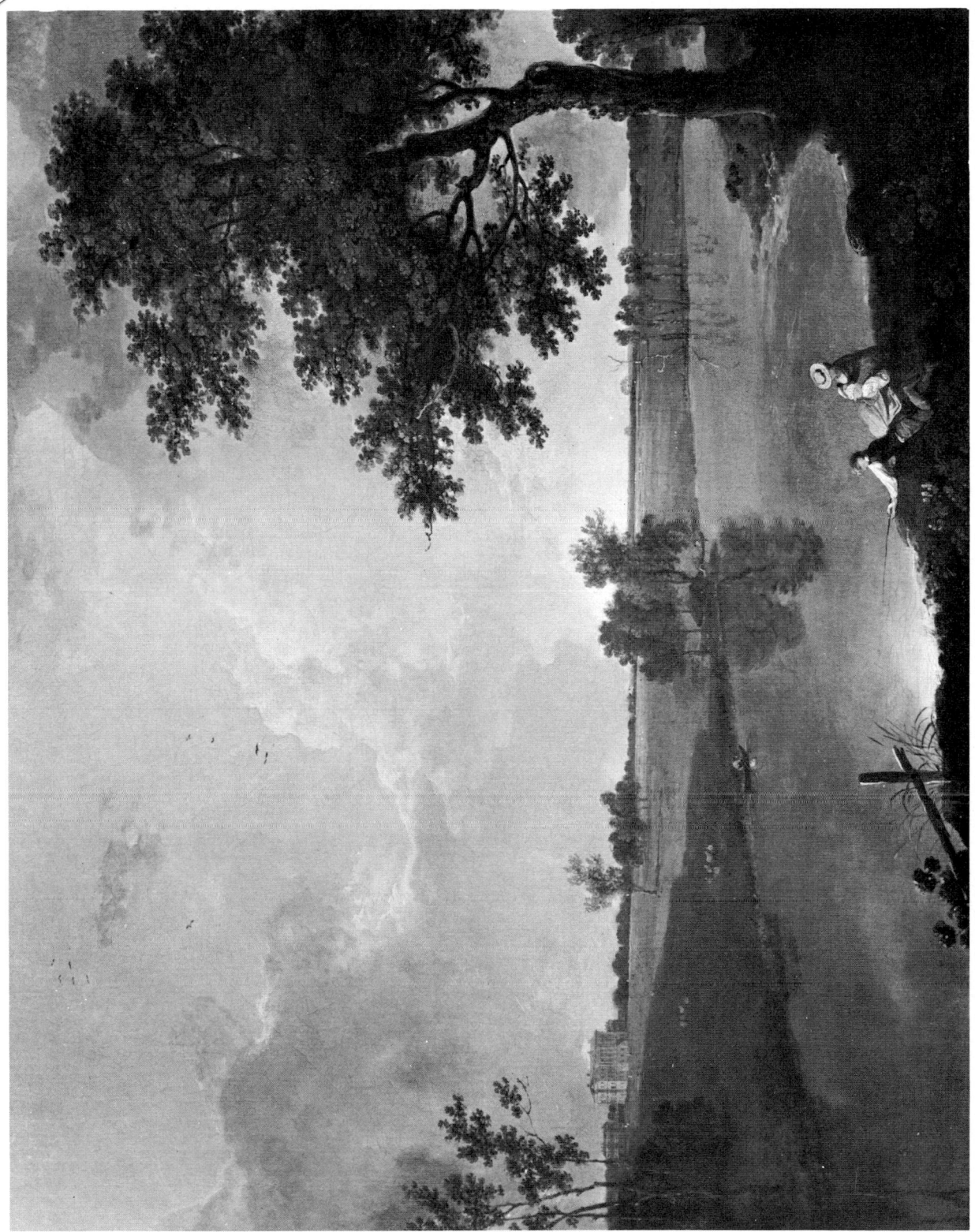

53 Richard Wilson *View of Tabley House, Cheshire, the Seat of Sir John Leicester*
Canvas 39½×49½, 100·4×125·8
Lord Ashton of Hyde, Moreton-in-Marsh. *See page 58*

54 Richard Wilson *Valley of the Mawddach, with Cader Idris* Canvas $39\frac{3}{4} \times 42$, $101 \times 106 \cdot 8$
Walker Art Gallery, Liverpool. *See page 59*

55 Richard Wilson *Solitude*, 1762

Canvas $39\frac{1}{4} \times 50\frac{3}{8}$, 100·4 × 128
Glynn Vivian Art Gallery, Swansea. *See page 59*

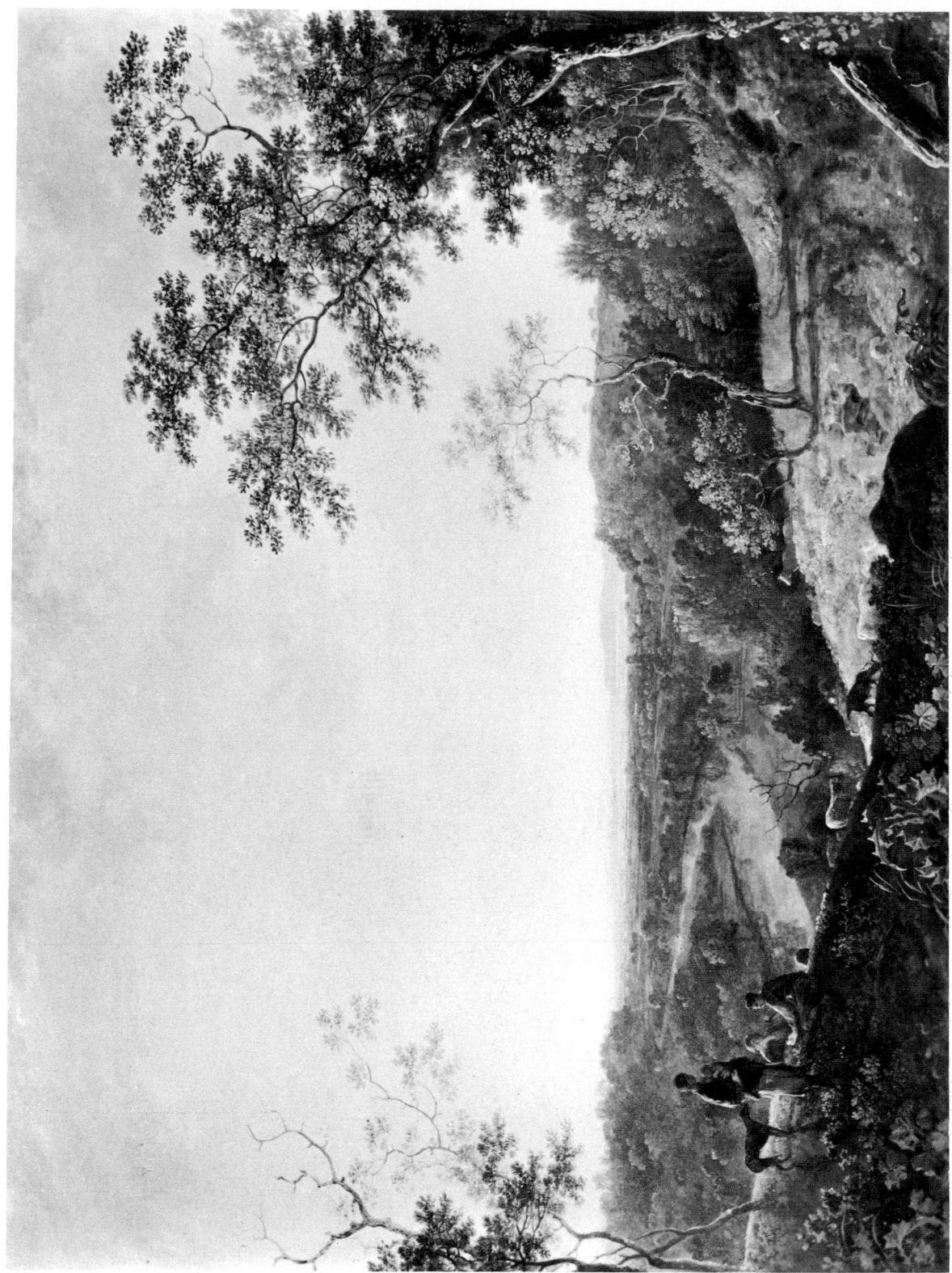

56 Richard Wilson *The Valley of the Dee*

Canvas 58¼×76¼, 148×193·7
Tate Gallery, London. *See page* 55

57 Richard Wilson *Lake Avernus and the Island of Ischia*

Canvas 18½ × 28½, 47 × 72·4
Tate Gallery, London. *See page 60*

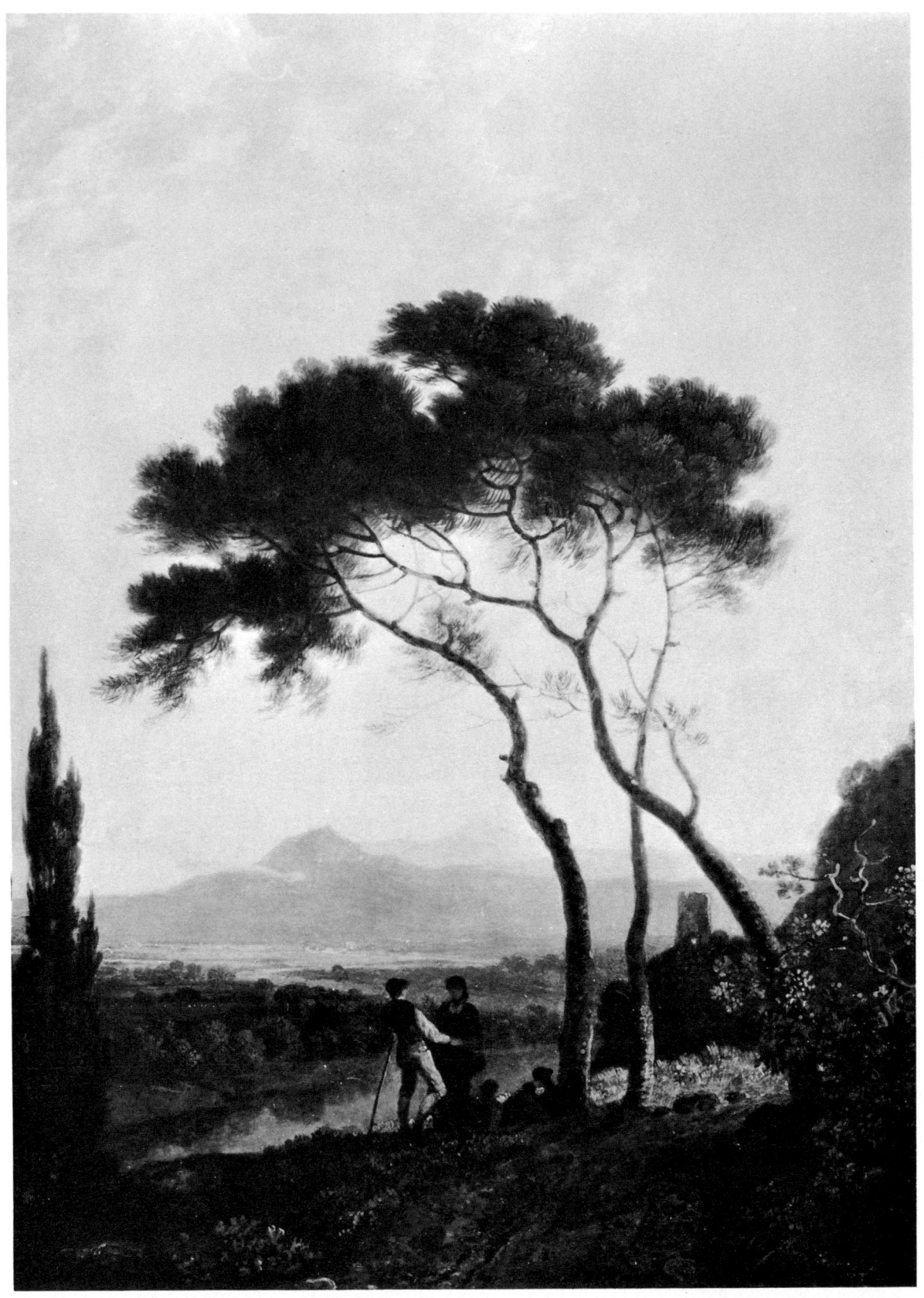

58 Richard Wilson *The Vale of Narni*

Canvas 26 × 19, 66 × 48·2
Brinsley Ford Collection, London. *See page* 60

59 George Barret *View of Dalkeith Park with the Town in the Distance* Canvas 91 × 78¾, 231·3 × 200
The Duke of Buccleuch and Queensberry, Bowhill. *See page 62*

60 George Barret and Sawrey Gilpin *Llyn Peris with Dolbadarn Castle, 1777* Canvas 48×67¼ 121·9×170·8
Castle Museum and Art Gallery, Nottingham. *See page 62*

61 William Marlow *Distant View of Bridlington Bay and Flamborough Head*

Canvas 30 × 50, 76·2 × 127

M. Wickham-Boynton, Esq., Burton Agnes Hall, Yorkshire. *See page 63*

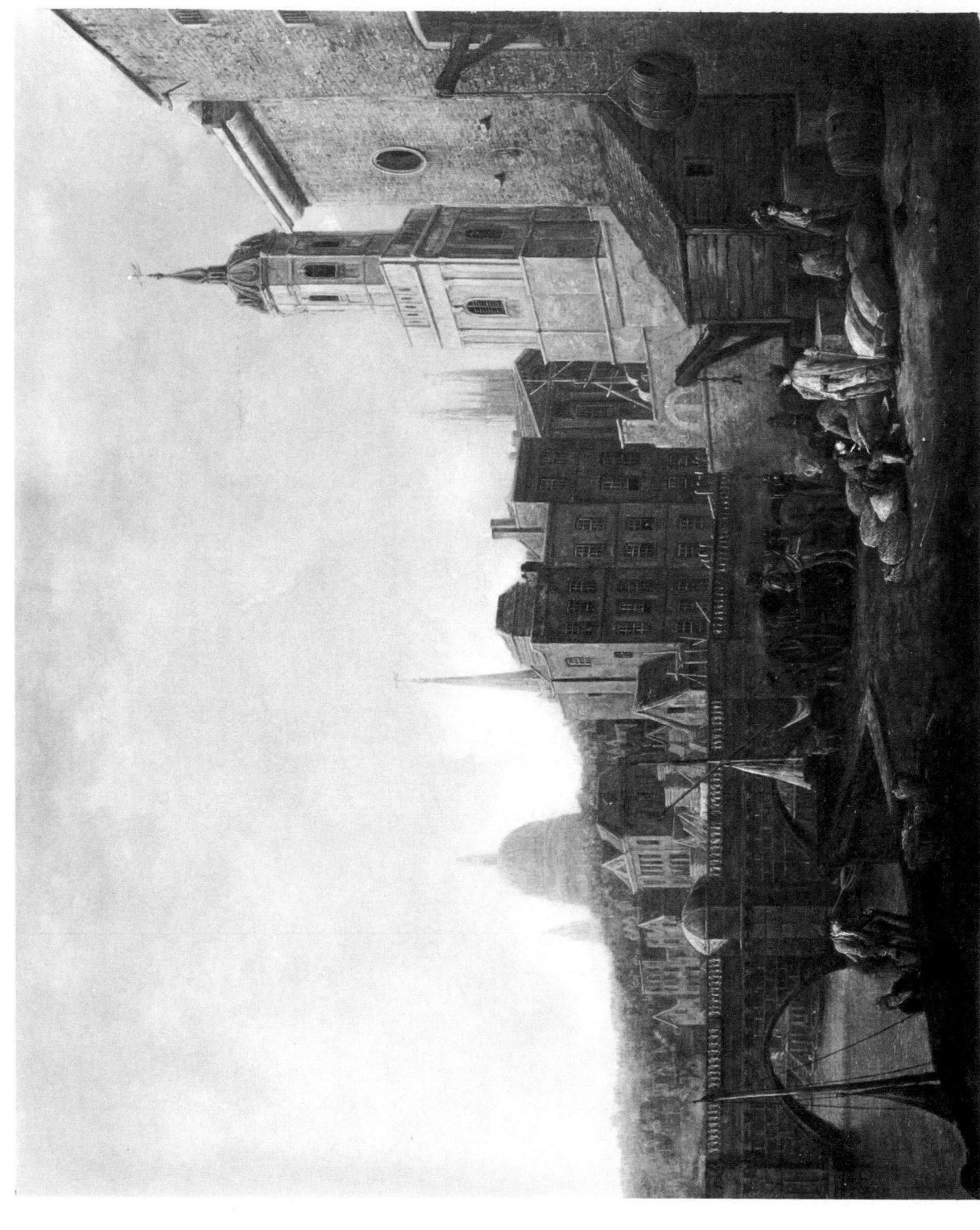

62 William Marlow *A View of London Bridge* Canvas 40×49¾, 101·6×126·4
The Royal Collection, Buckingham Palace. (*Reproduced by gracious permission of Her Majesty The Queen*) *See page 64*

63 William Marlow *View in Lyons* Canvas 19¼ × 25½, 49 × 64·8
City Art Gallery, Manchester. *See page 65*

64 William Marlow *Italian Landscape*

Canvas 28¾×38¾, 73×98·5
Fitzwilliam Museum, Cambridge. *See page 64*

65 Joseph Wright (of Derby) *Albano*

Canvas $39\frac{1}{4} \times 48$, 99.7×121.9
National Museum of Wales, Cardiff. *See page 90*

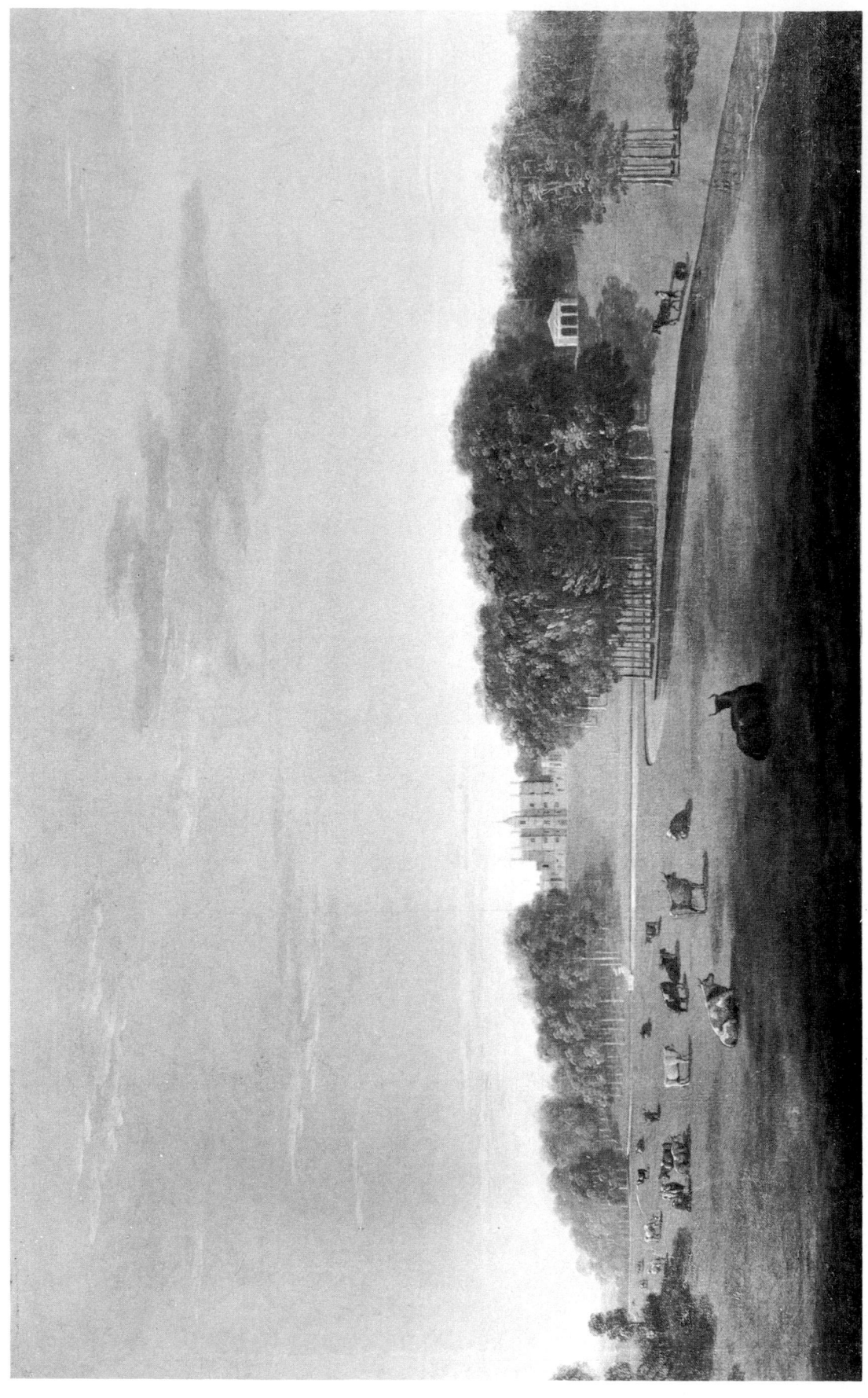

66 Thomas Jones *Rousham House, Oxford*, 1773 Canvas 24×36, 61×91·5
C. Cottrell-Dormer, Esq., Rousham House, Oxford. *See page 67*

67 John Inigo Richards *Chepstow Castle*

Canvas 31 × 43, 78·8 × 109·2
National Museum of Wales, Cardiff. *See page 66*

68A Thomas Jones *Buildings in Naples, 1782*

Canvas 5½×8½, 14×21·6
National Museum of Wales, Cardiff. *See page* 68

68B Thomas Jones *'Pencerrig'*, 1772

Canvas 9×12, 22·9×30·5
National Museum of Wales, Cardiff. *See page* 66

69 A Jacob More *Rape of Deianira*, 1786

Board 40 × 54, 101·6 × 137·2
Present whereabouts unknown. *See page* 70

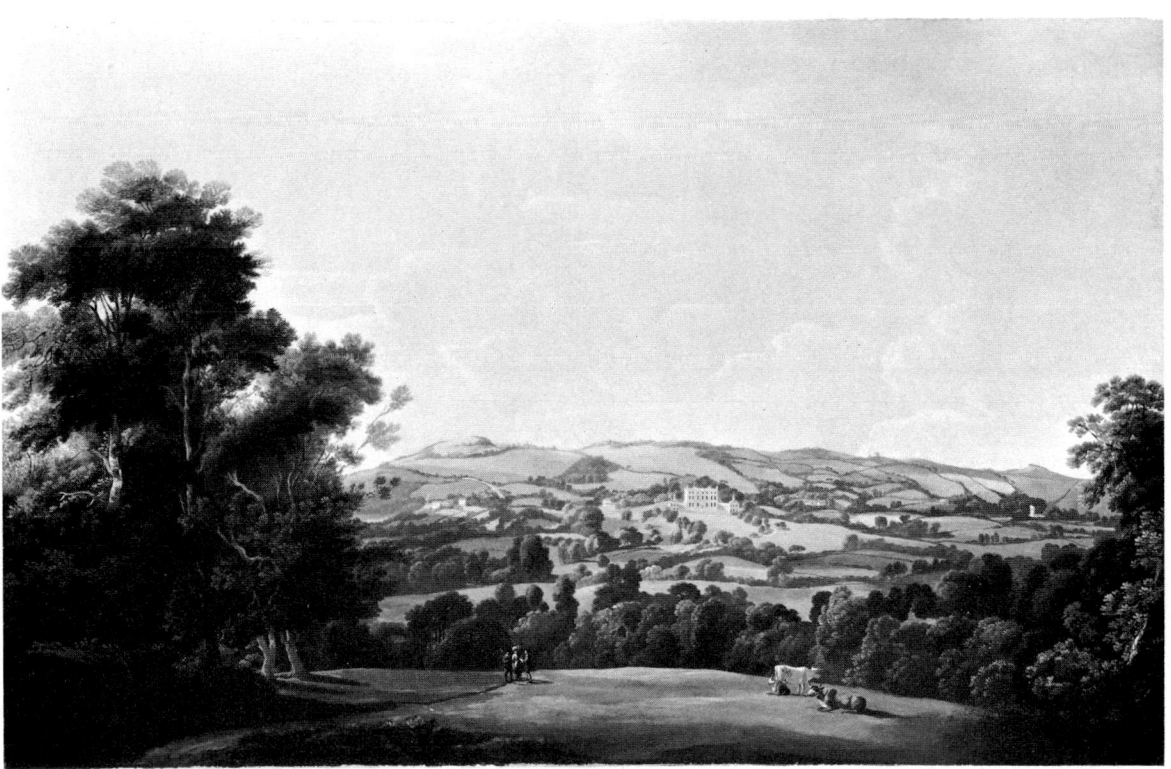

69 B Francis Towne *View of Haldon Hall, near Exeter*, 1780

Canvas 32⅛ × 50⅛, 81·6 × 127·3
Tate Gallery, London. *See page* 75

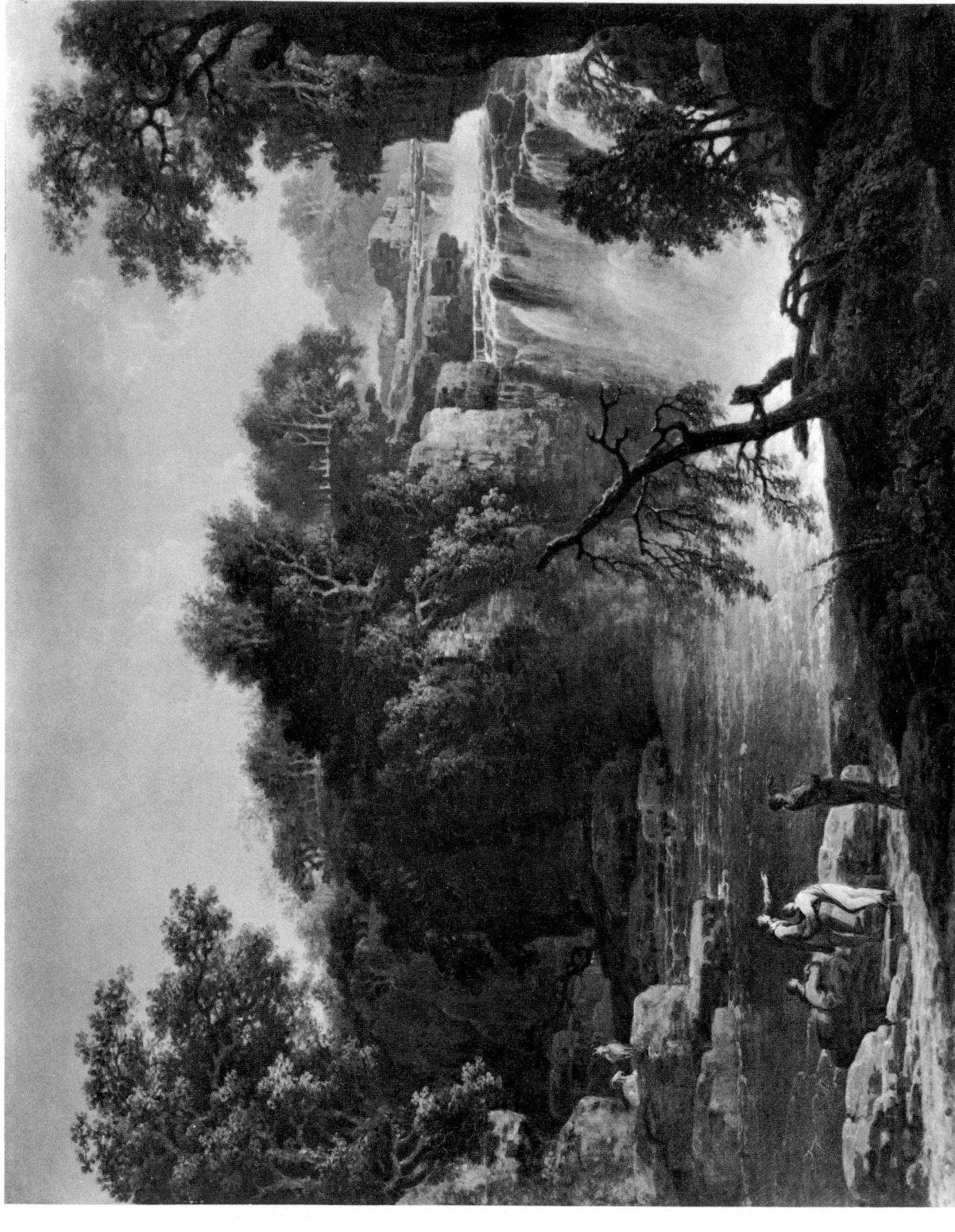

70 Jacob More *The Falls of Clyde*

Canvas 31¼ × 39½, 79·4 × 100·3
National Gallery of Scotland, Edinburgh. *See page 70*

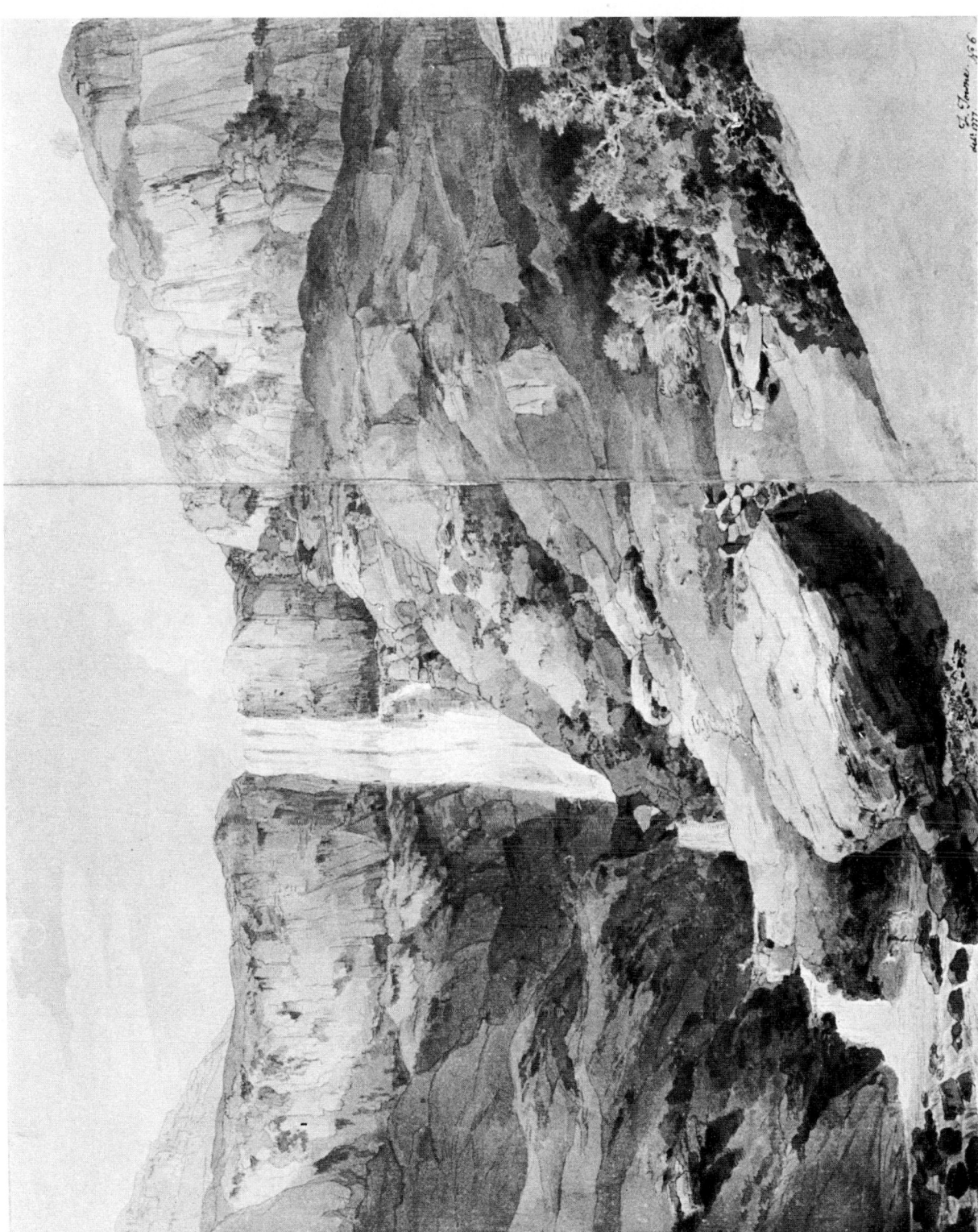

71 Francis Towne *Pistyll Rhaiadr*, 1777

Pen and ink and water-colours $11\frac{3}{4} \times 14\frac{3}{4}$, $30 \times 37 \cdot 5$
Mrs. M. Spooner, London. *See page 76*

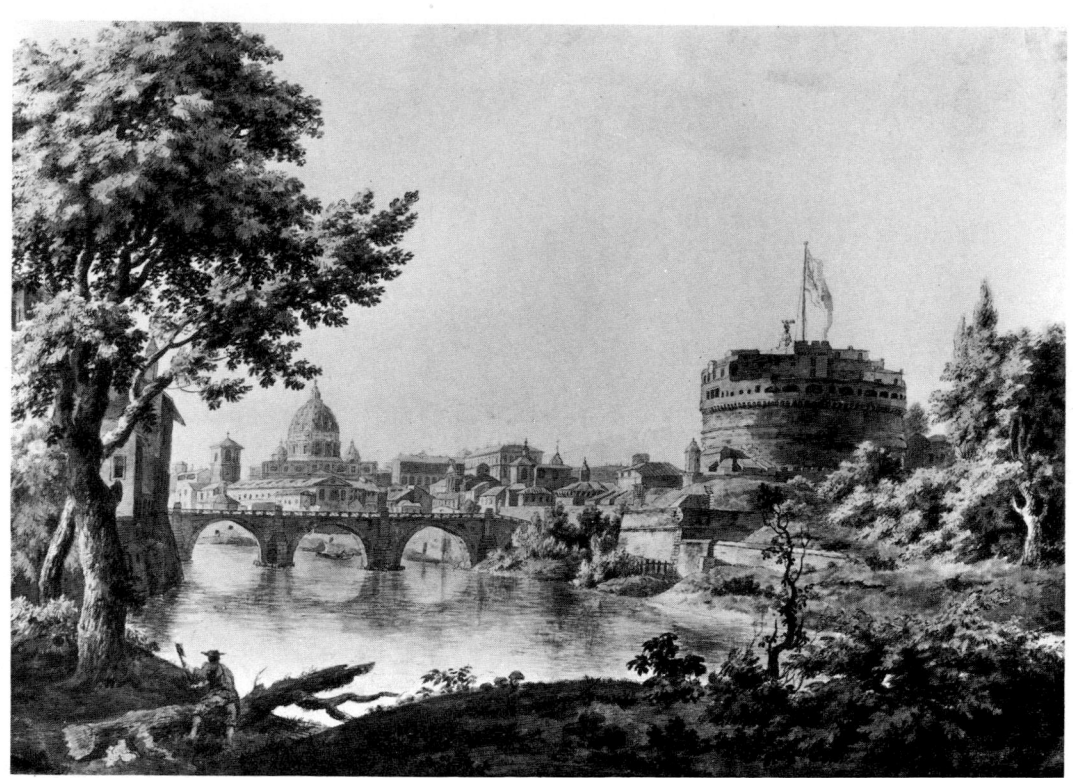

72A Jonathan Skelton *Castle and Bridge of Sant'Angelo, Rome*, 1758

Pen and ink and water-colours $14\frac{1}{2} \times 20\frac{7}{8}$, 37×53
Victoria and Albert Museum, London. *See page* 72

72B Jonathan Skelton *Villa of Maecenas, Tivoli*, 1758

Pen and ink and water-colours $15 \times 21\frac{1}{2}$, $38\cdot1 \times 54\cdot6$
City Art Gallery, Birmingham. *See page* 72

73A William Pars *The Temple of Venus, Rome*

Pen and ink and water-colours 12 × 16½, 30·5 × 42
Mr. and Mrs. Paul Mellon, Oak Spring, Virginia. *See page* 73

73B John 'Warwick' Smith *'Tomb of the Plantian Family, near Tivoli, and Ponte Lucano'*, 1795

Water-colours 5 × 7½, 12·8 × 19·2
Ashmolean Museum, Oxford. *See page* 74

74A John 'Warwick' Smith *The Temples of Saturn and Vespasian, Rome*
Water-colours over pencil 18 × 28, 45·7 × 71·1
British Museum, London. *See page* 73

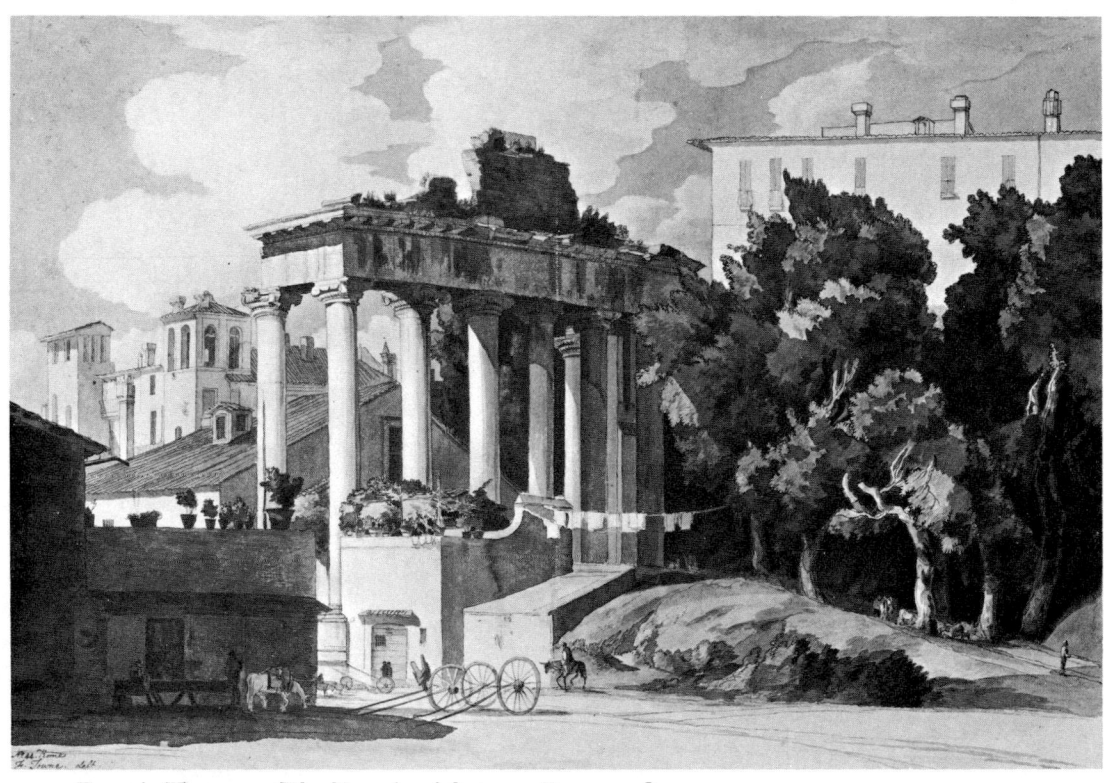

74B Francis Towne *The Temple of Saturn, Rome*, 1781
Pen and ink and water-colours 12⅝ × 19, 32 × 48·2
British Museum, London. *See page* 76

75 A Francis Towne *Near Naples*, 1781 Pen and ink and water-colours $12\frac{5}{8} \times 18\frac{1}{2}$, 32×47
British Museum, London. *See page 77*
For detail see Colour Plate IX

75 B John Robert Cozens *View on the Galleria di Sopra, above the Lake of Albano*
Water-colours $14\frac{3}{8} \times 20\frac{5}{8}$, $36 \cdot 5 \times 52 \cdot 4$
Williamson Art Gallery and Museum, Birkenhead. *See page 87*

76 Francis Towne *The Source of the Arveiron; Mont Blanc in the Distance, 1781*

Pen and ink and water-colours 16¾ × 12¼, 42·5 × 31·1

Victoria and Albert Museum, London. *See page 78*

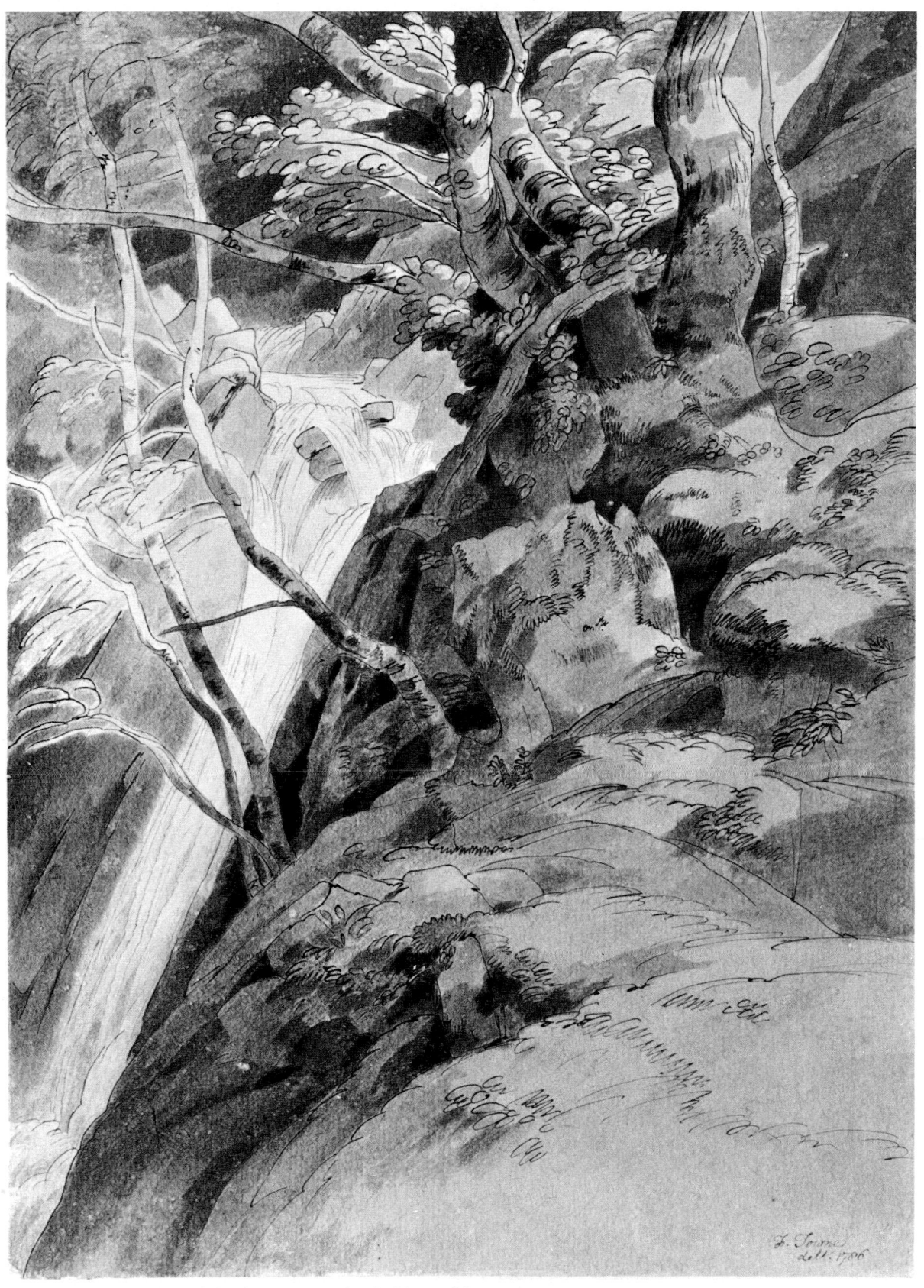

77 Francis Towne *The Cascade at Ambleside*, 1786

Pen and ink and water-colours $14\frac{3}{4} \times 10\frac{3}{8}$, $37\cdot7 \times 26\cdot5$
Ashmolean Museum, Oxford. *See page* 78

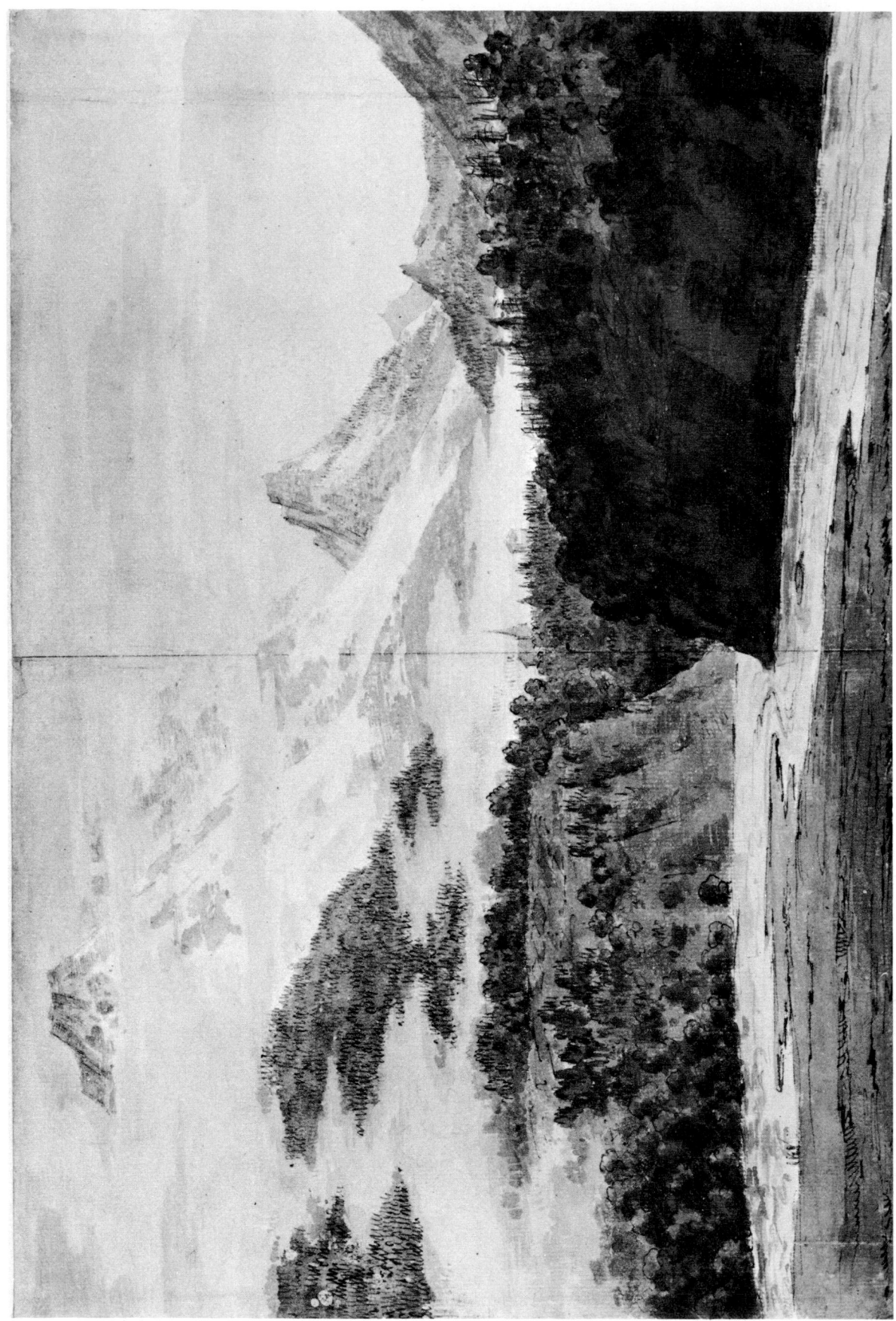

78 John Robert Cozens *Mont Blanc and the Arve near Sallanches*, 1776
Pencil, pen and ink and washes $9\frac{1}{8} \times 13\frac{7}{8}$, $23\cdot4 \times 35\cdot5$
British Museum, London. *See page 85*

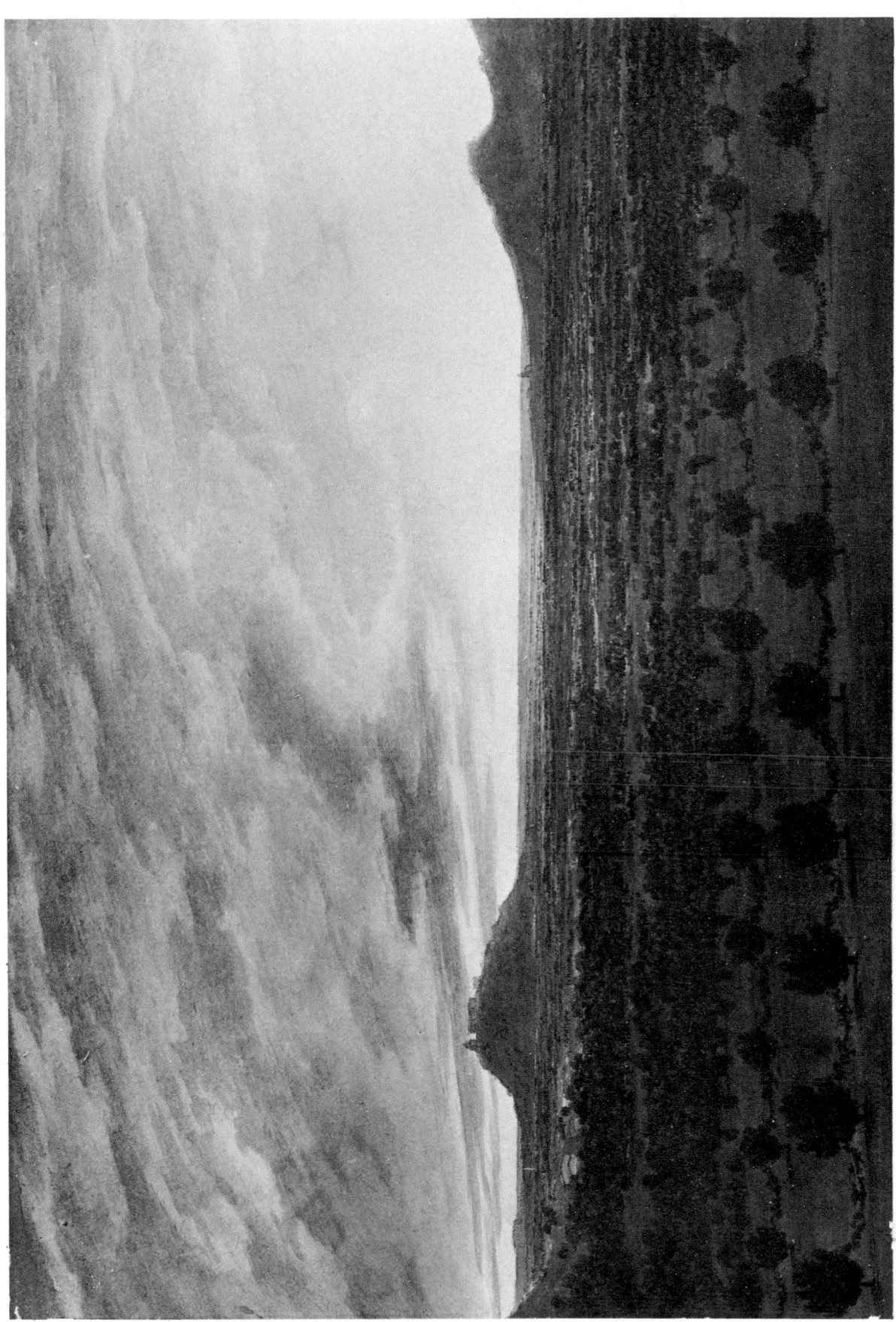

79 John Robert Cozens *View from Mirabella, the Villa of Count Algarotti on the Euganean Hills,* 1782 Water-colours $9\frac{7}{8} \times 14\frac{3}{4}$, $25 \times 37 \cdot 4$
Victoria and Albert Museum, London. *See page 88*

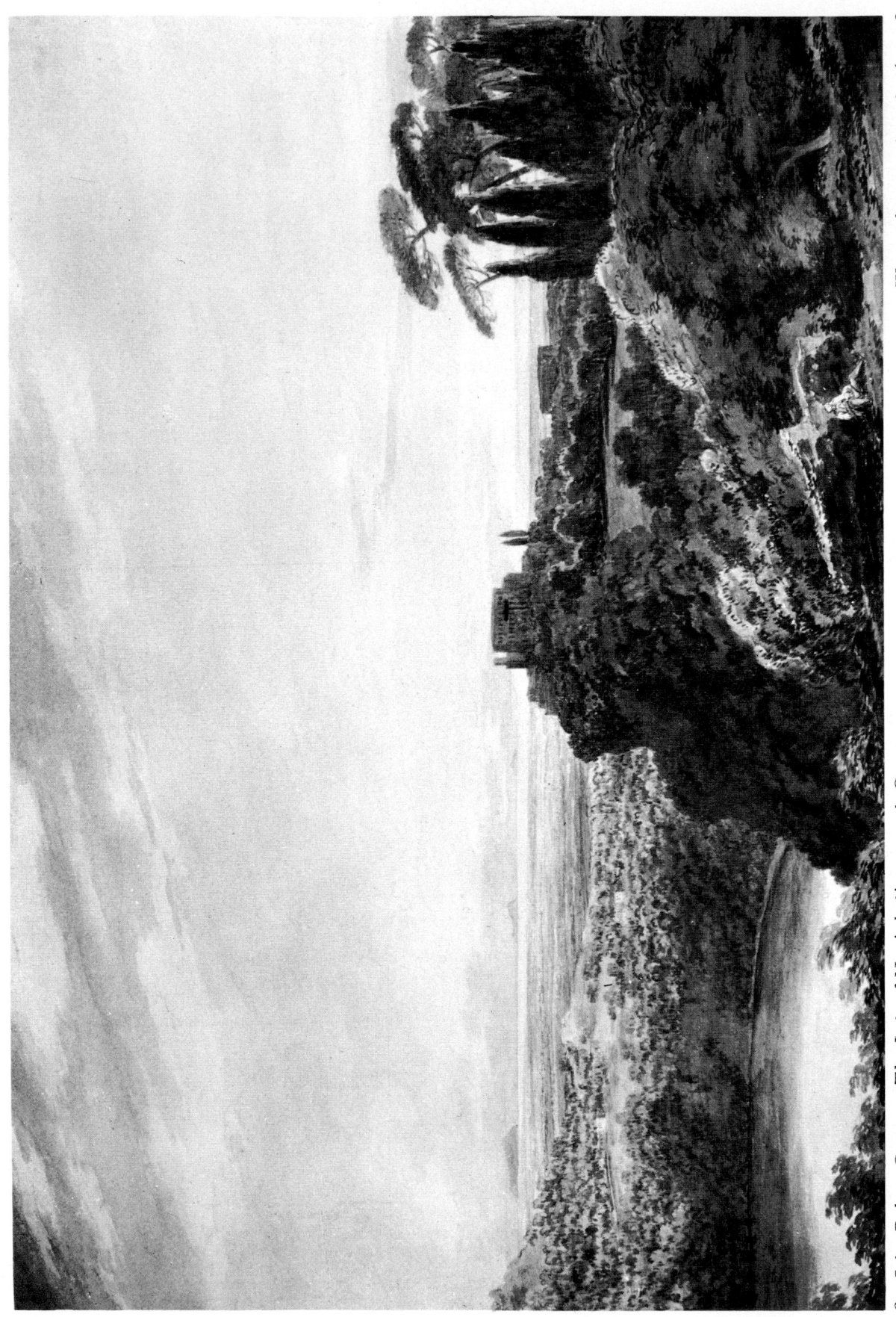

80 John Robert Cozens *The Lake of Nemi, looking towards Genzano*

Water-colours $14\frac{7}{8} \times 20\frac{3}{4}$, $36 \times 52 \cdot 8$
Whitworth Art Gallery, Manchester. *See page 87*
For detail see Colour Plate X

81 John Robert Cozens *Windsor Castle from the South-West*

Water-colours $19\frac{3}{8} \times 27\frac{3}{8}$, $49\cdot2 \times 69\cdot5$
Cecil Higgins Art Gallery, Bedford. *See page 88*

82 Joseph Wright (of Derby) *Matlock Tor, Moonlight*

Canvas 25 × 30, 63·5 × 76·2
Mr. and Mrs. Paul Mellon, Oak Spring, Virginia. *See page 90*

83 Joseph Wright (of Derby) *Landscape with a Rainbow*

Canvas 32 × 42, 81·2 × 106·7
Derby Museum and Art Gallery. *See page 90*

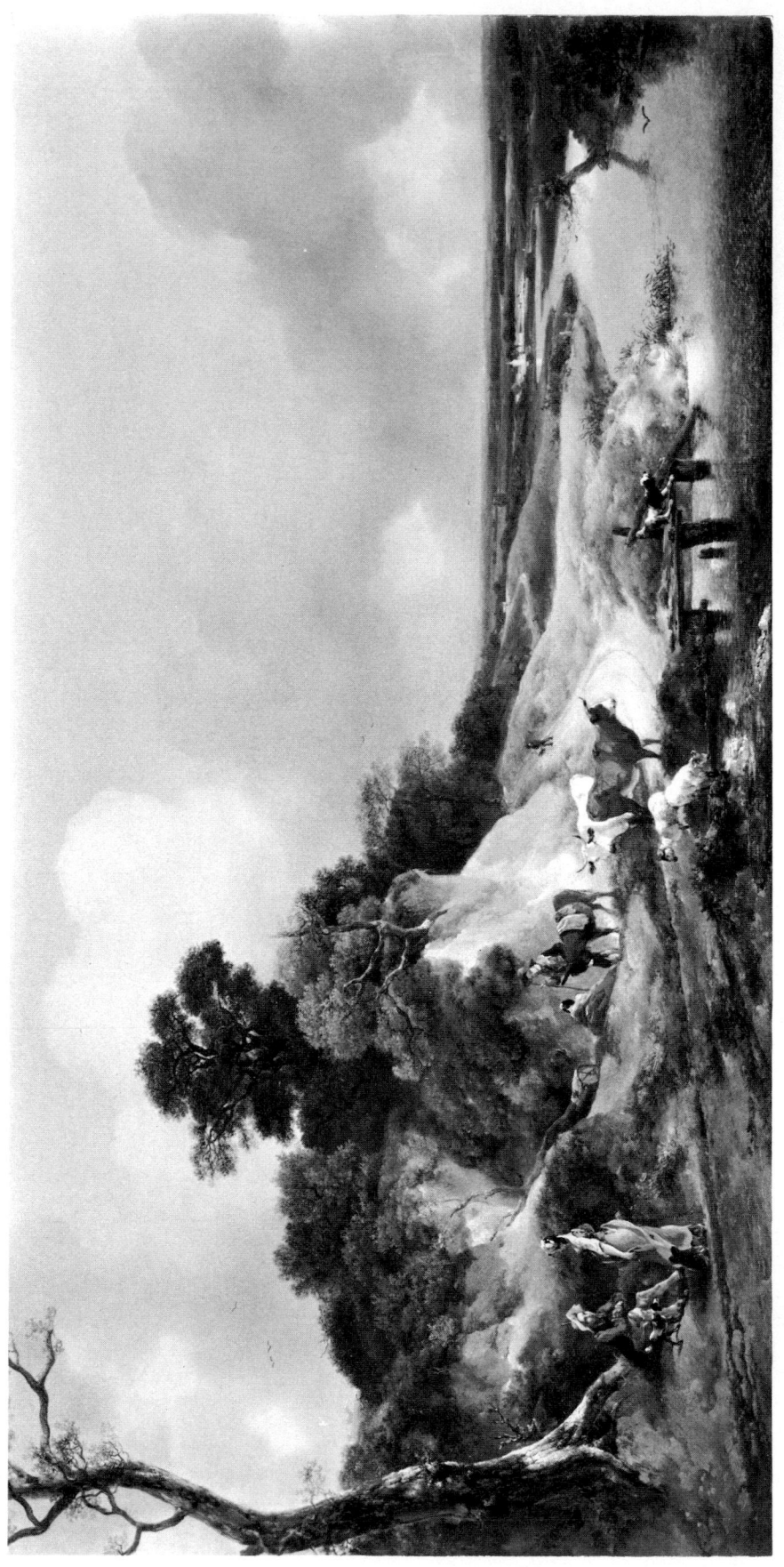

84 Thomas Gainsborough *Landscape with a distant View of Cornard Village*

Canvas 30 × 59½, 76·2 × 151·1
National Gallery of Scotland, Edinburgh. *See page 93*

85 Thomas Gainsborough *Gainsborough's Forest ('Cornard Wood')*, 1748
Canvas 48 × 61, 122 × 155
National Gallery, London. *See page 93*

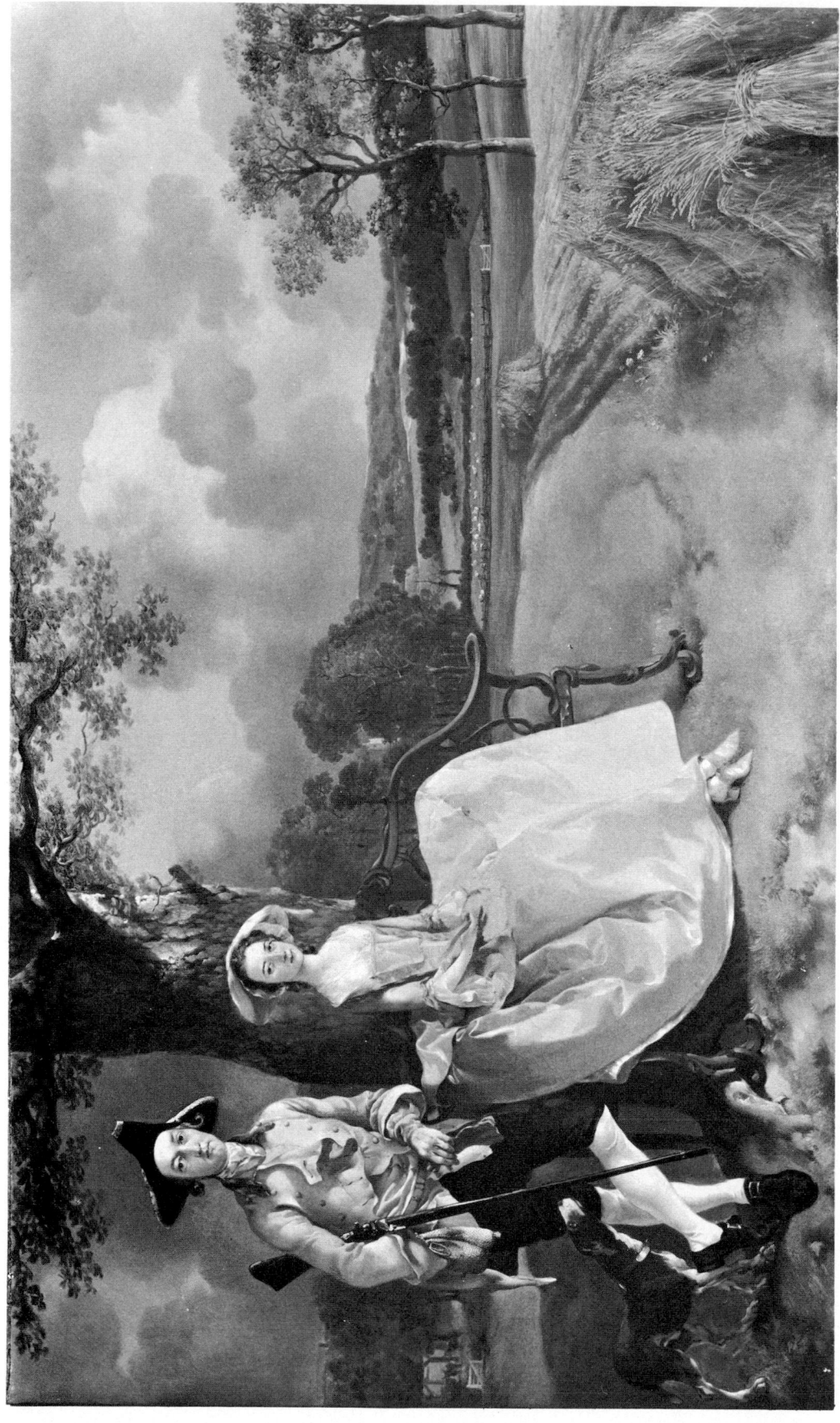

86 Thomas Gainsborough *Mr. and Mrs. Andrews*

Canvas 27½ × 47, 69·8 × 119·4
National Gallery, London. *See page 94*
For detail see Colour Plate XI

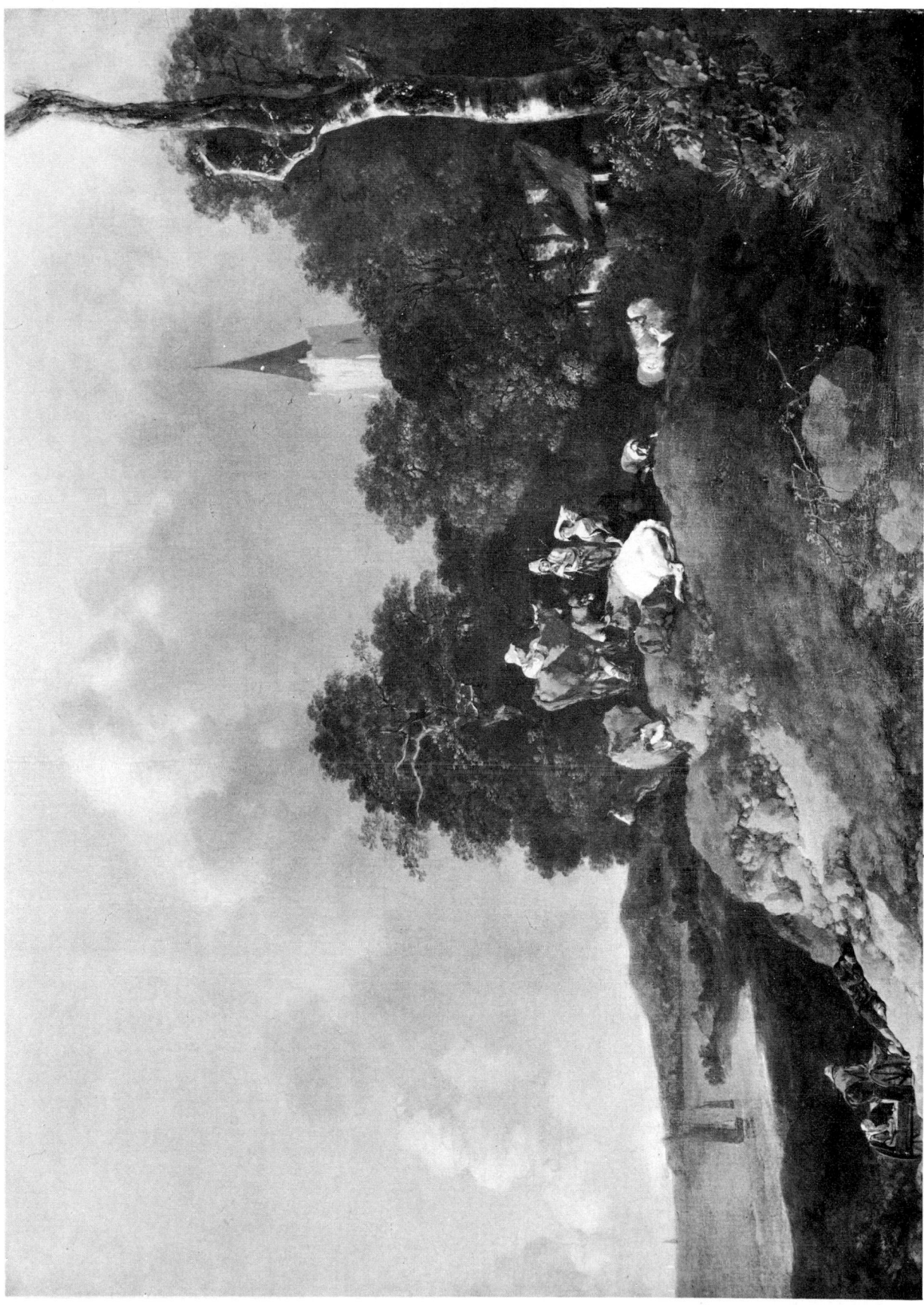

87 Thomas Gainsborough *A View near the Coast*

Canvas 32 × 42½, 81·3 × 108
Christchurch Mansion, Ipswich. *See page 95*

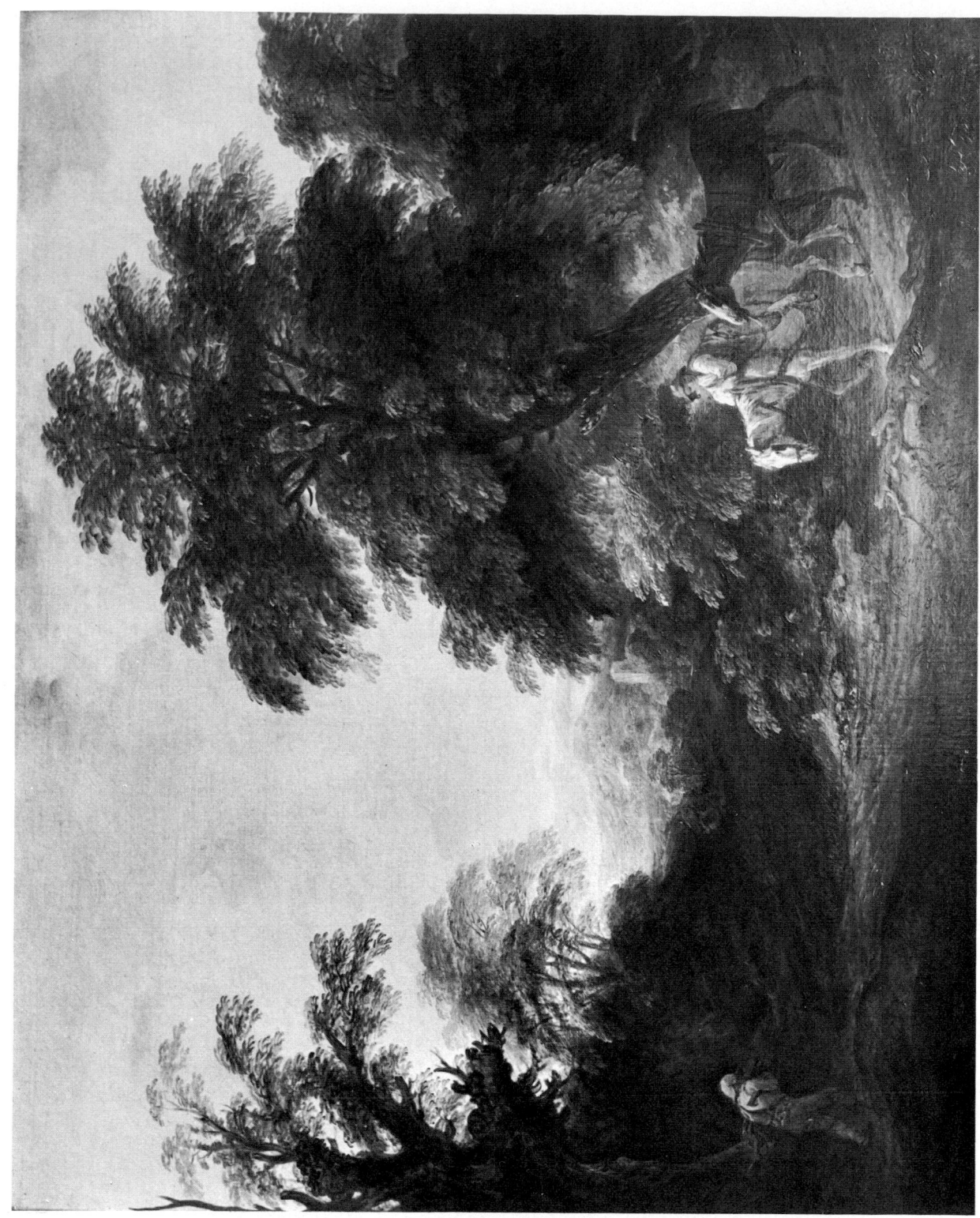

88 Thomas Gainsborough *Wooded Landscape with a mounted Farmboy leading a Horse and a Woodman returning*
Canvas 40 × 50¼, 101·6 × 127·6
Private Collection. *See page 96*

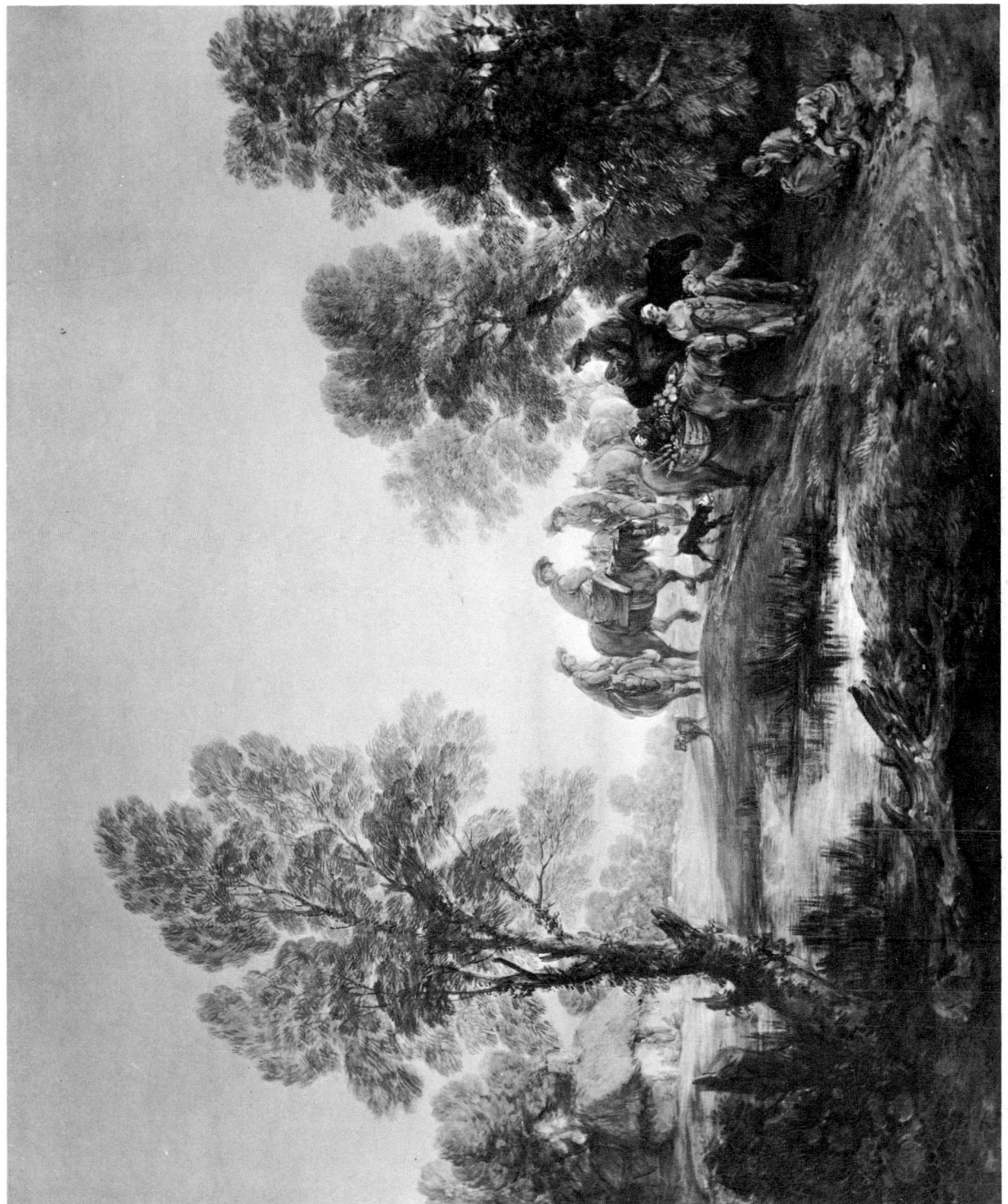

89 Thomas Gainsborough *Going to Market*

Canvas 48 × 58, 122 × 147·4
The Iveagh Bequest, Kenwood. *See page 97*

90 Thomas Gainsborough *River Landscape with Figures in a Boat*

Canvas 46¼ × 66¼, 117·5 × 168·3
Philadelphia Museum of Art. *See page 97*

91 Thomas Gainsborough *The Watering-Place*

Canvas 58 × 71, 147 × 180
National Gallery, London. *See page 99*
For detail see Colour Plate XIII

92A Thomas Gainsborough *Wooded Landscape with Figures and distant Mountain*
Water-colours and body-colour, with traces of paper, on brown paper $10\frac{7}{8} \times 14\frac{3}{4}$, $27\cdot7 \times 37\cdot5$
Ashmolean Museum, Oxford. *See page 97*

92B Thomas Gainsborough *Wooded Landscape with Herdsman and Cattle*
Pencil, water-colours and body-colour, on pinkish paper $8\frac{3}{8} \times 11\frac{1}{8}$, $21\cdot4 \times 28\cdot3$
Major Michael Ingram, Driffield. *See page 98*

93A Thomas Gainsborough *Wooded mountainous Landscape with Sheep*

Black chalk and stump $11 \times 15\frac{7}{8}$, $28\cdot1 \times 40\cdot3$
Private Collection. *See page 98*

93B Thomas Gainsborough *Wooded Landscape with Packhorses descending to a Pool*

Black and white chalks, and grey and grey-black washes $12\frac{1}{2} \times 17\frac{3}{4}$, $31\cdot7 \times 45\cdot1$
Cecil Higgins Art Gallery, Bedford. *See page 98*

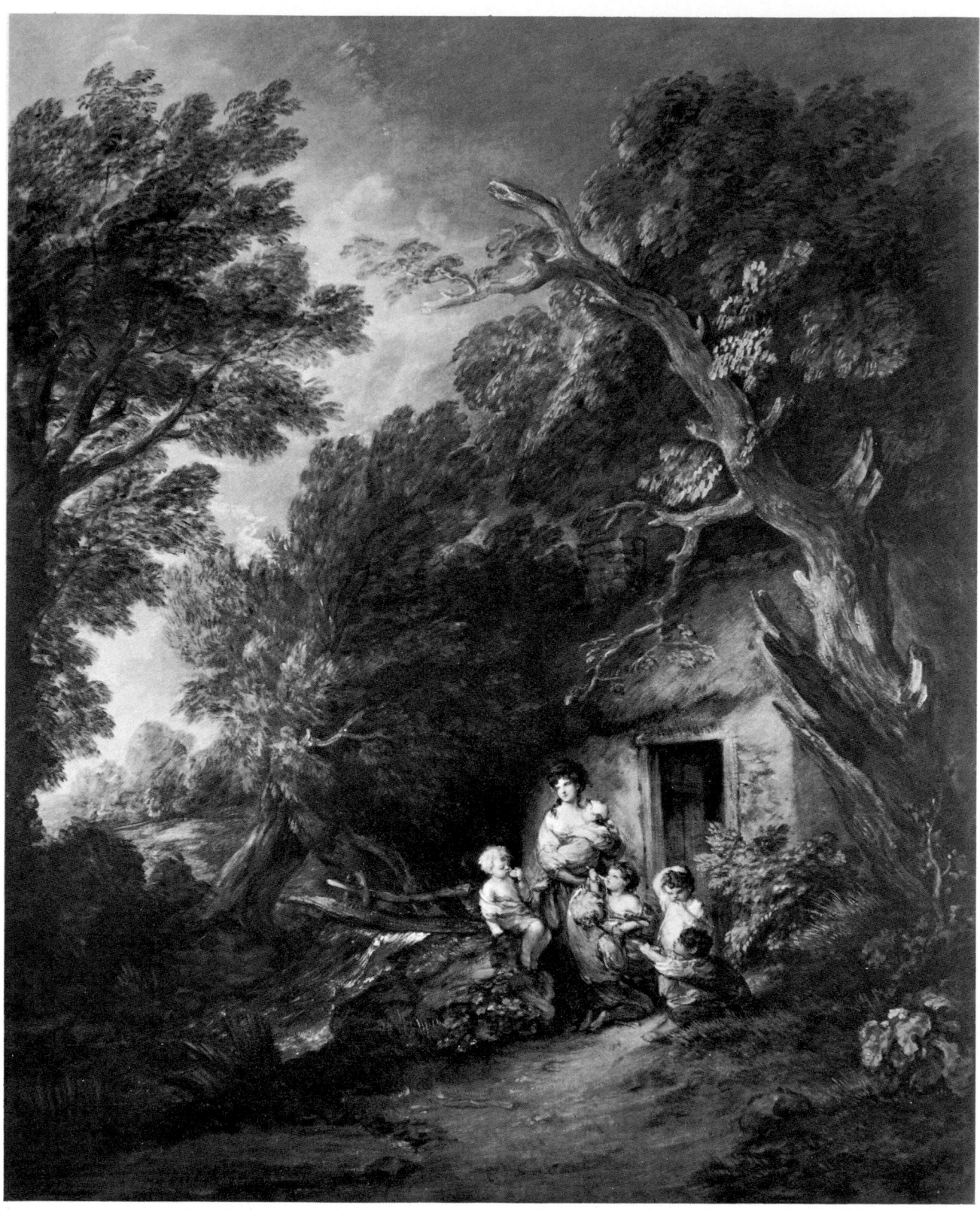

94 Thomas Gainsborough *The Cottage Door*

Canvas 58×47, 147·3×119·4
The Huntington Art Gallery, San Marino, California. *See page* 100

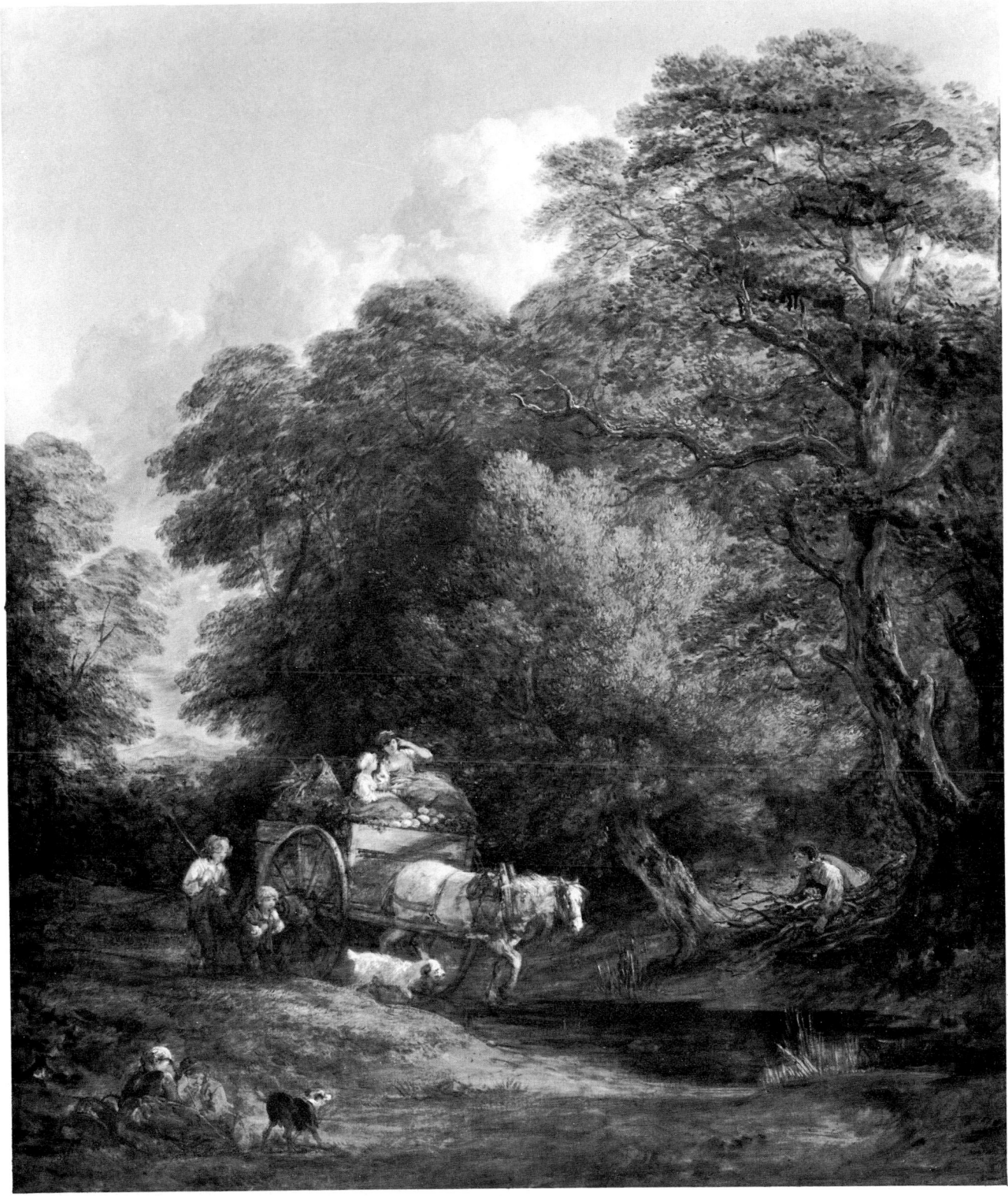

95 Thomas Gainsborough *The Market Cart*, 1786

Canvas $72\frac{1}{2} \times 60\frac{1}{4}$, 184·2 × 153
Tate Gallery, London. *See page* 104

96 Thomas Gainsborough *Coast Scene: Selling Fish* Canvas 39 × 50, 99 × 127
The Trustees of the Grosvenor Estate. *See page* 101

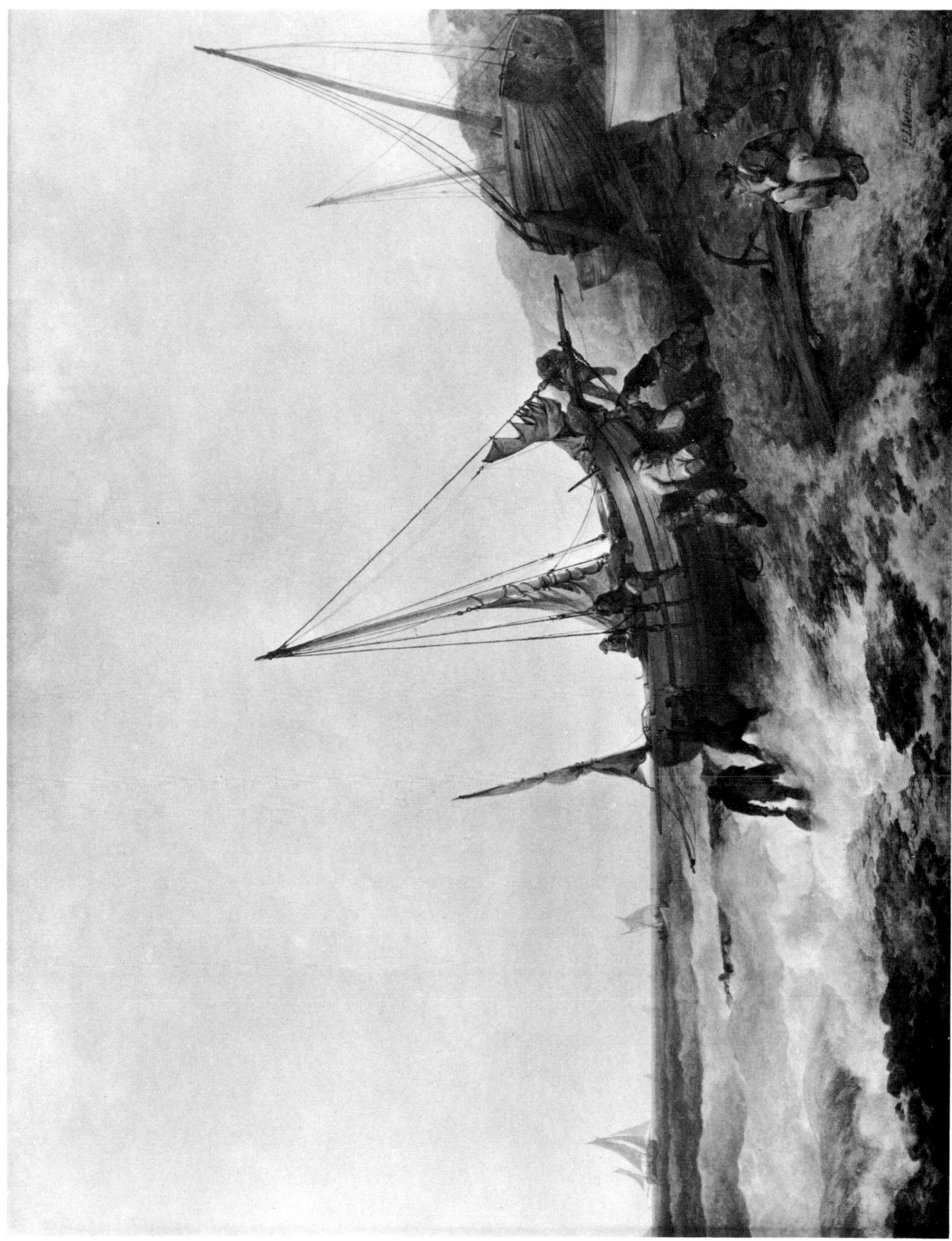

97 Philip James de Loutherbourg *Fishermen launching their Boat*, 1784

Canvas 38 × 51¼, 96·5 × 130·8
The Trustees of the Grosvenor Estate. *See page 115*

98 Thomas Gainsborough *Girl with Pigs*

Canvas 49½ × 58¼, 125·8 × 148·6
George Howard, Esq., Castle Howard, Yorkshire. *See page 103*

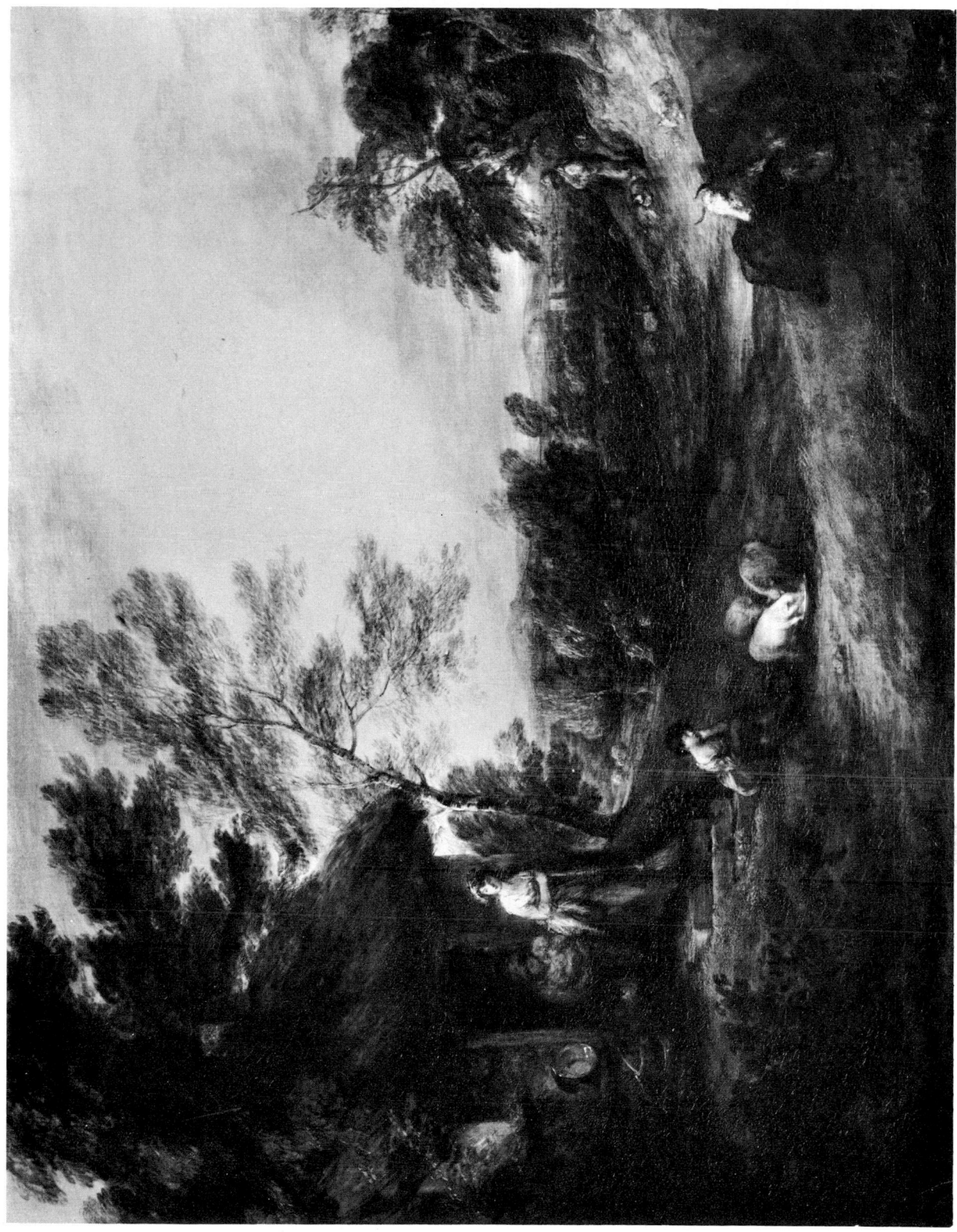

99 Thomas Gainsborough *The Cottage Door*, 1786 Canvas $38\frac{3}{4} \times 48\frac{3}{4}$, 98·5 × 123·8

Mrs. H. Scudamore, London (on loan to Victoria and Albert Museum). *See page* 104

100 Thomas Gainsborough *Rocky Mountain Landscape* Canvas $45\frac{3}{4} \times 56\frac{1}{2}$, $116 \cdot 2 \times 143 \cdot 5$ National Gallery of Scotland, Edinburgh. *See page 102*

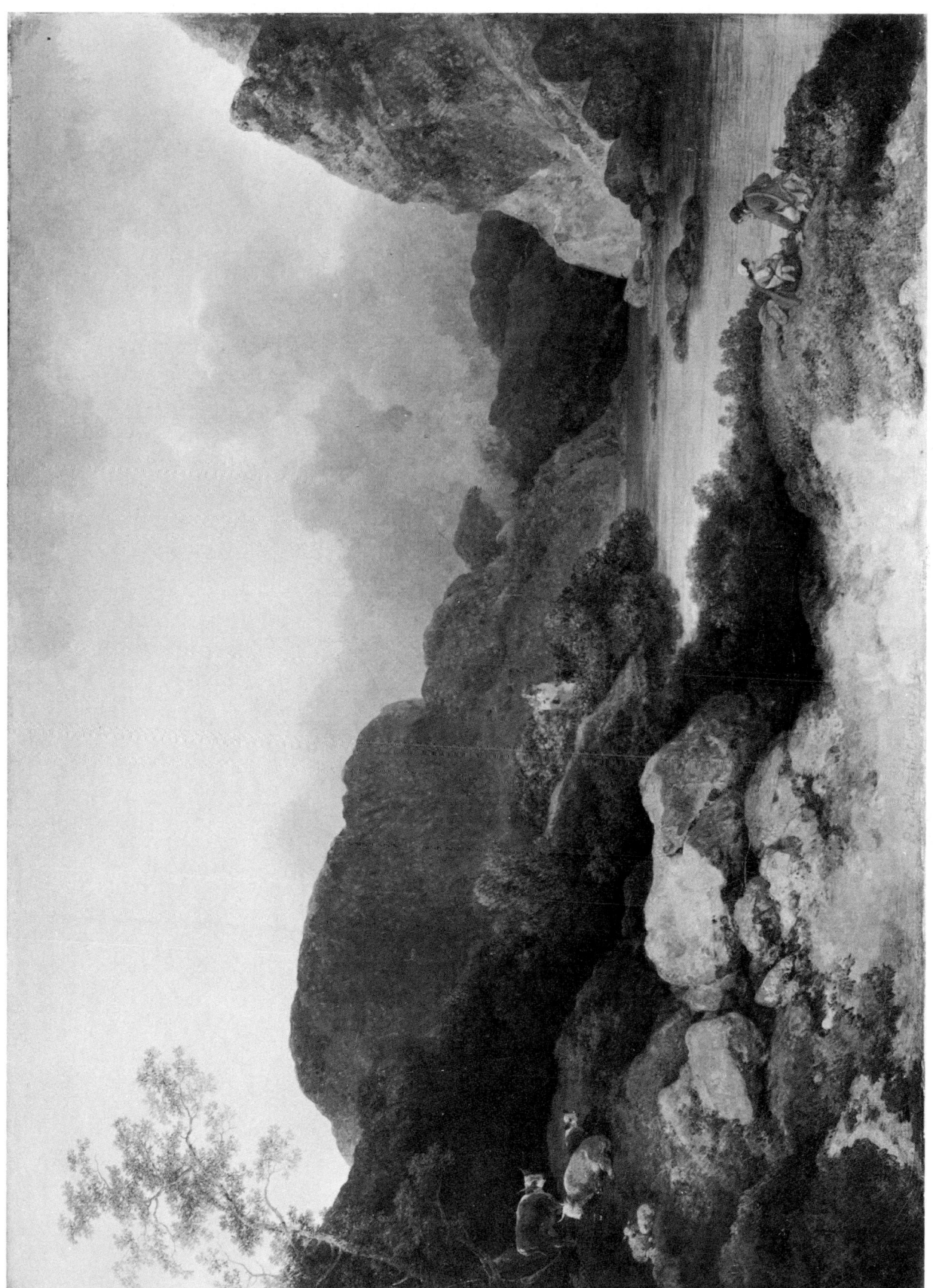

101 Philip James de Loutherbourg *Lake Scene in Cumberland: Evening*, 1792

Canvas $16\frac{3}{4} \times 23\frac{3}{4}$, 42·5 × 60·3
Tate Gallery, London. *See page* 114

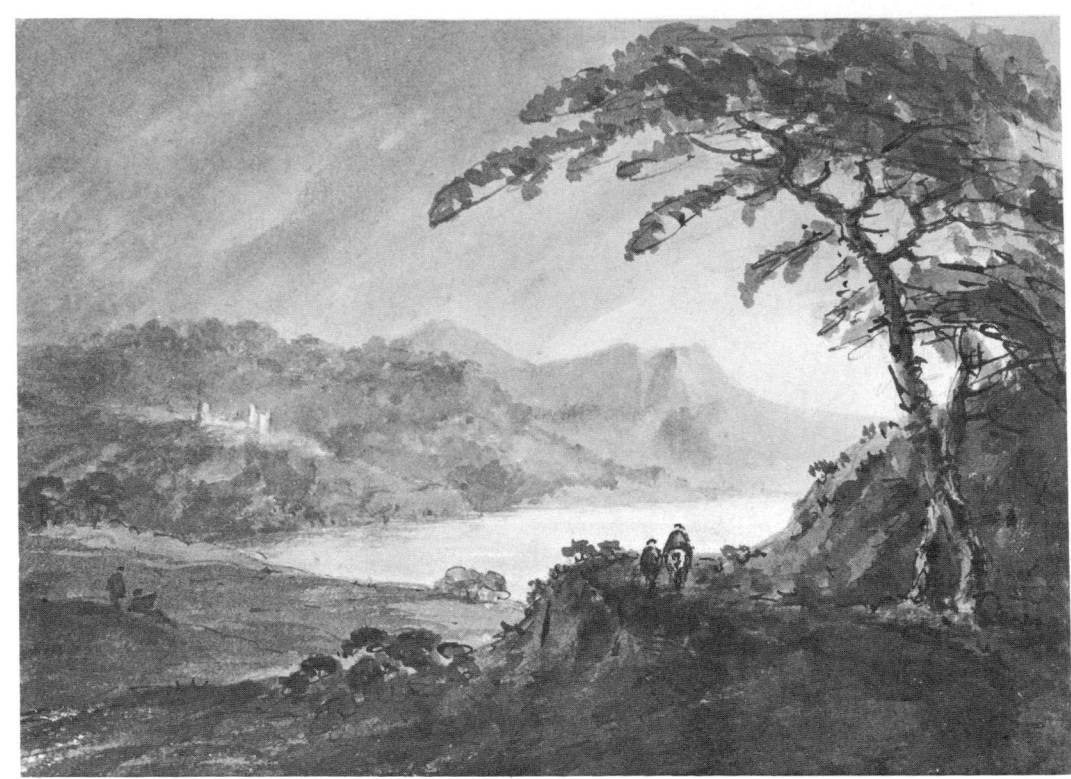

102A William Gilpin *Lakeland Scene*

Reed pen and ink and grey wash $10\frac{7}{8} \times 14\frac{1}{4}$, $26\cdot3 \times 36\cdot2$
Private Collection. *See page* 112

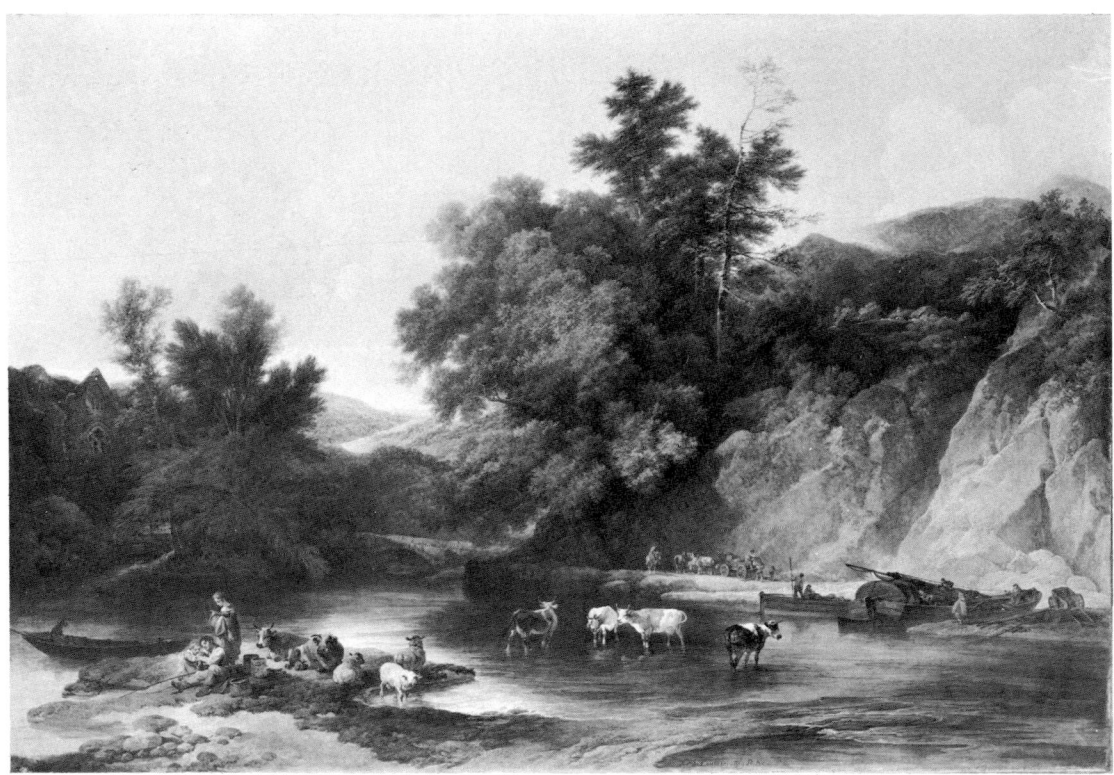

102B Philip James de Loutherbourg *Tintern Abbey on the River Wye*, 1805

Canvas $42\frac{1}{2} \times 63\frac{3}{4}$, 108×162
Fitzwilliam Museum, Cambridge. *See page* 116

103A Philip James de Louterbourg *An Avalanche in the Alps*, 1803

Canvas $43\frac{1}{4} \times 63$, 109·9 × 160
Tate Gallery, London. *See page* 115
For detail see Colour Plate XV

103B Philip James de Louterbourg *The Shipwreck*, 1793 Canvas $43\frac{1}{2} \times 63$, 110·5 × 160
Southampton Art Gallery. *See page* 115

104A George Stubbs *The Rubbing-down House, Newmarket*

Canvas 12 × 16¼, 30·5 × 41·5
Mr. and Mrs. Paul Mellon, Oak Spring, Virginia. *See page* 108

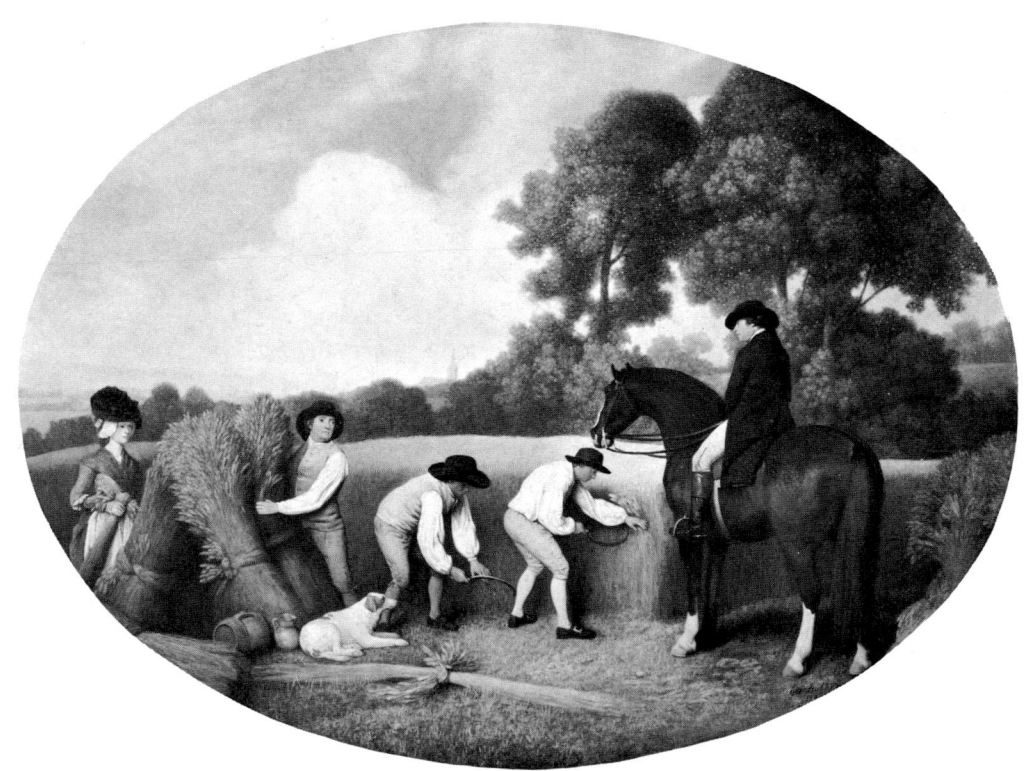

104B George Stubbs *The Reapers,* 1795

Enamel on Wedgwood plaque 30¼ × 41½, 76·8 × 105·4 (oval)
Mr. and Mrs. Paul Mellon, Oak Spring, Virginia. *See page* 109

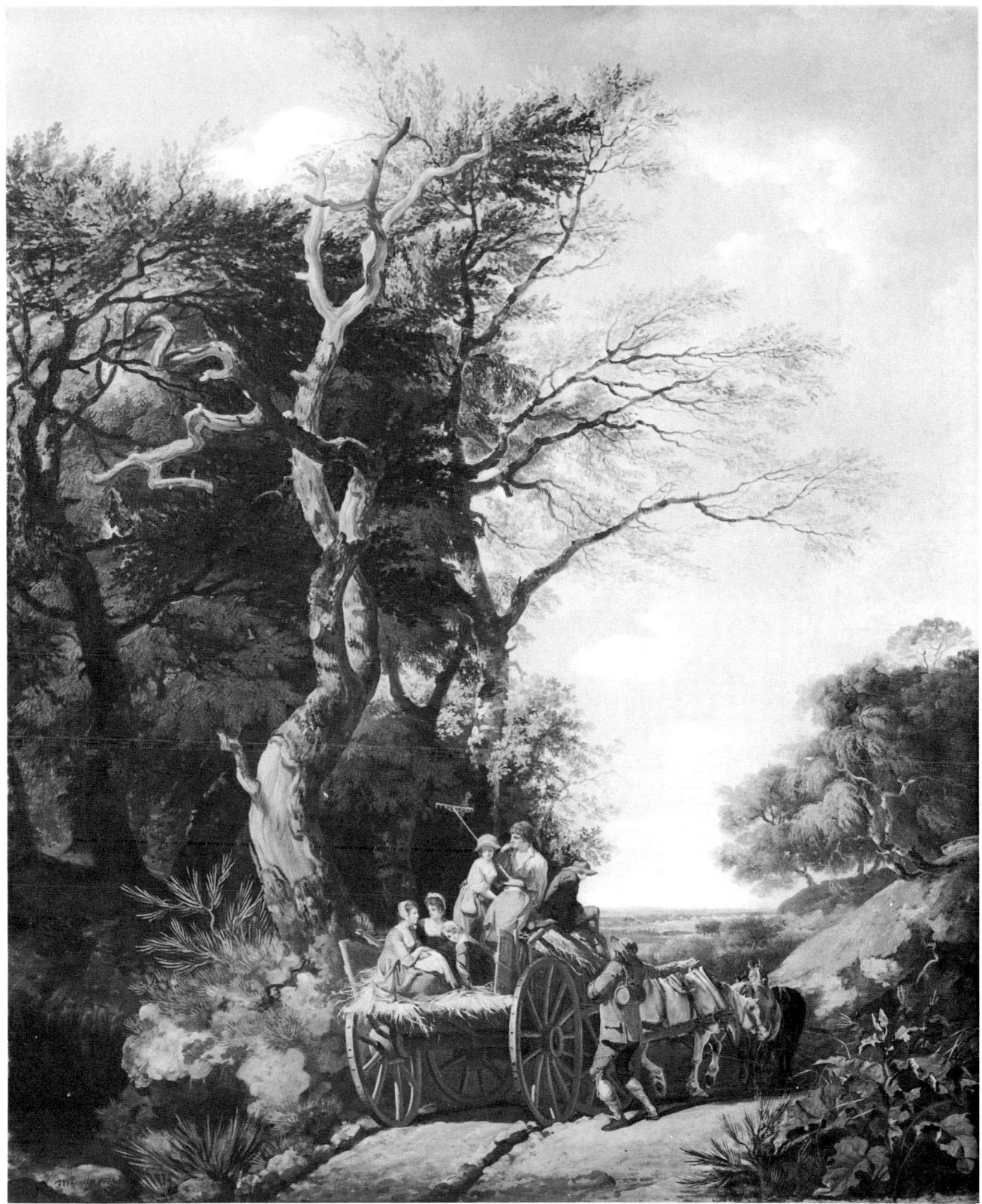

105 Francis Wheatley *The Harvest Waggon*, 1774 Canvas 50½ × 40, 128·3 × 101·6
Castle Museum and Art Gallery, Nottingham. *See page* 117

106A Francis Wheatley *Lake Windermere* Water-colours and pen and ink 6¼ × 10¾, 15·9 × 27·4
Ashmolean Museum, Oxford. *See page 118*

106B Sir Francis Bourgeois *View on the Sea-shore* Canvas 39 × 48¾, 99 × 123·9
Dulwich College Picture Gallery. *See page 116*

107 A George Morland *A Gipsy Encampment* Canvas 18 × 25, 45·7 × 63·5
City Art Gallery, York. *See page* 119

107 B George Morland *Quarry Scene* Canvas 10 × 14, 25·4 × 35·6
Joan, Lady Altrincham (on loan to the City Art Gallery, Bristol). *See page* 118

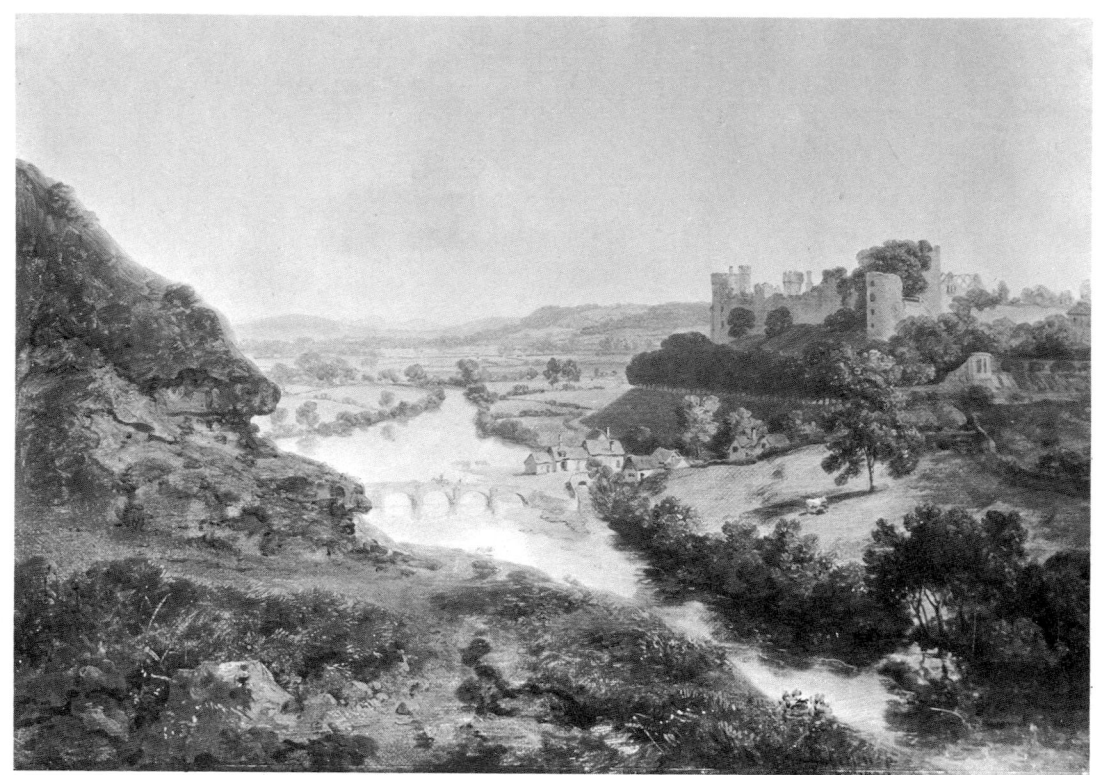

108 A Julius Caesar Ibbetson *Ludlow Castle*, 1792

Canvas $12\frac{1}{2} \times 17\frac{5}{8}$, $31 \cdot 7 \times 44 \cdot 8$
City Art Gallery, Manchester. *See page* 120

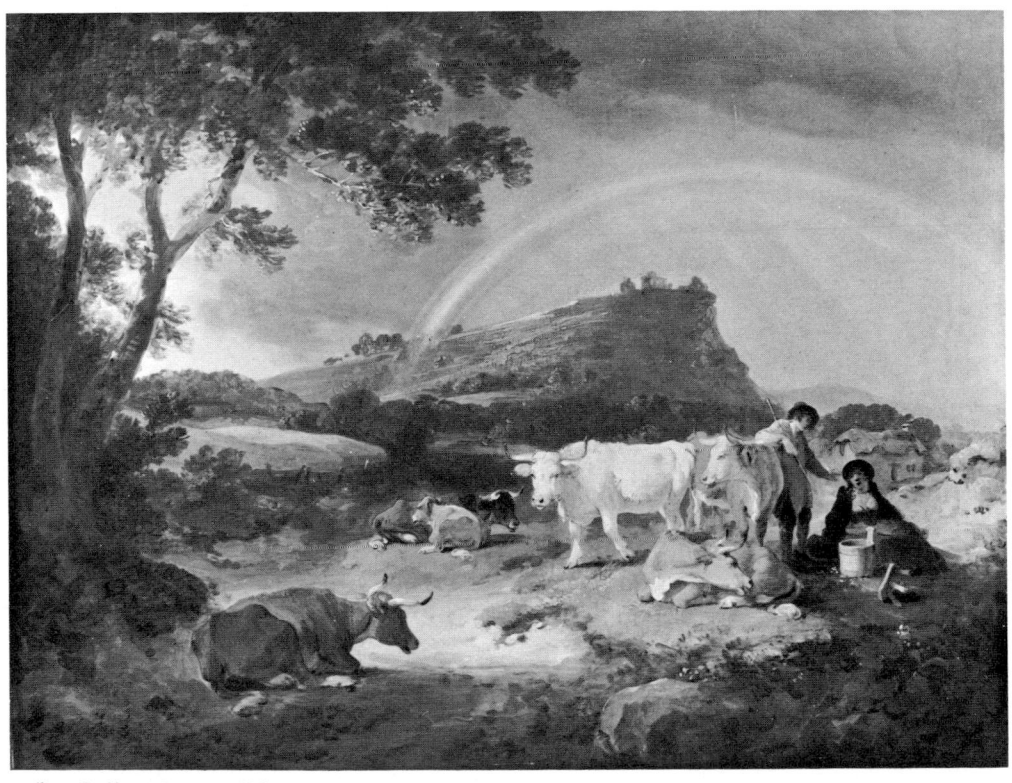

108 B Julius Caesar Ibbetson *Beeston Castle, Shower of Rain*, 1793

Canvas $13\frac{1}{2} \times 17\frac{1}{2}$, $34 \cdot 2 \times 44 \cdot 5$
Castle Museum and Art Gallery, Nottingham. *See page* 120

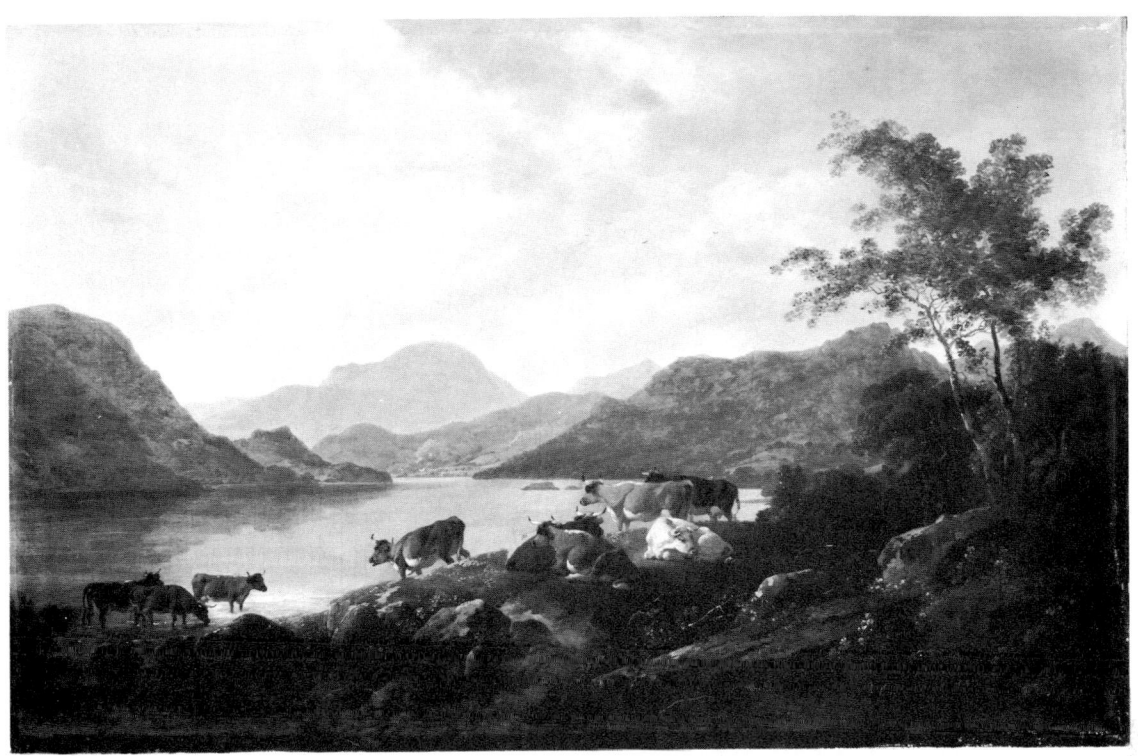

109A Julius Caesar Ibbetson *Ullswater from the Foot of Gowbarrow Fells*, 1808
Canvas $22\frac{3}{4} \times 34\frac{1}{2}$, $57\cdot8 \times 87\cdot6$
Fitzwilliam Museum, Cambridge. *See page* 121

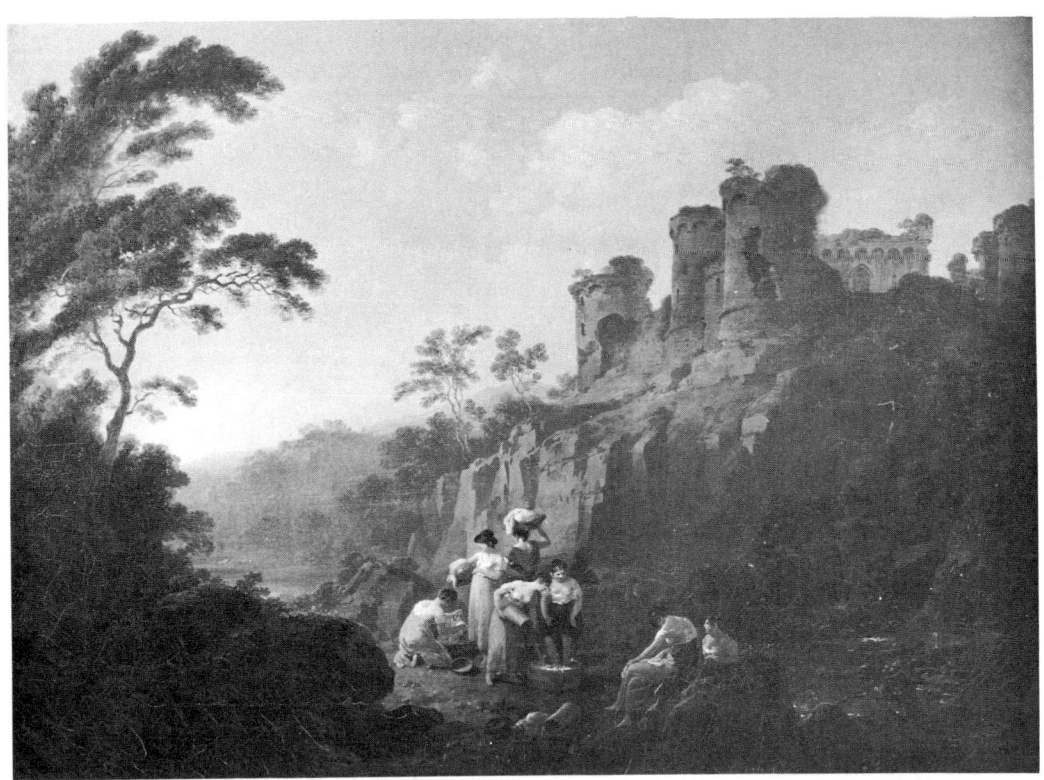

109B Julius Caesar Ibbetson *Landscape with Figures: Masham Castle*, 1811
Canvas $18\frac{1}{2} \times 24\frac{3}{4}$, $47 \times 62\cdot8$
Leicester Museum and Art Gallery. *See page* 121

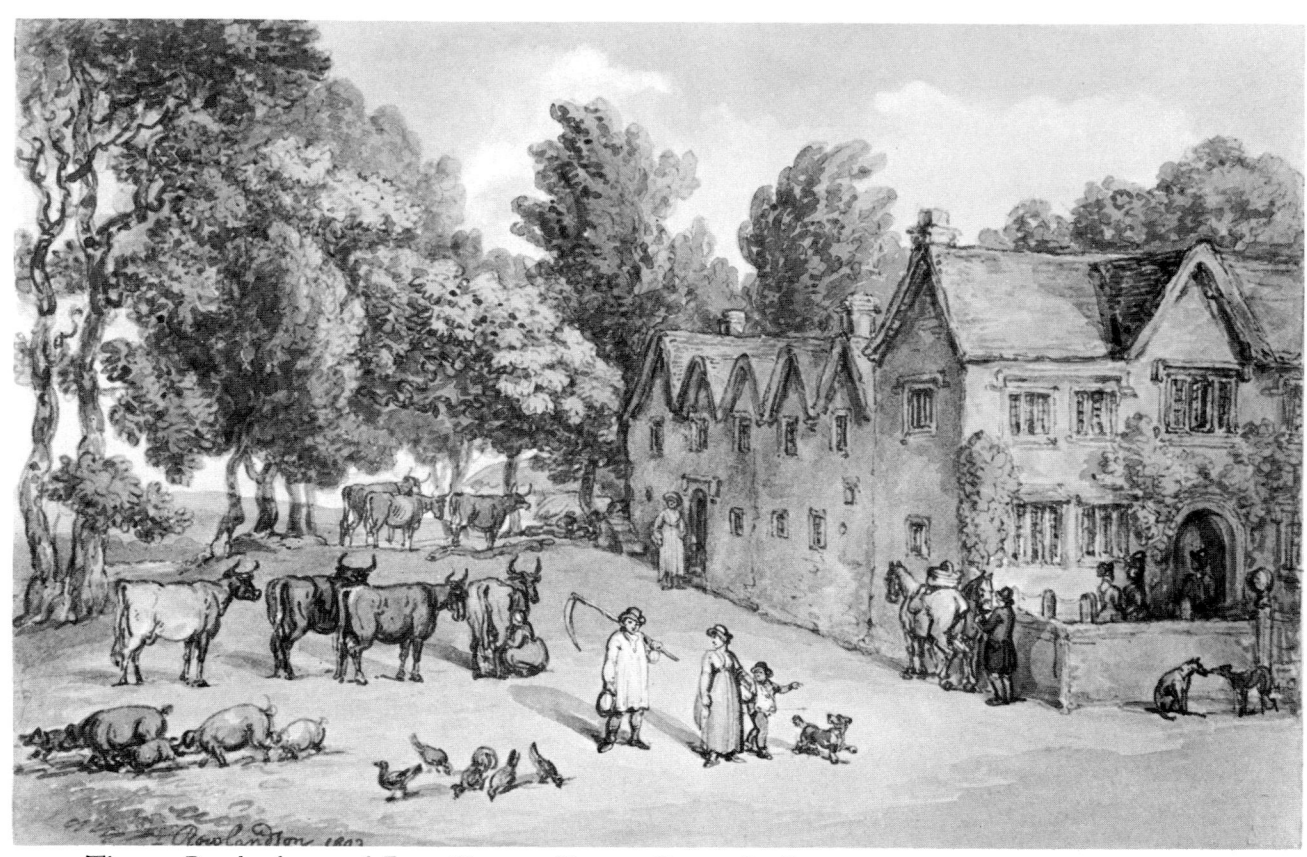

110A Thomas Rowlandson *A Farm House at Hengar, Cornwall*, 1803

Pen and ink and water-colours over pencil $6\frac{3}{4} \times 10\frac{5}{8}$, $17\cdot2 \times 27$
Ashmolean Museum, Oxford. *See page* 122

110B Thomas Rowlandson *Pont Aberglaslyn* Pen and ink and wash with some water-colour $5\frac{3}{4} \times 17$, $14\cdot6 \times 43\cdot2$
The National Library of Wales, Aberystwyth. *See page* 123

111A Joseph Farington *Great Marlow*, 1792

Pen and brown ink with grey wash, over pencil $12\frac{7}{8} \times 18\frac{1}{8}$, $32 \cdot 7 \times 46 \cdot 2$

Ashmolean Museum, Oxford. *See page* 125

111B Joseph Farington *Carlisle*

Pen and ink and wash, over pencil $12\frac{5}{8} \times 18\frac{1}{4}$, $32 \times 46 \cdot 4$

Whitworth Art Gallery, Manchester. *See page* 125

112 Joseph Farington *The Oak Tree*

Canvas 25 × 24, 63·5 × 61
Tate Gallery, London. *See page* 124

113 Thomas Barker (of Bath) *Landscape*

Canvas 30 × 24, 76·2 × 61
Tate Gallery, London. *See page* 127

114 Thomas Barker (of Bath) *Landscape, near Bath*

Canvas 32 × 42, 81·3 × 106·7
Tate Gallery, London. *See page 127*

115 Alexander Nasmyth *Rocky wooded Landscape with ruined Castle by a Loch, 1817*
Canvas $30\frac{1}{8} \times 45\frac{3}{8}$, $76 \cdot 5 \times 115 \cdot 2$
Art Gallery and Museum, Glasgow. *See page 127*

116 William Hodges *The Cape of Good Hope*, 1772

Canvas 38 × 49¼, 96·5 × 125
National Maritime Museum, Greenwich. *See page 129*

117 William Hodges *Monuments on Easter Island* Canvas 30½×48, 77·5×122
National Maritime Museum, Greenwich. *See page 129*

118 Thomas Daniell *The Ghauts at Benares*

Water-colours 15 × 21¼, 38·1 × 54
The India Office Library, London. *See page* 130

119 William Hodges *The Ghauts at Benares*

Canvas 36 × 51½, 91·5 × 130·8
Royal Academy, London. *See page 130*

120 John Webber *View of Macao*, 1784

Canvas 48×62, 122×157·5
The Admiralty, London. *See page* 131

GENERAL INDEX

This includes artists (principal reference in heavy type), collections, other persons (excluding sitters for portraits), and selected subjects mentioned in the text. Authors quoted or discussed in the text are indexed, but those only referred to in footnotes are not. In the entries for collections, works are cited under artists' names, listed alphabetically. A Topographical Index follows.

GENERAL INDEX

TOPOGRAPHICAL INDEX

This index includes regions, towns and country houses forming the subject of pictures mentioned in the text. The first part covers Great Britain and Ireland, followed by a second sequence of overseas locations, arranged by country or region; these foreign locations have not been exhaustively indexed.